ART
IN EUROPE

D1327062

Cover: Keiichi Tahara, photographic emulsion on stone, 1999.
Gold and platinum leaves. 39$^{1/4}$ x 39$^{1/4}$ in. © Keiichi Tahara.

© 2001 Assouline Publishing, Inc. for the present edition
First published by Editions Assouline, Paris, France

Assouline Publishing, Inc.
601 West 26th Street
18th floor
New York, NY 10001
USA

www.assouline.com

ISBN: 2 84323 248 1

Translated from the French by Deke Dusinberre
Proofreading: Stephanie Iverson

Printed and bound by Leefung-Asco (China)

All rights reserved.
No part of this publication may be reproduced,
stored in a retrieval system, or transmitted in any
form or by any means, electronic, mechanical,
photocopying, recording, or otherwise,
without prior consent from the publisher.

ART
IN EUROPE

FROM THE VANDALS TO THE AVANT-GARDE

PASCAL BONAFOUX

ASSOULINE

To Manon

*I wanted to try to link or group all subjects in a series of tableaux
liable to hold the attention of the readers that I primarily had
in mind, and to make them wish to know more than I could
teach them. I therefore proposed to instill the art of a painter rather
than a scholar's profounder knowledge. I also had
in mind a particular purpose: I wanted to cover again for myself,
in an agreeable order, the little that I knew of each subject.*
Charles BONNET, *Mémoires Autobiographiques*

CONTENTS

The idea of culture, intelligence, and magisterial works entails,
for us, a very ancient relationship with the idea of Europe
—so ancient that we rarely go all the way back.
Other parts of the world have had admirable civilizations
along with first-rate poets, builders, and even scholars.
But no part of the world possessed this unique physical
property of the most compelling power of absorption linked to
the most compelling power of emission. Everything has come
to Europe, everything has come from it. Or almost everything.
Paul VALÉRY, *Variété, La Crise de l'Esprit*

Allegorical map of Europe.
Extracted from Sebastian Münster's
Cosmographia, 1628. Basel, Switzerland.

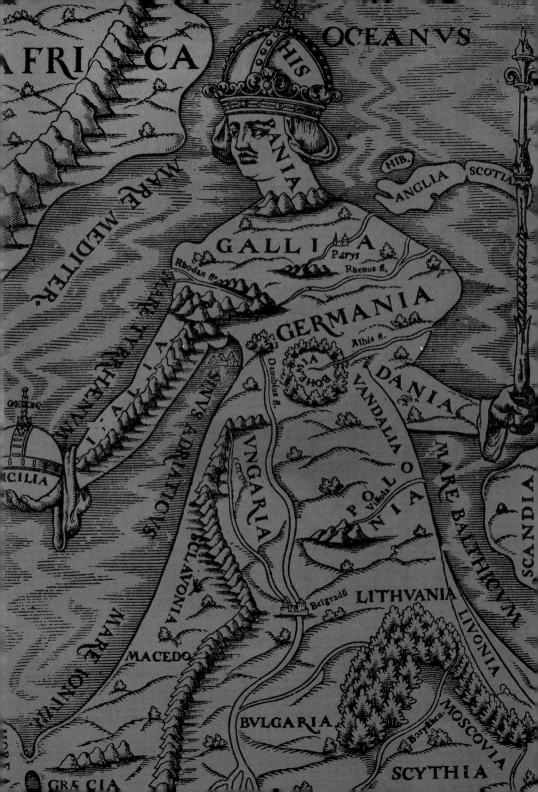

INTRODUCTION

"The count of *** claimed to be a connoisseur of painting. One day, Louis XV pointed to a superb painting of Jesus Christ on the cross and asked, 'Who is this Christ by?'

"'Surely your majesty jests, sire,' replied the count.

"'All the same, which master did it, do you think?'

"'Anyone can see, sire, unless he's blind, that it's by INRI.'"

In a strange paradox, this count—who was undoubtedly baptized and raised by chaplains as well as tutors, and who perhaps had his own confessor—knew absolutely nothing of the gospel according to John. The gospel reports, "Pilate also wrote a title, and put it on the cross; it read 'Jesus of Nazareth, the King of the Jews.' Many of the Jews read this title, for the place where Jesus was crucified was near the city; and it was written in Hebrew, in Latin, and in Greek." Louis XV's unknown artist had painted just the first letter of each word in Latin capitals, leaving INRI (*Iesu Nazarenus Rex Iudaorum*). This "superb painting of Jesus Christ on the cross" therefore displayed both the unique style of a painter and respect for the gospels according to Matthew (28:37), Mark (15:26), Luke (23:38), and John (19:19). The latter was the only one to add that the Pilate's text appeared in three languages: "What I have written I have written." Religious painting is theological or it is nothing. There is no history of Christian art that is not first of all a history of the Christian religion, a history of dogmas, debates, and schisms. For centuries and centuries, the form taken by art was determined more by councils than by manifestoes—assuming the painting of images was even permitted. Obviously the count of *** who attributed this painting to INRI was ignorant of all that.

When confronted with artworks, I have often been caught off-guard like the count of ***, at a loss like him. It was not a question of attributing a given painting to a given master, so it was impossible to dodge the issue, impossible to answer "INRI" to questions raised by the works I was dealing with. I have found myself unable to decipher the scene depicted

by the frescoes in a chapel, or the characters carved on some capital in the half-light of a crypt, or the grotesque motifs swarming over the walls and ceiling of some palace gallery. What were the scenes describing, what did those forms represent, what role did they play? What values, what requirements, and what criteria fashioned them? What discovery—or perhaps what arbitrary preconception—changed the way, in a given era, in which things were to be depicted? And so on and so on. The presence of a work, its indecipherable intensity, always triggers a flurry of questions. The cynical claim by an artist in March 1968 that "modern art has the great advantage of making it clear to us how vain art has been in every age" might have allowed me to stop asking such questions. I simply needed to accept a lack of cultivation, to remain indifferent. To accept cynicism and amnesia.

No, thanks. Baltasar Gracián y Morales wrote, "Man is born barbarous, and only culture rescues him from the condition of animals; the more cultivated he is, the more human." (The count of ***, strangely, once again, had not read the French translation of Gracián's *Art of Worldly Wisdom,* which right from its 1647 publication in Spain became Europe's key to what every gentleman should know and what precepts he should follow.) This certainty of Gracián's, however anachronistic, is a certainty I share and one which I willingly confess.

I have therefore stuck to the observation made by Karl Marx in 1857 in his *Introduction to a Critique of Political Economy:* "The difficulty does not consist in understanding that Greek art and epics are linked to certain forms of social development. The difficulty consists in understanding how they continue to give us aesthetic satisfaction." This comment by a disconcerted Marx—who avoided offering an answer—refers not only to "aesthetic satisfaction," to the emotions provoked by the very presence of an artwork. Defining such "satisfaction," the emotions stirred by some ancient artwork, would refer only to the effect, saying nothing of the cause. And what is that cause? Well, I think of Baudelaire's

poem *The Beacons,* because it offers what may be the only valid answer. Baudelaire listed the works of Rubens, Leonardo da Vinci, Rembrandt, Michelangelo, Puget, Watteau, Goya, and Delacroix, which he called, "These curses, blasphemies, these maledictions, groans / These ecstasies, these pleas, cries of *Te Deum,* tears." Baudelaire was convinced that they were an "echo respoken by a thousand labyrinths," providing the "best witness . . . that we might give . . . of human dignity." It is this "witness of human dignity" that I want to deal with, the "ardent sob that rolls onward from age to age." For therein lies the sole reality that withstands time—the passing of time—the sole reality that offers a sign of permanence.

This book points to the factors determining the forms taken by art century after century, which does not mean that it is a history of art. It displays only one of the attributes of a proper history—chronology. Perhaps in the end it might read more like a novel, a "novel" in the sense proposed by poet Louis Aragon: "A novel, that is to say a language invented to explain, it might be argued, the unique activity to which painters and sculptors deliver themselves, to call by their ordinary names those explorers of stone and canvas whose art resides precisely in what escapes textual explanation."

You therefore know what you are dealing with right from the start. The circumstances history thinks it describes provide neither a passkey nor a crowbar. We can never solve the enigma of art that commits infractions. It should be remembered that posterity acts as a kind of bailiff to history—a whimsical bailiff who eliminates, abandons, loses, and recovers; a kind of vandal who tries to pass as an archivist. Legends provide another reason to keep our distance from history—is Don Juan a product of Tirso de Molina's sixteenth century, of Molière's seventeenth century, of Mozart's eighteenth century, or of Byron and Pushkin's nineteenth century? And so on. The power of legends belongs to an imaginative faculty that can dispense with time.

Europe itself is as much legend as continent. In 1643, Jean Baudoin published *Iconologie,* a book presented—in part—as an "Iconology or New Explanation of Several Images, Emblems and Other Hieroglyphic Figures of Virtues, Vices, Arts, Sciences, Natural Causes, Various Humors and Human Passions. . . ." Baudoin's book was of course "based on the research and figures of Cesare Ripa" and claimed that "Europe was named after Europa, the daughter of Agenor, King of Tyre, who was carried off by Jupiter and taken to the

Island of Crete." As was fitting, the allegorical figure of Europe was "a lady royally dressed in a gown of several colors," surrounded by attributes that leave nothing to chance. If her dress is "of several colors," that is because "this part of the world is greatly rich and diverse in beauties." If Europe "holds a temple in her right hand," that is because it "signifies that the true and perfect religion is cultivated in her domain." Baudoin also mentioned that the books, globes, compass, ruler, paintbrushes, and musical instruments at her feet revealed "the excellence of minds both Greek and Latin that she has produced in all kinds of fields." It hardly mattered that for centuries Europe had completely forgotten these Greek and Latin minds; Baudoin was convinced—as was Cesare Ripa, who in 1593 had published the first *Iconologia,* translated into every language—that "Europe" had a collective memory. And everyone in Europe was convinced that the nine muses—Calliope, Clio, Erato, Euterpe, Melpomene, Polyhymnia, Terpsichore, Thalia, and Urania—could fulfill their role only because they were the daughters of Mnemosyne, who was none other than Memory personified.

When, in 1827, Ingres painted *The Apotheosis of Homer,* he placed around Homer the likes of Sophocles and Corneille, Aeschylus and Racine, Euripides and Molière, Camoëns and Gluck, La Fontaine and Socrates, Plato and Shakespeare, not to mention Michelangelo, Aesop, Raphael, Mozart, Tasso, and others. The forty-odd figures gathered around Homer were presented as contemporaries of one another. The twentieth century was the first to abandon these anachronistic assemblies, the first to shun its heritage. (Past art was consigned to the formaldehyde of commemorations; regular ritualistic reverence supplanted the lasting role model it was supposed to play.) By 1912, poet Guillaume Apollinaire already noted that young painters were "moving further and further from the old." The twentieth century heralded a period when people sought an "art that displays the sole feature of inventiveness, and not those of chameleon or ape as seen in cultured art." That claim was made by Jean Dubuffet in 1948 in his call for *art brut,* "raw art." The twentieth century was iconoclastic, and chose amnesia. It wanted a clean slate and pro-duced the first "ready-mades"—but that is another story.

It was the final episode of everything that began in 732. Because 732 was the year the his-tory of Europe commenced—despite itself. Although Europe was not yet aware of itself as such in 732, the people invading it knew what they were confronting. The chronicler who

recounted what turned out to be the defeat of the Arabs near Poitiers, in what is now central France, used the term "Europeans" to describe the men fighting under Charles Martel. The only thing all those "Europeans" had in common was their religion—they were Christian. Only those people who accepted the teachings of the Roman church were Europeans. The Rome of the popes no longer had anything in common with the Rome of emperors several centuries earlier. The Europe which claimed to be heir to the Roman Empire was salvaging a legend. Catholic Europe was simply a region that was holding out against both the Arab and Byzantine empires. It is far from certain that monks who painted illuminated gospels in the eighth and ninth centuries thought they were producing works of art. They were simply offering up a prayer, a prayer worthy of God's splendor, nothing more.

Similarly, the abbot who oversaw the construction of his monastery a few centuries later did not realize he was producing "Romanesque" architecture. For good reason: the abbot could hardly have read the letter written in 1818 by Charles Duhérissier de Gerville, who first used the term "Roman" to refer to architecture that had been called "old Gothic" up until then. Likewise, when Abbot Suger built the basilica of Saint-Denis he did not know it was "Gothic," because that adjective was first used in the seventeenth century as a term of contempt when Molière criticized the "bland taste for Gothic ornament." In the same way, the independent painters who in April 1874 exhibited their canvases in a studio on Boulevard des Capucines in Paris—a studio lent to them by the photographer Nadar—did not know that art critic Louis Leroy would contemptuously ridicule them with the label of mere "impressionists." Such government-approved labels (Romanesque, Gothic, Impressionist, etc.), labels that classify and sort, overlook the main point: namely, the issues that shape a unique style.

What turns an exception into the rule? Rules maintain a special relationship with exceptions, making you wonder whether art is based on rules yet builds its history on exceptions. Maybe rules produce works that are merely useful (and forgotten once no longer useful), whereas memory records and recalls only the exceptions. Maybe the history of art is no more than the history of artists. Artists who learn the rules (the way they learn studio gimmicks and formulas) in order to break them. Maybe, century after century, artists were the same ilk as William Webbe Ellis who, in 1823, scorned the rules of soccer and

took the ball into his opponents' goal with his hands—inventing a game at a school called Rugby. Yet even admitting that artists are "cheaters" does not explain how the broken rule—the "trick" or deliberate fault—becomes a model itself. At the risk of upsetting and disappointing audiences at the court of Florence, Jacopo Peri (in 1598) and Giulio Caccini (in 1600) each presented a *dramma per musica* rather than a standard pastorale intercut with *intermedi;* in nearby Mantua in 1607, Claudio Monteverdi borrowed the musical form sketched by the Florentines for his *Orfeo.* Thus began the history of opera, a history that all Europe would make its own.

It is the forms and styles—the histories of forms—adopted by Europe that is the subject of this book. It goes without saying that a scrupulous account of every history of every style—emergence, apotheosis, and downfall—would require a whole library. This single volume is hardly that, and because it cannot recount "everything," it will merely point to key highlights. From period to period, it will lead to the special places devised by Europe—from monastery to private study and from opera house to literary salon—places where corresponding forms and styles could be nurtured.

This book represents an invitation. An invitation to discover how the arts—painting as well as music, architecture as well as poetry—have shaped Europe's growing awareness of itself. During the Renaissance, humanist architect Leon Battista Alberti wrote, "Rather than please a few, I'll try to be useful to the greatest number." I will take Alberti's motto as my own, which means avoiding an accumulation of details, dates, names, references, and technical terms (at the risk of seeming trite or appearing to lack scholarly rigor). Like an orientation table perched high above a fine vista, these pages point to the main features of Europe's imaginative faculty over the centuries, indicating the various forms it took from Venice to Madrid, from Rome to Prague, and from Vienna to Paris, Amsterdam, London, Berlin, and Saint Petersburg.

ROME, GOD, EMPEROR

Before Europe existed, there was the Roman Empire—an empire assailed, sacked, and finally ruined by barbarians. Nomadic tribes, each with different beliefs and ambitions, then fought and harried one another for centuries before finally settling down together. They began to listen to the promise of a better world made to them by the priests of the old empire and soon sought baptism in the church whose God had sacrificed his only Son, Christ the Lord. New art forms would soon spring from this fertile soil of ancient ruins, nomadic crafts, and shared faith—but in order to understand that art, a little history is required.

EUROPE BEGAN AT POITIERS

Europe meant nothing to the men who gathered for battle near Poitiers at the end of October 732. It is not even known whether the name "Europe" was known to them. Those men came from Austrasia, from Neustria, from Burgundy. Others probably came from Gascony and Aquitaine, which the Arabs had already swept through. In just a few years after crossing the Strait of Gibraltar in 711, the Arabs defeated and pushed the Visigoths toward the Pyrenées; the Visigoths no longer constituted an obstacle to Arab incursions further north. But never had the Arabs pushed so far. Poitiers, in what is now central France, was threatened. A chronicler ends his account of the expedition led by Abd al-Rahman with these lines: "Drawing sword from scabbard as dawn broke, the Europeans saw the tents of the Arabs aligned the way camps of tents were normally arranged. They did not know that the tents were all empty and thought that inside them were phalanxes of Saracens ready for battle; but the scouts they sent

Figured poem from *De Laudibus Sanctae crucis.* Texts by Rabanus Maurus, handwritten on parchment. Early 9th century. Osterreichische Nationalbibliotek, Vienna, Austria.

AST·SOBOLES·DOMINI·ET·ONS·DOMINANTIUM·UBIQ·HIC
EXPANSIS·MANIBUS·MORI·FORMANTIS·HABENDUM·EN
PERDOCET·HUNC·UNUM·GR·XIUSTIFICAT·COLIT·ATQE
ET·SIC·MORE·FATIGANTI·XPUCE·NAM·SUA·MEMBRA·HAC
RITE·PROBANT·PLEBES·VTIS·SPONDET·QE·PARENTEM
NA·HUNC·SCRIPTURA·AE·TIV·CVLMINE·IESUM
ET·PROBO·QUOD·REX·AI·IV·INVENTA·MALORUM·EST
QAE·OCCIDIT·REGEM·I·SV·XA·TAM·ATQE·POTENTER
TELA·RUPIT·UAH·MARTI·IV·DOGMATA·CONPLENS
PRITUM·NOS·SIM·AL·ACRE·BIT·ET·MALE·QUIS·Q·HINC
AETERNU·DOMINU·TA·CET·O·AUCTOR·SANCTHI·COR·EST
RASIS·UMMI·CUNCTA·DECENT·QUIA·SANGUINE·DEM·TAM
EXTER·ADERIPUIT·PRAE·EAM·PROBA·SANCTA·PROFVN
C·POSITUS·DE·DE·E·RAT·DEUS·ARCE·COR
PRINCIPIUM·HIC·DEUS·E·MANUEL·AC·FINIS·ORIG·EST
LUX·ET·IMAGO·PATRIS·OS·PLENDOR·GLORIA·CRISTUS
HOMO·YSION·PATRI·ZO·UERBUM·EX·LUMINE·LUMEN·CUM
AEQUA·MANU·DOMINIS·E·VVIRTUS·UX·QE·PROPHETA·EST
QUE·UNIGENAM·I·USTE·QEM·PRIMI·GENORE·FATEMUR
NAZAREUS·QUUM·OFF·ES·IOPITA·C·SCANDALI·INIQUIS
ANGUL·ATQUE·LAPI·S·TE·SANS·OHI·C·IANUA·MUNDO
INDUTAE·NUERITAS·QUID·DOGMATE·CHRISTUS
INDICET·EXPONALE·GE·MARVAH·EC·QUOD·QUE·UESTIS
SIGNIFICAT·NAMQE·HIC·TEGITUR·IN·GRAMMATE·RARO
SUMMIPOTENS·AUCTO·RQUI·CONTINET·OMNIA·RECTOR
ATQUEM·MUNDUS·PERTI·IN·E·TASTRA·C·PONTE·TA·ETHER
NOSTRAQ·NATURA·ART·AIATUES·OCIATA·CREANTIER
NAM·AUCTORE·HAEC·ILL·UM·PAL·OQIC·LAUDIT·ET·ARUA
OBTEGIT·HUMANO·AUT·E·CLAUDIT·VISU·ECCE·POTENTEM
PSE·TAMEN·OSTENS·UBI·QES·UO·ESTO·PER·EORBI·HUIC
ANGELUS·HUIC·SPONS·VS·PAX·ST·E·EST·DEUOTIO·PLEBI·ET
ATQ·DOCENS·SAPIENT·ONIS·DIV·NAQ·PETRA·MAGISTER
ONS·BRACHIUM·ET·PA·TAPACIFICUS·QUOQUE·CUSTOS
TELLA·ORIENS·QI·ET·CURA·POT·ENS·INTENTA·MEDELA
CLAUIS·ET·HIC·DAUID·LLAETA·VIA·ET·AGNUS·HONESTUS
SERPENS·SANCTIFIC·ANS·IN·LUSTRIS·FIT·MEDIATOR
ERMIS·HOMO·ISQE·RE·TRAXIT·AB·HOSTE·UITA·RAPINAM
MONS·AQUILA·PARACL·YTUS·SIC·LEO·PASTOR·ET·EDUS
FUNDAMENTUM·OUIS·SAC·REDDENS·PIE·UOTA·SACERDOS
MELCHI·PONTIFICIS·S·ADE·CHUINUM·QUOQUE·PANE·ET
QUI·UITULUS·ARIES·CAR·NE·EQUA·EST·SACRA·FINCTUS
UICTIMA·PATRE·QCUBE·NES·IT·SATUS·ABSQUE·CADUCO
QI·DAMPNA·SENSIT·ET·L·GNE·QUI·OMNIBUS·ANTE·EST
QI·ASTRA·EST·SIDERE·HIC·REDE·IT·OMNIA·LUCIFER·UANTE
UIRGINE·HIC·EST·NA·TUS·MATRE·UM·TEMPORE·IN·ARTO
ATQUE·HOMINE·MUT·SE·UARET·AD·RAM·HIC·CRUCIS·IUIT
QUIES·SATOR·AETERNUS·XPS·BENEDICTUS·IN·AEUUM

discovered that the columns of Ishmaelites had fled. During the night, they had left in good order, all silent, heading for their homeland. The Europeans, however, feared that the Saracens might be hiding along the path to ambush them. Thus they were surprised to find themselves alone after having vainly made a tour of camp. And, since the above-named Europeans were not concerned with pursuit, having already shared out spoils and booty, they returned cheerfully to their own lands." The only thing in common between those "lands" was that all were Christian. It was the first time that a chronicler—probably a Mozarab, a Christian who perhaps converted to Islam—used the word "European." Europe first dawned as a reality in the eyes of its enemies. It was above all a Christian reality.

ROMAN TIME, CHRISTIAN TIME

In the "lands" of the men who fought alongside Charles Martel, the Church of Rome alone claimed precedence over all other churches. Alone, it proclaimed itself *Mater Ecclesia.* In 644, during the synod of Whitby, it imposed its calendar on Anglo-Saxon Christians, a calendar called "Julian," because Julius Caesar reformed it in 46 B.C.E.; a calendar orchestrated around nones, ides, and calends; a calendar that Roman legions brought to the world. Yet time had not been reckoned in the same way since the Roman monk Dionysius Exiguus performed calculations again and again, sometime between 526 and 530, to determine the start of the Christian era, the Year of Our Lord, *Anno Domini* (A.D.). It hardly matters that Dionysius's calculations were inaccurate, that he was not familiar with the figure zero (absent from Greek and Roman numerals), and that Christ was probably born in the year 5 or 6 B.C.E. (given Dionysius's erroneous computations). Time was no longer what it was, once it measured the span of the promise of what Saint Augustine called the "City of God." It was up to men of the Church to pray and work toward the advent of the promised city in order, finally, to bring about this "Sabbath that will have no evening, the rest of the saints that will have no end" (*City of God,* 20:421). The Christian promise altered the meaning of existence. Life—the life whose tribulations had been eased for centuries only by the wisdom of long-forgotten Stoic and Epicurean

Plaque from book binding (detail, the encounter of Abner and Joab's armies). Court of Charles the Bald, circa 870–875. Ivory. Treasury of Saint-Denis. Musée du Louvre, Paris, France.

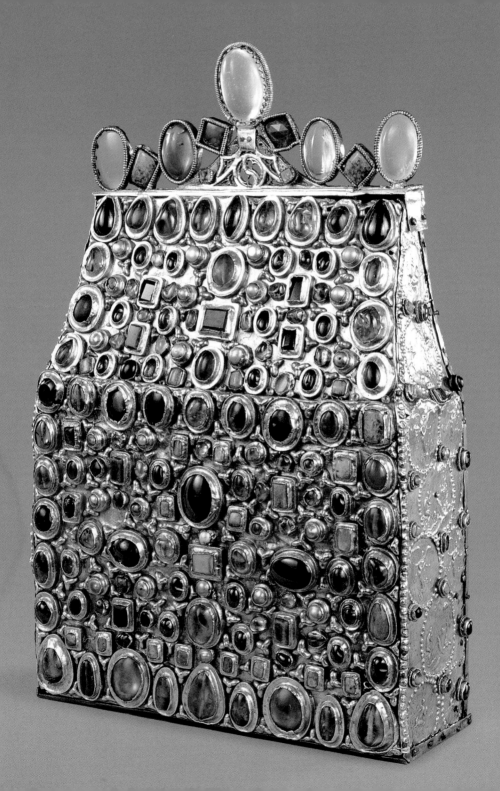

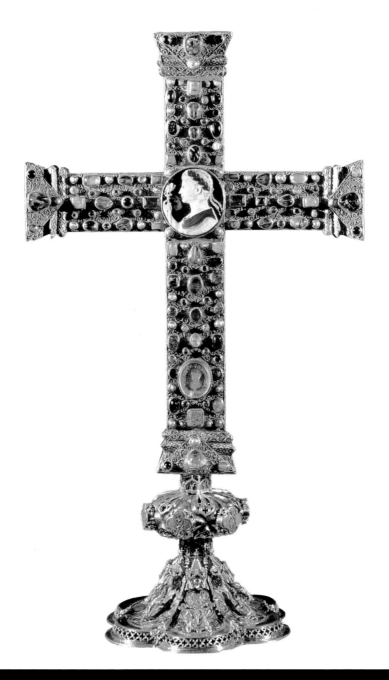

BOOKS WERE THE EARLIEST MONUMENTS PRODUCED BY CATHOLIC EUROPE.
BOOKS CONVEYED THE WORD OF GOD—
BOOKS ALONE COULD OPEN THE DOOR TO THE HEAVENLY JERUSALEM.

Opposite: Reliquary of Saint Stephen, 9th century. Kunsthistorisches Museum, Vienna, Austria.
Above: Coronation cross, completed circa 1000 in Cologne for Emperor Otto III.
Copper, gilding, gemstones. Treasury, Aachen cathedral, Aachen, Germany.

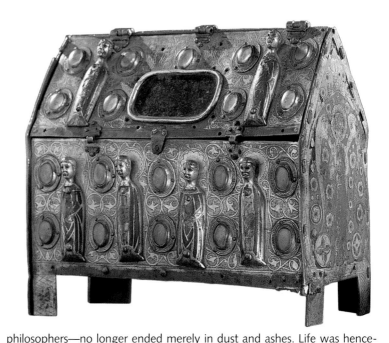

philosophers—no longer ended merely in dust and ashes. Life was hence-forth just one stage in a process of weeding the outcasts from the elect for salvation beyond the grave. As the eighth century dawned, popes no longer hesitated to assert the power that was theirs in the West; in 729, Pope Gregory II addressed the following affirmation to the emperor of Byzantium: "The entire West looks to our humble self . . . and to Saint Peter . . . to whom all the kingdoms of the West pay homage. We go to the most distant confines of the West in order to administer baptism." Gregory's determination echoed that of a predecessor, Pope Sylvester I. Elected pope on January 31, 314, Sylvester refused to leave Rome for any of the various councils that combated heresy (Arles in 314, Alexandria in 232, and Nicaea in 325). The first pope to reign for more than twenty years—he died on December 31, 335—Sylvester asserted from Rome itself that, as bishop of Rome, he was first among bishops, the only true heir to the apostle Peter. It was at Rome that Peter was crucified, head downward. It was this apostle to whom Christ had said, according to the gospel of Matthew, "You are Peter, and on this rock [petra] I will build my church." So it was in Rome, on the tomb of Peter, that the Church must rise—Rome.

Above: Enameled chest, Limoges, circa 1215–1220. Gilded copper, champlevé enamel, crystal and glass cabochons. Treasury of Saint-Denis. Musée du Louvre, Paris, France.

Opposite: Interior of the Palatine chapel, 796–805. Aachen, Germany.

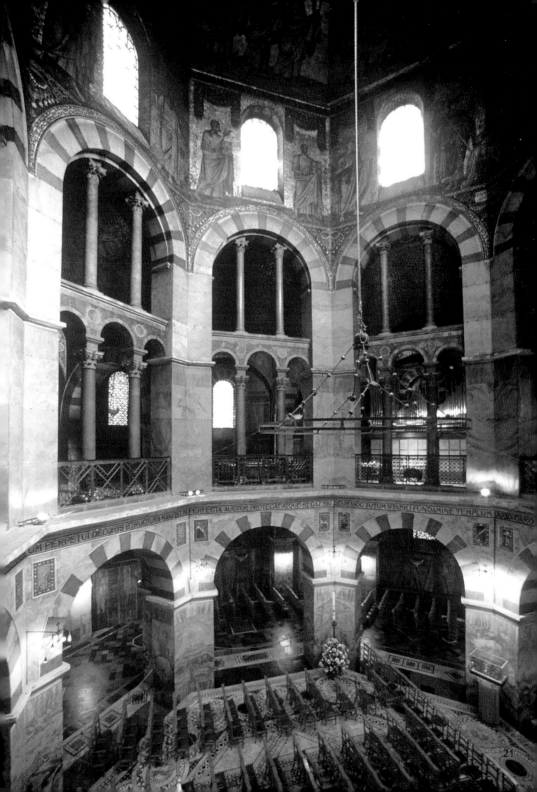

21

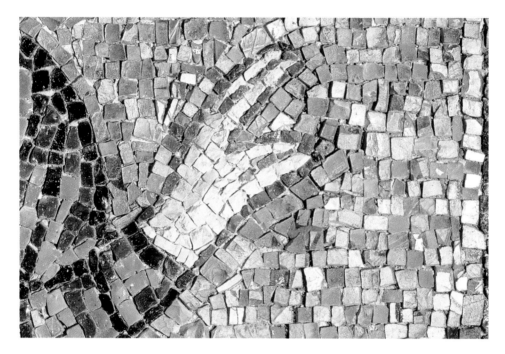

Ruins of an Empire

Above:
The hand of Christ (detail). Mosaic in Sant' Apollinarius, 6th century. Ravenna, Italy.

Opposite:
First page of the book of Matthew. Lindisfarne Gospel, illuminated under Bishop Eadfrith, circa 698–700. British Library, London, Great Britain.

By issuing the edict of Milan in 313, Emperor Constantine intended to make Rome Christian. Yet even though Constantine ordered the building of several basilicas there, he did not intend the city to remain the imperial capital. Rome ceased to be capital of the empire in 330, abandoned for Byzantium (renamed Constantinople). Rome soon became a provincial town dotted with ruins and brambles. Europe itself was little more than that—for centuries the barbarians had been sweeping down from the east and north, one wave mingling with the next. The Huns brought with them the Sarmatians, Alani, and Ostrogoths they had defeated. Paradoxically, the very barbarians who smashed the empire revered Rome. They styled themselves with Roman titles: consul, senator, etc. Theodoric even adopted the Roman name of Flavius. He let the emperor in Constantinople know that he was *servus vester et filius* (your slave and son). Although Theodoric saw himself as heir to the Western empire, nothing remained of what had been the *pax romana,* the peace established by a city originally founded back in 753 B.C.E. Did anyone even remember that Roman peace?

By the time Charles Martel rallied the "Europeans" and repulsed the Arabs at Poitiers, the lands of Europe had been trampled repeatedly for hundreds of years by the four horsemen of the Apocalypse—plague, famine, war, and death.

War and death: barbarian conversions to Christianity did not lead to new peace, but merely triggered new battles in an effort to stamp out heresy. Among those heresies was that of Arius, who neither recognized the divinity of Christ nor admitted that Christ could be one with the Father. Arianism was condemned at the council of Nicaea in 325, but it was to Arianism that Vandals, Ostrogoths, and Visigoths had converted. The Frankish king Clovis, who wanted to be baptized by Bishop Remigius in order to extend his power, fought for the church and reduced the heresy of the Arians, whom he defeated in 507. Pushed south of the Pyrenées, the Visigoths only finally renounced Arianism at the council of Toledo in 589.

During those same decades of the sixth century, the Lombards (hard pressed by Avars arriving from the steppes) swept down on the Po Valley. They were pagans with no interest in a god who died on a cross. It was a time of violence, a time of suffering. Bishop Gregory of Tours (circa 538–594) commented in his *History of the Franks* that "many crimes were committed in those days. . . ."

Plague: in 543, bubonic plague began to ravage Europe, an implacable, dreadful epidemic that lasted over fifty years.

Famine: it was a time of want. Bishops who saw themselves as heirs to Roman patricians provided charity to the *humilores* (the humble, the humiliated, the dispossessed). They preached the model of the biblical Job, the Job of loss and resignation. A time of penitence.

The horsemen of the Apocalypse did not spare Rome. Rome had not amounted to much since Alaric sacked it in 410; since Odoacer, king of the Heruli from the Black Sea, overthrew Romulus Augustulus, last of the emperors, in 476. Then Odoacer was assassinated on the orders of Theodoric the Great, king of the Ostrogoths in 493. For centuries, Rome had been a civilization of architecture and roads. Now the temples, arenas, and amphitheaters built by Rome became quarries; Roman roads were no

Exterior view
of San Vitale,
Ravenna, Italy.
522–547.

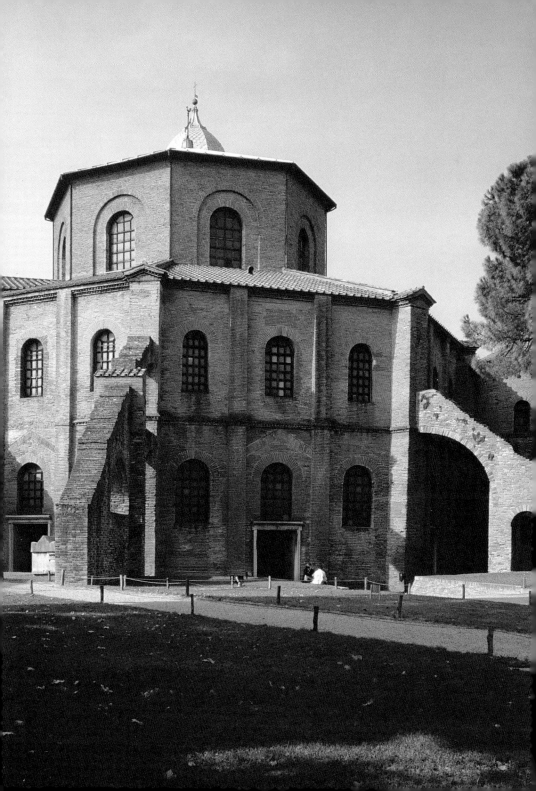

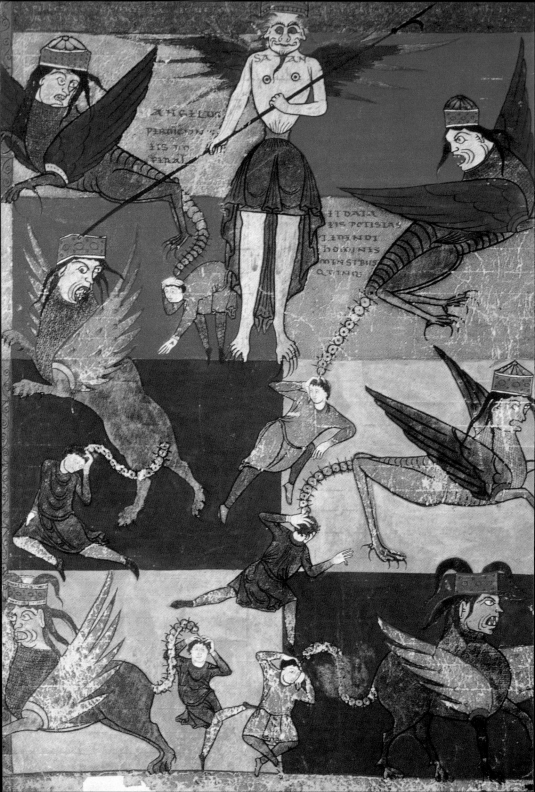

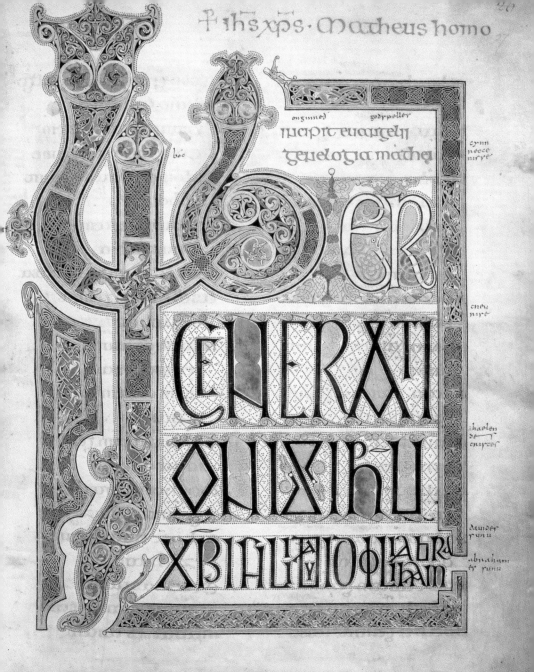

RELIQUARIES AND CRUCIFIXES, BEFORE BEING CONSIDERED WORKS OF ART,
WERE DESIGNED TO PROCLAIM THE POWER OF THE CHURCH.

Opposite: Plague of locusts with human heads and scorpion tails. *Book of Revelation*, 9:3 ff. Saint Sever *Apocalypse*,
commentary by Beatus of Liebana. Gascogny, third quarter of 11th century. Bibliothèque Nationale, Paris, France.
Above: Page from the Lindisfarne Gospel, illuminated under Bishop Eadfrith, circa 698–700. British Library, London, Great Britain.

longer maintained. Twice the Lombards invaded the city anew, in 752 and 755, devastating the Roman countryside each time. Each time, the monastic communities with their buildings and fields were sacked and burned. Aqueducts no longer worked, the catacombs were crumbling, and the churches of Saint Peter, San Paolo, and San Lorenzo were on the verge of collapse.

THE CHURCH BUILDS

It was only with the pontificate of Adrian I, between 772 and 795, that Rome sought to regain its splendor. The city that was beginning to rebuild had been under Byzantine influence for nearly two centuries: thirteen popes of Greek or Syrian origin had occupied the papal throne between 606 and 752. Emigrés, civil servants, merchants, and monks driven from the Levant by the arrival of the Arabs in the east and south of the Eastern Empire, founded their neighborhoods in Rome, with churches where the mass was said in Greek.

God and God's church were being glorified by the enormous beams cut from the trees of the forests near Spoleto for the roofs of the churches of San Paolo fuori le Mura, Santa Maria Maggiore, and Saint John Lateran, by the silver-plated icons hanging there, by the precious fabrics, the altar cloths, the silk tapestries of purple and gold draped in the choirs, by the silver leaf lining the floor of Saint Peter's. The new construction projects and the arts that people began developing once more in Rome and the Christian world were like so many prayers. The skill of men who carved stone, or who set precious gemstones, or who illuminated the pages of bibles or psalters, or who recopied the holy texts, was in its own way a prayer, a way of praising God.

Techniques employed by warlike peoples who were still nomads basically concerned weaponry, embroidery, finery, and amulets they could carry with them. Yet here and there, the ancient arts that Burgundians, Germans, Vandals, Saxons, Alamanni, Franks and Lombards brought to what had been the Roman Empire began to serve the faith. In monastic scriptoriums, gospels would be decorated with interlacing patterns of entwined snakes

and dragons (or else spirals and zigzags would wrap around the animals themselves). The same knotted tracery might be carved on the edge of a sarcophagus, or chased on the lip of a chalice. Sometimes, in northern Europe, the figures that appear on an illuminated page or on a deeply carved ivory plaque seem to have been modeled on some Byzantine icon (ivory long remained a rare substance once infidels had conquered northern Africa, with whom trade relations had almost completely ceased). It was a special period when barbarian patterns, Byzantine magnificence, and Roman traditions intersected. Some monks imitated the Roman building technique of *opus mixtum,* alternating brick and stone. In every "European land," the most important construction sites were monastic. These monasteries were precisely where the abstract, simple forms inherited from the barbarians and the ones bequeathed by Rome began to merge during the years of Charlemagne's rule.

The Faith of the Empire

In 775, a priest named Cathwulf praised the great Charles for having been chosen by God to become the "glory of the empire of Europe." And according to the theologian Alcuin, who left York to head the abbey of Saint-Martin-de-Tours and later became one of Charlemagne's advisers, Europe was the "continent of the faith." The emperor imposed the Roman rite on all the lands he ruled. Beyond what local tradition required here or there, art forms everywhere henceforth served the same style of worship. It was via the monasteries that adopted the rule of Benedict of Nursia (circa 480–540) that the Christian world built its unity, via these Benedictine monasteries where people read, studied, and copied the writings of ancient authors and the Church fathers. Such unity was uniquely spiritual.

Charlemagne wanted his empire to have the same faith and same liturgy everywhere. It was Alcuin who convinced him of the importance of this. And Alcuin's insistence led Rabanus Maurus (776–856)—a disciple who had studied under Alcuin at Tours before going to Fulda—to attempt to establish correlations between the knowledge of Greek and Roman pagan antiquity and the revealed truths contained in the Old Testament.

Rabanus's treatise, *De rerum naturis* (On the nature of things), called for a *nova lex vivendi* (new law of life) within Christian society that would favor the study of scripture. His rigor remained exemplary for centuries, as was, earlier, the rigor of Isidore of Seville, who back in 621 compiled a vast etymological anthology of the secular world—*Etymologiae sive Origines*—twenty volumes that became a key reference work for monks throughout Christian Europe. Such research contradicted neither the certainties of the faith nor the arguments in Saint Augustine's *De Doctrina christiana,* which held that the sole reason for learning was to lead to recognition of the truths of "Eternal Wisdom."

The Liberal Arts

According to Alcuin, the liberal arts were the path to this quest for wisdom. "'Wisdom has built her house, she has set up her seven pillars.' Although these words apply to Divine Wisdom, nevertheless we must understand that, in the same way, human wisdom is based on the seven pillars of the

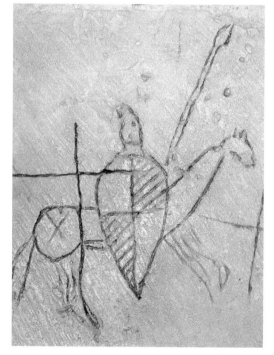

Soldier, 12th-century graffiti in the church of Saint-Martin. Moings, France.

liberal arts and that one can attain perfect knowledge only by raising oneself on these seven pillars or, if you prefer, these seven steps." The seven pillars or seven steps of the liberal arts were divided into the trivium and the quadrivium. The trivium included grammar, logic, and rhetoric, while the quadrivium was composed of music, geometry, astronomy, and arithmetic. A copy made in the abbey of Saint-Martin-de-Tours of *De Institutione arithmetica* by Boethius (circa 475/480–524) attributes the muses' features to these fields of study. The liberal arts, whose sole purpose was knowledge, were the only ones worthy of a free man. It is therefore no coincidence

Capital,
12th century.
Mailhat, France.

that the earliest works produced by Western Christendom were books. The splendor of illuminated manuscripts and bindings were proof of the power and glory of the word of God. The mastery of the "mechanical arts"—the techniques of those who drew and painted the pages, those who set the bindings with precious stones and gems—served the texts that were crucial to the commentaries and debates within the liberal arts. Neither architecture, painting, nor sculpture was admitted to the ranks of "liberal arts," nor were they even considered "mechanical arts." They only gained recognition as the twelfth century came to a close, among people who began to want to define and classify human capacities in the face of an Almighty God.

LITURGY AS ARCHITECT

Just as the splendor of books revealed the Divine Word, architecture was designed to serve it.

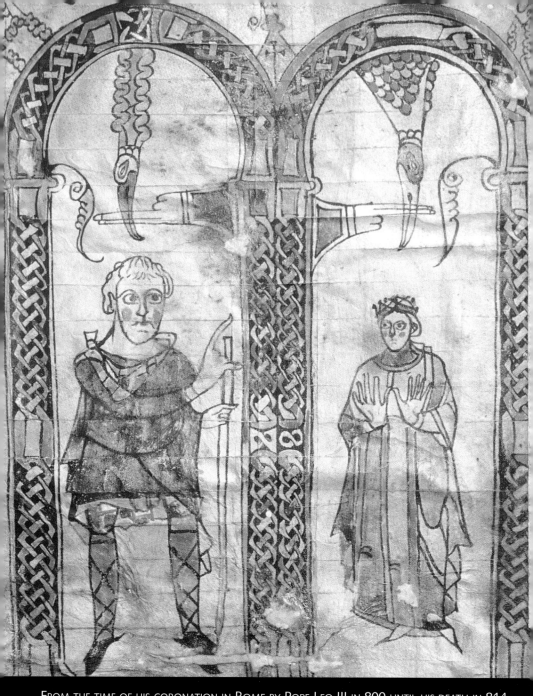

FROM THE TIME OF HIS CORONATION IN ROME BY POPE LEO III IN 800 UNTIL HIS DEATH IN 814, CHARLEMAGNE WAS SAID TO HAVE RESTORED THE WESTERN CHRISTIAN EMPIRE.

Above: Charlemagne and his wife. Manuscript illumination, 8th–9th centuries.
Library, church of Saint Paul, Labanthall, Germany.
Opposite: Charlemagne's scabbard. Ile-de-France, 8th century. Gilded silver, precious stones,
gold-embroidered velvet. Treasury of Saint-Denis, Musée du Louvre, Paris, France.

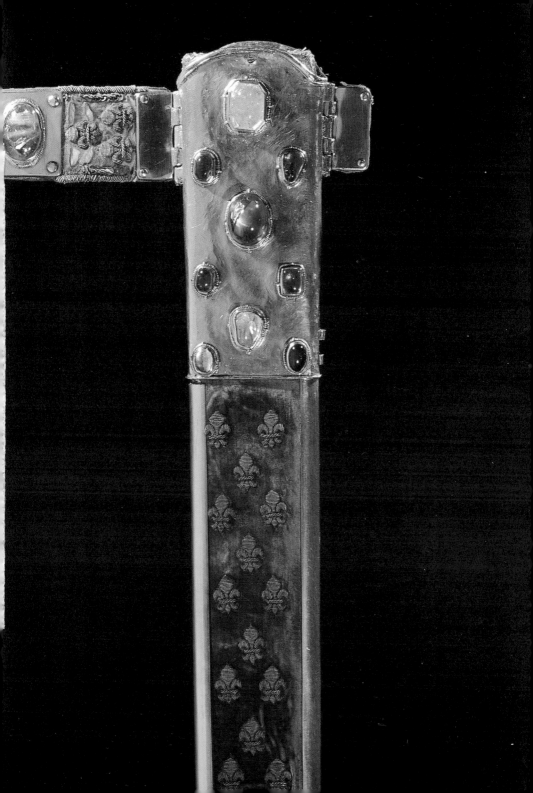

Throughout Charlemagne's empire, application of the *ordines Romani* meant that priests celebrated the mass facing the congregation, *ad orientem*. This was true in all churches, and the abbey of Saint-Denis was no exception. Charlemagne and his brother Carloman had ordered the construction of that vast basilica, built around sixteen columns and modeled on Roman basilicas. It was consecrated in 775 by Abbot Fulber. For the first time, a west façade was topped by two towers, while at the eastern end an apse extended beyond the transept. A text of 799 reports that during high holy days four measures of oil were required for each of the twelve hundred lamps that lit the church. Windows, meanwhile, let light into the ring-shaped crypt, like those in Rome—this crypt was a *martyrium* housing the sarcophagi of Saint Denis and his fellow martyrs Eleutherius and Rusticus. Some years later, between 790 and 799, Abbot Angilbert employed the same model when building Saint-Riquier in Centula; at the west end of the church, over the low entrance hall was a square bay open to the nave and flanked by aisles, topped by a tower, forming an architectural ensemble. This ensemble, called the westwork, constituted a chapel dedicated to the Savior.

The circular plan of these crypts, like the multiplication of altars with the churches, stemmed from liturgical needs. And the need for apsidal chapels reflected another liturgical requirement—a church had to have several altars for performing services devoted to special aspects of the Work of Redemption. The worship of apostles and martyrs supplemented that of the Nativity, the Passion, the Resurrection, and the Ascension. Liturgy defined architecture. It governed all, even determining the number of monks that an abbot would gather around himself. Thus, when Abbot Angilbert brought together 300 monks and accepted ninety-nine students in the *schola* (divided into three groups of thirty-three), he was showing pious respect for the figure three, the sacred number designating the Holy Trinity.

Scenes from the life of Saint Jerome. Second Bible of Charles the Bald, circa 846. Manuscript illumination. Bibliothèque Nationale, Paris, France.

MONASTERY AS HOLY CITY

The empire of Charlemagne and Louis the Pious was one big construction site in the years 700 to 855. The site extended from Catalonia to Bavaria

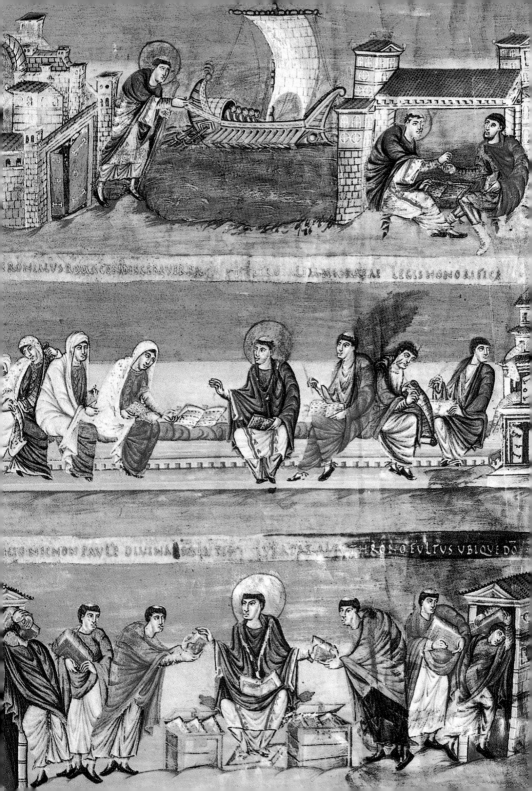

HIERONIMVS ROMAM CONSECRAVERAT · · · HIERONIMIA MORASAE LEGIS HONORIFICA

CTIS NECNON PAVLE DIVINA IEIVNITAS · · · IN A BABALATI HIERONIMO CVLTVS VBIQVE DO

(conquered in 788) and from the North Sea to Saxony (annexed in 802). In a matter of years there arose hundreds of imperial residences and nearly thirty cathedrals. And in those same years, over four hundred monasteries were built.

Around 830 work began on the abbey of Saint-Gall. The central location of the church and cloister, set between the other buildings required by monastic life, was based on pastoral, liturgical, and disciplinary requirements established during councils held in Aachen in 816 and 817. During these councils, Saint Benedict of Aniane defined the organization of a monastery, whose buildings were to include the monks' cells, stables, refectory, guest quarters, storehouse, and scriptorium. This latter was a silent workshop, where monks began recopying texts by Virgil and Cicero, by Horace and Pliny the Elder, by Suetonius and Terence. A monastery was to be a *civitas sancta,* a "holy city." In those at Reims and Tours, at Orléans and Compiègne, there sprouted a precocious Renaissance inspired by the ancient manuscripts admired by the monks. There also emerged a new type of writing, Carolingian miniscule, whose clarity led to its adoption all over Europe.

Like the bishops, abbots were heirs to the old Roman families, the aristocracy of Rome's empire. Such men constantly corresponded, regularly met during assemblies, and sought to assert the glory of their ecclesiastical authority through the splendor of rites, music, and works devoted to God.

Already, copies of the treatise called *De Architectura,* which Roman architect Vitruvius had dedicated to Augustus, were beginning to circulate from building site to building site. Throughout the empire, people wanted to build in *more romano,* "in the manner of Rome." Roman models were adopted not only because the Holy Catholic and Apostolic church was Roman but also because the empire was conceived as *Nova Roma,* a "new Rome."

But this Rome was threatened by new invasions. The Muslims, initially contained in Spain, seized Sicily and then won ground in Provence. The Vikings ravaged Ireland, England, and Normandy. Hungarian hordes, driven from the plains of the Volga, swept in from the east as early as 898.

THE ROLE OF EMPEROR

The palatine chapel of Aachen, a key feature of the imperial palace, was consecrated in 805. If Charlemagne called his palace the Lateran, that was because Emperor Constantine's palace in Rome had borne the same name. The church, meanwhile, was modeled on San Vitale in Ravenna, consecrated in 547 and itself based on the Church of the Resurrection (or Holy Sepulcher) in Jerusalem. If these models were followed, if marble columns brought from Rome and Ravenna were used, that was because this crucial feature of the imperial residence was designed to demonstrate that the emperor held his power from God Himself. Architecture had to confirm the text of the *Liber pontificalis,* describing the coronation of Charlemagne as Holy Roman Emperor: ". . . the people were gathered again in Saint Peter's basilica on the most holy day of the Lord's birth. When the king rose up from prayer, the venerable and august Pope Leo placed a very precious crown on his head. Then all the faithful people of Rome, seeing the defense that he gave and the love that he bore for the Holy Roman Church and her Vicar, by the will of God and of the blessed Peter, keeper of the keys of the kingdom of heaven, cried with one accord in a loud voice: 'To Charles, the most pious Augustus, crowned by God, the great and peace-giving Emperor, long life and victory.' This cry went up three times before the Confession of the blessed Peter; many saints were invoked; everyone proclaimed him emperor of the Romans. Immediately after, the very reverend bishop and pope anointed with holy oil the emperor's most excellent son, Charles, on the same day of our Lord's birth."

It was the role of this imperial chapel to demonstrate to all that the emperor was like the pope. From his throne placed on the tribune facing the Savior's altar, the emperor could raise his eyes to Christ-the-King on the dome. The middle of the Cross of Lothair—a cross donated to Aachen cathedral by Emperor Othon III (died 1002)—is set with a cameo of the profile of Emperor Augustus, constituting a radical sign of the confusion of divine and imperial powers.

Paradoxically, although Charlemagne was crowned in 800 by the pope in Rome, the Christ toward which he raised his eyes bore Byzantine features.

Christ's Syrian-type face had been devised in Byzantium; Byzantium had chosen that long oval shape, that black hair and beard; Byzantium banished the blond, young Christ still found here and there in Ravenna. This image of Christ was that of a god made man, that of a god incarnate. This divine decision justified the existence and role of imagery in the West. The *Libri carolini*, or "Carolingian books," composed by Bishop Theodulf of Orleans for Charlemagne, eliminated images that might lead to idolatry; but the didactic impact of imagery soon got the better of such scruples. The illumination of Western manuscripts strove for the same splendor as the mosaics of Byzantium, where the choice of gold for the background was justified by several major texts. According to Saint John Damascene, the apostles, martyrs, and saints had to be "depicted in a state of blessedness, dressed in the divine splendor that is theirs after martyrdom." According to Saint Basil the Great, gold has a "simple and indivisible beauty" which is "the closest to God's [beauty]." Finally, Pseudo-Dionysius the Areopagite claimed that "God is beauty, because He confers beauty on every being according to its measure, which is the cause of the harmony and splendor of the raiment of every creation."

Paten (eucharistic plate) of serpentine. Plate, 1st century B.C.E. or C.E., and late empire; mounting from the court of Charles the Bald, second half of 9th century. Treasury of Saint-Denis. Musée du Louvre, Paris, France.

ABBEY, CATHEDRAL, PALACE

PILGRIMAGE AND JUBILEE

Europe was a holy place: a place of penitential acts of pilgrimage; a place whose fields were often traversed ("pilgrimage" comes from the Latin *per ager,* meaning "across the fields"); a place whose roads led toward Rome, or toward Compostela, or toward the Holy Land. Each of these roads was a *via sacra,* a "holy path." A path which, through Christ, led to the Father. Whether setting out from Utrecht or Cologne, Lérida or Genoa, Venice or Leicester, pilgrims were blessed, just as their walking sticks and pouches were blessed. Pilgrims who traveled on foot to experience the mysterious presence of true relics of the saints, and the people who housed pilgrims in hostels, all had faith in the words of Christ as recalled by the rule of Saint Benedict and the *Codex Callixtinus,* "Whoever receives and houses them enthusiastically will have as guest not only Saint James but Our Lord Himself, as he said in his Gospel: *Qui recepit vos me recepit* (He who receives you receives me).

Once Pope Boniface VIII, convinced that the era of the crusades was over, inaugurated the Jubilee in 1300, a pilgrimage to Rome henceforth promised a complete pardon, or "plenary indulgence," for all sins. And all of Europe responded to Rome's promise. A chronicler reported that "men, women, members of the clergy, laymen, monks, nuns, and kings went to Rome from all over Lombardy, France, Burgundy, Germany, other regions, and all Christian lands; countless barons, knights, and noble ladies, nameless crowds of men and woman of all conditions, classes, and ranks went to Rome for the Jubilee." Through the Jubilee indulgences it granted, Rome intended to reinforce both the spiritual and temporal power of

Statue-columns, north porch of Chartres Cathedral, France. Photolithograph by Henri Le Secq, 1875–1880. Centre canadien d'architecture, Montreal, Canada.

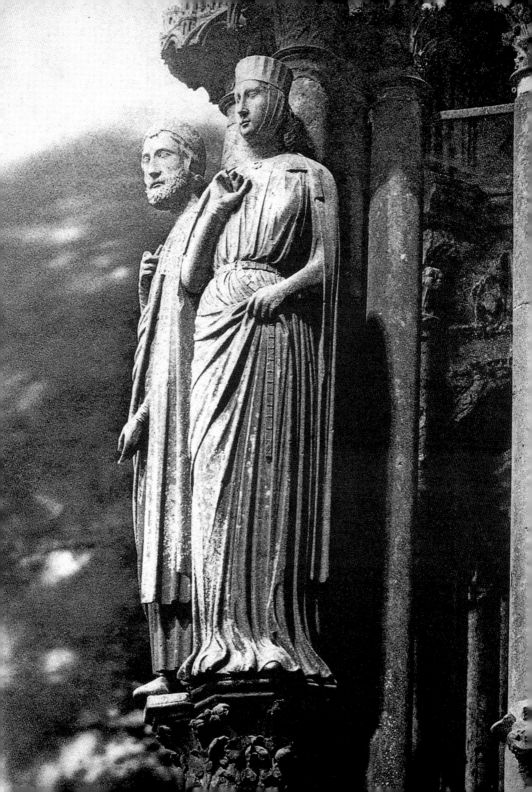

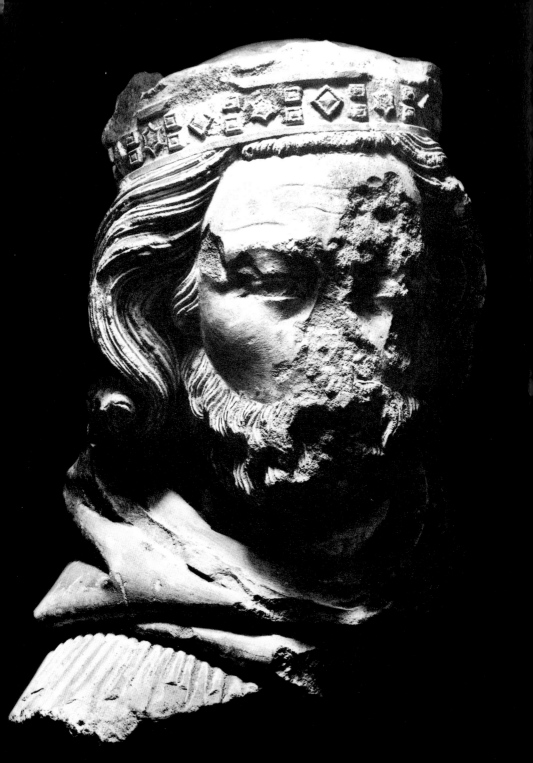

Roman popes, underscoring their preeminence over merely temporal powers. Apart from this political significance, the launching of the Jubilee year was a recognition of the key role played by pilgrimages for over three centuries in a Christendom whose unity was forged by the Benedictine orders.

ROUTES AND RITES

The rites and liturgies of Compostela and Rome capped the act of penitence undertaken by those who had abandoned everything for the road. The *Codex Callixtinus,* for example, required in the twelfth century that pilgrims arriving at Compostela "pray before the altar of the church throughout the night, holding lighted candles in their hands, standing and not sitting." Only in the morning could pilgrims then go behind the altar to kiss a statue of Saint James and finally touch the shell hanging from the apostle's neck. They knew that by completing this pilgrimage they had earned the right to be buried in a church (as had Charlemagne, who in a dream had been told by Saint James to "combat the pagans, free my path and my kingdom, and visit my tomb"); Innocent IV ordered in 1241 that the cathedral of the diocese in which such pilgrims died must accept their remains. On their return from Compostela, they hung around their necks the shells sold by the cathedral chapter; pilgrims returning from the Holy Land, meanwhile, carried pouches containing olive branches from the Garden of Gethsemane, or a flask of water from the River Jordan, or perhaps even earth or shards of stone gathered at the Holy Sepulcher. All these objects were *sacra,* humble relics consecrated by the presence of Christ on this earth. Thus a palm frond cut in Jerusalem, or even mere dust from the Holy Land, became a relic providing grace and salvation to all.

After the year 1000, relics played a decisive role within a Church that equated itself with Christendom, a Christendom that equated itself with the very body of Christ. Solemn processions of relics were conducted to ward off an epidemic or calamity. An oath taken on a relic became sacred. Cutting the bones of a saint into fragments enabled the very rich to carry a relic on their own bodies.

Head of one of the Three Kings. Musée de Cluny, Paris, France.

43

Pilgrimage routes, like rivers, led pilgrims from the mouth of the Rhine or Lake Constance to Santiago de Compostela via Tours, Poitiers, and Saintes, or via Burgundy, Vézelay, and Saint-Léonard-de-Noblat. Shared art forms arose from pilgrimages—the crucial role of relics in the rite long determined the shape taken by both architecture and art objects. Crypts built in the ninth and tenth centuries were designed to display relics to pilgrims. Ambulatories around the choir, facilitating veneration of relics by the faithful, appeared in all the churches of a way-station such as Poitiers: Saint-Hilaire-le-Grande (consecrated in 1049), Saint-Nicolas (consecrated in 1053), Notre-Dame-la-Grande (consecrated circa 1070), Sainte-Radegonde (consecrated twenty years later), and Montierneuf (consecrated in 1096).

The routes taken by pilgrims helped give coherence and unity to European artworks from one end of Christendom to the other. Despite the organization of trades requiring that everyone keep to his station and remain content with mastering an endlessly repeated task, despite guild solidarity that forbade competition between workshops, innovations were ultimately shared. The finest workshops soon became well known; the pull of pilgrimage drew artisans down the roads of Europe, freeing them from constraint and routine. Journeying from place to place, master craftsmen dealt with the same monastic congregations. Art objects, manuscripts with their illuminated pages, statuettes, reliquaries, and jewelry circulated throughout Europe along with the craftsmen.

GOLDEN RELIQUARIES

Over the centuries, the splendor of a reliquary—a coffer for holding or displaying relics—was the most conclusive sign of holiness. The veneration of relics drained all wealth toward monasteries and later toward cathedrals. The chronicler of King Robert the Pious reported that the king "found his contentment in the relics of saints, which he covered in gold and silver, in white vestments, in priestly ornaments, in precious crosses, in chalices of fine gold, in censors that burned the choicest incense, and in silver vessels used for the priest's ablutions."

The medieval church's treasury contained the holy books, liturgical vestments and ornaments, chalices, ciboria and patenas, and candelabra and censors, whose main purpose was to insure the salvation of souls. All rich people were expected to make such gifts to the Church. The fame of a saint and the miracles attributed to his or her relics were a source of material profit for churches, since the rich and powerful could enter the kingdom of heaven by displaying generosity, giving the alms they could well afford.

Gold was still the prime symbol of the splendor of ecclesiastical treasure. Gold sheathed the wooden core of objects and was in turn decorated with cameos, intaglios, gems, and enameling, or studded with cornelian, chalcedony, agate, jasper, and amethyst.

In the days of crusades—Urban II launched the first crusade in Clermont in 1095, while the ninth and last ended in 1291 with the failure to recapture Acre—coffers for relics displayed oriental origins. Exotic motifs adorned priestly chasubles, damasks, and silks, merging with the influences of Byzantine art and late antiquity. One of the most important items of ecclesiastical treasure was the decoration along the front of the altar, called an "antependium." Such altar panels favored the reemergence of sculpture in Europe, hinting at the role it would assume from the late eleventh century onward.

Reliquary busts—such as those of Saint Baudime in Saint-Nectaire, Saint Caesarius of Arles, or Saint Rémacle—gave the saint an entirely different presence. A pilgrim of 1040 observed: "I contemplated, for the first time, the statue of Saint Gerald set on an altar. A statue remarkable for its very fine gold, its very valuable stones, and its artful reproduction of the features of a human face, so that peasants who looked upon it felt pierced by a clairvoyant gaze and sometimes perceived, in the gleam of his eye, the sign of more indulgent favor toward their wishes."

For centuries, pilgrimage stirred the same sense of wonder by underscoring the physical presence of relics.

The last item to appear in cathedral treasures—the last item of worship to symbolize, more than any other, the indescribable presence of God—was

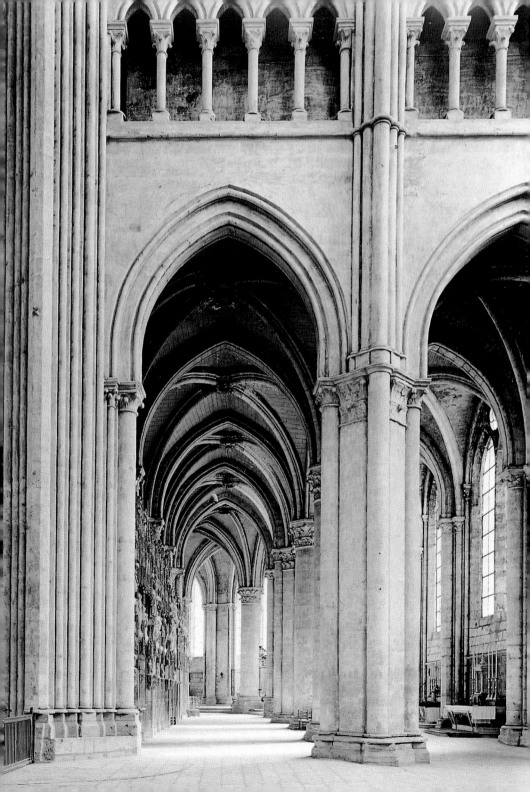

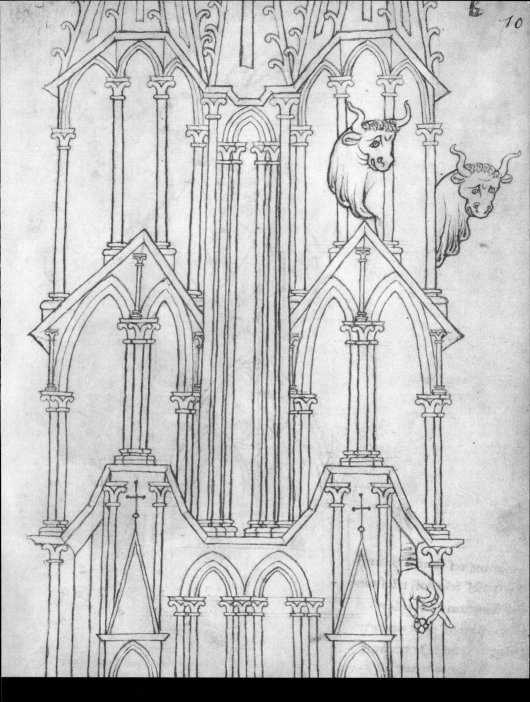

ALL OF EUROPE, FROM PRAGUE TO LONDON TO CHARTRES TO PARIS,
ERECTED CATHEDRALS EMBODYING MANKIND'S LOFTY AMBITIONS.

Opposite: Interior of Chartres Cathedral. 12th–14th century.
Above: Laon Cathedral, elevation. From Villard de Honnecourt's *Album*. Bibliothèque Nationale, Paris, France.

the monstrance (in which the host of Holy Communion was displayed for all to see). The monstrance was part of the liturgy of Corpus Christi, the celebration of the body of Christ in the form of the eucharistic host.

THE POWER OF CLUNY

On September 11, 909—or perhaps 910—Guillaume III, duke of Aquitaine and count of Mâcon, gave several monasteries to Berno, abbot of Baume-les-Messieurs. One of them was the *villa* of Cluny, not far from Mâcon. As part of the endowment, Guillaume renounced all power over the institution, leaving the community free to elect its own abbot. The monastery therefore answered solely to the pope. Thus began the history of Cluny.

In 931, Odo, the abbot who succeeded Berno, received authorization from Pope John XI to make his Benedictine order the largest in Europe. There had been only twelve Cluniac monks at Cluny itself in 911; by 1150, the daughter houses and lands attached to Cluny throughout all of Europe were vaster than any kingdom. In 981, for the consecration of the second church at Cluny—called Cluny II—the order purchased relics of the apostles Peter and Paul. The abbey obtained exemption from all but papal authority from Pope Gregory V in 998, a privilege extended by John XIX in 1024 to all Cluniacs "wherever they be." Cluny became a second Rome, and the order became *Ecclesia cluniacensis,* the "Cluniac Church." Abbot Hugh of Semur implanted Cluny in an England conquered by William, duke of Normandy, just as Hugh's predecessors had planted it in Auvergne, Provence, and Italy. Despite reservations on the part of the imperial government, which tried to keep monasteries under its control, Cluny assumed a place in the Holy Roman Empire in the second half of the eleventh century.

The same "Cluniac spirit" was therefore present in the monumental and ornamental forms adopted by abbeys in Burgundy and all along the paths to Compostela, as seen, say, on the capitals of a church in Aquitaine or the tympanum of an abbey church in Spain. Monks built the same choir everywhere, whether at Hirsau in Germany or Thetford in England.

It was in the abbey church of Cluny II that the rite established by Odo and his successors became a strict, almost ascetic, ceremony. Rules governed the divine service down to the tiniest details. Surviving documents suggest that the plan of Cluny II was based on the Carolingian monastery of Saint-Gall. Even as builders at Cluny showed respect for the religious reform undertaken by Louis the Pious and his adviser, Saint Benedict of Aniane, the construction of Cluny II represented a new era of architecture.

A EUROPE OF ABBEYS

In 1088, Abbot Hugh of Semur began to remodel Cluny, convinced that the holy apostles Peter and Paul, whose relics were housed there, had requested him to do so. The abbey church that he built would remain the vastest church in Christendom for four hundred years, until Saint Peter's in Rome was rebuilt under Pope Julius II in 1506. From the west portal topped by a chapel dedicated to Saint Michael to the choir ringed by ambulatory and apse containing five chapels, Cluny III measured nearly 624 feet long. The eleven bays of the nave were covered by a vault that rose some one hundred feet high. The scale of Cluny III, whose altar was consecrated by Pope Urban II in October 1095, represented a terrific way of "snatching souls from the power of evil demons."

The abbey at Cluny, which prayed for the dead and the salvation of souls and said 900 masses in the thirty days following the death of a brother, was a "celestial citadel."

Everything there was symbolic. Numerals and numbers played a decisive role. Take the number four, for example: it evoked four virtues (the theological virtues of faith, hope, and charity, plus the cardinal virtue of justice); the four elements (earth, air, fire, and water); the four rivers of paradise (Euphrates, Tigris, Gihon, and Pison); the four winds (Boreas, Eurus, Notus, and Zephyrus); the four liberal arts (arithmetic, astronomy, geometry, and music); and the four evangelists (Matthew, Mark, Luke, and John). Or take another example: 153 was a special number because tradition held that 153 fish were caught in the nets of the miraculous fishing expedition recounted in the gospels. Meanwhile, on the route to Santiago de

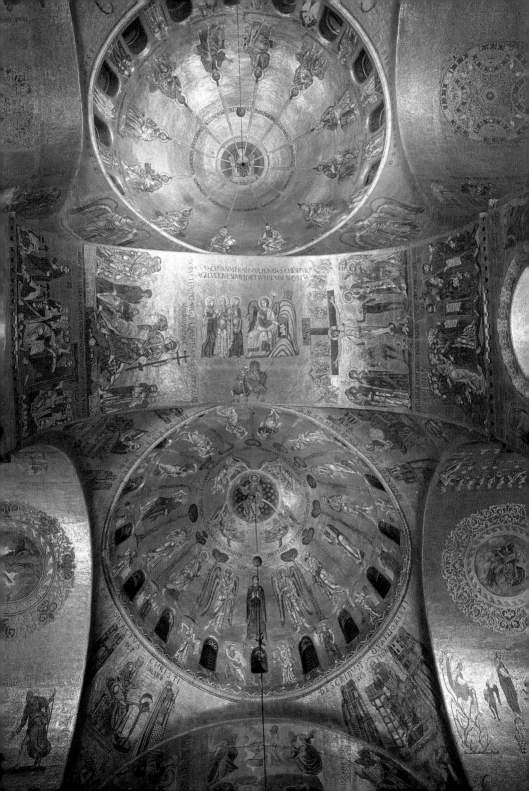

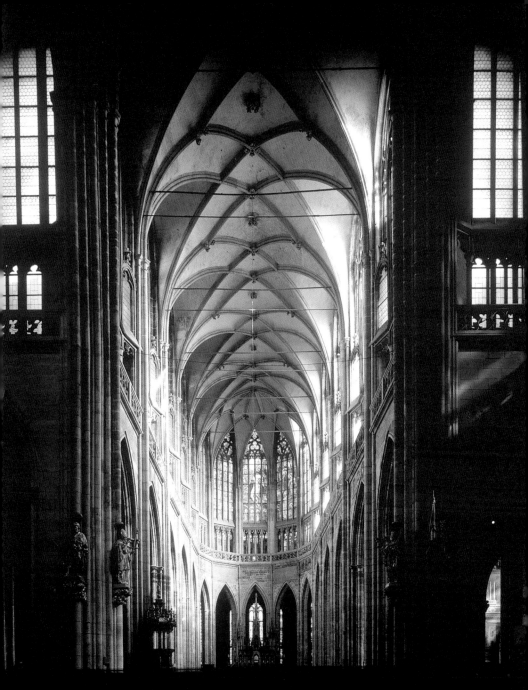

BYZANTINE DOMES AND POINTED ARCHES ROSE TO THE GLORY OF A GOD
WHOSE ESSENCE AS LIGHT WAS SYMBOLIZED BY GOLD AND STAINED GLASS.

Opposite: Vault showing the Passion of Christ flanked by cupolas showing Pentecost and the Ascension.
Circa 1200, 12th-century mosaic. Saint Mark's basilica, Venice, Italy.
Above: Choir of Saint Vitus Cathedral (begun by Matthias of Arras and Peter Parler
in 1348, completed in 1929). Prague, Czech Republic.

Compostela, the relics of twelve-year-old Sainte Foy (Faith), martyred in 303, could be venerated at the abbey of Sainte-Foy-de-Conques, which featured a triple nave in the image of the Holy Trinity.

It was at Cluny that sculptors first carved the capitals of columns with ornamental and animal motifs of extraordinary diversity. Some capitals seemed Corinthian, others presented apocalyptic threats, while still others depicted metamorphoses. Here the volumes might be almost cubic and abstract, there the stone would recount an episode from the Bible.

Above the abbey's sole portal appeared the Christ of the Last Judgment. This depiction of Christ alluded to the Gospel according to Matthew: "When the Son of man comes in his glory, and all the angels with him, then he will sit on his glorious throne. Before him will be gathered all the nations, and he will separate them from another as a shepherd separates the sheep from the goats. . . . Then the King will say to those at his right hand, 'Come, O blessed of my Father, inherit the kingdom prepared for you. . . . Then he will say to those at his left hand, 'Depart from me, you cursed into the eternal fire prepared for the devils and his angels.'"

The same Christ of the Last Judgment also appeared on the tympanum of portals of churches in Moissac, Angoulème, and Autun. Everywhere the tympanums, highly colored at the time, presented the same images to pilgrims. Everywhere they symbolized the passage from a world of the flesh to the sacred world of liturgy and prayer.

This Christendom, which was covering itself "with a white cloak of churches," also resounded everywhere with the same Gregorian chants (the name of Saint Gregory was associated with plain song during the thirteenth century, though it is not certain that he himself composed any of the chants he incorporated into the liturgy). Everywhere, after singing the *Introit,* monks would sing *Kyrie eleison,* one of the rare Greek phrases amid all the Latin, brought to Rome by Levantines and adopted by the Roman liturgy. Everywhere resounded the hymn of *Gloria in excelsis Deo,* followed by the *Sanctus* and *Agnus Dei,* sung as the priest partook of the host. Priests and monks were choristers who did not know how to read music and learned these sacred chants through oral tradition. Until the

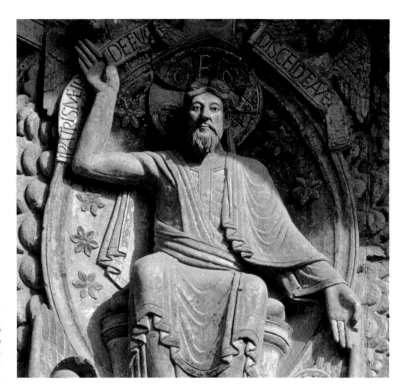

The Last Judgment,
11th century.
Christ on the
tympanum of the
abbey of Sainte-
Foy, 1035–1060.
Conques, France.

ninth century, musical notation indicated nothing other than the melodic line with its rises and falls. It was Guido of Arezzo who first recommended in his *Aliae Regulae,* around 1030, the use of a staff composed of lines and spaces, one of which would indicate the reference pitch, or clef. Later, in the thirteenth century, a hymn to Saint John the Baptist finally provided names for the pitches (at the time, "ut" was used instead of "do"):

Ut queant laxis
Resonare fibris
Mira reatum
Famuli tuorum
Solve polluti
Labii reatum
Sancte **Io**annes

Notwithstanding discord arising from claims of precedence or special privilege, monasteries constituted a vast fraternity from one end of Europe to

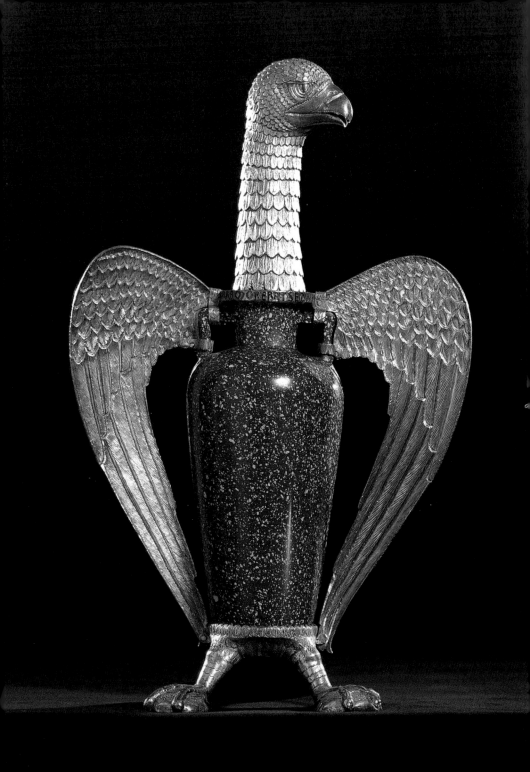

the other. They were united in a shared liturgy, and enhanced by frescoes such as the ones in the abbey church of Saint-Savin-sur-Gartempe in central France, or in the chapel of Berzé-la-Ville, where the abbots of Cluny are buried. Berzé-la-Ville features a Christ in Majesty surrounded by apostles, saints, and deacons. The same Christ in Majesty looks down from the apse of the church of San Angelo (affiliated with Monte Cassino, one of the richest Cluniac monasteries)—the open book held by Christ is inscribed with the words *Ego sum alfa et omega, primus et novissimus* (I am alpha and omega, the first and the last).

These Benedictine monasteries were the strongest sign of the unity of Christendom and the power of the Church. They shunned no symbol of magnificence, from gems to precious metals, that might accompany a liturgy worthy of the Eternal. In 1025, the council of Arras removed all ambiguity over the use of images; although they "should not be worshiped as objects made by the hand of man," they were acceptable insofar as they were "made to stir inner feeling."

CISTERCIAN ASCETICISM

Some people could not tolerate all that splendor. In 1098, Robert, abbot of the Cluniac monastery of Molesme, left his abbey with fourteen of his brothers and withdrew to the wilderness of Cîteaux, not far from Dijon. They wanted to return to a strict observance of the rule of Saint Benedict. Soon they were joined by a monk from Cluny, Bernard de Fontaines, along with thirty other brothers. In 1112, Bernard and some of these monks founded a new abbey at Clairvaux. By 1133, the new order, called "Cistercian" (from Cîteaux), already numbered sixty-nine monasteries. At Saint Bernard's death in 1153, the order he founded boasted 343 monasteries.

Suger's eagle. Vase, prior to 1147. Red porphyry, gilded silver, niello. Treasury of Saint-Denis. Musée du Louvre, Paris, France.

The Cistercians's adoption of asceticism banished all decoration from monastic architecture. Their harsh code of purity was not only a quest for austerity but a search for authentic forms. Stone, for instance, was left bare—frescoes were ruled out, and walls were not even plastered. As in Benedictine abbeys, the cloister was the heart of the monastery. It was

spare and simple, as was the abbey church. Refectories, meanwhile—as seen, for example, at the abbeys of Saint-Martin-des-Champ in Paris, Thoronet in Provence, or Maulbronn in Swabia—prove that Cistercian monks everywhere designed space to accord with the most intense spiritual rigor.

A comparison of the Tre Fontane abbey in Rome with those at, say, Eberbach and Cabuabbas would imply that Bernard made his Clairvaux abbey a model: the same architectural forms are found everywhere. In all Cistercian monasteries the abbey church was designed along the same lines—the same Latin cross, the same nave with two aisles, the same choir flanked by chapels, the same semicircular vaults running the length of the nave. Saint Bernard's asceticism was a mysticism that took shape in stone, defining a style in which nothing would distract from prayer. In accordance with this strictness, manuscripts illuminated in Cistercian abbeys were monochromatic.

The formal approaches imposed throughout Europe by the two Benedictine orders—Cluniac profusion and Cistercian austerity—were the very ones that would be labeled "Romanesque" in the nineteenth century.

Romanesque Forms

Romanesque art emerged shortly after the year 1000, even though the adjective did not appear until the nineteenth century. In 1818, Charles Duhérissier de Gervile sensed that the forms typical of the art then called "old Gothic" were inspired by Roman models and examples, so he suggested calling them "Romanesque," a term which was permanently adopted after 1860.

Romanesque art developed within a Christendom that answered solely to Rome, which Emperor Otto III had made his capital in the year 1000. Romanesque art thus grew in a Christendom irrevocably divorced from the Byzantine church after the schism of 1054. Yet despite the schism, and despite the dream of Otto III (who, ensconced on one of Rome's seven hills, the Aventine, thought he was restoring the Rome of the Caesars), Rome was not Christianity's true center of gravity. The monasteries

Portrait of John II
the Good. French
school, second half
of 14th century.
Tempera on wood.
Musée du Louvre,
Paris, France.

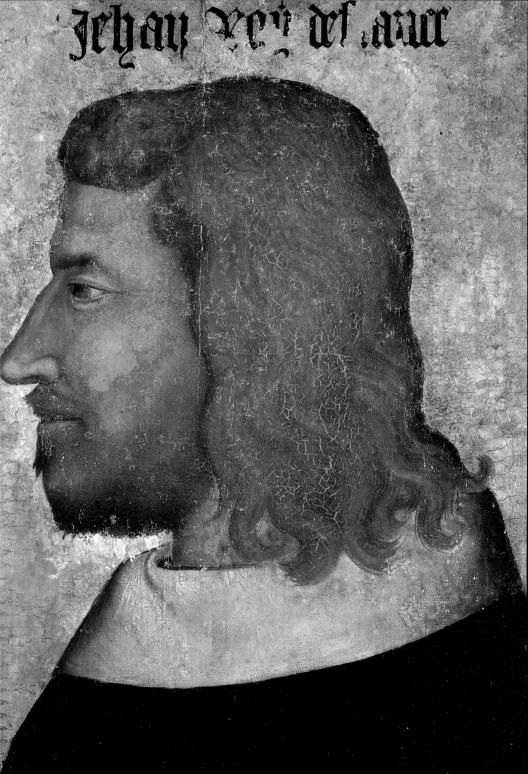
Jehan rey de fuate

constituted its conscience and strength. Romanesque art began to take shape in the monasteries of Catalonia, of northern and central Italy, of Provence, and even further north in the monasteries of the valleys of the Rhône and Saône rivers. The heritage of Roman traditions merged with influences from both Byzantium and Islamic Spain.

Starting in the tenth century, timber roofs over churches were replaced by barrel vaulting set on transverse ribs. In Catalonia, cupolas began to appear over the crossing of nave and transept.

When it came to spreading these new construction techniques throughout Europe, conquest and political maneuvering were no less efficient than pilgrimage routes dotted with abbeys and hostels. William, duke of Normandy, claimed the crown of England after the battle of Hastings, where Harold died on October 14, 1066, and he immediately surrounded himself with bishops and abbots he could trust: Lanfranc, abbot of Saint-Etienne in Caen, thus became archbishop of Canterbury by the grace of William the Conqueror, just as Thomas of Bayeux became archbishop of York. William's companions, meanwhile, were building the castles needed to defend their new kingdom.

In 1077, the construction of the priory of Saint Pancras in Lewes, Sussex, was the first Cluniac monastery in England; consecrated in 1145, the church was an exact replica of Cluny itself, though not of the same dimensions. Thus the Burgundian forms adopted by the Normans made their way to England.

Venice, however, did not turn to Cluny for inspiration. The Byzantine architects—who erected the five domes over the Greek cross of Saint Mark's, consecrated in 1094—took as their model the church of the Holy Apostles at Constantinople, built by the architect of the church of Hagia Sophia (Holy Wisdom), itself "copied" from the church of the Holy Sepulcher in Jerusalem, which also served as a model for San Stefano in Bologna.

Italian architecture was distinct in yet another way, namely the baptisteries that were built opposite the cathedral, as seen in Florence and Pisa. The white marble of the Pisan baptistery nevertheless contrasts with the

diamonds and rectangles of colored marble on the façade of the baptistery in Florence.

FAÇADES, VARIATIONS

It was the job of façades, which differed here and there, to reveal the special role played by the church as it came into view of the approaching faithful.

Cistercian abbeys kept laymen apart—their façades remained "mute." Thus, in the lands of the Holy Roman Empire, church façades could be austere and simple, without any decoration. Some rose implacable, like the keep of a castle, in Westphalia and Lower Saxony. These silent façades always seemed to repeat the inscription cut into the stone of an abbey church built in the late ninth century: *Civitatem istam tu circumda Domine et Angeli custodiant muros ejus* (Surround this city, Lord, and may angels guard its walls).

Conversely, in Provence and Aquitaine, church façades looked more like an arch of triumph: they proclaimed the victory of God, they gloried in a Church that rejected imperial authority, a Church that wanted to continue to believe in unity despite the schism that split it from 1130 onwards. All churches that received pilgrims had to convey—on the façade itself or in the narthex—the sacred reality of the sanctuary that the faithful were about to enter.

Two inscriptions cut into the stone of the tympanum on the abbey church of Santa Cruz de los Seros in Aragon make this crystal clear. The first asserts: *Janua sum praepes. Per me transite fideles* (I am the door to happiness. Pass through me, ye faithful), while the second warns: *Corrige te primum valeas quo poscere Christum* (Repent firstly, that you may be worthy of entreating Christ). In the same way, flanking the portal of the cathedral of Borgo San Donnino are statues of David and Ezekiel holding scrolls on which are carved these words, respectively: *Hec porta Domini / Justi intrabunt per eam* (This is the Lord's door / The just will enter it); *Vidi portam in domo Domini clausam* (I saw the door to the Lord's house closed). The church is therefore open only to those who have repented.

The tympanum—the area inside the arch just above the doorway of a church—could leave no doubt in the minds of pilgrims entering the church. A tympanum with its sculpture was one of the most striking features of Romanesque style. At the church of Saint-Trophime in Arles, the tympanum of Christ in Majesty includes the symbols of the four evangelists: the bull for Luke, the lion for Mark, the eagle for John, and the angel for Matthew. These symbols correspond to the vision of Ezekiel (1:5–12), who glimpsed their divine sparkle, "like burnished bronze."

This Christ in Majesty, this Christ the Judge, similarly appears on the tympanum of the abbey church of Moissac, surrounded by the twenty-four elders mentioned in the book of Revelation. At Conques-en-Rouerges, he is flanked by angels bearing the instruments of Passion. The Passion of Christ was also carved on the church at Santiago de Compostela, rebuilt by the king of Castile, Alfonso VI, beginning in 1075 (or perhaps 1078). Work at Santiago was only completed fifty years later.

Suger's Light

Around 1130, Abbot Suger decided to build a new porch to the entrance of the basilica of Saint-Denis, just outside Paris. He wanted Christ's ancestors to be carved into the stone flanking the portal. He wanted the gilded bronze doors to show the Passion and Ascension of Christ. And he wanted the windows of the apse (and, later, those of the ambulatory) to be decorated with stained glass whose sparkle would be greater than the glitter of the gold on the enamels and gems on the reliquaries, ciboria, and monstrances. Suger believed that light was God incarnate. It only remained for stone to take the forms required by this theological conviction. Suger, inspired by *On Mystical Theology* (thought to be written by Dionysius the Areopagite, whose relics the abbey claimed to possess), was convinced that works that were "nobly bright" would "brighten minds so that they may travel, through the true lights, to the True Light where Christ is the True Door."

This was the light perceived by the Doctors of the Faith, the same light mentioned by Bonaventure and Thomas Aquinas. Now, Suger wanted his

Giotto, *Franciscans before the Sultan*, 1295–1300. Fresco in the basilica of Saint Francis, Assisi, Italy.

60

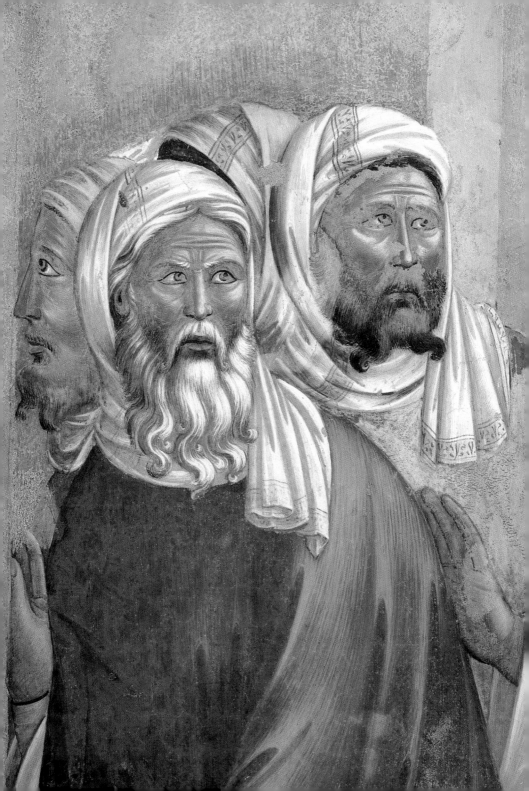

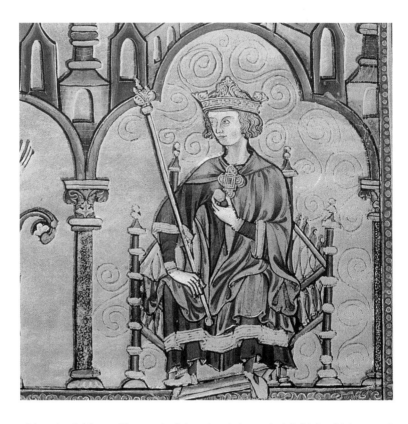

Above:
Saint Louis. Detail
from a 13th-
century illuminated
manuscript.
Pierpont Morgan
Library, New York,
United States.

Opposite:
Saint Lubin (bishop
of Chartres in the
6th century).
Stained-glass
window, Chartres
Cathedral, circa
1200–1210.
Chartres, France.

abbey to "shine with wonderful and uninterrupted light," which meant that the walls of the church had to be effaced, becoming nothing more than ribs and ridges of stone—pure line. They had to give way to glass; architecture was to be nothing more than a setting for stained glass.

Pieces of glass—clear, translucent, or colored—were therefore assembled in a framework of lead. On some of them, details and decoration might be painted; when fired, this painting became a kind of enamel on the surface of the glass. This technique changed little until the late thirteenth century, when glass, which had been translucent up till then, became transparent. Each piece was of a single color, and each color was outlined in lead.

It was in order to deal with these psalms of glass—these stained-glass windows—that architecture adopted new techniques. Such techniques were not really new, however: Cluny III had already employed high, pointed arches, and the nave of Saint-Lazare in Autun was topped by pointed

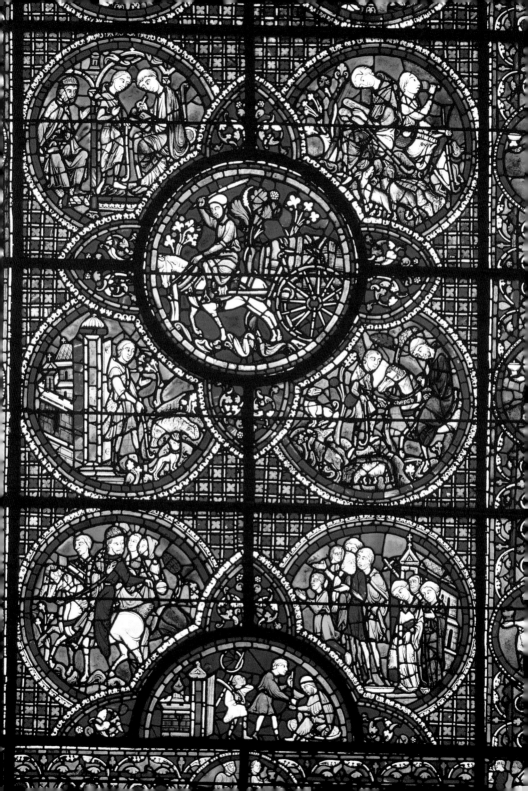

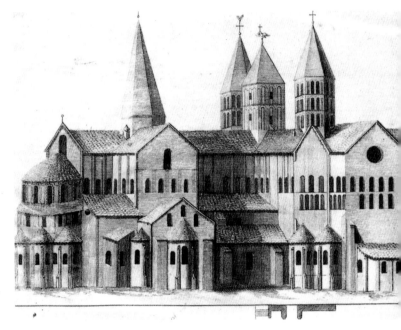

View of the abbey church of Cluny. Engraving by P. F. Giffart, 18th century.

barrel vaulting orchestrated around transversal arches. Durham, meanwhile, was one of the first cathedrals in Europe to use ribbing that sprang across the nave diagonally from one pier to another; this stone ribbing made it possible to produce lighter vaults much than the standard "barrel" vaults.

Vaults and Arches

Changing construction techniques and inventing new ones was not without complications at a time when the Church itself felt that "novelties" could only be indecent and immoral, leading only to sin. The heritage of the past, confirmed by tradition, was all that counted. Furthermore, a church was a symbolic entity as much as an architectural one. If its plan was circular, it symbolized the perfection of God; if it took the shape of a cross, it incarnated the very cross on which Christ died, the four cardinal points, and the dimensions of a universe destined to become the Heavenly Jerusalem. Thus, for the builders of cathedrals, new techniques were less a question of change than of greater fidelity to God, as condoned by the Church.

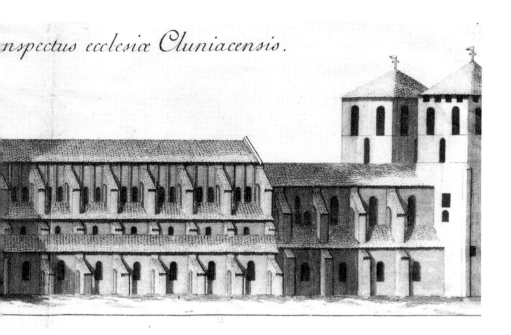

Lancet arches, rib vaulting, and flying buttresses were ways of implementing an architecture dedicated to light. Pointed arches could rise higher from their piers than semicircular ones. But in order to support the stress of the weight they bore, they had to be reinforced by a counterbalancing thrust, which was the role of flying buttresses.

The combination of pointed arches, rib vaulting, and flying buttresses rose like a prayer of stone and light toward God. Such were cathedrals.

Although Benedictine abbot Suger's decision to rebuild his abbey of Saint-Denis spurred architecture to take up this challenge, it was not via abbeys scattered across the countryside that the new forms would spread but rather via the cathedrals. Via cities.

Romanesque art was an art of abbots.

Gothic art was an art of bishops.

Gothic art was, above all, cathedral art. A cathedral was the church of a city, the seat of episcopal government. (The Latin word *cathedra*, itself borrowed from Greek, refers to the bishop's throne or seat.) All across Europe, it was in cities that trade, markets, and fairs were attracting

financial power. It was in cities that princes established their courts and asserted their temporal power. Bishops wanted their own power to be as evident as any other powers.

A bishop, after all, was heir to the apostles. It was up to the bishop to guide the faithful toward salvation. This was the apostolic mission stressed by Pope Callistus II in 1119. The exemplary, age-old church had to spread the word of Christ, to preach the epistles of Paul and the Acts of the Apostles, to reform the behavior of laymen, to lead them to the Heavenly Jerusalem. It did so via communion, via confession—a believer had to take communion at least once per year. This requirement, decreed by the fourth Lateran Council in 1215, meant that sinners had to make themselves worthy of communion through confession and penitence.

Cathedrals were erected for the liturgy of communion, for processions led by bishops and canons. Rising in the middle of Europe's cities, towering above lowly, cramped dwellings, cathedrals extolled episcopal power and the glory of God.

THE AGE OF CATHEDRALS

The skyward thrust of stone that began at Saint-Denis and other churches in the Paris region (such as Sens, whose high altar was consecrated by Pope Alexander III in 1164) continued throughout Europe for three centuries, from Canterbury to Burgos to Prague. In 1160, work began on Notre Dame in Paris and the cathedral of Laon, followed by those of Mantes, Reims, Bourges, Chartres, Amiens, Beauvais, and so on. A French architect, William of Sens, was called to England to rebuild Canterbury Cathedral, which had burned down in 1174. For the cathedral of Saint Vitus in Prague, Emperor Charles IV called on another French architect, Matthias of Arras, who died in 1352, before work was completed.

In the image of a "divine nature," which Thomas Aquinas claimed could maintain all things in "a conformity devoid of confusion," these cathedrals were the mark of the unchallenged victory of Catholic dogma over all heresy. The cathedral of Albi confirmed the victory of sword and stake over Albigensian heresy, while the cathedral at Burgos marked the victory

of Christian kingdoms continuing the reconquest of Spain from the Muslims.

Everywhere the light of God—the light of cathedrals—began to reveal the reality of the world. Once it seemed as though the troubles of the times might be avoided, mankind could view the world the way the first humans did in the aftermath of Creation: the world was good, the world was beautiful. And maybe mankind could finally believe that the days of penitence were coming to an end. Objects and forms would no longer be necessarily symbolic.

Most power had shifted from the hands of local feudal lords to the hands of the most powerful among them—princes and kings. This did not, however, simplify the complex web of laws, taxes, and duties that princes, bishops, and abbots imposed on humble folk.

The vaulted ceiling of Beauvais cathedral was raised to a height of one hundred and sixty feet, only to collapse in 1284. No more resources were available, given the increasing cost of raw materials and labor and the failure of banks that had continued to lend to indebted princes even as money was being devalued. So it is hardly surprising that, between 1280 and 1306, riots and revolts broke out at Bruges, Toulouse, Tournai, Rouen, and Béziers.

STATUE-COLUMNS AND ROOD SCREENS

Just as architecture changed in order to make place for light, so sculpture changed. Theological considerations altered the instructions given to sculptors.

At places like Vézelay and Moissac, the tympanum was design to reveal the invisible to pilgrims. In cities, meanwhile, cathedrals had to demonstrate to all, like some theological dissertation, the coherence and beauty of the world, of its creation, and of the human condition as salvaged by God's sacrifice of His only son. Sculpture, which did not play a role in Romanesque buildings until the eleventh century, took its place in Gothic architecture immediately. The Ascension of Christ and the presentation of Christ in Majesty gave way in the 1160s and 1170s to the Last Judgment,

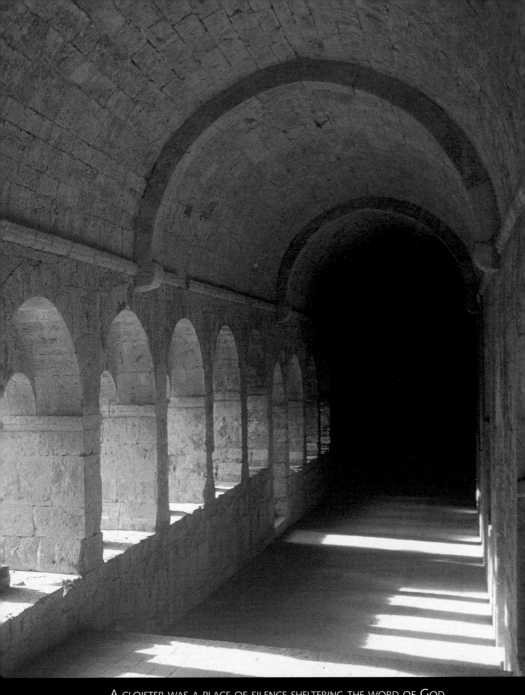

A CLOISTER WAS A PLACE OF SILENCE SHELTERING THE WORD OF GOD,
THE BETTER TO MEDITATE ON IT. A CATHEDRAL WAS A SYMBOL OF THE POWER
OF THAT WORD AND ITS TRIUMPH OVER ALL HERESY.

Above: Cloister of the abbey of Le Thoronet, 1146. Le Thoronet, France.
Opposite: Sainte-Cécile Cathedral, 1282–15th century. View of east end, Albi, France.

to a Christ pointing to His wounds. Another theme, the Coronation of the Virgin, also appeared around 1170.

These subjects favored the New Testament. The Old Testament was only present insofar as it prefigured the New. Below the tympanum, the lintel might still depict the Dormition and Assumption of the Virgin. Elsewhere, as at Bourges, the Adoration of the Kings might be featured. Even the voussures rising above and around the tympanum and lintel were henceforth sculpted. And, in a completely new way, the columns flanking the recessed doorway became statues. In this way, the apostles were seen to flank the Redeemer.

For the first time, thanks to a decision by Abbot Suger, twenty-three kings and queens of the Old Testament were aligned in the form of statue-columns along the three doors of the basilica of Saint-Denis. The three sections of the royal portal at Chartres, meanwhile, were adorned with twenty-four statue-columns around 1150. This type of statuary was imitated only in northern Europe, unlike the Suger-inspired architecture, which concerned all of Europe.

In Reims, the church where kings of France were crowned was covered all over with angels who guarded the Heavenly Jerusalem and whose "perpetual peace" echoed the peace the king was expected to bring to his earthly kingdom. The presence of royal statues among the angels demonstrated to everyone the close link between the "sacerdotal" and "regal" orders.

Within cathedrals themselves, religious rites required that the space reserved for the clergy be distinct from the one allocated to the faithful, so immense rood screens went up. Even as they separated space, rood screens began providing a visual catechism during the thirteenth century: the sculptures set in them recounted the Passion of Christ; here and there the stations of the cross would be accompanied by scenes of the childhood and life of Christ. Only a few rood screens still stand today. The Council of Trent, held between 1545 and 1563, decided that priests should no longer be separated from the faithful when celebrating communion; most screens were then taken down.

Flying buttresses,
Notre-Dame
Cathedral,
Paris, France.

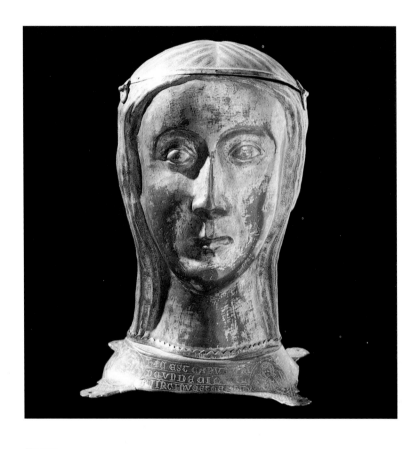

TOMBS

In this period when funerals were a major social ritual, there also appeared an unprecedented type of sculpture, the recumbent figure. Initially, in the late tenth to eleventh centuries, recumbent figures were simply an idealized evocation of the deceased; by the 1350s they had become true portraits.

Sometimes, in France and northern Europe, a tomb might combine a sculpted likeness of the deceased with another one of the naked, decomposing corpse. These dreadful depictions were not self-indulgently morbid but rather the sign of a certainty: these mortal remains showed that the deceased had rid himself of the body while awaiting—buried in the church, head pointed toward the east—the return of Christ and the resurrection of the body.

Above: Reliquary head of one of the *Eleven Thousand Virgins of Cologne.* Limoges, France, late 13th century. Hammered, engraved, guilloched and gilded copper. Collegiate church of Saint-Martin, Brive, France.

Opposite: The large bedchamber, Papal Palace, Avignon, France.

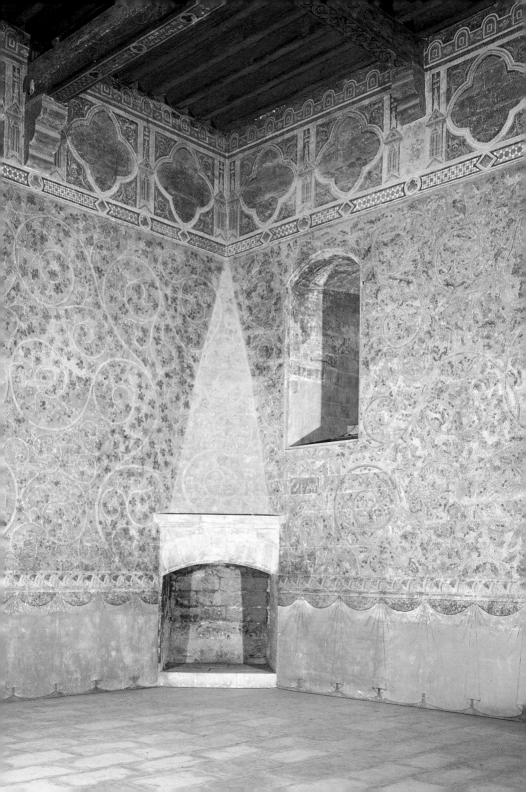

Starting in the thirteenth century, recumbent figures—previously carved in the stone slab, formed of glazed tiles (in Normandy), or sometimes composed of mosaics (in Picardy)—began to be produced in bronze, gilded copper, and enameling. The mastery of enameling techniques enabled artisans in Limoges to win orders for recumbent figures from beyond France's borders. Then sculptors turned to marble. The white-marble recumbent figure of Isabella of Aragon rests on a black slab. The flow of her garments accord with that of a horizontal body, dispensing with the conventional folds for vertical bodies, and thereby pointing to what tombs would become.

Tomb sculpture no longer depicted a cadaver once it began depicting the living who awaited death. A "praying figure," usually kneeling with hands clasped, could thereby continue to pray after death for the salvation of his or her own soul.

Powerful rulers would call on famous sculptors to design and execute their tombs. Philip the Bold, duke of Burgundy, summoned Claus Suter, a member of the Brussels stone carvers guild, to Dijon in 1389. In Westminster, it was Jean of Liège who sculpted the tomb of Philippa of Hainault, wife of Edward III. In 1416, Janin Lomme, a sculptor from Tournai, executed the alabaster tomb of King Charles the Noble and Queen Leonora in Pamplona cathedral.

Although their rank required rulers to commission tombs proclaiming their Catholic faith, they no longer devoted all their resources to works of pure piety. The art henceforth found in cathedrals was itself imbued with a beauty, grace, and elegance that were no longer solely an homage to God and His church.

FROM CASTLE TO PALACE

Around the year 1000, the average castle—not only an instrument of war but an assertion of power as political and economic as it was military—was little more than a fortified tower, or keep (also known as "donjon," from the term *dongio*, meaning a mound surrounded by a ditch). Everywhere possible, builders would site such strongholds on high cliffs, elevating

them further still. Within the high walls of the stronghold would be a well, a cistern, a forge, stables, and a chapel. This model was followed throughout Europe.

The special conditions imposed by a given site and requirements of military efficiency led to the abandonment of square towers for stronger, round ones. The keep thereby became a fortress. Drawbridges, corner towers, and crenellation strengthened defensive properties. Ditches became broader. Curtain walls went up. Paradoxically, to protect themselves from potential rebellion by mercenaries clamoring for their pay, kings and princes even had to build another stronghold within the fortress. In the castle of Vincennes, Charles VI of France built a square keep whose walls rose more than one hundred and sixty five feet high.

The grand scale of these castles was dealt a serious blow around 1453, once catapults using stones gave way to cannons with iron balls. Only the most powerful of rulers could cope with the new situation, for they had to finance the reinforcement of the old stone-and-mortar defenses, had to pay for the construction of lower but thicker and denser walls with smooth surfaces that deflected projectiles.

Hence, over the centuries, the role of castles changed even as they remained the site of power. It was in the castle hall, or "great hall," where such power would be exercised. There the lord would assemble his vassals, hold council, render justice, and receive visitors. Some lords even slept in this same hall, or *camera,* which slowly became a space identified as the residence within a castle, especially when the *camera*—literally, "chamber"—was endowed with other little rooms such as the wardrobe. Some of these apartments opened onto an oratory next to the chapel. In the later fourteenth century, yet another space was developed, that of the gallery. In none of these places was stone left bare; it would be plastered and then painted with decoration either simple (such as an imitation-stone pattern) or complex (geometric or foliate). Major aristocratic dwellings boasted walls decorated with hunting scenes, tournaments, and episodes from courtly legends of processions of knights and ladies with all their retainers.

Following pages:
Overall view of
Château Gaillard,
Eure, France.

A LAY CLIENTELE

Architects, sculptors, and painters were henceforth employed by this clientele of nobles, "condottieri" (warlords), and burghers—characters straight out of Chaucer and Boccaccio.

It was for them that Simone Martini painted, in Siena's town hall in 1328, one of the earliest secular frescoes in Europe. Eleven years later, Ambrogio Lorenzetti began, for the same Sienese building, a fresco showing the effects of *Good and Bad Government,* completed in 1343. It was for the Duke of Berry that the Limbourg brothers illuminated a book of hours, *Les très riches heures du duc de Berry,* with secular images of work in the fields, the social graces, and the delights of courtly life.

Sacred art was no longer destined for abbeys and cathedrals alone. It became an art of chapels. The Sainte Chapelle, built alongside the royal palace in Paris, was modeled on a reliquary, becoming a giant coffer of stone and stained glass, where King Louis IX placed the crown of thorns he had brought back from the Holy Land.

Similarly, the chapel of Karlstein Castle outside Prague, where Emperor Charles IV prayed before reliquaries, had walls studded in gems and paintings by Theodoric.

A new technique, developed in Italy in the late thirteenth century, made it possible to replace opaque enameling on copper plates with translucent enameling on silver or gold plates; the shimmer of precious metals and the colors of objets d'art produced in workshops in Paris, Barcelona, London, and Avignon were soon seducing a new clientele.

It was also for chapels—for the humble oratories of wealthy burghers—that Paris workshops began carving scenes of the Passion or the life of the Virgin in ivory. Parisian sculptors carved combs as well as religious subjects for this clientele, and such ivory work was copied throughout Europe.

The same clientele was also targeted by the "alabastermen" in York and Burton-on-Trent in England. In the closing decades of the fourteenth century, their alabaster carvings were exported by merchants to places like Iceland and Croatia, Portugal and Poland.

It was in a chapel that Europe's first painted portrait appeared: Giotto's

fresco portrait of Enrico Scrovegni was painted between 1303 and 1305 for the Paduan burgher's private chapel, a chapel attached neither to a cathedral nor to the basilica of Sant'Antonio, where the Franciscans had summoned Giotto a year earlier.

Scrovegni had Giotto paint the walls of his chapel with the story of the Virgin's parents, the life of the Virgin, and the childhood of Christ followed by the Passion, Resurrection, and Pentecost. Thirty years later, Matteo Giovannetti would decorate the Stag Chamber of the Papal's Palace in Avignon with hunting scenes.

Art, therefore, was no longer solely a church affair.

God was no longer the sole "subject" of art.

Thanks to the patronage of a few great rulers, the stakes behind art had become political.

PARIS, PRAGUE, AVIGNON

From the early 1300s onward, Paris imposed its artistic taste, ideas, and styles on all of Europe. One after another, the kings of France made sure that Paris remained the capital of art. Philip IV the Fair did not hesitate in 1298 to send his painter, Etienne of Auxerre, to Rome to complete his training. In 1304, Philip accorded the title of "painter to the king" to Filippo Rusuti and his son, as well as to Nicolò dei Marzi. Jean Pucelle, meanwhile, returned to Paris to share the discoveries he had made in Avignon and, probably, Florence, where he stayed sometime around 1320 or 1323. John II the Good—whose picture is thought to be Europe's first free-standing portrait (sometime before 1350), that is to say the first that was not part of an ensemble—summoned Flemish artists to Paris. Charles V ordered the construction of the keep at Vincennes and enlarged Philip-Augustus's Louvre with a monumental spiral staircase that was widely imitated. Stained-glass windows assumed new dimensions; the flame-like pattern of tracery (the stonework between the panels of glass) was so striking that the nineteenth century dubbed the style "flamboyant." Anxious to enrich his library, Charles V ordered numerous translators to undertake translations of Latin texts, just as Pierre Bessuire had translated Livy's

Following pages:
Bayeux Tapestry
(detail), 11th
century. Musée
de la Tapisserie,
Bayeux, France.

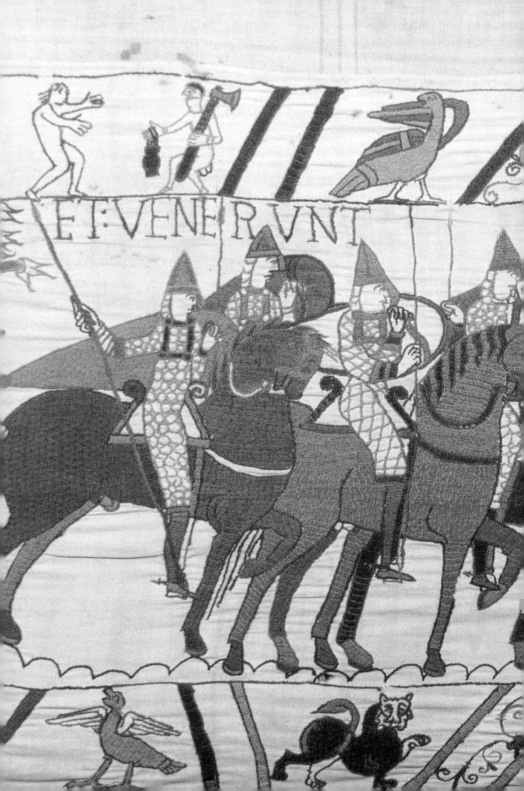

ET·VENERVNT

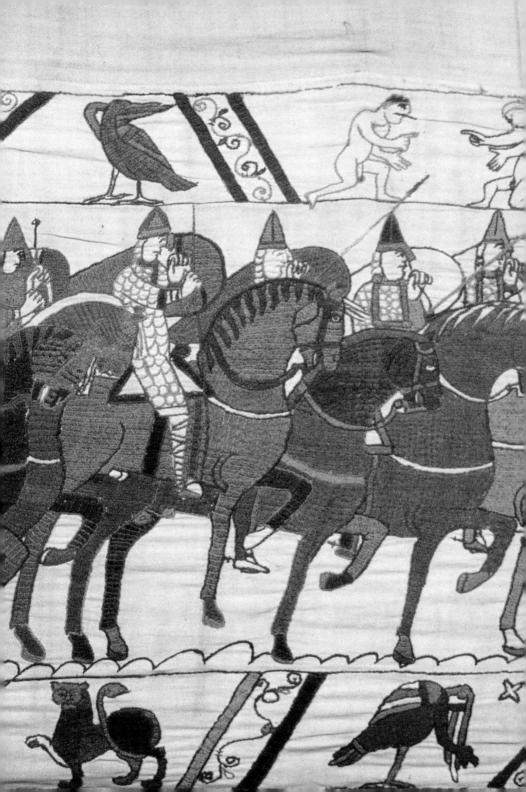

History of Rome for John the Good; he also commissioned the chronicles known as the *Grandes Chroniques de France* and *The Coronation of Charles V* in which everyday life was depicted. It was in Paris that Jean Froissart—who had spent time in England in the service of Philippa of Hainault before traveling to Scotland, Savoy, Avignon, and Italy; who was known to Wenceslas of Bohemia; and who had met Petrarch and Chaucer—wrote his *Chronicles* of the Hundred Years' War. The exchanges encouraged in Paris by French kings, the mixing of influences from Flanders and Italy, became an exemplary model for other rulers, adopted by the likes of the duke of Berry and the duke of Burgundy.

It was also adopted by Charles IV in Prague, who became king of Bohemia in 1246 and Holy Roman Emperor in 1347. Charles had been raised in the Valois court in France and at the Papal Palace in Avignon, surrounded himself with Italian educated advisers, and was brother-in-law to the king of France—his sister, Bonne of Luxemburg, married John II the Good in 1332. In 1346, Charles asked Matthias of Arras to supervise the construction of the cathedral of Saint Vitus; just as he chose a French architect, so he turned to Parisian goldsmiths, even if it meant shipping Bohemian crystal from Prague to Paris. And he redistributed and spread these models throughout the Holy Roman Empire, from the Rhineland to Lower Saxony. The role assumed by Prague—of summoning artists from all over Europe and setting standards for the empire—had been played in a different way by Avignon since 1309. That was when Pope Clement V called a council in Vienna and moved the papacy to the Avignon site, purchased by the Holy See in 1229. It was in 1348, the year of a plague epidemic that wiped out half the town's population, that Joan of Naples, countess of Provence, finally sold the rest of Avignon to Pope Clement VI. And it was only in 1415 that the council of Constance ended the great western schism by rallying everyone around a single pope, Martin V, thereby allowing the popes to return to Rome

Ambrogio Lorenzetti, *Good Government,* 1338. Town hall, Siena, Italy.

For more than a century, then, the popes did everything in their power to make the magnificent pomp of their new papal court dazzle the rulers of Europe. Already Clement V and John XXII had enlarged the episcopal

palace that served as papal residence. One after another, the popes of Avignon summoned the most famous composers of *ars nova* from Paris and the best painters from Siena. Benedict XII hired the Tuscan artist Simone Martini, who, in the palace chapel of Saint John, painted Western Europe's first cycle of frescoes devoted to the stories of both Johns—the baptist and the evangelist—covering all the walls and even the ceiling. In the ongoing construction site of the papal palace, Italian painter Matteo Giovannetti—who worked in Avignon from 1343 to 1367—met French artist Robin de Romans, just as he met precious metalworkers from Paris, Montpellier, and Limoges. These constant exchanges led to an international style above and beyond the unique features of each artist with his techniques and expressive characteristics. One of the most revealing works of this International Gothic style is Gentile da Fabriano's *Adoration of the Magi*. Painted in 1423 for the Strozzi chapel in the church of Santa Trinità in Florence, it is a long procession that stretches across the entire altarpiece, revealing courtly magnificence through wonderful fabrics, jewelry, finery, teams of horses, and so on.

Although this procession was paying homage to God incarnate, its true subject was, henceforth, mankind.

The Uniqueness of the Artist

We do not know the names of the stone carvers who built the abbeys for the Benedictine monks of Cluny and Cîteaux, nor of the sculptors who carved all those figures over portals and capitals. Nor do we know the names of the artists who illuminated the manuscripts produced by monastic scriptoriums.

Around 810, a drawn figure of a man kneeling before the cross was accompanied by red lettering that spelled out the words, "I beg you, O Christ, in your Mercy and Goodness to justify [i.e., forgive] me, Raban." For perhaps the first time in the history of Western Christianity, a man dared to depict himself. Not, however, because the manuscript he was presenting to Christ was a work of art, but because it was a prayer.

On one of the first pages of a codex given to Emperor Otto III around 990,

the following words appear in gold capitals: "May God, eminent Otto, clothe your heart with this book. May you remember that you received it from Liuthar." And Liuthar, who was addressing the emperor and not God, depicted himself with a book in his arms. Herrad, abbess of the convent of Hohenburg by the grace of God, was shown standing before her community as she presented the *Hortus Deliciarium* (Garden of delights), a volume copied in her convent and designed to sweeten the soul like honey.

During those same years—or perhaps somewhat earlier, in the 1150s or 1160s—the stained-glass worker Gerlachus depicted himself in a window of Arnstein-on-the-Lahn, hoping for divine mercy on judgment day.

In Villard de Honnecourt's book of architectural drawings, façades, and plans that he compiled from Laon to Strasbourg to Cologne, his pictures of people and animals include a portrait of himself, perhaps done around 1250.

Between 1379 and 1386, Peter Parler the Younger, given charge of building the cathedral of Prague, sculpted his own portrait in stone inside the cathedral itself.

Such cases were nevertheless exceptions during those centuries. Around 1400, Cola Petruccioli painted himself in one of the friezes of the frescoes executed in the church of San Domenico in Perugia; the brush in his right hand points toward a goblet held in the left, representing the first allusion of this type (it was only half a century later that, for the first time, artist Jean Fouquet dared depict himself all alone).

Until the fifteenth century, portraits of painters, architects, master glassmakers, and monks who illuminated manuscripts were rare. For a long time their work was designed solely to accompany the prayers of the clergy and guide the prayers of lay people. When, little by little, the books being copied and painted were no longer destined solely for abbeys and cathedral schools, when books were acquired by powerful patrons and connoisseurs, society began to want to identify and record the names of artists who demonstrated exceptional mastery.

If Benedetto Antelami dared to engrave his name on the architrave of the baptistery in Parma, that was because he knew that this baptistery, dated

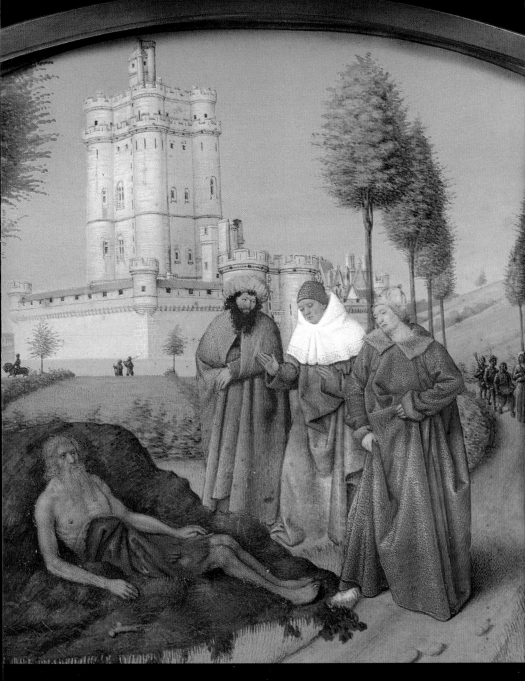

THE THEMES OF CHIVALRY AND COURTLY LIFE
INSPIRED THE ARTS OF TAPESTRY AND MANUSCRIPT ILLUMINATION.

Opposite: The Whore of Babylon, *Apocalypse Tapestry*, 1375–1380. Château d'Angers, France.
Above: Jean Fouquet, *Book of Hours of Etienne Chevalier*, Job on his dung heap.
Illuminated manuscript, circa 1455. Musée Condé, Chantilly, France.

1196, was the largest and tallest in northern Italy. His "signature" was a kind of challenge.

In a Catholic Europe evangelized by abbeys, in a Europe that thrust the steeples of its cathedrals skyward for the greater glory of God, in a Europe where secular palaces now had to display the power of government, the nature of works of art was changing. For centuries, art had been a humble prayer addressed to God alone, but it had now become a distinguishing mark of the person who had commissioned it. Between the eleventh and fifteenth centuries, a work of art slowly began to be linked to an individual name—that of the artist—but only from the moment that human eyes recognized this work as a startling exception.

Catholic Europe, having adopted the international Gothic style developed in Paris, Avignon, and Prague, was just waiting to be startled. It was awaiting the exceptional.

Baptistery (south-east view), 10th–11th centuries, Florence, Italy.

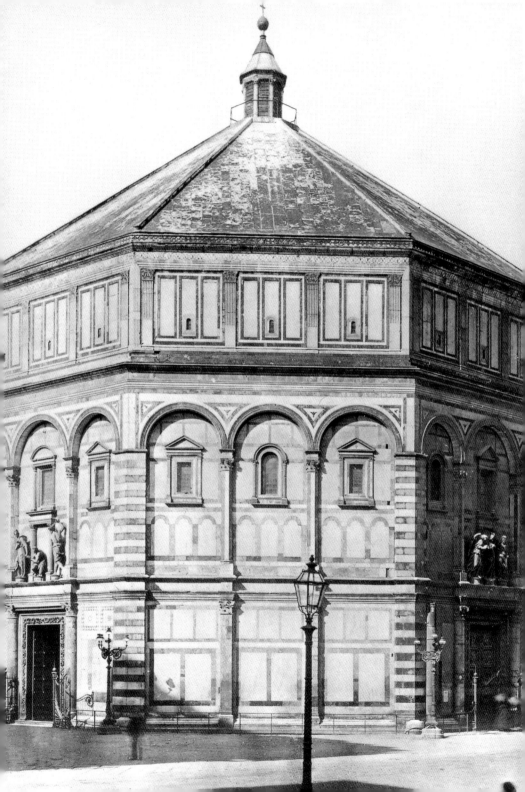

MANKIND, PERSPECTIVE, ANTIQUITY

DOME

1420: The cathedral in Florence was still uncompleted. Since 1367, a dome had been planned for the crossing over the transept. The wool merchants' guild, *arte della lana,* which was sponsoring the work, had organized a competition two years earlier, in 1418, which Filippo Brunelleschi had won. The totally unknown building method proposed by Brunelleschi avoided the need to erect vast scaffolding. In this year of 1420, construction began. It would take some fifteen years before the dome with its octagonal structure finally rose above Florence, unlike any other edifice. For the first time in Europe, a dome rather than a tower or steeple crowned a cathedral, and it was first time since antiquity that, in this completely Catholic Europe, builders took the risk of erecting a dome. It was not to be like the Byzantine cupolas topping Saint Mark's in Venice, but rather like the Pantheon in Rome, the sole surviving dome from antiquity. Brunelleschi owed his learning to antiquity. According to one of his followers, it was in Rome that Brunelleschi divined what must have been the architectural methods of ancient Rome. "He clearly thought he recognized a kind of order like limbs and bones, as a man enlightened by God for great things; he took good note, because this type of construction appeared to him very different from the one then being used."

Brunelleschi's other construction projects also astonished Florence: the Ospedale degli Innocenti (Hospital of the innocents) with its loggia overlooking Piazza Santa Annunziata; the church of San Lorenzo, a vast basilica orchestrated by Corinthian columns (financed by Cosimo de' Medici); the Pazzi chapel, where gray stone (*pietra serena*) was set against white

Leonardo da Vinci, *Study for a Warrior's Head,* circa 1504–1506. Szepmüveszeti Muzeum, Budapest, Hungary.

plaster to underscore the balance and proportions of pilasters, cornices, and string courses; the church of Santo Spirito; the cloister of Santa Croce; the church of Santa Maria degli Angeli with its central plan, and so on. It hardly matters that some of his projects were not completed until after his death in 1446—Brunelleschi represented the birth of a new history of architecture in Europe. He endowed the idiom of ancient architecture with new elegance and power.

Some twenty years younger than Brunelleschi, Michelozzo di Bartolommeo followed a rigorous approach when choosing the Ionic order for the cloisters of San Marco. He displayed a boldness similar to Brunelleschi's when he designed a centrally planned tribune for the church of Santissima Annunziata. Michelozzo himself elaborated a new model in the façades of the palace he built in Florence for the Medicis.

Similarly, Leon Battista Alberti constantly kept Brunelleschi's models in mind. Alberti built the façade of the church of Santa Maria Novella in Florence yet also helped to spread the Florentine example throughout Italy. He wanted to turn the church of San Francesco, which he was modifying for Sigismondo Malatesta in Rimini, into an antique-style temple. In Mantua, he organized the space of San Sebastian around the plan of a Greek cross. Also in Mantua, the scale he gave to the façade of the church of San Andrea echoed the grandeur of ancient Roman baths.

These Florentine domes, façades, and spaces were the first monuments to a new era.

READINGS AND ANCIENT MODELS

Such monuments were not, however, the first signs of that era.

Around 1410, Brunelleschi then roughly

The first French translation of Vitruvius's *De Architectura*, by Jean Martin, Paris, 1547. Bibliothèque Nationale, Paris, France.

thirty years old—sculpted a wooden crucifix for the church of Santa Maria Novella in Florence. In order to give form to the crucified body of Christ, he used a live model (probably one of his teenage studio assistants)—something no one had done in Christian Europe. In sketch after sketch, Brunelleschi sought to convey the anatomical reality of that tortured body. This new practice of life drawing became a rule that no studio or academy anywhere in Europe would dare to break for some five hundred years.

More than other sculptors, perhaps, a certain Donatello studied Brunelleschi's crucifix. Twenty-five years old himself at the time, Donatello was working on a monumental statue for the cathedral of Florence. To give form to the prophet Joshua, he thought of employing an ancient technique—as recorded in Pliny's *Natural History*—that had not been used for centuries, namely terracotta. Was it Brunelleschi who suggested to Donatello that he revive this technique? Perhaps. Brunelleschi's own reading of Pliny had informed him that the most famous painters of antiquity used live models. Like Brunelleschi, Donatello wanted to rediscover antiquity; he therefore adopted terracotta. Both artists wanted to revive antique forms.

And they succeeded. Donatello supplied the wool merchants' guild with the first of his free-standing sculptures. These statues were completely independent of the architecture (unlike low and high reliefs), constituting objects that could be viewed from every side. Donatello's statue of Saint Mark had been commissioned for one of the niches of Or San Michele in Florence. The Florentines thus discovered a statue unlike any other depiction of the evangelist. The beard he displayed and the drape of the toga he wore—the softness and accuracy of its folds—lent Mark a solemnity similar to that of a Roman senator.

For centuries, all the saints and biblical kings carved on the façades of cathedrals stood straight up, the folds of their garments obeying strict verticality, maintaining an almost hieratic immobility. Donatello rid himself of all that—the left leg of his *Saint Mark* is bent, the shoulders are slightly angled. And the folds of the toga falling on Mark's hip underscore

FLORENTINE ART PATRONS SURROUNDED THEMSELVES WITH ARCHITECTS, SCULPTORS, AND PAINTERS WHOSE BOLD CREATIONS REPRESENTED A RESPONSE TO ANTIQUITY.

Opposite: Donatello, *Prophet* (called *Zuccone*), circa 1423–1426. Museo dell'opera del Duomo, Florence, Italy.
Above: Marco Rustici, *Santa Maria del Fiore*, 1447. Illuminated manuscript. Seminario Arcivescovile, Florence, Italy.

Francisco di Giorgio Martini, *Ideal City*, circa 1470. Galeria Nazionale della Marche, Urbino, Italy.

the pose of placing most weight on a single leg. Few sculptors in preceding centuries had dared to use this *contrapposto* (twisted pose), formerly employed in antique statues.

It was *contrapposto* that Andrea Sansovino and Michelangelo would use to lend life to their sculpture, after having studied the antique statues that Lorenzo the Magnificent had collected in his garden.

A few years later, around 1415 or 1417, Donatello placed another statue in Or San Michele. It was *Saint George,* but this Saint George was no mere archangel-knight—he was a centurion. At the base of the statue, Donatello depicted Saint George slaying the dragon. Because this work was commissioned by the armorers's guild, which made breastplates and swords (*arte dei corazzai e spadai*), the archangel bore the arms shown on the guild's escutcheon. In carving this scene, Donatello developed a new technique of low relief (*schiacciato* or *stiacciato*) in which he barely etched the marble—it was almost like a drawing, a drawing that light and shadow completed by bringing volumes into play. And, behind the

princess dressed like a vestal virgin, carved like a bas-relief figure on an antique metope or frieze, were columns and arches describing a vanishing point over the archangel's shoulder, establishing one of the earliest examples of perspective.

THE INVENTION OF PERSPECTIVE

A few years before winning the competition for the dome of Florence's cathedral, Brunelleschi had performed a unique experiment, on several occasions, in front of that same cathedral. On a panel held in his hand, he had scrupulously painted a view of the San Giovanni baptistery. A hole was cut into this panel. Antonio Tuccio Manetti, who witnessed Brunelleschi's experiment, reported: "He wanted the person to place one eye at the back of the painting, where the hole was bigger, and hold it close to the eye with one hand; in front of the painting, the person would hold a flat mirror that reflected the painted scene: the distance between the mirror and the [painting] was proportional, in miniscule spans so to

Following pages: Paolo Uccello, The Battle of San Romano, circa 1456. Niccolo da Tolentino Leading the Florentines, leftmost panel of three. Wood. National Gallery, London, Great Britain.

speak, to the same distance in real spans between San Giovanni and the spot where he had placed himself to paint; so that in looking at it, thanks to other elements mentioned, the darkened silver, the square, etc., from this point it seemed as though one were looking at reality itself."

Thus "perspective was demonstrated for the first time." Manetti went on to add, "So that no mistake could be made in viewing the work, the painter had to determine a single spot where it could be viewed, both in height and width and equally in angle and distance, so true was it that any shift changed what the eye sees." The name given to this new science, "perspective," was derived from the Greek *optike,* which meant a direct, distinct view. And this term, in ancient science, designated an unveiling of things. With perspective, painting began a dialogue with mathematics and science after having discoursed solely with theology for centuries.

Masaccio was one of the first to learn linear perspective from Brunelleschi himself. The *Trinity,* painted by Masaccio around 1425 for the church of Santa Maria Novella, was the first example of a perspective technique called *sotto in sù* (from below upwards) opening an illusionary space in the wall that extended the reality of actual space. He used this new technique in the Brancacci chapel of Santa Maria del Carmine, where he continued the series of frescoes on the Life of Saint Peter following the death of Masolino. Giorgio Vasari reported that Masaccio was full of enthusiasm and admirably ingenious in developing "new techniques of . . . foreshortening." (His ingeniousness probably served as a model for the likes of Paolo Uccello, Mantegna, and Piero della Francesca, who combined their careers as painters with theoretical research and treatises on perspectives.)

Death struck Masaccio in 1428, when he was twenty-six. The Brancacci chapel remained unfinished, but it immediately served as inspiration. A little more than half a century after Masaccio's death, Vasari paid him this tribute: "His work deserves unstinting praise, especially because of the way he formed, in his painting, the beautiful style of our own day. How true this is, is shown by the fact that all the most renowned sculptors and

painters who have lived from that time to this have become wonderfully proficient and famous by studying and working in that chapel."

Invented around 1413–1415, then, perspective reorganized the world and established a new place for mankind. The world now made sense from the standpoint of the human eye and the human eye alone. Perceptive mankind had become the center of the world.

CENTER OF GRAVITY

By 1436, Giuliano da Maiano was executing intarsia panels (wood inlay) in the sacristy of Santa Maria del Fiore in Florence, creating perspective's first trompe-l'oeil effects. It is no coincidence that in Florence intarsia specialists were known as *maestri di prospettiva* (masters of perspective) and were soon being asked to decorate the aristocracy's *studioli* (private studies).

A *studiolo* was a Renaissance site par excellence; a site where the Renaissance could take root. Petrarch was the first to assert the importance of a private study in *De Vita solitaria* of 1356. Where else could texts by ancient authors be read in peace? Where else could one find the open-mindedness required for learning, other than a room similar to the ones described in the letters of Pliny the Younger and Cicero?

A place of meditation, a place dedicated to the contemplative life, the *studiolo* was also the room where nobles such as Leonello d'Este (in Ferrara), Cosimo de' Medici (Florence), Federico da Montefeltro and Isabella d'Este (Mantua) kept their rare objects, both religious and secular: collections of medals and gems, vases of precious stone, perhaps astrolabes, cameos, and of course books by Latin and Greek authors, by Dante and Petrarch and others.

On the walls the muses might be depicted here, famous men there (philosophers, poets, legislators, mathematicians, theologians). And everywhere these *studioli*—full of unique, lavish objects worthy of the *magnificientia* of a prince, plus books containing all the knowledge in the world—were covered with paneling and trompe-l'oeil intarsia composed of several varieties of wood. Perspective might suggest an open cupboard

Andrea Mantegna,
*Lamentation over
the Dead Christ,*
circa 1480.
Pinacoteca di Brera,
Milan, Italy.

door revealing books on shelves, or buildings aligning a street, or loggias and arcades, or musical instruments. By depicting objects and urban settings, intarsia heralded "genres" that had not yet emerged, such as still life and landscape.

Furthermore, a *studiolo* symbolized the humanist aspirations of patrons whose fortune went to commissioning works designed to keep their names alive in mankind's fickle memory.

Augsburg banker Raimond Fugger, whose *secretarium* and *cenaculum* boasted ancient coins and marbles alongside paintings by Cranach, perhaps believed he was making a better investment than his relative Jakob II Fugger, who financed the election of Charles V as Holy Roman Emperor in 1519.

As a place of study, the *studiolo* was forerunner to the "cabinet of curiosities." In a certain way, it provided the Renaissance's center of gravity: it incorporated order as drawn by perspective, knowledge as revived by humanism, and financial power as mobilized by patronage.

In the final analysis, *studioli* could be interpreted as a type of secular chapel, where humanity's new powers were nurtured.

Humanists were freer to work in administrative chanceries than in religious universities, and what they really invented—beyond rediscovering ancient culture derived from *humanitas* and *humanae litterae*—was an open, critical, rational spirit.

Humanism was an elite occupation. Discussing, debating, and polemicizing in Latin and Greek was not the occupation of all. Although humanism's growing intellectual influence gave people the boldness to attempt all things, it only granted that faculty to those people judged to be exceptional. The works thus commissioned were addressed only to the few people able to decipher all the allusions and issues at stake.

Hans Memling, *Last Judgment Altarpiece* (detail, group of blessed), 1471–1473. Museum Pomorskie, Gdansk, Poland.

HUMAN SCALE

For centuries, the world's only finality was God. Now mankind dared to think, as it had never quite done before, that God himself had placed it at the center of the world. Although mankind continued to doubt itself,

THE BATTLE BETWEEN ARCHANGEL MICHAEL AND THE DRAGON
SYMBOLIZED THE BATTLE OF EUROPE'S CATHOLIC KNIGHTS AGAINST HERESY.

Opposite: Raphael, *Saint George and the Dragon,* 1505. Musée du Louvre, Paris, France.
Above: Gerard David, *The Michael Altar,* circa 1500–1510.
Triptych. Wood. Kunsthistorisches Museum, Vienna, Austria.

it now wanted to think itself capable of being whatever it chose to be. The humanist Pico della Mirandola proclaimed that the Supreme Architect "made man a creature of indeterminate and indifferent nature, and, placing him in the middle of the world, said to him, 'Adam, we give you no fixed place to live, no form that is peculiar to you, nor any function that is yours alone. According to your desires and judgment, you will have and possess whatever place to live, whatever form, and whatever functions you yourself choose. All other things have a limited and fixed nature prescribed and bounded by Our laws. You, with no limit or no bound, may choose for yourself the limits and bounds of your nature. We have placed you at the world's center so that you may survey everything else in the world.'"

Placed in the center of the world, mankind imposed its scale on the world itself. In *De Pictura,* the earliest treatise on painting in the Western world, published in Latin in 1435 and in Italian in 1436, Leon Battista Alberti asserted, "Since man is the thing best known to man, perhaps Protagoras, by saying that man is the mode and measure of all things, meant that all the accidents of things are known through comparison to the accidents of man." The immediate upshot of this certainty was that architecture was no longer conceived in terms of God but in terms of mankind. A theorist of the day could then write: "Given that the body of man is better organized and more perfect than any other, it is appropriate that any building may be assimilated to him." Michelangelo, in one of his rare texts on architecture, ended on these words: "It is certain that the members of architecture remain in relation to the members of the human body—he who has never truly mastered the human figure, and therefore anatomy, will never understand anything."

PROPORTIONS

The proportions of the human body remained crucial. The quest for ideal proportions was shared by Leonardo da Vinci, Albrecht Dürer, and others. They all referred to the same source, Vitruvius, a Roman architect of the first century B.C.E., who wrote a treatise titled *De Architectura.* Leonardo

noted in his own notebooks, "The architect Vitruvius states in his work on architecture that the measurements of a man are arranged by Nature thus: that is, that four fingers make one palm, and four palms make one foot, six palms make one cubit, four cubits make once a man's height, and four cubits make a pace, and twenty-four palms make a man's height, and these measurements are in his buildings." And the opening pages of Dürer's treatise on proportion clearly assert that "anyone who desires to know something should read Pliny and Vitruvius, and he will be sufficiently instructed."

Even though Vitruvius's treatise had been known for centuries, it remained within the clergy, who had not used it to design any building or organize any construction site. Vitruvius only became a model once architecture was conceived as science—a liberal art whose classical orders orchestrated a new beauty—thanks to the architecture of Alberti and Bramante, plus the first Italian translation of his treatise (published in 1521 by one of Bramante's disciples).

Confidence and Doubt

The rediscovery of antiquity made it possible to develop a new definition of humankind, to rediscover what Aristotle defined in his *Nicomachaen Ethics* as its "divine and heroic virtue." That virtue was an "overabundance of qualities that transcend the ordinary and allow man to participate in the divine; this high degree of perfection is firstly that of the heroes of mythology, raised to the status of demigods."

This conception of mankind required that everyone, the nobility above all, be capable of *virtù*. According to Machiavelli, *virtù* was the determination to acquire power. A Spaniard then defined it as "the strength or ability that makes it possible to reach any goal one sets oneself." As a rule of conduct or code of behavior, *virtù* might entail wiles as well as strength. It could even be construed as trickery, a way of getting the most out of any situation, just as it could be similar to the "virtues" advocated by the ancient Stoics. This *virtù*, which rid itself of religious connotations, had nothing in common with medieval virtue. Only men able to demonstrate *virtù* were

worthy of *fama,* of being wreathed in fame. Men now wanted to remain etched in humankind's memory. The humanist Marsilio Ficino declared, "Man tries to remain on men's tongues for the whole future."

Man is—should be—what he wills to be. Never before in the Christian world, which sought to be guided only by the will of God, had the role and power of mankind been asserted with such confidence. Humanism developed a model of the perfect man who would be poet, artist, sage. This requirement made no strict distinction between science on the one hand and art on the other. The definition of art was still as complex as it was vague—it was a discipline and an aspiration.

It was the role of music and architecture, as the most scientific of arts, to render the true beauty of the world. Poetry played a similar role through the way verses paced and orchestrated words. Painting, in order to aspire to the same status, had to draw on what poetry recounted, organizing itself around a spatial perspective governed by mathematics.

Humanism's challenge was all the more daunting insofar as mankind continued to doubt humanity, a doubt that continually disparaged men. According to Machiavelli, men were "ungrateful, fickle, secretive." Alberti felt that human nature continued to be "perverse, nasty, and egotistical." In 1518, Martin Luther warned: "Man sins mortally by doing what he can. Man must entirely despair of himself in order to receive the grace of Christ." Whereas it had been the book of Revelation that had previously haunted souls, it would henceforth be the *Imitation of Christ,* written in 1420, that guided the meditations of the faithful.

This doubt engendered a special dialogue with the confident attitude that questioned, invented, and discovered. The messianic visions of people convinced that the world would soon be confronted with terrible upheavals, of astrologers predicting a religious revolution, of a Dominican such as Savonarola who imposed austerity on Florence (driving out the Medicis and announcing a purification of the world) were countered by dreams such as Thomas More's Utopia and the abbey of Thélème imagined by Rabelais: "And thus Gargantua founded it, their only rule being these words, 'Do what you will.'"

Mathis Gothart Grünewald, *Crucifixion* (detail), circa 1513–1515. Issenheim altarpiece. Musée Unterlinden, Colmar, France.

Even as it looked back at history, the Renaissance began a quest for fulfillment, an attainment that would be the work of mankind and of human confidence. Dürer proclaimed that "only a fearful mind lacks self confidence to the point of thinking it can make no new discovery, to the contrary always following the beaten path, walking in others' footsteps without having the audacity to take ideas beyond those limits."

The Renaissance, itself along with Alberti, seemed to affirm that "man was born not to rot on his bed but to rise and act." Alberti had no doubt about what a man's ambition should be: "Man was born to be useful to man." These certainties about humanity were the origin of the rise of portraiture.

Above:
Martin Schongauer,
Bearing the Cross,
16th century.
Copperplate
engraving.
Musée Unterlinden,
Colmar, France.

Opposite:
Masaccio, *Trinity,*
circa 1426–1427.
Fresco, Santa Maria
Novella, Florence,
Italy.

INDEPENDENCE AND RIVALRY

The France of Louis XI, the England of Henry II, and the Spain of the Catholic kings (who completed the reconquest of Spain with the capture of Grenada in 1492) appeared to be imposing the same kind of state all

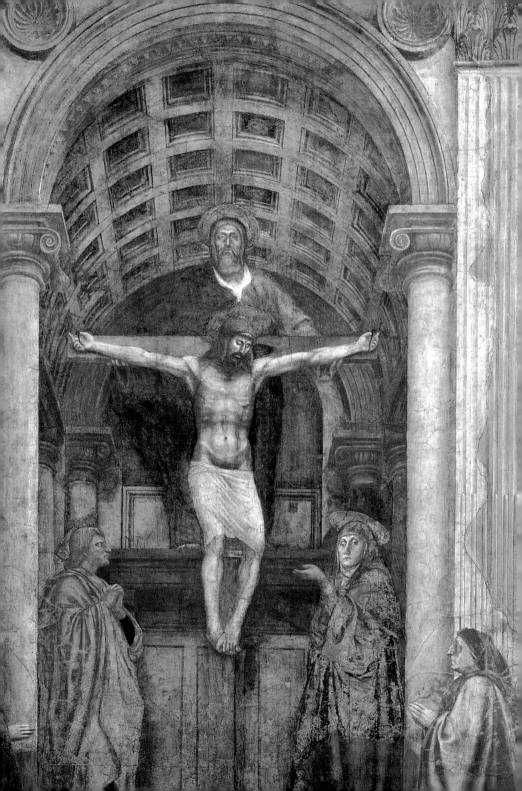

over Europe. Within the Holy Roman Empire, however, cities were too attached to their ancient privileges to agree to submit to the authority of the emperor alone. Throughout Italy, meanwhile, cities had another reason to reject the sovereignty of emperor or pope: they considered themselves (or aspired to be) heirs to the *urbs*—"the city"—that was Rome. They felt obliged to claim independence and liberty.

During the thirteenth century, Italian cities backed either the Ghibelline party (loyal to the emperor) or the Guelph faction (loyal to the pope), primarily in order to play the independence-threatening papal and imperial powers against one another. Each city endowed itself with political institutions that affirmed its uniqueness. The *arti maggiori* (major guilds), the less wealthy *arti medie,* and the *popolo* they represented sought to share public offices and the power of the *signoria* (governing body), which was developing in various cities. Yet, slowly, *podestas* (head magistrates or governors) and *condottieri* (military chieftains) installed dynastic regimes: the Gonzaga family in Mantua, the Montefeltri family in Urbino, the Este dynasty in Ferrara, the Visconti family in Milan.

In Florence, the Medicis—Cosimo the Elder (*pater patriae*) and Lorenzo the Magnificent—long maintained the fiction of republican institutions. But that did not prevent them from doing everything to concentrate power in their hands between 1434 and 1494. All the artworks commissioned by Cosimo and Lorenzo were aimed at an elite public, namely their court. Perhaps it was because the Florentine burghers no longer understood such works—reserved for an overly exclusive, narrow, and aristocratic club—that the Medicis were driven from power in 1494. Public resentment made it all the easier to accept the austere purity preached by Savonarola. Yet the Medicis returned to power in 1512 and established a government of Florentine bankers, whose offices throughout Europe were bringing in great wealth (a proverb claimed that *Passeri e Fiorentini sono per tutto il mondo*—"sparrows and Florentines are found everywhere in the world"). In 1537, after the brief restoration of a republic between 1527 and 1530, after the abolition of the ancient *signoria,* Cosimo I could claim to be the sole ruler of Florence.

Venice was the exception among Italian cities. Venice alone was not founded by the Romans. The Venetian Republic elected its doge ("duke" in the local dialect) for life, and he symbolically married the sea—Venice's lifeline—every year. Venice only assumed a permanent place as a leading Italian city with the Peace of Lodi in 1454, although it had exploited the fourth crusade in 1204 to pillage Constantinople and appropriate a quarter of the Byzantine Empire. The city lost half its population in the Black Death of 1348, yet was able to get the better of its maritime rival, Genoa, even though Dalmatia slipped through its hands (having been annexed by the king of Hungary). Venice later had to confront the Turks, who captured Constantinople in 1453, and despite everything managed to hold onto its possessions in the eastern Mediterranean even as it consolidated its territorial ambitions by annexing the nearby cities of Padua, Vicenza, and Verona. In 1529 and 1530, two treaties permanently settled the borders of the Most Serene Republic, as Venice was known, which then renounced other ambitions on mainland Italy and chose to remain neutral. Since Europe had not yet been transformed by the discovery of a new world across the Atlantic (whose riches were still unexploited), Venice was confident of its power and position: it controlled trade routes and trading posts in the Mediterranean (the *Mare Internum*), importing silks and spices from the Orient, which were then sold to guaranteed markets in northern Europe. The only city to scrupulously insure that none of its political institutions became all-powerful, Venice shared one certainty with all other Italian cities: its splendor should be conveyed by the arts.

The Renaissance grew out of the confidence and haughtiness of these cities and their aristocrats. It thrived on their competition and rivalry.

Following pages:
Jan and Hubert
van Eyck,
The Mystic Lamb,
completed 1432.
Left and right panels
(detail): Adam
and Eve. Church
of Saint-Bavo,
Ghent, Belgium.

UNIVERSAL ROME

More than any other city, Rome considered itself without peer—simply because it was Rome.

Although pilgrims arriving from all over Europe may have viewed it as a biblical Babylon populated by arrogant, wily, irreverent men, and

ADAM

ADAM NOS IN MORTE DEICIPT

although it was abandoned by the popes until Gregory XI returned on January 17, 1377, Rome remained the capital—the sole capital—of Christianity; the city where the apostle Peter was crucified.

Meanwhile, Constantinople—Byzantium—huddled behind ramparts now too vast for it; it was no longer the capital of an eastern Roman Empire, which had disintegrated. In 1423, the Venetians took control of the depopulated city, whose buildings were crumbling. Just thirty years later, in 1543, Constantinople fell to the Turks. Humanists fled the city, while enormous libraries were shipped to Rome and Venice. Cardinal Bessarion's library became the Saint Mark library in Venice, and Venice was able to publish the earliest reliable editions of Greek texts that had been known previously only in fragmentary form.

When Gregory XI returned to Rome, it was not much different from Constantinople. It was infested by fevers and was regularly flooded by the Tiber. Potable water was scarce, because the aqueducts had not been maintained—nor had streets and bridges. Aurelian's wall, built in the third century, now enclosed a mere 30,000 inhabitants as well as churches and monasteries overrun by gardens and vineyards and enclosed ruined buildings exploited as quarries. And yet these ruins were still the remnants of *caput mundi* (the head of the world) that is to say, the Rome of the Caesars.

Under Martin V, whose papacy brought the Great Schism to an end, Rome began to rebuild in 1420—and never stopped. Rome knew it had once again become—and would remain for centuries and centuries—the center of Western Christendom. The magistrates who composed the *magistri aedificiorum*, reestablished in 1425, were responsible for urban hygiene and for maintaining streets and buildings; in 1480 they won the right to expropriate property from those people who refused

to sell (to make room for papal construction) or who dared to disobey the new regulations. The decisions of the *magistri aedificiorum* were severe. Furthermore, the popes had the means to implement the building policy they consistently followed, one after another: the income from papal states doubled between 1492 and 1525, when Perugia and Bologna were brought into line.

By the time Sixtus V died in 1590, he had completed the dome of Saint Peter's, had erected obelisks, and had built new roads between the main churches to facilitate processions of pilgrims.

Despite being struck year after year by plagues, scarcity, or floods, Rome was the only city that could claim to be the capital of the world. In the Jubilee year 1500, some 200,000 pilgrims assembled on the square in front of Saint Peter's. Every single monarch and prince wanted to be represented there—in dazzling style.

French poet Joachim du Bellay, who lived in Rome from 1553 to 1558 while performing lowly tasks for his uncle, Cardinal Jean du Bellay, wrote:

> From day to day
> Rome delves into her ancient ways,
> rebuilds herself with works divine.
> [*Comme de jour en jour*
> *Rome fouillant son antique séjour*
> *Se rebâtit de tant d'oeuvres divines.*]

In 1583, Blaise de Vigenère, a French gentleman and diplomat, published a translation of Livy in which he agreed with the Roman historian's claim that "Rome was the world, and the world is Rome's." All men of standing aspired to go to Rome to discover the grandeur of the Caesars. All men of letters and all artists aspired to receive the patronage of cardinals and popes there.

SUCCESSIVE STAGES

Florence was a Guelph (papal) city that held out against the emperors. Thanks to the Medicis, Florence nurtured the debates that would become known as "humanism," although that term was not invented until 1859. It was in Florence, in the Careggi villa that Cosimo the Elder placed at his disposal in 1462, that Marsilio Ficino founded the first "Platonic Academy," named after the Akademos garden in Athens where Plato had taught. Ficino surrounded himself with *confilosofi* (fellow philosophers) to whom he probably submitted his translations of Plato's *Dialogues,* completed in 1477. During these discussions, Ficino probably elaborated his *Platonic Theology,* published in 1492.

Florence was the first crucible where, following early humanist debate, the arts underwent a rebirth (or "Renaissance," although the term was not used until Jules Michelet popularized it in the nineteenth century) thanks to the likes of Brunelleschi, Donatello, and Masaccio. According to Vasari, Florence played a key role for three reasons: "The first was that many people were extremely critical, because the air there encouraged freedom of thought, and people were not satisfied with mediocre works. The second was that people had to work hard to survive, which meant constantly using one's mind and judgment, because Florence was not situated in the midst of a vast, fertile plain where one might have lived cheaply, as in other places. The third was the aspiration for honor and fame the air inspires among men of all professions."

And it was in Florence in 1563 that the same Vasari founded the *Accademia del disegno*—Academy of Drawing. The name of this first academy sufficed to indicate that, along with perspective as developed by Brunelleschi and Alberti, drawing was the foundation of all arts. It was drawing, according to Alberti, which gave birth to beauty defined as "a kind of accord and agreement of part in a whole, following a determinate number, a special proportionality and arrangement, as demanded by the harmony that is the supreme and most perfect law of nature." Writing of Michelangelo in 1537, Pietro Aretino declared that "the perfection of drawing" is the "key to pictorial expression."

Hieronymus Bosch,
Heaven,
16th century.
Doges's Palace,
Venice, Italy.

The works of Michelangelo to which Aretino was referring had been done in Rome. Julius II, elected pope in 1503, realized more acutely than any of his predecessors the power and glory to be gained from works such as those Florence was commissioning. This conviction on the part of Julius II (who died on February 21, 1531) meant that Rome pursued the movement begun in Florence. It was Julius who asked Michelangelo to drop his Florentine projects and move to Rome; Julius was the pope for whom Bramante notably developed a new architectural monumentality for Saint Peter's, for whom Raphael painted, for whom Michelangelo worked.

According to Vasari, Raphael "so enhanced the art of painting that it equaled the faultless perfection of . . . Apelles and Zeuxis, and might even be said to surpass them" (Apelles and Zeuxis were famed painters in ancient Greece). As to Michelangelo, he earned the epithet "divine."

MANIERA, MANIERISMO

The oeuvre of Raphael (who died on April 6, 1520 at the age of thirty-seven), along with that of Michelangelo (who died in 1654), provided the frame of reference for what Vasari called *maniera* in 1550. Vasari used the term to describe a particular manner and to praise a new freedom of style.

Yet "mannerism" remained a concept unknown to Jacopo Carrucci (called Pontormo, after the village where he was born in 1494), who was barely twenty years younger than Michelangelo; to Francesco Mazzola (called Parmegiano); to Angelo di Cosimo (called Bronzino); to Giulio Pippi (called Giulio Romano); and to all the other artists who began painting around 1520 or 1525, not to mention Demonikos Theotokopoulos (nicknamed El Greco in Toledo, where he painted elongated bodies and shimmering fabrics). It was not until 1792 that a certain Luigi Lanzi—archaeologist, philologist, and art historian—first employed the word *manierismo* to describe their work. Tainted with a connotation of contempt, the term came to refer to a style marked by the deformation of bodies, languid forms, porcelain-hued skin shown in acid light, precisely

chiseled details, and complex settings with much finery and accessories. Mannerism was perceived as the vestiges of a perverse refinement of expressiveness, an affectation associated with the indecipherable allegorical puzzle of the grotesque heads painted by Giuseppe Arcimboldo.

This connotation was accepted by Eugène Delacroix when he noted in his diary on January 25, 1857 that "the main feature of mannerism is a lack of sincerity in both feeling and depiction." He went on to add, "Titian began the broad execution that broke with the dryness of his predecessors and was painterly perfection." By the early twentieth century, Cézanne would confirm that "painting, what is called painting, only began with the Venetians." The Venetians Cézanne was referring to, in addition to Titian, were Tintoretto and Veronese.

The Venetian painting admired by Delacroix and Cézanne stressed color, unlike Roman painting, where draftsmanship prevailed. In Rome, on leaving the Belvedere studio where he was visiting Titian, who had just completed a painting of Danaë, Michelangelo told Vasari that "it was a shame that in Venice they did not learn to draw well from the beginning and that those painters did not pursue their studies with more method."

Florence developed perspective, creating space on a human scale. Rome stressed the primacy of draftsmanship. Venice, finally, asserted the power of color. These criteria, which would govern rules and debate in European art for several centuries, were henceforth firmly established.

And yet Europe only slowly adopted these new forms offered by Italy. The town hall built in Basel between 1508 and 1521 was still Gothic. The architects of the new cathedral begun in Salamanca in 1513 continued to use pointed arches. In Segovia some ten years later, the remodeled cathedral was still Gothic, as were the cathedrals going up in England in those days. It was only around 1530 that Paris began to display ornamentation that had already appeared in several châteaux along the Loire, based on models primarily from Milan rather than Florence.

In Augsburg, Italian-style decoration was applied below the Gothic vaults of a chapel in the church of Saint Anne, as decided by the patrons, the local Fugger family.

FROM ARTISAN TO GENIUS

In order to fulfill the expectations of patrons, whose fortunes seemed boundless, an "artist" had to master every technique, meet every challenge, pick up every gauntlet. All were convinced they enjoyed unrivaled means. In 1457, a Florentine noted in his diary, "We think that our times, since 1400, have more reason to be content that any other since Florence was founded." Other cities displayed similar pride.

The fact that Leonardo da Vinci referred to himself as *omo senza lettere*—"an unlettered man"—because he knew neither Greek nor Latin did not prevent him from writing, "I am probably able to measure up to any other architect, as adept in constructing private or public buildings as in bringing water from one place to another." And, in that same letter of 1492 to the patron he hoped to serve, Leonardo thought it worth pointing out that "whether it is a question, moreover, of painting or of work in marble, metal, or clay, I will produce works that will certainly bear comparison with those done by any other person whomsoever." Why should Leonardo, then aged forty, doubt his own abilities? Why should he not claim to be capable of everything? He was hardly the first person to display such self-assurance and pride.

In 1472, some twenty years before Leonardo wrote that letter to Ludovico the Moor listing everything he could do better than anyone else, there died a man who had made similar claims. In 1428, aged twenty-four, that young man obtained his doctorate in law from the University of Bologna and the same year completed a treatise titled *De commodis litterarum atque incommodis:* "The Uses and Abuses of Books" (it mattered little that he himself had authored just one rather poor play, which he passed off as a translation from a Latin playwright). In 1430, this author apparently accompanied a cardinal to Switzerland, Germany, and France on a diplomatic mission for Pope Martin V.

In 1435, he wrote the first treatise on painting, *De Pictura,* in which he explained the mathematical rules of perspective for the first time; he also authored one of the first treatises on architecture in 1452 (*De Re aedificatoria*), published an Italian grammar, and wrote poetry and short stories

Intarsia (panel of wood inlay), 15th century. Palazzo Schifanoia, Ferrara, Italy.

(one of which, *The Story of Leonora and Ippolito,* recounting the love between a girl and boy from two feuding families "as rich in pride as in property," was translated into English and provided Shakespeare with the thread of *Romeo and Juliet*). The same author designed the church of San Francesco de Rimini in 1450, the churches of San Sebastian and San Andrea in Mantua, and the façade of Santa Maria Novella in Florence (built between 1456 and 1470). This doctor of law, this poet, theorist, mathematician, grammarian, architect, and so on, was named Leon Battista Alberti.

Although Alberti was one of the first to assert it baldly, he was not the only person who thought that "a man can do what he wills." Brunelleschi was not only sculptor and architect but also goldsmith and engineer; Antonio del Pollaiuolo was painter, sculptor, and goldsmith; artist Piero della Francesca was the author of one treatise on perspective and others on math; Germain Pilon in France was an architect, sculptor, metal-caster, goldsmith, and painter; Albrecht Dürer in Germany was painter, engraver, and engineer (having written a *Treatise on the Fortification of Towns and Castles*).

Michelangelo, born in 1475, three years after the death of Alberti, shared the same confidence. He wanted to be a sculptor. And he became one, just as he became architect, painter, poet. In 1556, a Florentine paid tribute to Michelangelo in these terms: "Although well before you and your times certain people honorably distinguished themselves in this or that art, you were the first person to practice them all with the same success, in such a way that you will remain a peerless model."

When the Renaissance began, an "artist" was still little more than a tradesman summoned by a client to execute a humble "mechanical art." By the time it was over, the artist had become a celebrity worthy of outstanding favor.

In April 1506, exasperated by Pope Julius II, who seemed to lose interest in the tomb he had commissioned, Michelangelo left Rome without seeking permission to do so. Instead of exploding in anger, the pope sent the following letter to the authorities in Florence. "The sculptor

Brunelleschi, dome of Santa Maria del Fiore, 1296–1436. View from the east end. Florence, Italy.

Michelangelo, who left us for no reason and on an impulse, is afraid to return, as far as we understand; we have nothing to reproach him, for we know the temperament of men of this type. However, so that he may be free of all suspicion, we call on your good faith in us to promise him, on our behalf, that if he returns he will be neither mortified nor abused by us, and that we will once again show the same apostolic favor that he enjoyed prior to his departure."

By the end of that century, all of Europe agreed that a work of art was not merely proof of technical mastery and respect for a client's wishes. On April 25, 1595, Emperor Rudolf II declared in Prague, "Henceforth, painting must no longer be considered as an artisanal technique but as an art."

CHALLENGES, EXPLOITS, FEATS

Over a two-hundred-year period, in Germany as well as Italy, technological innovations of all kinds were developed for both civil and military applications. Imagination was as technical and scientific as it was artistic. No artist would scorn that aspect of the profession—the technical exploits and feats attempted by some of them were a way to amaze both clients and rivals.

A witness recounted that one day, on the main square of Florence, some men were discussing Dante and called upon Leonardo da Vinci to explain a passage which seemed obscure. Suddenly Michelangelo showed up, and a sly Leonardo asked him to explain the passage in question. Michelangelo angrily replied: "Explain it yourself, you who designed a horse to be cast in bronze but, unable to cast it, had to abandon it." Harshly, Michelangelo added, "And to think those fools in Milan believed you. . . ."

Being able to meet a challenge, to accomplish an exploit, was a way to win fame.

Brunelleschi owed his fame to the dome on the cathedral in Florence, completed in 1436. Without abutments or buttresses, without external scaffolding or reinforcing beams, it rose to a height of 375 feet, higher

Pieter Bruegel, *The Tower of Babel*, 1563. Kunsthistorisches Museum, Vienna, Austria.

than any other dome, after sixteen years of construction. Lorenzo Ghiberti was not the only person to predict sarcastically that the whole thing would crumble when the crowning lantern was placed on top. But the lantern was added—and the dome did not collapse.

Other exploits: in Bologna in 1455, architect Aristotele Fioravanti managed to move a church tower—weighing over four hundred tons—some sixty feet.

The feat caused such a sensation that he was summoned to Moscow by Czar Ivan III to build the Cathedral of the Assumption (or Dormition) within the fortress of the Kremlin. In Rome, in 1586, at the urging of Pope Sixtus V, architect Domenico Fontana managed to erect an obelisk some seventy-two feet high (a 300-ton mass that had been lying on its side since antiquity) on Saint Peter's square, in line with the basilica. Fontana's reputation won him a call to the kingdom of Naples some time later, to build the royal palace there.

Donatello, meanwhile, was summoned to Padua once he had proven in

L'Abbaye: la cathédrale et le palais

AS A SIGN OF THE SPLENDOR OF GOD'S CREATION, THE TINIEST BLADE OF GRASS
BECAME MORE THAN AN OBJECT OF PRAYER—IT WAS HENCEFORTH AN OBJECT OF HUMAN STUDY.

Above: Leonardo da Vinci, *Study for an Anemone and Other Plants,* latter half of 15th century.
Pen and red chalk. Royal Library, Windsor Castle, Great Britain.
Opposite: Albrecht Dürer, *Tall Grasses,* 1503. Watercolor on paper. Albertina, Vienna, Austria.

Florence that he could master the terracotta technique forgotten since ancient days.

In Padua, between 1446 and 1451, he also undertook to design and cast the first equestrian statue since antiquity (of *condottiere* Erasmo da Narni, called "Gattamelata"). The only model Donatello had to go on was the statue of Marcus Aurelius, the sole equestrian statue from antiquity that survived destruction, which Michelangelo later set in the square in front of the Capitol in 1538.

Although these technical feats and accomplishments were superlative, and although they altered the history of art and architecture in Europe, no innovation transformed minds and history more than the printing press.

PRINTING

It was around 1450 that Johannes Gensfleisch zum Gutenberg invented a new system for making books. Not only did he develop metallic letters cast from an alloy of lead, tin, and antimony—letters that were interchangeable and reproducible—but he devised a special press with sliding chassis and concocted an ink with the consistency of a varnish that adhered to the letters as desired.

For nearly five centuries, printing technology would barely change, undergoing only minor modifications.

In 1456, Gutenberg's press produced the first copies of a Bible, with forty-two lines printed on every page. In just a few years, the use of the printing press spread from Mainz to all of Germany and into Italy. In a few decades it had reached Stockholm and Grenada, Lisbon and Brno, Dantzig and Messina. All of Europe acquired printing presses. By the end of the century, some fifteen or twenty million books had already been printed.

Venice soon acquired a leading position in the field. A key hub of international trade, the city boasted over one hundred and fifty presses by the late fifteenth century and had become the capital of the book market. (Venice was where printer Ludovico degli Arrighi introduced into the

Roman alphabet the previously overlooked distinction between the letters *U* and *V, I* and *J*.) It was no coincidence that Erasmus decided to go to Venice, where he met Aldus Manutius, the publisher of octavo volumes of Plato, Aristotle, Sophocles, Thucydides, and Herodotus, as well works by Dante, Petrarch, Boccaccio, and leading humanists such as Pietro Bembo and Erasmus himself.

Printing transformed mentalities not only because it facilitated the publication of ancient texts, both religious and secular, but also because it rescued certain languages from oblivion even as it codified the "vulgate" tongues.

Thanks to printing, books were no longer the preserve of monks and priests. There were good economic reasons for that: a printed book was twenty to fifty times cheaper than a hand-copied one.

The Imitation of Christ, probably written by the German Thomas à Kempis, first published in Augsburg in 1471, was reprinted a hundred times before the century was out.

In the same way, Erasmus's *Adages,* published in 1500, went through seventy-two printings in twenty-five years. Printed books furthermore permitted discussion, debate, and even polemics between writers from different cities all over Europe.

Without printing, the words of Martin Luther, who spoke out against the Church of Rome, would not have been heard. Between 1517 and 1520, some 300,000 copies of his texts were printed. Without printing, there would have been no Reformation.

The power of the printed word swiftly became such that religious and political authorities were soon seeking ways to contain and oppose it. In 1559, the Church published the first list of banned books, the *Index librorum prohibitorum.*

Thus, printing paradoxically gave birth to censorship. The censorship offices established all over Europe, however, never succeeded in reducing anyone to silence—a book considered dangerous in one place, and therefore subject to censorship, could always be printed someplace else and then distributed everywhere.

PRINTS

A new art instantly accompanied the rise of publishing, namely print-making. It was probably in Burgundy and Germany, around 1380, that woodcuts were developed, the first form of engraving. A smooth, compact plank of wood would be covered with lead white, on which a drawing would be made and then cut into the wood. The first woodcuts were religious images (the earliest dates from 1418).

Then another technique was developed: "black line engraving." Rather than cutting the lines of the drawing itself, the white spaces were cut away, leaving the "black lines." These ridge-lines were then inked, and a great number of prints could be made before the plate became too worn. They could also be printed on the same presses used for books. Publishers from Basel to Florence, Paris to Nuremberg, and Lyon to Venice could now boldly publish illustrated books that had the look of the books of hours of yore.

It was in the workshops of German metalsmiths, around 1430, that artists began to engrave plates of metal—copper, iron, steel. Copper-plate engraving could be done by pulling a drypoint, or needle, across the surface of the metal. The residue of metal fragments on either side of the tiny furrow, called the "burr," was what picked up the ink. But the burr was fragile and soon wore down from the weight of the press, so only a few good prints could be made from this technique.

The use of a burin, or "graver," on the other hand, created a clean, V-shaped line that took the ink and could withstand the pressure of multiple printings. A much greater number of copies could therefore be produced from a single plate before it deteriorated. Around 1450 or 1460, this new technique arrived in Italy. The likes of Andreas Mantegna, perhaps at the very moment he entered the service of the Gonzagas in Mantua, immediately adopted it.

Aware of the potential advantages of prints, engravers conducted all kinds of experiments and trials concerning burins, papers, and inks. Some developed monochrome techniques that underscored values of dark and light, while others attempted to introduce color.

Pontormo,
*Descent from
the Cross* (detail),
1526-1528.
Church of Santa
Felicità, Florence,
Italy.

MARKETS AND FAME

The first collectors of prints were aristocrats and humanists who considered them to be artworks just like paintings.

Some people even backed paper prints with canvas and had them hand colored. Prints by Martin Schongauer were sought by art lovers throughout Europe.

Although print making had become an art like any other, it was not merely that. It was also the most efficient way for a painter to publicize his particular inventiveness and to win recognition throughout Europe. Engravings made it possible to see what Rosso and Primaticcio were doing in Fontainebleau. Raphael could hand engravers a drawing with shadows merely indicated by washes, as a model of what he wanted the plate to look like. Similarly, Titian entrusted one such "translator"—the Dutchman Cornelis Court, who arrived in Italy in 1565—with the job of "reproducing" his paintings.

Printshops were beginning to realize that prints would decisively change the relationship between artist and admirer. The personal relationship between artist and patron was no longer the only possible one; that relationship had been based on the reality of a sole and unique work, commissioned and anticipated by the patron, accepted and owned by him or her. Prints made it possible for engravers to be sought after, desired, and praised by collectors all across Europe. Print making became a go-between that opened the road to fame, enabling connoisseurs in Antwerp, Nuremberg, and London to see what a given artist had painted in Venice, Rome, or Mantua; making it possible to picture the ruins of Rome in Augsburg, Amsterdam, and Paris. The success of the twenty-five views of Rome published in Antwerp in 1551 by Hieronymus Cock was such that Jacques Androuet du Cerceau published a small-scale version in France just four years later.

Piero della Francesca, *The Finding and Miracle of the True Cross* (detail), 1452. Fresco, church of San Francesco, Arezzo, Italy.

Schongauer served as model for the young engraver named Dürer, who set out for Colmar to meet him. But Schongauer had died in 1491, a year before the arrival of Dürer, who found only Schongauer's son. The father's oeuvre nevertheless remained a challenge to be met.

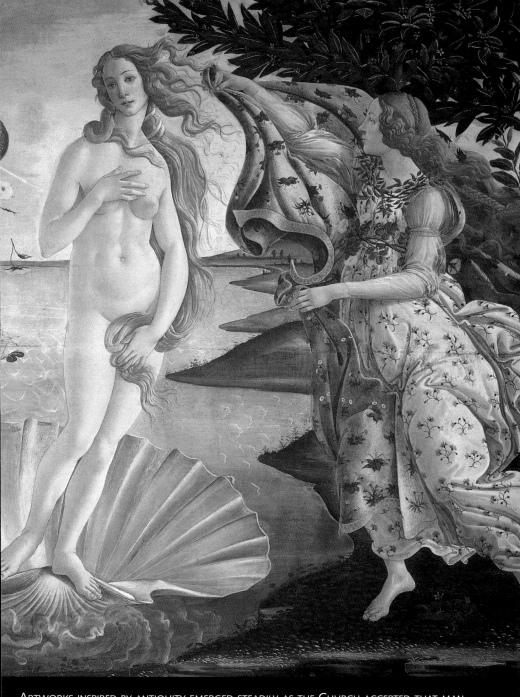

ARTWORKS INSPIRED BY ANTIQUITY EMERGED STEADILY AS THE CHURCH ACCEPTED THAT MAN
—THROUGH WHOM GOD HAD BECAME INCARNATE—WAS THE MEASURE OF THE WORLD.
DEPICTIONS OF NUDITY COULD THEREFORE TRANSCEND ORIGINAL SIN.

Opposite: Michelangelo, *David,* circa 1501–1504. Marble. Accademia, Florence, Italy.
Above: Sandro Botticelli, *The Birth of Venus,* circa 1482. Uffizi, Florence, Italy.

Twenty-five years later, when he arrived in Venice in January 1506, Dürer's reputation as an engraver had already been made. By April, he had come into conflict with Venetian painters, whom he described as "very adverse"—on three occasions they hauled him before the *signoria*, and he was ordered to pay "four florins to their school" in order to enjoy the right to paint in Venice itself. Six months later, in a letter dated September 8, 1506, he wrote to one of his friends back in Nuremberg: "But I silenced the painters. They said I was good at engraving but had no experience at color. Now everyone says they have never seen such beautiful colors."

Thanks to prints, an art market emerged and grew throughout Europe. This market sometimes targeted the general public and did not hesitate to publish and distribute bawdy or downright smutty woodcuts from erotic tales; yet the market could also be elitist, publishing plates that accorded with humanist ideals and arcane knowledge, in the form of enigmas riddled with allusions.

OIL AND CANVAS

According to the author of *Liber de viris illustribus* (Book of famous men) written and published circa 1420, Jan van Eyck allegedly discovered "the properties of colors handed down by the ancients, which he learned by reading Pliny and other authors." If this writer was correct, Van Eyck was probably the first modern artist to master the technique of oil painting, which, like other humanist knowledge, had received antiquity's seal of approval.

In *The Lives of the Most Excellent Painters, Sculptors, and Architects,* the first anthology of biographies devoted to artists, published in 1550, Giorgio Vasari wrote: "Oil painting was a very fine invention and much facilitated the art of painting; its first inventor was Johann of Bruges [Jan van Eyck], who sent a painting to King Alfonso in Naples and another to Duke Frederick II of Urbino. He also did a Saint Jerome, which belonged to Lorenzo de' Medici, and a great many other esteemed things."

These "esteemed things" won Van Eyck special consideration. When he

threatened to stop working for Duke Philip the Good of Burgundy due to lack of payment, the duke sent a letter on March 2, 1435 to the Lille treasury office that had withheld the salary, instructing immediate payment "because we want to engage him for certain grand works, on which we intend to busy him hereafter, and we find no other so equal to our taste nor so excellent in his art and science."

Philip the Good was not the only person to pay tribute to Van Eyck. Every painter passing through Ghent wanted to see his *Adoration of the Lamb*. In April 1521, Albrecht Dürer himself went into the church of Saint Bavo to study the altarpiece, writing in his notebook: "It is of outstanding worth and great intelligence, and Eve, Mary, and God the Father in particular are very good."

Neither tempera (which used egg as a binder) nor fresco (which required that the water-based colors be applied to fresh plaster—*a fresco*) offered the same transparence or brilliancy of colors made possible by oil paint. Every painter therefore had to master the new technique.

Apprenticeship was no easy matter. Vasari commented that Perugino did not take the time to let the first layer of paint dry before beginning another. Others, not wanting to abandon either tempera or fresco (or trying to develop a new technique that would win them fame similar to Van Eyck's), took the risk of mixing media and binders. These experiences in mixtures and varnishes sometimes meant having to give up on an uncompleted work, the way Leonardo da Vinci abandoned *The Battle of Anghiari* in 1506, begun in the Council Chamber of the Palazzo Vecchio in Florence.

THE VENETIAN PREFERENCE

It was in Venice that painters were the swiftest to take advantage of the possibilities offered by oil paint. Giovanni Bellini, nearly fifty years old, abandoned tempera; perhaps he used the new technique, known in Venice as *alla ponentina* (northern style), in 1474, to paint a portrait of Jörg Fugger, the young banker from Augsburg, then aged twenty-one. The possibilities of oil were confirmed in Bellini's eyes a year later, when

Antonello da Messina passed through Venice. Antonello had spent time in Naples on several occasions between 1450 and 1463, and since Naples had become a possession of the Aragon family, he was able to see tapestries from Flanders and paintings from France as well as works by Jan van Eyck and Petrus Christus. From Antonello, Bellini acquired a previously unknown quality of light and transparence.

In November 1514, Bellini received the balance of payment for his painting *The Feast of the Gods,* which long hung in the "alabaster study" of Alfonso d'Este, Duke of Ferrara. The duke's collection also soon acquired *Offering to Venus* and *Bacchanal.* The latter was signed TICIANUS F. (Ticianus was the Latin form of "Titian," while F. stood for *faciebat* or *fecit,* Latin for "made this").

It would seem that *The Feast of the Gods* by Bellini (who died in November 1516, aged ninety) was altered by Titian himself, especially the landscape. That painting, plus *Offering to Venus and Bacchanal* by Titian (who was barely twenty-five when the paintings were delivered to Ferrara in 1519) were similar in format. All three were done in oil on canvas.

Since leaving Padua (where he executed frescoes for the Scuola del Santo) for Venice, Titian had begun to paint almost exclusively in oil. Although he occasionally painted on wood panels, never again would he paint a fresco.

Bellini had been among the first to use canvas, when, in 1474, the Serene Republic decided to replace the damaged Pisanello frescoes in the Grand Council Chamber of the Doges's Palace. Similarly, Carpaccio opted for canvas for the paintings he did for several Venetian *scuole* (Sant'Orsola, San Giorgio dei Schiavoni, Scuola degli Albanesi, and Santo Stefano). The cost of canvas was considerably less than panels of wood, which not only had to be prepared, worked, and assembled but were also heavy and unwieldy once they exceeded a certain size. Frescoes, meanwhile, demanded work *a giorno,* "on a daily basis;" every morning assistants would apply wet plaster to the surface that the painter would then hurry to complete that very day. Oil on canvas also offered the advantage of guaranteeing more stable colors.

Michelangelo,
*Nude for the
Battle of Cascina,*
Casa Buonarroti,
Florence, Italy.

PORTABLE PAINTINGS ON CANVAS BY THE LIKES OF TITIAN,
WHO PORTRAYED CHARLES V AND DOGE GRIMANI KNEELING BEFORE FAITH,
FUELED A TRANS-EUROPEAN ART MARKET THAT HAD PREVIOUSLY DEALT IN PRINTS.

Above: Titian, *Charles V in Mühlberg,* 1548. Prado, Madrid, Spain.
Opposite: Titian, *The Doge Dandolo,* 16th century. Doges's Palace, Venice, Italy.

Nor were those the only advantages of using oil on canvas. Raphael spent the years 1508 to 1517 decorating the papal apartments, or *stanze*, notably the Stanza della Segnatura, the Stanza d'Eliodora, and the Stanza dell'Incendio; Michelangelo, meanwhile, had finished the ceiling of the Sistine Chapel in 1512 (he would later spend another five years, from 1536 to 1541, painting *The Last Judgment,* only completing the frescoes in the Pauline Chapel in 1550). But all those frescoes could be viewed solely in Rome, in the apartments or loggias where they had been painted by order of the popes.

Titian's paintings, however, were on canvas and could therefore be transported all over Europe. Although they had initially been commissioned by one patron or another, they could always be given or sold to another collector. This meant that further paintings might be commissioned by new patrons and connoisseurs, who henceforth knew exactly how inventive the painter could be.

Titian's preference for oil paint on canvas was a sign of a new relationship that patrons and connoisseurs were establishing with painting, a new relationship between artists and an emerging market for art as an object of ever escalating bids.

NUDES, SIN, BEAUTY

For centuries, nudity was solely associated with Adam and Eve. Prior to touching "the tree of knowledge of good and evil," prior to eating its fruit, "the man and his wife were both naked, and were not ashamed." They ate the fruit despite being forbidden to do so by God. "Then the eyes of both were opened, and they knew that they were naked; and they sewed fig leaves together and made themselves aprons." Nudity was—and could only be—associated with these lines from the third chapter of Genesis by every Catholic mind in a Europe that prayed to a God who sacrificed His only Son for the redemption of sins. Nudity was—and could only be—a sign of guilt and sin.

It was this guilty nudity that was still being carved in wood in the Würzburg workshops of Tilman Riemenschnieder in the early sixteenth

century. It was this nudity of sin and lust that Hieronymus Bosch was still denouncing, in that same century, when he painted *Hay Wain,* with a procession of grotesque, fantastic, and terrible visions, alluding to beliefs, superstitions, popular sayings, metaphors, and allegories that have become indecipherable riddles.

In northern Europe, artists were painting and sculpting pious, moral works that accompanied the creation of Beguine convents, that met the requirements of mystical, anxious devotion. Such works were already providing the fertile soil in which Luther's Reformation would take root, begun in 1517 when he posted his ninety-five theses on the door of the church of Wittenberg castle.

In Italy, however, commentaries by humanists who read Greek and Roman literature, plus the status accorded to mythology and the excavation of ancient sculpture, provided examples of beauty that had recently begun to win legitimacy for depictions of the naked body.

In the 1480s, Sandro Botticelli painted for Lorenzo the Magnificent the first nude in the history of Christian Europe that was not associated with sin: *The Birth of Venus.* Botticelli took his subjects from Latin poetry, such as Ovid's *Metamorphoses* and *Fasti* (Calendar), as well as from humanist commentaries steeped in Neoplatonist philosophy. Nuptial symbolism was probably the justification used by aristocrats who commissioned other Venuses.

Even that justification could not be used by the Church's aristocracy, which also commissioned nudes in an era hardly known for its chastity— an era of "gambols" according to French poet Ronsard, one in which Rabelais could laughingly write that "spermatic vessels" were "like a puff pastry" and that a man should "not die with his balls full." In September 1544, Cardinal Alessandro Farnese was advised by Aretino—author of pornographic sonnets—that "Titian has almost completed, at my lord's instructions, a nude that may well arouse the very demon in Cardinal San Silvestro. The nude that my lord saw in Pesaro in the apartments of the Duke of Urbino is a nun compared to this one." Ten years later, commenting on another Venus that Titian was about to dispatch to Madrid,

Following pages:
Tomb of Henry II
and Catherine
de' Medici
in coronation dress
(detail). Abbey of
Saint-Denis, France.

145

a visitor to the artist's studio wrote: "I swear to you, my lord, that there is no perceptive man alive who would not take her for a woman of flesh and blood. There is no man so bowed by years, no man whose senses are so dulled, that he would not feel warmed, touched, and moved throughout his entire being."

Sculpted nudes enjoyed a similar role. In 1527, Aretino wrote to Federigo Gonzaga of Mantua to reassure him that "Jacopo Sansovino, with his rare talent, will decorate your room with a Venus so real and living that she will fill the soul of every viewer with concupiscence."

Nudes were not found solely in the bedrooms of Italian aristocrats. Lucas Cranach the Elder, painter to the electors of Saxony, executed the first secular nudes in Germany. His *Venus and Cupid,* painted around 1520–1525, was no less sensual than the Venuses painted by Titian; a gauzy veil underscores the goddess' genitals more than it hides them. That veil was little different from the one painted over the body of another young woman by Hans Baldung Grien in 1517. Yet the latter served as a warning, for the painting was more a question of death than sensuality—the figure of Death himself, standing next to her, leads her away, her long hair clenched in his fist, unmoved by the clasped hands of the maiden praying for mercy.

Nudes, when justified by scholarship, could also find a public place in the city. Michelangelo's *David* was set up in the Piazza della Signoria in Florence in 1504. Giorgione painted nude men and women on the façade of the Fondaco dei Tedeschi in Venice in 1508.

Nudes could even be found in churches. Luca Signorelli's *Resurrection of the Flesh* was painted between 1499 and 1502 in the San Brizio chapel in Orvieto Cathedral.

Michelangelo dotted the ceiling of the Sistine Chapel with *ignudi,* not to mention the nudity of the elect and Christ himself in his *Last Judgment,* painted between 1536 and 1541 above the altar in the same chapel. Michelangelo justified himself in the following words: "What mind could be so uncultivated that it fails to see that man's foot is more noble than his shoe, that his skin is more noble than his clothing?"

Tintoretto, *Manna from Heaven,* circa 1577. Scuola Grande di San Rocco, Venice, Italy.

In 1564, the Council of Trent judged Michelangelo's figures obscene and ordered that they be decently covered. This task was given to Daniele Ricciarelli da Volterra, remembered primarily by the nickname he earned from this job, *braghettone* (loinclothier). When Braghettone painted the loincloths demanded by the Church to repair the blasphemy of nudity, the era of Counter Reformation had already begun. The days of the Renaissance, the days of its exploits, were over.

Left: Benvenuto Cellini, Francis I Salt Cellar (Neptune and Ceres), 16th century. Kunsthistorisches Museum, Vienna, Austria. *Right:* Gallery of Francis I, 16th century. Château de Fontainebleau, France.

GRANDEUR, SPLENDOR, RIGOR

A BAROQUE CENTURY

It was a glorious century, it was a dreadful century—which perhaps prompted Thomas Hobbes's harsh comment in *Leviathan*, published in London in 1651: "To this war of every man against every man, this also is consequent: that nothing can be unjust. The notions of right and wrong, justice and injustice, have there no place."

It was the century of a plague that left over 80,000 dead in England between 1630 and 1665, the century of a great fire in London that reduced the city to ashes in 1666. It was the century of a series of plagues that ravaged Spain from 1597 to 1603, from 1647 to 1652, and again from 1676 to 1685. It was also the century torn by the Thirty Years War. And yet, paradoxically, the seventeenth century was perceived as a "golden" or "grand" era—the United Provinces of the Netherlands labeled it the *Gouden Eeuw*, Spain called it *Siglo de Oro*, and France dubbed it *Le Grand Siècle*.

Such a tormented century was thoroughly "baroque." Yet it was not solely "baroque" everywhere. Quotation marks still flank the term, because it is—and has long been—ambiguous. "Baroque": the French dictionary published by Antoine Furetière in 1690 leaves no doubt as to its etymology—the word came from the Spanish and Portuguese terms for irregular pearls (*barrueco* and *barroco*, respectively). Such irregularity was not at all scorned at the time. In contrast, by the early eighteenth century, disdain was evident in a writer such as Quatremère de Quincy, who felt that baroque implied "a touch of the bizarre" that "brought with it a touch of silliness taken to an extreme." Baroque was perhaps

Opposite:
Bernini, *Louis XIV*, 1665. Marble. Musée national du château de Versailles, Versailles, France.

Following pages:
Gallery of Mirrors, decorated under the supervision of Charles Lebrun, 17th century. Chateau de Versailles, Versailles, France.

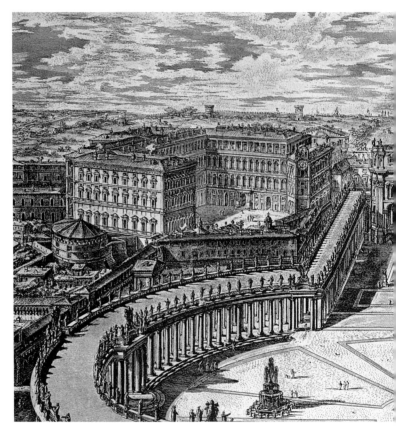

Piranesi,
*The Vatican
Basilica of Saint
Peter's,* plate 120
from *Views of
Rome,* 1775.
Engraving,
subsequently
colored.

extreme, but it had every reason for being so. It was extreme to the point of contradiction.

The Council of Trent was held from 1545 to 1563. This council was convened by a Church that, for the first time in its history, had to deal with a Europe in which the Church's spiritual authority was being seriously challenged—by the Reformation. After the Council of Trent, the Society of Jesus, founded in 1540 by Ignatius of Loyola, spearheaded all the other monastic orders in a campaign to reconquer souls led astray by the Reformation. Its goal was clear in the motto *Ad majorem Dei gloriam* (For the greater glory of God), while the additional two words *Todo modo* made it clear what means would be used to achieve that end—every means. The Jesuits wanted above all to assert free will

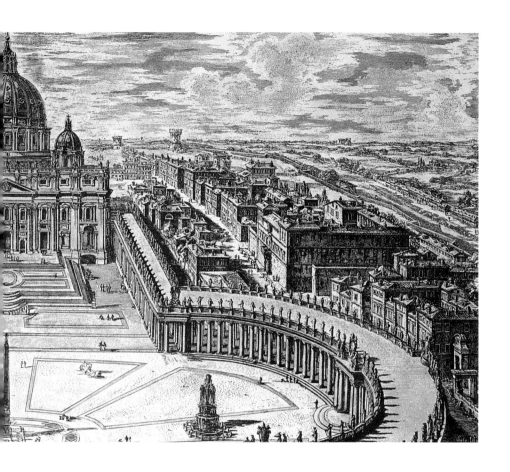

in opposition to Protestant predestination. They had to glorify the beauty of the world as a testament to the perfection of its creator. They had to repair "the torn robe of Christ." The baroque was a battle against heresy in Europe, even as it converted new souls on other continents. Everywhere, it knew which doubts and hesitations it had to overcome.

Strangely, this century was also one of curious libertines who celebrated a varied, changing world. Like the Jesuits, libertines were convinced that everything here on earth was mere appearance. Both groups might have uttered the words that Spanish playwright Calderón de la Barca attributed to one of his characters: "It's decided—we'll behave this way because we live in a world so strange that life must be a dream."

IN DESIGNING ITS CITIES, EUROPE GLORIFIED FAMOUS ARCHITECTS
WHO EXCELLED IN THE ART OF PROPORTIONS AND ATTENTION TO DETAIL.

Opposite: Nicolas Poussin, *Study from Antiquity* (including a putto hiding behind the mask of an old man),
17th century. Pen and brown ink, brown wash. Musée Bonnat, Bayonne, France.
Above: François Mansart, *Dome of the Chapel of Saint-Denis,* 17th century. Engraving.

THE CENTURY'S OPERATIC SPIRIT

Perhaps it was this dream that the seventeenth century staged year after year. The spirit of the times probably inspired these words by Oratorian cleric Bernard Lamy: "I say again that substance governs style. When things are grand and cannot be imagined without stirring some grand movement, the style that describes them should necessarily be lively, full of movement, enriched with figures and all kinds of metaphors." By "grand" things, Lamy was referring to God. But the duties and requirements of temporal powers were no different—it was still a question of grandeur. Rulers could no longer simply be rulers: they had to show it. Eloquently.

Opera was "lively, full of movement, [and] enriched with figures," and was therefore instantly baroque. It combined all modes of expression, whether architectural, musical, pictorial, or poetic.

Opera first emerged in Florence, in the form of Jacopo Peri's *Dafne,* during the carnival of 1597. Ovid's *Metamorphoses* provided the subject matter for Peri's pastorale, which ended with a hymn to love. Peri's *Euridice* constituted a second step, when it was performed on October 6, 1600, at the Palazzo Pitti, a performance that accorded with the matchless splendor organized for the marriage—by proxy—of Marie de' Medici to Henry IV of France. This wedding was not merely a question of diplomacy, as so many other marriages were, it was also a political signal directed at all of Europe: a French king, in order to accede to the throne, renounced his Protestant religion and married a Medici at a time when another Medici was pope.

Yet the history of opera only truly began when Claudio Monteverdi presented *Orfeo* on February 24, 1607, in Margherita Gonzaga's apartments in the ducal palace of Mantua. By 1637, the doors of the first public opera house, the Teatro San Cassiano, opened in Venice. Vocal virtuosity was matched by the exploits of stage machinery. As one spectator recounted, "The entire earth began to smoke, expand, rumble, and tremble and, collapsing little by little, revealed a vast cave that could be viewed in all its depth, which, more than any other thing, left the audience amazed and wondering. Because, seeing the great void below the

stage, the audience did not understand where the great machines were located, which were usually still visible. But the most wonderful thing was that from the cave there issued strong winds, freshly scented and so bracing that the entire theater, which was very full, was flooded with their fragrance, which delighted everyone."

The operatic splendor that was born with the century, featuring "great machines . . . which were usually still visible," was ultimately the very sign of "baroqueness." All of Europe immediately consulted the treatise on stage mechanics written by Niccoló Sabbatini, *Pratica di fabbricar scene e macchine ne' teatri.* Everywhere opera had the same aims, everywhere it obeyed La Bruyère's dictum that "the role of this spectacle is to subjugate mind, eyes, and ears in equal enchantment." Everywhere, from Madrid to Paris to Vienna, opera generated the same rapture.

And everywhere in Europe people sought the services of Italians who knew how to operate such machines. In 1618, Spanish king Philip IV hired Cosmo Lotti from Florence, whose scenic tricks, illusions, and marvels earned him the epithet "sorcerer." Parisians gave the same nickname to Giacomo Torelli, lured by Cardinal Mazarin in 1645 to France, where, some thirty years earlier, around 1615, the Florentine Tommaso Francini had already installed complex machinery. Such machinery generated apparitions, unleashed storms, made castles crumble (or rise) dazzlingly, and effected all the metamorphoses undergone by ancient gods.

THEATER OF FAITH

In Rome, Andrea Pozzo painted the vaulted ceiling and dome of Sant' Ignazio, a Jesuit church dedicated to Saint Ignatius Loyola. In the middle of the vault, divine light illuminated the saint as well as allegories representing the four corners of the world. No one entering the church could doubt the reality of the dome, no one doubted that the vault, decorated between 1685 and 1694, opened onto mystic heavens above the structure of the nave. And yet neither dome nor vault existed. Pozzo had painted illusions. He had fooled the eye. He was staging a theater of faith, thanks to his perfect mastery of perspective.

COMMISSIONS NO LONGER CAME SOLELY FROM GOVERNMENTS—FROM MADRID
TO AMSTERDAM, ARTISTS BEGAN PAINTING THE MORE PRIVATE WORLD OF THE BOURGEOISIE.

Above: Diego Velázquez, *Portrait of the Infanta Marguerita,* 1659. Prado, Madrid.
Opposite: Jan Vermeer, *Young Girl in Blue,* circa 1663–1664. Rijksmuseum, Amsterdam, Holland.

At the same time, Pozzo wrote a treatise on the rules, principles, and precepts of perspective, titled *Perspectiva pictorum et architectorum.* Published in 1693, Pozzo's treatise was an immediate sensation throughout Europe. It was used by architects, by painters, by everyone who built and decorated churches and palaces in the Holy Roman Empire, in German principalities, in the Austrian empire. It was also used in the kingdom of France. Everywhere, baroque meant "a variety that surprises the mind and delights the eye," a definition offered by Molière in his celebration of the fresco painted on the dome of Val-de-Grâce by Pierre Mignard in 1663.

The church of Sant'Ignazio in Rome was not the only "theater" of faith. Another one can be seen in a chapel in the church of Santa Maria della Vittoria, which Gianlorenzo Bernini executed on behalf of Federigo Cornaro. The skeletons set into the paving, who turn toward redemption, are those of Cornaros buried below the slabs; other members of the family are shown on right and left, in oratories similar to theater boxes. Paradoxically, they do not turn toward the main "spectacle," namely the ecstasy of Saint Teresa. Facing Teresa and, like her, drenched in the light of the Holy Spirit, is a smiling angel who wields an arrow that, in the words of the saint herself, "left [her] totally aglow with the love of God." All the gold, bronze, colored marble, and light flooding the chapel directly evoke the inexpressible experience undergone by Teresa, founder of the order of Discalced Carmelites.

In churches, architectural space and light and color merged with marble, stuccowork, sculpture, and painting—everything blended into everything else. Everything was organized to set the soul aglow, to infuse it with a kind of giddy transport. Nothing was designed to argue, everything was designed to move. To move toward the giddy rapture of God. To reveal His splendor and His glory.

Staging the City

The first specially designed square in Europe was laid out in Rome, on the Capitol. Commissioned by Pope Paul II, who was preparing a council to

launch the Counter Reformation (finally held in Trent in 1545), it remains exemplary. The antique equestrian statue of Marcus Aurelius, brought over from Saint John Lateran, was thought at the time to be Emperor Constantine, who converted to Christ's Church in 313. Thus the first square in Europe had as its center of gravity a statue representing the political power of both the empire of Rome and the Church of Rome.

Pope Sixtus V continued the work begun by his predecessor. In 1585, he decided to connect Rome's holiest sites by wide avenues. And Alexander VII, pope from 1655 to 1667, displayed the same determination to embellish Rome when he had two domed churches built opposite Porta del Popolo, the starting point for three avenues running into the city.

The most important construction site in Rome was Saint Peter's Square, designed by Bernini. This crucial project had to lend full scope to the basilica built over the very tomb of Saint Peter. Reaching the square in those days meant wandering through a maze of narrow lanes, along the shadow-darkened valleys of Roman streets. Suddenly the square opened up, revealing the dazzling dome and multicolored marble façade of the largest church in Christendom. The power of the Church was there for all to see.

On Piazza Navona, it was Bernini once again who directed work on the Fontana dei Quattro Fiumi (Fountain of four rivers) between 1648 and 1651. The fountain was commissioned to celebrate the revitalization of the world promised by the pope for the holy year of 1650. Four figures embody the rivers Danube, Nile, Ganges, and Plate, symbolizing the four continents and the four elements of earth, air, fire, and water. Contrasting with the chaotic rock formation on which the figures sit is a taut, straight obelisk that Pope Innocent X placed in the middle. Rising into the sky, the obelisk asserts the order of the faith that the Church intended to impose on the world. But this ambition was no longer shared by the people of Rome; the Romans rebelled against the cost of this work, claiming that "you can't feed people on obelisks and fountains." A few years later, architect Francesco Borromini marked his disapproval in another fashion: he was charged by Innocent X with modifying the

façade of the church of Sant'Agnese opposite the fountain. The work lasted from 1653 to 1657. Borromini stripped the church of all sculpture, except for one: a statue raises her hand and turns her head in order to avoid seeing, below, the fountain by Bernini, a long-time rival of Borromini.

THE LANGUAGE OF CITY AND NATURE

Throughout Europe, as in Rome, city squares became theaters for society. They provided a permanent stage for ephemeral events that underscored the pomp of government. Gilded arches of triumph; structures of wood, canvas, and stucco that assumed airs of marble; and parades and fireworks, all contributed to the "theatrical productions." Coronations, weddings, and funerals with their processions and corteges were designed to ease the fear, pain, and mourning of peoples sorely tried by war, famine, and plague.

In Rome, this staging concerned the government of popes, the government of God. In France, it concerned the government of kings. The construction of Place Dauphine in Paris in 1607 was significant, because it opened onto the central island of the Pont Neuf, where the equestrian statue of King Henry IV was placed. Meanwhile, Place Royale (now Place des Vosges) was built, between 1606 and 1612 in the Marais district of Paris, to serve as a site for festivities. In Madrid, work began in 1619 on Plaza Mayor, designed in 1617 by Juan Gomez de Mora. These squares were like theaters; the balconies of surrounding buildings henceforth acted like theater boxes, as had long been the case at Piazza Navona in Rome.

The Renaissance dream of an ideal city—as functional as it was beautiful—survived and even spread across Europe. Salomon de Brosse took up this challenge when designing the Protestant town of Henrichemont, as did Prince Carafa Branciforte di Butera in 1699 when rebuilding Grammichele after its destruction by an earthquake. The same dream was pursued by Nicodemus Tessin the Elder when designing the Swedish cities of Kalmar and Landskrona, and the same challenge was accepted

Georges de la Tour, *The Angel Appearing to Saint Joseph,* circa 1640–1645. Musée des Beaux-Arts, Nantes, France.

Plaza Mayor in
Madrid, 1619.
Engraving.

by Jacques Lemercier when building the chateau and town commis-
sioned by (and named after) Cardinal de Richelieu. Everywhere, the con-
struction of these "ideal cities" created spaces that lent symbolic reality
to the values of those in power. At a time when European cities were
undergoing extraordinary growth, the new town planning reflected the
issues, symbols, and spaces that reinforced a social hierarchy.

Nature, like the city, was invited to join in the festivities. First in Italy,
then all across Europe, the seventeenth century generated a new dia-
logue between nature and architecture. As a certain Tommaso
Campanella asserted at the time, nature was "a living temple of God
which depicts His gestures and inscribes His concepts, and which He has

decorated with statues that are pure and lifelike in the heavens but com-
plex and awkward on earth, yet all of which point toward Him." The
issues were the same at Versailles as they had been at Villa Frascate, not
far from Rome, begun in 1601 by Giacomo della Porta and completed
by Carlo Maderno. A key difference, however, was that Italian architects
built villas and princely dwellings on a height or slope, whereas French
architects were wary of overly steep terrain. Neither Salomon de Brosse
(who built the Luxembourg Palace in Paris for Marie de' Medici between
1615 and 1636), nor Louis Le Vau (who built the chateau of Vaux-le-
Vicomte for financier Nicolas Fouquet) designed buildings that over-
looked a garden from on high.

THE RHETORIC OF ARCHITECTURE

The baroque was expressed through and with architecture. In Rome, Pietro da Cortona, Francesco Castelli (called Borromini), and Bernini were designing the new spaces required by the liturgical decisions taken at the Council of Trent.

The columns, pilasters, arches, friezes, and pediments of baroque architecture were the ones the Renaissance had already employed, having taken ancient ruins as its model. Vitruvius's treaty on architecture was studied over and over. The barrel vaults and pendentive domes rising above the crossing of the transept were the same in Andrea Palladio's San Giorgio Maggiore in Venice (begun 1566) as in Giacomo della Porta's church of Gesù in Rome (completed in 1577)—the Gesù served as a model throughout Catholic Europe. Yet despite appearances, the two churches no longer have anything in common. The syntax of the ancient orders adopted by Palladio for Venice is perfectly distinct, whereas in the Gesù the gilding, stucco work, and paintings done in 1679 by Baciccia for *The Triumph of the Name of Jesus* merged all architectural and decorative elements into a single ensemble.

Such elements henceforth served as rhetoric. They became symbols that revealed the authority and power of the Church. They proclaimed the triumph and apotheosis of heavenly and earthly glory.

Façades undulated so that salients caught the light while niches created shadows. Curves and counter curves carved depths and heights. Perspectives seemed to beckon. The sculptures punctuating the space caught the eye, paintings led the gaze to the heavens, where saints rose while angels and allegories romped. All these forms and all these elements constituted a discourse not unlike music, which, in order to stir emotions, was composed of an introduction and an exposition with theses and antitheses similar to the tropes of classical rhetoric. Both space and music were eloquent orators. All methods of convincing the public were valid, from hyperbole to metonymy to metaphor. Emanuele Tesauro, author of a treatise on rhetoric, wrote, circa 1650: "Through the magic of rhetoric, what is dumb can speak, what is insensate lives,

Peter Paul Rubens, *Descent from the Cross*, 1612. Museum of Fine Arts, Antwerp, Holland.

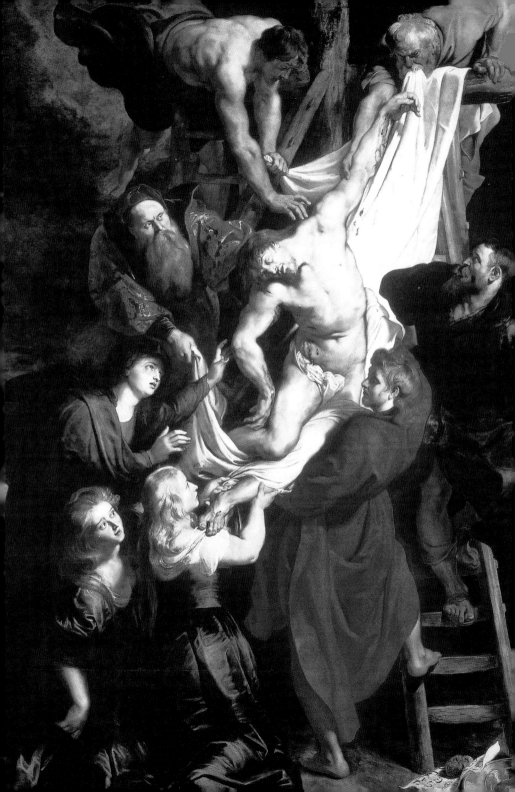

what is dead revives; thanks to that enchanter of souls, now tombs, marble, and statues can acquire life, spirit, and movement." All means were valid.

The new architectural vocabulary developed in Rome was soon adopted throughout Europe. One example among others was the College of Four Nations founded by Cardinal Mazarin in Paris; built by Louis Le Vau on the left bank of the Seine, across from the Louvre, it was modeled on the curving façade that Borromini had designed in 1642 for the Roman church of Sant'Ivo alla Sapienza, while the oval dome was similar to the one Borromini placed on San Carlo alle Quattro Fontane.

CLASSICAL RIGOR

Although the College of Four Nations was baroque, France did not tolerate such exuberance for long. A strange coincidence: it was in 1665 that Bernini began work on the colonnade in Saint Peter's Square in Rome; it was in 1665 that Le Vau began to expand what had been Louis XIII's hunting lodge into a vast complex at Versailles. The strict linearity of Le Vau, known as "French classicism," was exactly contemporary with Bernini's "baroque" curves.

Although both construction projects began the same year, Bernini knew exactly the effect he wished to produce whereas, Le Vau was perhaps less sure of himself. Versailles was situated on a terrain of moors, copses, and ponds; Le Vau, along with André Le Nôtre and Jules Hardouin-Mansart, was instructed to align the façades of the palace and the lanes and alleys of the garden and town so that everything converged on the king. On November 5, 1699, the duchess of Orléans, Princess Palatine, confessed in a letter: "The king himself admits that there are errors in the architecture at Versailles. It comes from the fact that, in principle, he did not want to build so vast a palace but only enlarge a little chateau located there. Subsequently, the king found the place pleasing. But he could not reside there, given the dearth of housing, so instead of demolishing the little chateau and building a bigger one to a new design, he saved the old chateau by erecting new buildings around it, covering it, so to

Jan Steen,
A Family Repast.
17th century.
Musée du Louvre,
Paris, France.

REMBRANDT FELT THAT A SIDE OF BEEF WAS AS WORTHY A SUBJECT AS A DRAPERS' GUILD.
NEITHER SUBJECT NOR GENRE WAS IMPORTANT—ONLY THE PAINTING MATTERED.

Above: Rembrandt, *The Slaughtered Ox,* 1655. Musée du Louvre, Paris, France.
Opposite: Rembrandt, *The Drapers' Guild,* 1662. Rijksmuseum, Amsterdam, Holland.

speak, with a fine cloak, only to spoil everything." It nevertheless remains that the king and his architects soon knew exactly what they wanted the "fine cloak" to show.

Also in the year 1665, Louis XIV summoned Bernini to France to complete the Louvre. The king knew that Bernini's buildings in Rome were designed to serve papal power and papal power only. Yet in France, ever since the death of Cardinal Mazarin in 1661 and the arrest of Nicolas Fouquet that same year, the king was the sole ruler. The Church itself became increasingly Gallican, that is to say subject to French administrative control. Louis XIV hoped that Bernini's inventiveness would serve him as efficiently as it had served the popes.

Bernini's plans for the façade of the Louvre were nevertheless rejected, perhaps because finance minister Jean-Baptiste Colbert found them too costly. The plans were perhaps also rejected to avoid a misunderstanding. Methods deployed to serve the king should serve only the king; but the architectural forms suggested by Bernini were too similar to the ones that asserted the power of the Roman Church. During his stay in Paris, Bernini served Louis XIV in his own way, by sculpting a bust and an equestrian statue of the king. The marble bust made Louis look like Alexander the Great, graced with a magnificent wig and jabot that tumble onto his breast armor—Bernini had not produced a portrait of a man; he sculpted a monarch who was the very incarnation of personal power. Louis XIV and Bernini were familiar with the maxim attributed to Queen Christina of Sweden: "Magnificence and liberality are a conqueror's virtues. They charm everyone."

CLASSICISM AND BAROQUE IN FRANCE

France's "classical" version of baroque served neither the same ideal nor the same reality as the baroque aesthetic initially conceived in Rome. The verve and movement employed at Rome were signs of struggle, whereas the France of Louis XIV was confident of its power. (Even when that power waned: during the war of the Spanish Succession, which lasted from 1701 to 1712, the king mobilized the resources necessary to win it.

The duchess of Orléans recounted once again, in a letter dated June 8, 1709, that "the king is so determined to continue the war, that this morning he sent his entire gold table service to the mint—plates, dishes, salt cellars, in short, everything—to be melted into coin.")

French "classicism" was a version of baroque art that was fully confident in the authority it served, fully confident in the absolute power of a monarch who, according to one diplomat, "mastered every grace, as well as everything that pertains to the political, military, and ecclesiastical state." No one could challenge any royal decision whatsoever. In his memoirs, the duke of Saint-Simon reported Louis XIV's anger over a trifle: "'I will come and go at my whim, and I will be left in peace.' This kind of outburst was followed by a silence in which you could hear an ant crawl; eyes were lowered, people barely dared to breathe." In every sphere, there was only one seat of power: the king and the king alone. Louis XIV concluded his advice to his grandson, about to become King Philip V of Spain, with the following words: "I will end on one of the most important counsels I can give you: do not let yourself be governed; remain the master; never have favorites nor prime minister; consult and listen to your council, but decide yourself; God, who made you king, will give you the enlightenment you require as long as your intentions are good."

In his *Maxims,* La Rochefoucauld claimed, "True eloquence means saying that which is necessary, and only that which is necessary." In a certain way, baroque art adopted the first half of La Rochefoucauld's saying—"True eloquence means saying that which is necessary"—but added, "while using every means to convince." French classicism, meanwhile, adhered to the rigor and economy of the second half of the maxim: "only that which is necessary."

Baroque meant diversity. Classicism sought unity. Baroque was ardor and verve. Classicism asserted confidence. Baroque curves, undulations, flights and falls, rhythms and ruptures, were met by the straight lines, symmetry, and balance of classicism. Yet all of it aimed always, and only, for grandeur.

Following pages:
Willem Claesz
Heda, *Breakfast
of Blackberries
and Pâté,* 1631.
Gemäldegalerie,
Dresden, Germany.

Louis XIV's absolute monarchy opted for an architecture of taut lines radiating from the king. It had to indicate, without the slightest ambiguity, that everything began and ended in the person of the king alone. Ever since the king had established his government in Versailles in 1682—once the wings added by Mansart made it possible to house the entire royal family, princes of the blood, and court—architecture and decoration, gardens and protocol were all choreographed around monarchic ritual. As Christina of Sweden noted, "France had a genius for monarchy."

In 1701, Louis XIV turned the salon in the very center of the chateau into his bedchamber; the windows of this chamber overlooked the rising sun, representing the culmination of the chateau as architectural symbol. André Félibien des Avaux, historian to the king and secretary of the French Academy of Architecture, observed: "Since the Sun is the Emblem of the King, and since Poets associate the Sun with Apollo, nothing in that superb House fails to relate to that divinity." The portraits of the king painted by Charles Lebrun had to be an allegory of the absolute power of the divinity he incarnated. The Royal Academy of Painting and Sculpture, like the Academies of Architecture, Music, and the French Academy at Rome (where talented young artists were sent) all devised works to honor the glory of the king. The royal manufactories of Gobelins, Beauvais, Savonnerie, and Saint-Gobin produced tapestries, mirrors, and other decorative items that served the pomp required by absolutism.

If Versailles welcomed the baroque into its gardens, galleries, and salons, that is because the baroque was a mark of splendor and glory. It could stir powerful emotions, as demonstrated by Pierre Puget's statue of *Milo of Crotona*. The sight of Milo, whose heroic body was twisted in suffering and pain, was unbearably moving. When the statue was unveiled on the grounds of Versailles in 1683, a countess who attended the inauguration cried, "Oh, the poor man!"—and fainted dead away. Puget had discovered this emotional power when studying in Italy between 1640 and 1643 and mastered its effects when working in Genoa between 1660 and 1669.

Jacob van Ruysdael,
Landscape,
17th century.
Alte Pinakothek,
Munich, Germany.

The countess' swoon was matched by the emotion of Madame de Sévigné. After having attended a performance of Lully's opera *Alceste* in 1674, she wrote, ". . . there were moments that merited tears; I was not the only one unable to hold them back." Notwithstanding such distress, nor the boredom described by the duchess of Orléans (". . . but I fear that in going further into the details of court life, I cause you the same boredom that I often feel"), Versailles became a model for all the monarchies of Europe, from Vienna to Stockholm and from Berlin to Saint Petersburg.

ROME'S DIALOGUE WITH PAINTING

Although Versailles was the sole model for the royal palaces going up in all European capitals, Rome remained the crucial reference when it came to painting. Rome was where painting entered into a dialogue with reality. It began with two artists, Annibale Carracci and Michelangelo Merisi, called Caravaggio. Between 1597 and 1601 Carracci composed the decorative scheme for the ceiling of the large gallery in the Palazzo Farnese in Rome, where paintings were framed by trompe-l'oeil work, grisailles, and stucco work. Bodies and proportions, even when movement is accentuated, respect and display the dictates of beauty established by Raphael.

When painting became "baroque," painters took as models the gestures and expressions of bodies painted by Carracci—but threw away the frames. As to Caravaggio, he illuminated the main protagonist of the *Calling of Saint Matthew* and the *Martyrdom of Saint Matthew*, painted for the Contarelli Chapel of San Luigi dei Francesi in Rome between 1599 and 1602. The intensity of this arbitrary light showed a harsh reality: the face of the saint who turns toward the angel is more than just wrinkled, it is positively furrowed—the face of a humble man marked by the years. Similar is Caravaggio's face of Saint Peter, depicted in 1600 on his cross, crucified head down. The Lord's Prayer asks that God's will "be done on earth as it is heaven"—here, earth means the dirty feet of the executioner prodding the cross onto which Peter has been nailed, the

Theater in the Middle of the Large Pool, representing the Isle of Alcina, Gardens of Versailles, 17th century. Engraving.

Theatre dressé au milieu du grand Estang
representant l'Isle d'Alcine, ou paroissoit son Palais
enchanté sortant d'vn petit Rocher dans lequel fut dancé
vn Ballet de plusieurs entrées, et apres quoy ce Palais fut
consumé, par vn feu d'Artifice representant la rupture
de l'enchantement apres la fuite de Roger

same earth trod by the bare feet and swollen ankles of the dying Virgin. Year after year, painters had to make a choice: either they decided, like Carracci, to follow Raphael, or they adopted the light and brutality of Caravaggio.

Like Carracci, Guido Reni, Nicolas Poussin, and Claude Lorrain idealized nature and depicted bodies whose beauty was dictated by the canons of ancient sculpture. In contrast, painters such as Ribera, Le Valentin, Vouet, Georges de La Tour, and even Velázquez became "caravaggists." As did Zurbarán, who perhaps saw in Seville the paintings Ribera did in Naples (a Spanish possession). So did Murillo, despite knowing Caravaggio's work only through variants perhaps seen in the royal collection at Madrid. This "genealogical tree" of painters going back to Carracci and Raphael on the one side, or to Caravaggio on the other, merely provides the broad lines of what was a continental divide between two styles—that divide marked two opposing conceptions of painting.

For some, painting was above all a question of the drawing that defined it. For others, painting was above all a question of color. The former, classic approach continued to look back to antiquity, while the latter exploited baroque profusion and diversity.

No artist, however, followed or accepted any hard and fast rule. All were exceptions. All invented their own styles.

The seventeenth century required only one thing of painters: that they complete their education in Rome. They had to have seen the work of Raphael, had to have discussed the criteria of painting—draftsmanship versus color—in chapels, palaces and studios. Rome constituted a key reference in every artistic career. The French painter Simon Vouet lived in Rome between 1614 and 1627, while the Spanish artist Jusepe Ribera was admitted to the Roman painters' guild, the Accademia di San Luca, as early as 1616. Once he arrived in Rome in 1613 or 1614, Valetin de Boullogne, from France, never left it. Georges de La Tour, from Lorraine, spent six years in Italy, from 1610 to 1616. Nicolas Poussin, from Normandy, only agreed to leave Rome, where he had arrived in 1624,

Vedula interna del I. R. Teatro alla Scala in Milano

Mailland,
La Scala Theater,
1776–1779.

when he was appointed painter to the king of France in 1640 (and was back in Rome by 1642). The Spaniard Diego Velázquez spent two periods in Italy, from 1629 to 1630 and from 1649 to 1651; the king had to summon him to back to Madrid in order to get him out of Rome. Claude Gellée, known as Claude Lorrain, only returned to his home in Lorraine for two years, going back to Rome for good in 1627. Flemish Anthony van Dyck spent the years 1621 to 1627 in Italy.

RUBENS AND REMBRANDT

The standard pilgrimage to Rome, capital of painting, suited neither Peter-Paul Rubens nor Rembrandt van Rijn. Rome was merely one stage in Rubens's career, whereas Rembrandt's ambitiousness never even allowed him time to stray from Leyden and Amsterdam.

Rubens, who arrived in Rome as early as 1600, witnessed the debates and controversies then raging over painting. He took note and then

transcended it all, serving the faith of the Catholic Church throughout Europe. Rubens worked for governments that recognized that Church, painting not only for the Jesuits in Antwerp but also for the Spanish authorities in Catholic Flanders. He painted in the Luxembourg Palace of Marie de' Medici in Paris, in Madrid for Philip III of Spain, in London under Charles I of England. All his decorative series display the same impetuousness, the same transparent touch that yields warm shadows against ochre grounds—Rubens's paintings were executed for the Church and the aristocracy.

Not so canvases by Rembrandt Harmenszen van Rijn, who moved permanently to Amsterdam in 1633, henceforth signing his work with his first name only, Rembrandt. He aspired to be the peer of Italian painters whose fame was assured once they were called only by their first name or nickname. In the United Provinces of the Netherlands, Rembrandt dealt mainly with shippers, merchants, magistrates, and regents (as did Frans Hals before him and Vermeer after him). Rembrandt made one reputation in Amsterdam through his portraits and another all across Europe through his engravings, whereas his colleagues were content with the fame that came with the mastery of a specific style. Gabriel Metsu and Jan Steen, for example, specialized in genre scenes, while Simon de Vlieger and Jan van de Cappelle painted seascapes. Philips de Koninck and Aelbert Kuyp were known for their landscapes, while the still lifes of Willem Kalf, Abraham van Beyeren and others testify to the lifestyle of their clientele of burghers, reflecting the moral values, ambitions, and dreams of wealth spurred by the Dutch East India Company.

A SPECIAL CASE: THE DUTCH ART MARKET

Whereas paintings produced in Italy and the rest of "baroque Europe" were done on the scale of churches and palaces, canvases produced in the United Provinces were all basically small in format, with the exception of group portraits showing men and women gathered together in civic, military, commercial, or charitable organizations.

That was because an art market had developed in the United Provinces. Paintings were produced for the houses that the industrious middle classes built along canals whose docks were heaped with silks and spices, furs and curiosities, porcelain and wool. People in this Calvinist land were wary of images that might be construed as idolatrous; having freed themselves from the domination of Catholic Spain, these provinces established a Calvinist government that published a state Bible. Painting was not forbidden, but artists could no longer expect the patronage of an ecclesiastical hierarchy—Protestant churches were devoid of paintings. And yet paintings were beginning to "ennoble" the shippers, bankers, and magistrates who commissioned portraits just like the ones ordered by aristocrats in the rest of Europe. And episodes from the Old and New Testament as painted or engraved by Rembrandt accompanied the reading of the Holy Scripture done in the middle-class houses that doubled as warehouse, bank, or trading post.

The domestic trompe-l'oeil subjects painted in Holland—a letter slipped behind a ribbon, an engraving hanging from a nail on a panel, a clock with dangling chains—were perhaps a mocking rejoinder to the trompe-l'oeil work done for the glory of the saints of the Roman Catholic Church. Such images perhaps represented a critique of mystical skies swarming with blessed saints, angels, and allegories.

Whereas Rome painted and sculpted *The Glory of Saint Ignatius, Faith Triumphing Over Idolatry, Religion Overcoming Heresy,* or *The Glorification of the Reign of Urban VIII* flanked by allegories of Faith, Hope, and Charity, Amsterdam was painting papers that might be contracts for the East India Company or bills of exchange; it was depicting tables piled with Chinese porcelain or lemons.

Rome painted a world that belonged to eternity; Amsterdam painted the daily business of its port, its docks, its markets.

VERVE AND RIGOR

Eclectic and diverse, the seventeenth century divided writers and poets in the same way it divided painters. The "battle of the books" that broke

out in England was analogous to the *poëtenstrijd* (battle of poets) in the United Provinces and the *querelle des Anciens et des Modernes* (quarrel of ancients and moderns) in France in the 1680s. The "ancients" thought that respect for classical rules was literature's only salvation; the "moderns" liked to think that new forms would enable them to express the exuberance of the world. In describing and recounting such exuberance, poets and novelists relied on hyperbole and antithesis, virtuosity and the burlesque.

Poets in the United Provinces of the Netherlands such as Constantijn Huygens and Jan Luyken used a rhetoric in their religious and love poetry that was similar to the one employed by French novelist Madeleine de Scudéry, whose *Clélie* expected suitors to follow a "Map of Affection" through places called "Attentiveness" and "Diligence," all the while avoiding the "Lake of Indifference." Such baroque writing indulged in both whimsy and excess. The magnificent riddles concocted by Luis de Góngora y Argote seemed to echo the extravagant myths dreamed up by Giambattista Marino.

Poets throughout Europe—Vincent Voiture in France, Jan Andrzej Morsztyn in Poland, Martin Opitz in Germany—gave way to the same mannerism and preciousness. Whereas poets chose mythological subjects, novelists based their burlesque, picaresque tales on reality. Neither Jan Chryzostom Pasek in Poland nor Savinien de Cyrano de Bergerac in France nor Francisco Gomez de Quevedo y Villegas in Spain stinted on inconsistencies, earthiness, cynicism, and humor. They produced a terrific blend of the most vulgar and coarse reality with the most ancient mythology.

Opposite:
Francisco de Zurbarán, *Saint Lucy,* 17th century. Musée des Beaux-Arts, Chartres, France.

Following pages:
Philippe de Champaigne, *Vanitas,* 17th century. Musée de Tesse, Le Mans, France.

STAGING FREEDOM

The freedom sought by playwrights was no different. There was no question of being corseted by rules. Lope de Vega rejected them in his *Arte nuevo de hacer comedias* (New art of composing comedies). Don Pedro Calderón de la Barca was equally skeptical of rigorous composition.

Both were crucial models, because Spanish influence was spreading throughout Europe—neither Andreas Gryphius in Germany nor Stanislaw Lubomirski in Poland remained indifferent to it, while in France Pierre Corneille was quick to borrow the character of El Cid from Guillén de Castro (author of *Las Mocedades del Cid,* "The Youth of El Cid"). Molière, meanwhile, stole the figure of Don Juan from *El Burlador de Sevilla* (The Seducer of Seville) by Tirso de Molina.

The main "characters" of seventeenth-century theater were honor and fame. Although honor and fame were an obsession of Jean Racine's characters, his plays were an exception insofar as the inevitable tragedies he staged required strict respect for the rules of unity: unity of action, place, and time.

With the exception of Racine's rigor—which nevertheless influenced English playwrights such as John Dryden and accorded with the call for spareness made by Dutch drama theorist Daniel Heinsius—it seemed that writers and poets everywhere in Europe were carried away by a flood of words in the fashion of Madame de Sévigné: "I shall send you word of the most amazing, most surprising, most wonderful, most miraculous, most winning, most stunning, most incredible, most singular, most extraordinary, most unbelievable, most unexpected thing; the greatest, the tiniest, the rarest, most ordinary, most dazzlingly, and most secret thing to date, also the most splendid and most desirable."

The austere and disconsolate voice of Jean de la Bruyère, in his *Characters* (1688), seems to offer a reply: "All has been said, we arrive too late; for over seven thousand years there have been men, and they have thought." Bruyère's chagrin was perhaps ultimately that of a "gentleman."

A "gentleman"—classical, austere, worldly, concerned with continuity—sought to recognize good sense, to be in harmony with nature, and to draw inspiration from the ancients (who remained in his eyes the models of a truth that his contemporaries ought to acknowledge).

And perhaps the call for clarity began to outweigh baroque flights of fancy. Don Juan—baroque and licentious (baroque because ungras-

pable, licentious because baroque)—nevertheless believed that "two plus two make four and four plus four make eight," thereby heralding the challenge issued by reason and enlightenment.

ELEGANCE, REASON, DREAMS

As the year 1699 approached, Versailles was agitated. According to the duchess of Orléans, "There is a great debate at court, and everyone is taking part, from the king to footmen. This is the subject of debate: Does the century begin in the year 1700, or the year 1701? Monsieur Fagon and his camp favor 1700 because, they say, a full one hundred years will have elapsed; but others hold that they will only have elapsed in the year 1701. Wherever you go, that's all you hear, even from sedan bearers who chime in." Just a few weeks later, in January 1699, people knew where they stood. "We called on the Académie [Française] and the Sorbonne as judges. Both censured M. Fagon and insisted that the century began in the year 1701. They said that the jubilee was set for the last year of the century so that we will enter the one next pure and clean." In 1701, then, no one doubted that the eighteenth century had begun. The calendar, the Académie, and the Sorbonne were right. Historians, however, feel that the eighteenth century only really began with the death of Louis XIV in 1715, which all Europe realized was the end of an era. History pays no attention to the calendar just as styles pay no attention to chronology. The seventeenth century was baroque and classical—and the eighteenth century would long remain that way.

French school (attributed to Lancret), *The Young Louis XV Dressed as a "Pilgrim to Cythera,"* early 18th century. Château de Versailles, Versailles, France.

LATE VARIATIONS ON BAROQUE AND CLASSICAL

For a good many years into the eighteenth century, Europe imitated Italian and French models. The royal residence that Luigi Vanvitelli began building at Caserta, not far from Naples, for Carlo III in 1752 was as classical as it was baroque; the *Reggia* was classical in the symmetry of the arrangement of

The Emperor's Hall, Palace of the Prince Bishop of Würzburg, 1720. Würzburg, Germany.

courtyards and apartments, underscoring royal power, yet it was baroque in the splendor of its decoration and ornamentation. The same combination of styles marked the chateau that Prince Esterhazy built from a hunting lodge in Fertöd, completed in 1763. Even though Peter the Great of Russia envisaged a baroque Saint Petersburg, the Versailles model was soon influencing the construction of the Peterhof, Oranienbaum, and Tsarskoye Selo, built a few leagues from the capital. Meanwhile, Frederick the Great of Prussia abandoned his capital of Berlin for Potsdam in the early years of his reign, where the chateau of Sans-Souci served as his Trianon (if not his Versailles).

Johann Balthasar Neumann worked continually on the palace of the Prince Bishop of Würzburg from 1719 until his death in 1753. The decoration of the façade by Johann Lukas von Hildebrandt combined and blended elements borrowed from France as well as from Italy. The skies painted by Giambattista Tiepolo on the ceilings of the dining room and ceremonial

Statue of Peter
the Great in
St. Petersburg,
by Etienne-Maurice
Falconet. Engraving
by Rouargue,
1766–1778.

staircase at Würzburg, in 1750 and 1753, were equally baroque; gods and allegories fluttered overhead as Fame and Virtue, assisted by putti, carried a portrait of Prince Bishop Karl von Greiffenklau—who commissioned the paintings—toward the heavens.

In Austria, baroque art seemed to symbolize the victory claimed by Vienna, which found it hard to forget that the Turks had been at its gates in 1683. The duchess of Orléans reported in a letter dated July 15, 1683 that "the Turk is so close to Vienna that the emperor, from his window, saw Tartars burning villages." The baroque had to mobilize all its forces in the Holy Roman Empire of Germany, where the Reformation had managed to create several Protestant states. In Austria, Bohemia, and southern Germany, numerous architects such as Domenico Martinelli and Antonio Beduzzi arrived from Bologna or Genoa or Rome and continued to deploy all the pomp and signs of the Catholic faith's ambitions and power.

This variety of baroque was obsessed by Roman splendor and strove to be a *gesamtkunstwerk,* or "total artwork," as exemplified by the monastery church of Rohr, built between 1718 and 1722. The architect was Egid Quirin Asam, who was also a sculptor and stucco artist, while his brother Cosmas Damian Asam was architect and painter. Together, they staged the interior of the church as a *tableau-vivant* of the Assumption of the Virgin, borne by angels. This spectacle was notably witnessed by the apostles, who gathered around the empty tomb in grandiloquent robes, making gestures of amazement, bewilderment, fright. In a similar vein was Neumann's pilgrimage church of Vierzehnheiligen (Fourteen intercessor saints), built near Lichtenfels in Bavaria between 1743 and 1772. Neumann organized the interior of the Latin-cross church around oval spaces that underscored the altar in the middle of the nave as the site of a miracle, a miracle whose reality would be impressed upon marveling pilgrims.

In the Austrian empire, baroque profusion served both the Jesuits's mission and the pious absolutism of Charles VI. Interlinking colors, materials, and spaces teemed and swarmed, representing the apotheosis of the baroque. It was a final salvo by a faith and a government as intoxicated on their certainties as they were alarmed by looming, deadly threats.

The baroque that deployed its splendors throughout the Catholic states of the Holy Roman and Austrian empires always looked to Rome for its model. Having started in Rome, the history of baroque art ended there. It almost seemed as though the baroque cascades that sprang from Bernini's Fountain of four rivers in Piazza Navona in Rome spilled into the Austrian rivers symbolized by Georg Raphael Donner's Mehlmarkt Fountain in Vienna, then flowed throughout Europe and the Catholic world, only to wind up at the feet of Neptune in the Trevi Fountain back in Rome, designed by Nicola Salvi and inaugurated by Pope Clement XIII in 1762.

FORMS AND CODES

When the eighteenth century began—according to the calendar—the baroque aesthetic was a code, a special language. The proof of this can be seen in the dialogue engendered by two works in two different capitals: the

portrait of Louis XIV by Hyacinthe Rigaud in Versailles and the Karlskirche by architect Fischer von Erlach in Vienna.

In Rigaud's portrait of Louis XIV, painted in 1701, the king is shown with all the attributes of power: ermine coronation cloak with gold embroidered fleur-de-lis, scepter, crown, hand of justice set on a cushion, etc. One unusual allusion was the way the cloak opened to reveal the king's legs in a stance that reminded viewers that Louis was once a reputed dancer; a second, more political allusion can be seen in the two bas-reliefs behind the king's scepter. They represent the virtues of Justice and Fortitude. And behind the hand placed on the scepter are two columns that are equally significant, because they symbolize a conflict that had set France against Spain for over a century.

Those twin columns represent the Pillars of Hercules that stand at the edge of the known world. It is hard to see them as anything other than the emblem of a government that claimed to extend to the limits of the world; it is hard to see them as anything other than the sign of a claim to a universal throne, especially since two similar pillars, according to the First Book of Kings in the Bible, were raised in front of Solomon's temple in Jerusalem. Furthermore, those columns also symbolized the virtues of Constancy and Fortitude. There could be no ambiguity. Holy Roman Emperor Charles V had been the first to use these pillars in the device that accompanied his motto, Plus Ultra. The Hapsburgs clung to these pillars, which they considered to be a symbol of the entire empire of Charles V, one of whose kingdoms was Spain. And when Louis XIV had Rigaud paint his portrait in 1701, his own grandson, the duke of Anjou, had been reigning in Spain as Philip V since 1700—which the Austrian Hapsburgs refused to accept.

Johann Bernhard Fischer von Erlach's Karlskirche—a church dedicated to Saint Charles Borromeo and erected in Vienna between 1716 and 1729—might be seen as a response to Rigaud's portrait. Built for Emperor Charles VI, the church's portico is framed by two pillars. The fact that they look like a pair of Trajan's columns alters nothing: they clearly allude to control over Spain. Just so that no one could doubt the reality of the Hapsburgs's claims to the Spanish throne, Fischer von Erlach also placed two more pillars in the imperial library of the Hofburg, begun in 1722.

These forms were part of a special dialogue: the pillars painted by Rigaud and the ones erected by Fischer von Erlach participated, in their own way, in the War of the Spanish Succession.

Forms, then, can constitute a language. Although no one would dispute this, the language is not always understood as intended. Thus, in the early years of the eighteenth century, the erection of a statue of Louis XIV on a square in Paris prompted an anonymous poem that noted that the sculptor had placed—

The Goddess Fame behind this warrior,

About to crown him with laurel.

And the ambiguous pose in which she stands

Now suits the submission of France;

Because on seeing the crown it is hard to say

Whether the goddess is giving or taking."

[*La Renommée au dos de ce guerrier,*

Qui semble le vouloir couronner de laurier.

L'attitude ambiguë où l'ouvrier l'a mise,

Convient bien maintenant à la France soumise;

Car à voir la couronne, on ne peut deviner,

si la déesse l'ôte, ou veut la lui donner.]

THE SALON CENTURY

A few months after the death of Louis XIV, the duchess of Orléans was already making a dismayed observation: "Young people do not know what respect is: they have never seen a true court." The young people then "entering society" would never again have to respect the strict protocol imposed on Versailles by Louis XIV. And soon Versailles would no longer be what it once was, insofar as the Regent (the duchess' own son, Philip of Orléans) handled the kingdom's business from Paris. By the time Louis XV returned to the chateau of Versailles, that theater of monarchic glory, his majesty had refurbished the interior with private dwellings that featured a "salon." The eighteenth century was, perhaps, above the salon century, the century of salons. The particular space of a salon seemed to govern everything else, or almost. First of all architecture: the modest space required by a salon had nothing

Rosalba Carriera, *Self-portrait: Winter,* 1731. Gemäldegalerie, Dresden, Germany.

Fig. 2.

ALL OF EUROPE WAS FASCINATED BY THE PUBLICATION OF DIDEROT AND
D'ALEMBERT'S *ENCYCLOPÉDIE DES SCIENCES ET DES ARTS*, DESPITE THREATS OF CENSORSHIP.
IT EVEN WON THE BACKING OF THE FRENCH KING'S MISTRESS.

Opposite: Upholstery, 1st and 2nd Preparations for Armchairs, a plate from *L'Encyclopédie*
edited by Diderot and D'Alembert, 1751–1781. Kunst & Geschichte Archives, Berlin, Germany.
Above: Maurice Quentin de La Tour, Madame de Pompadour, 1752–1755, Musée du Louvre, Paris, France.

to do with the vast galleries designed to stage power. And a salon called for special decoration, which meant that painting had to accept a new role. Instead of covering the vaults, domes, and ceilings of churches and palaces with heavens populated by saints and allegories of fame, painting henceforth had to accept its place on panels over doorways.

In 1736, François Lemoyne finished painting the ceiling of the Hercules Salon in Versailles, where, for the last time, baroque perspective, curves, and colors entwined torsos, clouds, and drapery. The painter Johann Christian von Mannlich realized that this was the last sign of pomp and splendor at Versailles: "The Gallery, the Hercules Salon, etc., the former painted by Lebrun, the latter by Lemoyne, the rich collection of paintings composed of masterpieces by Raphael, Guido Reni, Carracci and other grand masters, as well as the fine antique statues aligned in the Gallery, gave an idea of the taste, magnificence, grandeur, and power of the monarch who resided in that place."

Lemoyne's work was the last major royal commission for a ceiling. This was perhaps due to lack of funds—the national treasury could hardly support such lavish expenditure—yet perhaps even more to lack of desire. The court at Versailles was weary of demonstrations of pomp, which even Louis XIV seemed to neglect in the final year of his reign.

Louis XV, right from the start of his reign, had smaller apartments installed at both Versailles and Fontainebleau. These apartments created a new sense of space associated with the "rococo" style, a term derived from *rocaille* or "rock-work." Back in Renaissance days, Italian gardens and palaces had featured grotto-like spaces decorated with shells and rustic rock-work. This fashion, known to date back to antiquity, was imported into France by the Valois kings. Nineteenth-century use of the terms "rocaille" and "rococo" implied disapproval for an overly curvy style, but under Louis XV this style, with its niches, garlands, and curls of bronze (on furniture) or stucco (on walls), was simply called "new."

PSYCHE

Lemoyne's *Apotheosis of Hercules* accorded well with the scope of the gallery and the ostentatious tone set by Charles Lebrun. It would henceforth

be superseded by the *Story of Psyche* on overdoor panels and the vaults of ceilings. Thus, artist Charles-Joseph Natoire turned to that subject when decorating the oval salon of the Hôtel de Soubise in Paris between 1737 and 1739. The eighteenth century was perhaps placed under the sign of Psyche. In 1777, Johan Tobias Sergel sculpted *Cupid and Psyche,* while in 1793, Canova completed *Psyche Revived by Cupid's Kiss.*

The only ancient author to recount the story of Psyche was Apuleius. Psyche's beauty was such that men from everywhere came to gaze upon her, adore her, and worship her as though she were immortal. She was so venerated that temples dedicated to Venus were neglected, and the ashes on altars went cold. Furious, Venus ordered Cupid to put an end to the situation by arranging for Psyche to fall in love with the vilest creature on earth. But Cupid was overwhelmed when he saw Psyche's beauty and refused to obey Venus. Time passed. Psyche remained alone, sad, solitary. For a long time she did not realize that the invisible lover who came to her every night was Cupid himself. After numerous vagaries, the gods assembled and finally allowed Psyche to marry Cupid and become immortal.

Not unlike Psyche, the eighteenth century seemed to confuse sensuality with an ideal it was seeking. It accorded love a supreme role even as it sought to experience "the most interesting definitions of love, that highly ordinary word" (according to Félicia, a character in a licentious novel by André-Robert Andréa de Nerciat). The century itself aspired to embark on a *Pilgrimage to the Island of Cythera,* as painted by Jean-Antoine Watteau for his diploma piece at the Academy of Painting; submitted on August 28, 1717, Watteau's painting launched the fashion for *fêtes galantes,* or "scenes of flirtatious parties." The king of France himself joined in—the young Louis XV posed for a portrait dressed as a pilgrim to Cythera.

THE ART OF CONVERSATION

The eighteenth century's parties began in salons. The count of Ségur asserted that salons were "brilliant schools of civilization." As Abbé Morellet pointed ed out, "Conversation is the greatest school for the mind, not only because it enriches the mind with knowledge that would otherwise be difficult to

acquire from other sources, but because it renders the mind more vigorous, more accurate, more penetrating, more profound."

One paradox, however, is that all these salons perhaps constituted just one single salon. The members of this sole salon were never dispersed by the ruptures and rivalries between the likes of Madame du Deffand and Mademoiselle de Lespinasse. They could continue to meet, day after day, in the salon of either Duchess Le Maine or Marchioness Lambert. Even Madame de Tencin herself could not prevent the amazing fauna of her "menagerie"—the term was her own—from performing their tricks in other people's homes.

Another paradox: although this "salon" was, above all, Parisian (having decided, at the time of the Regency, to settle in Paris rather than remaining at Versailles), it embraced all of Europe. Europeans from everywhere met and conversed there. Marmontel asserted that Madame Geoffrin had managed "to make her home famous throughout Europe." Baron d'Holbach's salon, meanwhile, was soon dubbed "the café of Europe" by an Italian gentleman.

As Voltaire noted in a letter of 1767, "An immense republic of cultured minds is forming in Europe. Enlightenment is spreading on all sides." This republic was nurtured, decade after decade, in the salons. An increasing number of citizens of that republic adopted Montesquieu's values: "If I knew something that was useful to me but harmful to my family, I would banish it from my mind. If I knew something that could be useful to my family but not to my country, I would seek to forget it. If I knew something useful to my country but harmful to Europe and the human race, I would look upon it as a crime."

A SINGULAR CONVERGENCE

The improvised dialogue of conversation became a model for the other arts, which seemed to "fall into tune" with conversation (the tuning fork was invented in 1711).

By 1709, the posthumous concertos of Bolognese composer Giuseppe Torelli, which hinted at a dialogue between soloist and orchestra, served as example for Antonio Vivaldi, himself imitated by Johann Sebastian Bach. Concertos by Arcangelo Corelli, published in 1714, systematically alternated *soli* and *tutti* passages, establishing a dialogue that became a model

Johannes Zick,
*The Feast of
the Gods,* 1750.
Prince Bishop's
Palace, Würzburg,
Germany.

throughout Europe. The same Corelli precipitated another fashion, that of the trio sonata. He was one of the first to refer to these sonatas as *da camera*—"chamber"—to avoid any confusion with music *da chiesa*—"for the church." Thus was chamber music born, a music of salons where, from 1760 onward, everyone would play a new instrument called the piano (itself descended from the pianoforte, invented in 1709).

It was also in the eighteenth century that English painting popularized a new genre, the "conversation piece."

Novels represented another type of "conversation." It would be impossible to provide a complete list of the eighteenth century's epistolary novels—letters being another form of conversation—but the list would range from Montesquieu's *Persian Letters* (1721) to Samuel Richardson's *Pamela, or Virtue Rewarded* (1740) to Rousseau's *Julie, or the New Héloise* (1761, reprinted in French seventy-two times by 1800) to Goethe's *Sufferings of Young Werther* (1774) to Laclos's *Liaisons Dangeureuses* (1782).

Following pages:
Jean-Honoré
Fragonard,
The Bolt, 1777.
Musée du Louvre,
Paris, France.

Thus in every register and form of expression, the eighteenth century struck up every possible conversation. And it struck up conversations in a setting

where all the elements of interior decoration seemed to be conversing among themselves: tapestries responded to the moldings around mirrors, which dialogued with the woodwork, stucco work, and gilding. Parisian cabinet makers would soon create the intimate settee that would be dubbed a *causeuse* (chatterer), better known in English as a love seat.

The eighteenth century was one big salon, where no subject was taboo. People talked "seduction, ambition, philosophy"; they discussed everything, because, claimed the count of Ségur, everything "mingled and merged."

THE CENTURY'S CONTRADICTORY CONVERSATIONS

The eighteenth century was perhaps itself a "mingled and merged" century, however singular.

Beyond the terrific movement of the Enlightenment (with all its inquiring skepticism, intellectual feats, and demanding standards), the eighteenth century was a contradictory swirl. This is evident in the various connotations given to the movement. Locally called *Lumières, Auflkärung, Ilustracion, Illuminismo, Oswiecenie* and *Ilustraçoa,* the Enlightenment favored cosmopolitanism here but chauvinism there; in some places it disdained religion, in others urged piety; here it supported the establishment, there it tried to bring it down.

This century first donned the elegant, rococo garb of the baroque, then fell in love with the Orient—every Orient, from Turkey to China. It also rediscovered the grandeur of Rome and advocated a neoclassicism imbued with Roman rigor and virtue. And it discovered Greece. (These apparently unimpeachable ancient models nevertheless prompted Beaumarchais to ask in 1767: "Of what concern to me, a peaceful subject of an eighteenth-century monarchy, are the revolutions of Athens and Rome? What veritable interest can I take in the death of a tyrant in the Peloponnesus, or in the sacrifice of a young princess in Aulis?") At this very moment, when Rome and Italy were inducing connoisseurs to make the ritualistic Grand Tour, the Gothic style was coming back into fashion.

Here and there, painting and sculpture were being commissioned to extol "national" fame in a Europe where museums were beginning to open with

collections of items from all over the world, acquired for their beauty or strangeness.

Another contradiction: this era, which sought to place reason above all superstition and tradition, began to exhume ancient legends and tales steeped in murkiness. If necessary, such material was invented; in 1760 the Scotsman James Macpherson published *Fragments of Ancient Poetry Collected in the Highlands,* dubbed *The Works of Ossian,* a hoax that fascinated a Europe that could not have cared less whether the epic it was reading was a forgery or not. With the same enthusiasm, Europe read Daniel Defoe's *Robinson Crusoe,* translated into continental languages as soon as it was published in 1719. Likewise, all of Europe swallowed Swift's 1726 account of *Gulliver's Travels.*

Strange was the century that could read Ossian the way it read the *Encyclopédie.* Strange was the century that agreed with Diderot's 1755 comment, "All this ancient childishness should be trampled underfoot; barriers not erected by reason should be overturned; the arts and sciences should be given the freedom that is so precious to them."

Strange was the century that Edmund Burke, in his 1757 *Philosophical Enquiry into . . . the Sublime and Beautiful,* urged to enjoy a "sensation of pleasurable pain," otherwise called the sublime.

Strange was the century in which Fuseli's ghosts wandered among Piranese's ruins. It was a century of enlightenment marked by publication of the *Encyclopédie* in the 1750s, yet by 1770 it was also a century of *Sturm und Drang* (Storm and Stress) carried away by paeans of nostalgia and passion. This was a century that, in a somewhat different vein, pitted advocates of French music against supporters of Italian music, a dispute labeled the "quarrel of buffoons."

Strange was the century that went from licentious bedsheets so artfully depicted by Boucher to the heroic *Oath of the Horatii* painted by David, strange was the century that went from Watteau's *fêtes galantes* to Blake's anxious apparitions and Faust's diabolic revels (as published by Goethe in 1790).

Strange was the century that endlessly deciphered the waywardness of heart

EUROPE ASSIGNED THE ARTS OF GREEK AND ROMAN ANTIQUITY
A NEW ROLE VIA NEOCLASSICISM, SPURRING A REACTION FROM
GOETHE AND THE ROMANTIC "STORM AND STRESS" MOVEMENT.

Opposite: Jacques-Louis David, *The Oath of the Horatii,* 1784. Musée du Louvre, Paris, France.
Above: Henry Fuseli, *The Oath of the Rütli,* 1779. Kunsthaus, Zurich, Switzerland.

and mind even as it plumbed the depths of virtue's lapses, from Marivaud's refined affectation to Sade's refined torture. In such a century, nature might adopt the form of arbitrary, pastoral rocaille work, or an asymmetrical landscape garden, or the amazing and alarming theater of the sublime. This kind of century-long conversation between forms that echoed, contradicted, or rejected one another, between forms that fashion adopted and dropped by turns, respected no strict chronology.

ROCOCO AND EXOTICISM

Europe had been fascinated by the Orient ever since the crusades (when it conquered, then lost, Jerusalem), ever since it read Marco Polo's account of his travels, ever since the East India companies starting unloading spices, silks, and porcelain at European ports. A visit made by Suleyman Aga to France between November 1669 and May 1670 triggered an enduring European rage for all things Turkish. By October 1670 all of Paris society knew what was meant by *mamamouchi* (Grand Panjandrum) even though that honorary title invented by Molière had nothing whatsoever to do with the Turkish tongue. The fashion for Turkey enabled Racine to set his 1672 *Bazajet* in "Constantinople, otherwise known as Byzantium, in the seraglio of the Great Lord." Racine's tragedy was based on the tale of an event that occurred in 1637, as recounted to the playwright by the count of Crécy. The play was published with the following apology: "The distance of the country in some way compensates for the nearness in time. . . ."

The French translation of *A Thousand and One Nights*, published in 1707 by Antoine Galland, gave new life to that fashion. Variations on the theme soon appeared in the form of *A Thousand and One Days*, *A Thousand and One Hours*, *A Thousand and One Quarter-Hours*, *A Thousand and One Fiddlesticks*, etc.

Formal features imported from the Orient—or Orients—accorded well with this new style. Also known as the modern style, this mode favored elegance, lightness, gaiety. Voltaire's *Mondain* (Socialite) asserted:

> This secular age suits my manner well.
>
> I like all that is languid and lavish,

every pleasure and art you might wish.

All is tasteful, clean, ornamental.

[*Ce temps profane est tout fait pour mes moeurs.*

J'aime le luxe, et même la mollesse,

tous les plaisirs, les arts de toute espèce,

La propreté, le goût, les ornements.]

Such ornamentation was designed to create the setting for a lifestyle free from all formality. It inaugurated a dialogue of gracefulness and privacy. It inaugurated an era when apartments were furnished with settees accompanied by cushions known as "ottomans." It inaugurated a period when good taste—henceforth a topic of conversation—was honed by sensations and feelings as well as discernment.

Good taste inevitably fell into raptures over the fabrics, lacquers, and porcelain brought back by Europe's various East India companies. It inevitably succumbed to the charm of rivers and gardens depicted on Chinese scrolls and papers. Beauvais was the first tapestry workshop to produce a "Chinese wall hanging," and it soon commissioned painter François Boucher to draw mandarins and pagodas for the cartoons for other tapestries.

All of Europe became infatuated with *chinoiseries* of this kind. And Europe itself began supplying the porcelain—from Meissen in Saxony to Sèvres near Paris via Lunéville in Lorraine—made fashionable by the likes of Madame de Pompadour.

Europe's trajectory of discovery occurred in several stages, from the Chinese Monkey Room in the Hôtel Rohan-Strasbourg in Paris to the Chinese Room designed in the 1760s by Luke Lightfoot for Claydon House in Buckinghamshire to the Chinese Palace on the grounds of Sans Souci in Potsdam, not to mention the pagoda built at Kew Gardens outside London, Queen Maria-Amalia's porcelain room, and the Portici Palace in Naples (imitated in the salon of another royal palace in Aranjuez, Spain). China was everywhere: a Chinese figurine can be seen behind the servant setting a coffee pot on the mantelpiece of the bourgeois apartment where Boucher painted a *Breakfast* scene in 1739. In 1742, the same Boucher placed a screen with Japanese motifs behind the servant in *Lady Tying her Garter.*

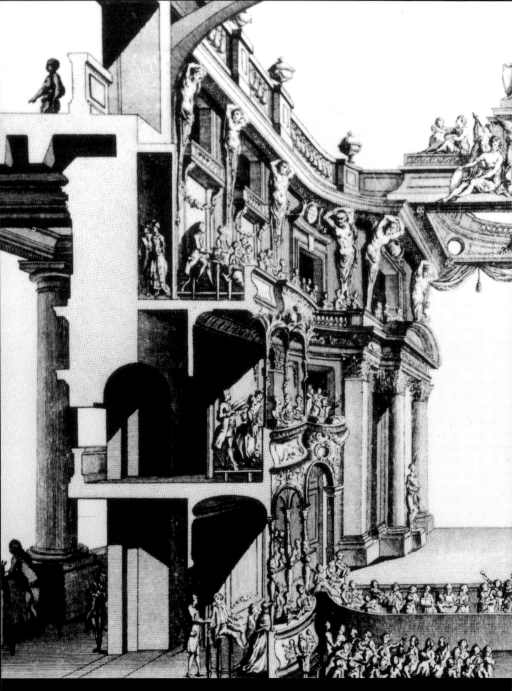

THE 18TH CENTURY SEEMED TO BE ONE VAST, ELEGANT PARTY
OPEN TO INTELLIGENCE, LICENTIOUSNESS, AND INSOUCIANCE
IN THE FORM OF SALON CONVERSATION, OPERAS, MUSIC AND PLAYS.

Above: Philippe de la Guepiere, *Cross Section of the New Opera House in Stuttgart.* Plate from *L'Encyclopédie* edited by Diderot and D'Alembert, 1751–1781. Kunst & Geschichte Archives, Berlin, Germany.
Opposite: Jean-Antoine Watteau, *Mezzetino with Guitar,* 18th century. Musée des Beaux-Arts, Alençon, France.

Around 1743, meanwhile, Gianantonio Guardi painted the *Garden of a Turkish Seraglio*, probably modeled on paintings by Jean-Baptiste van Mour, who accompanied the French ambassador to Constantinople in 1699—a collection of engravings of Van Mour's paintings, published in 1712 under the title "Various Nations of the Levant," was an enormous hit. It is even possible that this anthology influenced Montesquieu's 1721 publication of *Persian Letters*. The Orient—all these Orients—remained long in fashion. In 1732, Voltaire presented his tragedy *Zaïre*, set in Palestine; fifty years later, on July 16, 1783, the Burgtheater in Vienna premiered Mozart's *Die Entfürung aus dem Serail* (Abduction from the Seraglio), prompting a certain Christoph Friedrich Bretzner to proclaim loudly that "someone named Mozart has profaned my play."

From Flirt to Virtue

On August 28, 1717, Watteau presented *Pilgrimage to the Island of Cythera* as his diploma piece for the Academy of Painting in Paris. Painting thereby summoned the new century to a *fête galante;* whereas David's *Oath of the Horatii,* exhibited at the Salon of 1785, addressed a moral lesson to the waning century.

Yet it would be inaccurate to say that the eighteenth century began licentiously and ended morally. The century's clocks were not all running at the same pace. Twin movements traversed the age and its art: one renounced licentious pleasures and returned to a virtue modeled on what it thought Rome and Greece had offered, while the other abandoned the charms of flirtation in order to indulge in the power of whimsy and fairy tale.

In 1771, Jean Honoré Fragonard painted a series of four canvases for Countess du Barry's pavilion in Louveciennes; titled *The Progress of Love,* the series included *The Meeting, The Pursuit, Love Letters,* and *The Lover Crowned.* Less than ten years later, Fuseli would be inspired by the magical metamorphosis of Shakespeare's characters in *A Midsummer's Night Dream.* The lovers painted by Fragonard had their eyes open, like Cupid gazing at Psyche; although they may not have been completely wide-eyed, at least they knew they were guided by good taste. But everything changed

Jean-Baptiste-
Simeon Chardin,
*Basket of
Strawberries,*
1760–1761.
Private collection.

when Fuseli illustrated Shakespeare's comedy. One of Shakespeare's characters, Helena, expressed love's lack of judgment with the words, "Nor hath Love's mind of any judgment taste."

The flirtatious scenes depicted by Watteau early in the eighteenth century indicated a new social role for painting. Although the court was still a key patron, it was no longer an artist's only client. A different, crucial role was being played by the connoisseurs and collectors seen, for example, in Watteau's painting of an art dealer's shop, *L'Enseigne de Gersaint* (one customer in the painting turns away from a portrait of Louis XIV being consigned to a chest). The Academy of Painting itself was aware of this development, since it created the *fête galante* genre in order to accept Watteau; the genre corresponded to none of those already catalogued and fixed in a rigid hierarchy. In a singular "coincidence," the Academy agreed to loosen its hierarchy of genres at the very moment the French court was rejecting the fastidious protocol that studiously dictated, for

CHINOISERIES AND ORIENTAL MOTIFS WERE FASHIONABLE IN ENGLISH SUMMERHOUSES,
PRUSSIAN PALACES AND PARISIAN TOWN HOUSES. INFATUATION WITH EXOTICISM
THUS INSPIRED THE "PLEASURE HOUSES" BUILT DURING THE CENTURY OF REASON.

Above: View of Lake, Temple of Victory and Pagoda at Kew, 1774.
Opposite: Tea House, grounds of Sans-Souci, Postdam, Germany.

instance, that royal grandchildren ranked above princes of the blood yet enjoyed fewer privileges than royal children. . . .

At the same time, mythology was no longer just an excuse for depicting nudes. Nudity ceased to be the prerogative of goddesses and nymphs. Diana at her bath or Leda embracing a swan were no longer needed as alibis. Nudes could be licentious, even pornographic. The door being excitedly bolted by a young man in a painting by Fragonard clearly belongs to a Parisian household, not to the halls of Mount Olympus or some palace. Mythology had been abandoned—except for a lament on the order of, "O modesty, how weak you are when Venus and Bacchus together do battle with you!"

Middle-class homes were also the setting for genre scenes painted by William Hogarth. *Marriage à la Mode,* like *The Rake's Progress,* was a series of canvases that functioned as a sermon or fable that concluded with a moral (the rake, for instance, ends up in an asylum). Like Hogarth, Gaspare Traversi in Naples and Cornelis Troost in Amsterdam used satire in their genre scenes. Another type of sermonizing could be seen in the work of Jean-Baptiste Greuze, as in *The Father's Curse* (also known as *The Ungrateful Son*), 1777, a pendant to his *Punished Son,* 1778. No morality is to be found, however, in genre scenes by Giuseppe Maria Crespi, who showed everyday reality in a Venice where the aristocracy rubbed elbows with the middle classes and the poor.

Nor was there any sermonizing or storytelling in Jean-Baptiste-Siméon Chardin's *Morning Toilet, Saying Grace,* and *Working Mother.* Nothing is recounted; the silence of Chardin's painting was not aimed at the court but rather at people who considered themselves to be connoisseurs. Such people regularly attended the Salon, that is to say the public showing of work by members of the Academy, held in the Salon of the Louvre from 1735 onward. (Even when the exhibition forsook the Louvre and moved to venues such as the Palais de l'Industrie, it continued to be called the "Salon.") The exhibition generally opened on the feast day of Saint Louis; in the years just before the French monarch was swept away by revolution, some 60,000 people attended the Salon annually, which means that one out

Louis Joseph Watteau, *Festivities at the Coliseum,* 18th century. Musée des Beaux-Arts, Lille, France.

of every ten Parisians went to see the works on show. It had swiftly become the crucial art event in France, imitated by the rest of Europe. In London, the Society of Artists (which later became the Royal Academy) was organizing similar shows by 1760. Until 1746, the Parisian Salon prompted only brief accounts in the press, but starting in 1747, art reviews became a literary genre, inspired by articles by Denis Diderot, editor of the *Encyclopédie.*

THE GRAND GENRE

"History and myth must serve as subject; great deeds must be depicted as an historian would do; pleasant topics recounted as a poet would." There was no question of reaching the "highest attainments of art" unless a painter tackled one of the subjects which constituted the "grand genre" of history painting, a requirement laid down by Félibien des Avaux in his preface to the 1667 anthology of lectures given at the Academy of Painting founded by Louis XIV. Few people challenged this assertion, but William Hogarth was

Following pages: Michel Barthelemy Ollivier, *Mozart Playing for the Prince de Conti,* 1766. Musée du Château, Versailles, France.

one of them. In 1753, Hogarth published his *Analysis of Beauty*, which insisted that a curved line was more likely to yield beauty than an angular one; yet rather than a new treatise on painting, Hogarth's text was really a manifesto that not only rejected the influence of old masters and academic convention but also challenged the relevance of foreign artistic models.

Similarly, the count of Angiviller, who became superintendent of buildings to French king Louis XIV in 1774, intended to favor commissions that featured "national" themes. He thereby commissioned Nicolas-Guy Brenet in 1777 to paint patriotic subjects such as *Honors Paid to Connétable Du Guesclin by the City of Randon* and *The Death of Du Guesclin*, followed in 1783 by *The Courtesy of the Chevalier Bayard*. In England, meanwhile, John Singleton Copley created a sensation in 1785 when he exhibited *Charles I Demanding in the House of Commons the Five Impeached Members* [in 1641]. Thus, within a matter of years, in both France and England, events from national history were chosen to restore the "grand genre" of history painting to its preeminent place. A comment by German art historian and archaeologist Johann Winckelmann may have had a decisive impact—he noted that "Augustus had the portico of the Forum lined with statues of [Rome's] great men, who had made the nation glorious." Winckelmann's *History of Ancient Art* urged Europe to rediscover antiquity once again even as, at the same time, in another one of the era's many contradictions, it encouraged nations to invent their own imagery.

The eighteenth century's rediscovery of antiquity led to a further ambivalence. Around 1780, Fuseli painted a canvas showing himself and Johann Jakob Bodmer flanking a bust of Homer. Bodmer had suggested that Fuseli look to ancient literature for its use of the marvelous and awesome; enlightenment about antiquity therefore led to shadowy depths. This strange misconception of antiquity spurred an awareness of nation and glory that spawned nationalism, it favored a neoclassicism that sparked agitated dreams. Such dreams were already the realm of Blake and would be adopted by Goya.

The rehabilitation of the "grand genre," which led Angiviller in 1779 to commission François-André Vincent to paint *The Parlementarian Molé*

Being Arrested during the Fronde Rebellion, also had a civic purpose: to exemplify virtue. The same ambition spurred Louis XVI to commission twenty-four statues of *Great Men* men who earned immortal fame were to stand as examples for the nation. When he commissioned these works, Louis XVI was still unaware that "the nation" would soon decide it could do without him. He probably still believed that David's *Oath of the Horatii,* commissioned by his own superintendent, Angiviller, was a symbol of the nobility's loyalty to its king.

PARIS, CAPITAL OF EUROPE

Louis XIV's "grand century"—the seventeenth—imposed the French language on all of Europe. This occurred not only due to the publication of scholarly works and literature but also to the dispersion of Huguenots who fled France after the 1685 revocation of the Edict of Nantes. Paris had become the capital of Europe thanks to its academies, its manufactories, its observatory, and its botanical gardens.

Paris was also the capital of luxury as well as the capital of fashion to such an extent that a joke made the rounds of Europe: a painter, commissioned to depict every nation in its national dress, decided to show France naked, scissors in hand, surrounded by fabrics of all kinds. How else could you depict a nation that changes fashion so often?

Paris therefore dictated everything, or almost everything. It was hardly surprising that the new art called "modern style" was soon adopted all across Europe. In yet another paradox of this eighteenth century, some of the most important furniture makers working in Paris, such as Riesener, Oeben, Carlin, and Weisweiler, were of German stock. Their furniture found its way into every European court, whether ordered directly or received as a diplomatic gift. At the same time, anthologies of decoration were being printed and sold throughout Europe; French royal manufactories such as the Gobelins tapestry works were supplying weavers to courts like that of Maximilian II Emanuel in Munich. In 1713, the French weaver Pierre Mercier, who had already set up a tapestry workshop in Berlin, left it to his nephew to set up a new looms in Dresden. In 1717, it was once again

Venice continued to fascinate Europe even after it was no longer a commercial or artistic capital. The reputation of its courtesans and its carnival —which lasted a mere six months—made it a mandatory halt on the Grand Tour.

Opposite: Giambattista Tiepolo, *Young Lady in a Tricorn Hat*, 1755–1760. Samuel Kress Collection.
Above: Canaletto, *Saint Mark's Square in Venice*, 1723. Collection Thyssen-Bornemisza, Madrid, Spain.

French weavers who were hired by Peter the Great of Russia, on a visit to Gobelins, to open a tapestry workshop in Saint Petersburg.

MIGRANT CAREERS

Throughout the eighteenth century, artists—whether painters, architects, weavers, or sculptors—traveled constantly across Europe. The continent became one vast studio, where influences in all spheres overlapped and interbred. These steady migrations can only be sketchily suggested by the numerous dates—perhaps too numerous—that follow.

1707: Andreas Schlüter installed his equestrian statue of Great Elector Friedrich-Willem I in front of Charlottenburg Castle in Berlin. He had completed his training as a sculptor in Warsaw and had studied architecture in France and Italy. Schlüter ended his career in Russia, in the service of Peter the Great. Sculptors from the Netherlands were hired in Bavaria, while Italian artists were summoned to Saxony. In 1744, Carlo Rastrelli erected a statue of Peter the Great in Saint Petersburg. In 1768, Jacques-François Saly installed the equestrian statue of Frederick V in Copenhagen, while Pierre-Hubert Larchevêque executed that of Gustav IV Adolf in Stockholm in 1791.

1712: The elegance of his painting, derived from late seventeenth-century Italian pictorial values, earned Sebastiano Ricci a summons to London, where he stayed for four years. Another Venetian, Giovanni Antonio Pellegrini, had already arrived there a few years earlier and had begun to decorate aristocratic homes. Pellegrini left London in 1713 and migrated to several cities in Germany, then onto Paris in 1720, Vienna in 1727, and Mannheim in 1736 (where he painted four palatial ceilings).

1717: King John V of Portugal ordered construction of a monastery and palace at Mafra and hired architect Johann Friedrich Ludwig, originally from Hall in Swabia, who had first studied the goldsmith's trade in Augsburg, then worked for the Jesuits in Rome, and then went on to Lisbon (where be became known as João Frederico Ludovice). Around the same time, a certain Giovanni Carlo Galli da Bibiena built the royal theater in Lisbon. Other members of the Galli da Bibiena family, such as Giuseppe and

Antonio, impressed clients in Paris, London, the Hague, Saint Petersburg, Dresden, Mantua, Bologna, Nancy, and Berlin; everywhere new Italian-style theaters—where the invention of *scena per angolo* provided multiple vanishing points—delighted opera audiences.

1720: Rosalba Carriera, from Venice, conquered Paris with her pastel portraiture and was admitted to the French Academy of Fine Arts. Her pastels became fashionable in Modena, Florence, Dresden, and Vienna, where she was summoned by clients who tried to retain her. The Italian painter Jacopo Amigoni worked at Schleissheim and Nymphenburg in Bavaria and later at the court of Spain. Carlo Carlone painted at Ludwigsburg and Ansbach as well as at Schloss Brühl and Augustusburg. Canaletto left Venice twice to work in London.

1734: French architect François de Cuvilliés began building Amalienburg, a pavilion for Maria-Amalia on the grounds of Nymphenburg near Munich.

1739: When work began on a Catholic church at the court of Dresden, it was Roman architect Gaetano Chiaveri, who had already worked in Saint Petersburg and Warsaw, who was commissioned to build it.

1761: Accompanied by his sons Giandomenico and Lorenzo, Giambattista Tiepolo moved to Madrid in order to decorate Charles III's new royal palace. The fame Tiepolo had earned back in 1728 for his frescoes in the archbishop's palace at Udine had led him to Milan, where in 1731 he executed a *Story of Scipio* on a ceiling in the Palazzo Dugnani-Casati. Then back in Venice, he produced numerous works for the church of Santa Maria dei Gesuati, the Scuola del Carmine, the Palazzo Labia, and so on. Tiepolo was then summoned in 1750 by the prince-bishop of Würzburg to paint the ceilings of the Kaisersaal and the grand staircase of the residence.

1778: Wolfgang Amadeus Mozart, who was just twenty-two, returned to Paris for the second time, where he met Johann Christian Bach, son of Johann Sebastian Bach (who had died at Leipzig in 1750). Mozart had already met Johann Christian in London in 1764 and both had been students of Padre Martini in Bologna. Bach, born in Leipzig, was composer to the King's Theater in London, where he presented operas "in the Italian style." Perhaps Mozart and Bach discussed the concerts Mozart had given,

Following pages:
Piranesi, *View of Campo Vaccino,* 1775.

231

aged eight, during his first stay in Paris for the prince de Conti, to whom he had been introduced by the harpsichordist Johann Schobert from Silesia, whose sonatas and trios Mozart never forgot.

1780: Swiss artist Johann Heinrich Füssli, from Zurich, was in London translating books by, among others, the art historian Winckelmann. Henceforth known as Henry Fuseli, he was about to embark for Rome, where he would remain until 1778, discovering the "awesome power"—or *terribilità*—of Michelangelo's art.

1782: Scottish architect Charles Cameron was commissioned by Catherine the Great of Russia to build a residence in Pavlovsk for her son, Grand Duke Paul. Around the same time, Italian architect Giacomo Quarenghi built what was called the English Palace at Peterhof, plus the State Bank at Saint Petersburg. In Madrid, meanwhile, the royal palace was being completed by Italian architect Giovanni Sacchetti.

1787: Johann Heinrich Wilhelm Tischbein painted *Goethe in the Campagna,* having accompanied the German poet through Italy on his trip to Rome and Naples. Tischbein had already worked in Holland and Germany.

These migrations by artists often required them to pursue their careers under altered names. Dutch painter Gaspard van Wittel became known as Vanvitelli after he moved permanently to Italy in 1674; the Catalonian artist Hyacinthe Rigau y Ros became Hyacinthe Rigaud once established in Paris; Fuseli had been born Füssli in Zurich in 1741, and so on.

THE GRAND TOUR

Not only artists went on the Grand Tour to Italy, however. It became a social ritual, with the aim of refining the taste and knowledge expected of every gentleman. Those who undertook the trip had plenty of reading to take along, such as Jonathan Richardon's 1772 *Account of the Statues, Bas Reliefs, Drawings and Pictures in Italy, etc.*

Also useful was the 1750 publication of a guide to the collections of the Museo Capitolino, the first of its kind. Although Rome was a mandatory stop on the Grand Tour, Rome was no longer found solely in Rome; it was not the artists working there that people came to meet, it was the ruins and museums

they came to see. New ones were opening all the time: in 1734, Clement XI founded the Museo Capitolino; in 1756, the Museo Sacro in the Vatican Library opened its doors; in 1771, the new Pio-Clementino museum was named after Popes Clement XIV and Pius VI.

In 1768, Sir Gregory Turner posed for Pompeo Batoni. Heavy baroque drapery behind him is pulled aside to reveal Roman ruins. Eight years earlier, it was Charles John Crowle who posed for Batoni in front of the usual column and casts or scale models of ancient works such as the *Farnese Hercules* and the *Sleeping Ariadne* at the Vatican. Around 1777–1779, Sir Joshua Reynolds did several portraits of the Society of Dilettanti, a club of art lovers and connoisseurs whose very name was a fashionable mixture of English and Italian; in one Reynolds painting, some members study a vase, others admire gems. But could they be certain of the authenticity of the works they were examining? That was another question. According to a traveler of the day, "At Rome there are clandestine sculpture studios, where workers produce only arms broken at the elbow, heads of gods, feet of satyrs, and torsos that never belonged to anyone. A liquor has been invented which, when poured over marble, gives it an antique coloring. Here and there in the countryside are goatherds who take their flocks to pasture near ruins, then await the foreigners; they then tell them of the wonderful finds made every day, just by digging a few feet under ground. The English, above all, fall victim to these hoaxes; they give money to the goatherds who are stationed there by manufacturers of artificial ruins and who always know exactly where to dig. They first pretend to weary themselves in fruitless search but, after much sweat, finally strike the precious lode. The foreigners then pay up. England is full of six-month-old antiquities."

This racket did not prevent Johann Zoffany from gathering a few "connoisseurs" for a group portrait in the library of Charles Towneley on Park Street, London, in 1781 or 1783, the same friends he had painted back in 1772 in *The Tribuna of the Uffizi* in Florence. Everywhere men in powdered wigs were discussing the exemplary nature of the ancient works around them. All these portraits ultimately represent a similar kind of meditation

Jacques Sablet's 1791 *Roman Elegy* is another sign of the fascinated yet melancholy contemplation spurred by the rediscovery of antiquity.

In 1738, excavation began at the buried ruins of Herculaneum, discovered twenty years earlier. Pompeii's turn came in 1748. This "resurrection" gave new impetus to the ritualistic Grand Tour. The founding back in 1666 of the French Academy in Rome by Louis XIV was initially designed to enable young artists to complete their education in the Eternal City. Copies of sculptures by some of those artists were placed in the grounds of Versailles, just as their paintings were hung in royal galleries and apartments.

SOUVENIRS AND VEDUTE

People on the Grand Tour found they could not resist purchasing prints that depicted the splendors of Rome. They found it hard not to buy the likes of Vasi's *Magnificenze di Roma* or Piranesi's *Vedute di Roma*.

It was in Venice that the aristocracy on the Grand Tour had acquired a taste for *vedute,* or "views" of a city or town. A taste for views was perhaps not all they acquired, however; Charles de Brosses, who had just arrived in Venice, wrote to one of his friends on August 14, 1739, that "there is no place on earth where liberty and license reign more sovereignly than here."

Vedute were above all Venetian, even when they began to be painted in Rome. *Vedute* constituted a new genre, and were not just "incidental" landscapes. They were above all depictions of Venice with its squares, palaces, and canals. They were depictions of a unique city, which, by the eighteenth century, was no longer one of Europe's great ports yet had become a theater whose carnival occupied the stage for nearly six months a year. Following Vanvitelli (the Dutchman van Wittel who moved to Italy in 1674) and Luca Carlevaris (who, in 1703, had published a series of 104 prints of *Le Fabbriche e vedute di Venezia*), painters such as Guardi, Belloto, and Canaletto executed canvases that travelers bought as souvenirs. During the same period, Italian painters developed a variant of *vedute* called *capricci* (caprices), which combined the authentic architecture of *vedute* with imaginary ruins or landscapes. Artists such as Giovanni Paolo Panini and Hubert Robert owed their fame to *capricci*.

Portrait of Johann Joachim Winckelmann, copy of an Anton Maron's painting, 1768. Staatgalerie Moritzburg, Halle, Germany.

NEOCLASSICISM

Anyone who chose to go on the Grand Tour had to read certain books that became standard texts as soon as they were published. These included *Reflections on the Painting and Sculpture of the Greeks,* published in German by the "papal commissioner of antiquities," Winckelmann, in 1755 (soon translated throughout Europe). Then there was Julien-David Leroy's 1758 book *Les Ruines de Plus Beaux Monuments de la Grèce,* followed several years later by *Antiquities of Athens,* published between 1762 and 1787 by James Stuart and Nicholas Revett. These publications revealed the scope of Greek antiquity (last described back in 1676), thereby stimulating intense debate. There suddenly seemed to be a divide between authors who favored Rome's grandeur, vaunted by Piranese's *Carceri d'invenzione* (printed in 1745), and those who, liked Winckelmann and Marc-Antoine Laugié (author of an influential essay on architecture), preferred Greek naturalness and simplicity.

The English aristocracy wanted its new dwellings to be like Roman villas. Syon House, built in Isleworth in 1762 by Robert Adam is a perfect expression of that desire. And Palladio's antique-inspired buildings became another favorite model for English architecture, Inigo Jones and Christopher Wren having already established a kind of tradition. In London, Lord Burlington and William Kent's variation on Palladio's Villa Rotonda became Chiswick House. Meanwhile, in the English countryside, manors took on Palladian overtones. It was as though the English gentry, attached to its land and estates (which still provided its main source of income) was adopting the habits of the Venetian aristocracy, which, starting in the sixteenth century, had launched the *villegiatura* lifestyle—a country house that combined charm, casualness, and refinement.

A CENTURY OF LANDSCAPE GARDENS?

The broken column that François Barbier placed on the grounds of the "Desert of Retz" north of Paris was a vestige of *capricci.* Ruins were a crucial model for the pavilions and constructions called "follies," erected on estate grounds. The Pantheon in Rome inspired one of the buildings that

Robert Hubert included in a painting supposedly showing the port of Rome. The Pantheon was also used as model for a folly in Stourhead gardens in Wiltshire—gardens that were among the first to be styled "landscape gardens," soon known abroad as "English gardens." Such gardens signaled the end of the rigid alignment of pools, flowerbeds, and lanes associated with the "formal gardens" that had prevailed in Europe. Landscape gardens, spanning England, France, and Prussia, constituted a special maze, which wandered, via numerous detours, from the Gothic temple built in 1741 on the grounds of Stowe in Buckinghamshire to the *naumachia* (naval pond) built in the 1770s in the gardens of the duke of Chartres in Paris to the Chanteloup pagoda that the duke of Choiseul had built on his property not far from Amboise. While others were erecting ruins, Palladio-like bridges, and Chinese pagodas, Richard Payne Knight was beginning to build Downton Castle in Wales, a residence topped by Gothic towers and ramparts. At the same time, Horace Walpole built his strange manor, Strawberry Hill, in Twickenham between 1749 and 1755.

Nature was henceforth crafted into matchless promenades through meadows and clearings, past ponds to streams. This nature, so deliberately irregular, led to Elysian Fields, to a Paradise Lost, toward Arcadia. Paradoxically, the gardens at Stourhead evoked Virgil's *Aeneid* through landscapes modeled on Claude Lorrain's paintings; what a strange circuit—a French painter, nicknamed the "Lorrainer" when he lived in Rome, provided inspiration for English-style landscape gardens.

Europe refused to listen to the warning of Abbé Delisle when he composed an "art of embellishing landscape" in 1782:

Banish from gardens that wretched collection
Of sundry stones that fashion seeks:
Rotundas, obelisks, pagodas, kiosks
By Romans, Arabs, Chinamen, Greeks.
So pointless an architectural chaos
whose sterile abundance merely imprisons
the four ends of the earth in our gardens.
[*Banissez des jardins tout cet amas confus*

Johann Heinrich
Wilhelm Tischbein,
*Goethe in the
Campagna,*
1786–1787.
Städelsches
Kunstinstitut,
Frankfurt,
Germany.

D'édifices divers prodigués par la mode
Obélisque, rotonde et kioskes et pagodes
Ces bâtiments romains, grecs, arabes, chinois,
Chaos d'architecture et sans but et sans choix,
Dont la profusion stérilement féconde
Enferme en un jardin les quatre parts du monde.]

These gardens dotted with follies—gardens where antique, Turkish, and
Gothic forms merged; gardens where lanes, waterfalls, and grottos traced
a new "Map of Affection"; gardens where flirtatious meetings might take
place before a Temple of Virtue, a pyramid, or a glorious obelisk; gardens
where the "four ends of the earth" came together reflected the will of a

century determined to miss out on nothing. These gardens are perhaps a metaphor for the eighteenth century's sunset just as salons were a metaphor for its dawning.

THE CENTURY'S CLOSE

In 1799, the French were not concerned—as they had been in 1699— whether the new century would commence in 1800 or 1801. They were all the less concerned since as a revolutionary decree of 1793 had inaugurated a new calendar dividing the months into three weeks of ten days: Primdi, Duodi, Tridi, etc. Months were renamed according to the season, and the new year began in the autumn, with the harvest. Furthermore,

the new calendar commenced on September 22, 1792, the day the French Republic was declared, and that year was henceforth known as "Year I of the Republican Era." So how could the nineteenth century begin in Year VIII or IX?

The history of art—the history of dreams and the forms they take, the history of styles—once again ignored all calendars. Whether Christian or Republican, calendars changed nothing. Nor did the terrific upheaval in Europe triggered by the French Revolution in 1789 upset styles: the virtuous rigor of Roman-inspired neoclassicism was still in fashion. It even accorded with the dreams of Ossian, that forerunner of Romanticism. All of Europe repeated this line from the *Songs of Selma:* "Let the light of Ossian's soul arise!" (Diderot himself translated Ossian's poems into French, while Goethe translated them into German in 1771).

Romanticism did not seem to engender a new style right away. That was because the term "romantic" was initially associated only with nature. Europe long respected the definition established by Jean-Jacques Rousseau in his *Reveries of the Solitary Walker:* "The shores of the Lake of Bienne are wilder and more romantic than those of Lake Geneva, since the rocks and woods come closer to the water. . . ."

This usage prompted the Académie Française to define the term in the following way in its dictionary of 1798: "Normally used of places and landscapes that remind the imagination of poetic and novelistic descriptions. A new word derived from the English term *romantic,* used only for places, landscape, etc." It was only in 1810 that Madame de Staël reported that "the word *romantic* has been newly introduced in Germany to designate poetry that originated in the songs of troubadours, poetry born of chivalry and Christianity." Twenty years later, Victor Hugo would assert that "romanticism, so often poorly defined, is merely—and this is its true definition—liberalism in literature."

But the "artistic liberty" demanded by Hugo had not been on the agenda in the years of revolution and Empire that swept Europe. Neoclassicism helped the French Revolution to express its ambitions and glorify its martyrs. The Empire adopted classical forms that placed art at the service of the

regime. (The "Egyptian fashion," a new rage following Napoleon Bonaparte's campaign in Egypt—which triggered a lasting European infatuation—was ultimately nothing more than a variation on the old passion for things Oriental. After all, the "Egyptian room," commissioned by Prince Borghese for his Roman villa in 1782, had already served as a model for the rest of Europe; meanwhile, Egyptomania was kept alive well into the next century by the digging of a canal across the isthmus of Suez, inaugurated by Empress Eugénie in 1869.)

Architects Charles Percier and Pierre-François Fontaine, who organized Napoleon's coronation ceremony at Notre-Dame in Paris, placed statues of Charlemagne and Clovis in the niches of the portico erected in front of the cathedral. The emperor, crowned on December 2, 1804, was thereby presented as heir to the Carolingian and Merovingian dynasties. A painting of *Bonaparte Visiting Plague Victims in Jaffa,* completed that same year of 1804 by Antoine-Jean Gros, offered more proof of the emperor's legitimacy insofar as he laid his hands on soldiers stricken by the 1799 epidemic in Syria in the same way that kings traditionally laid hands on sufferers of scrofula on coronation day. Additional legitimacy—Roman, this time—was provided by the cloak worn by Napoleon in David's painting of the event as well as in a portrait that the legislature commissioned from Ingres: it was the royal purple worn by Roman consuls.

When architect Pierre Vignon transformed the proposed church of La Madeleine in Paris into a temple of glory dedicated to the soldiers of the French Empire, that temple could be nothing other than Roman, because Paris was to be seen as a new Rome (similarly, in Place Vendôme, Jacques Gondouin and Jean-Baptiste Lepère erected a column similar to Trajan's). It was this Napoleonic Rome (which considered the real Rome as just a provincial capital) that the rest of Europe opposed militarily. It was in reaction to an empire so classical—or, if you prefer, neoclassical—that romanticism aroused nationalist feelings.

The eighteenth century was by turns rabble-rousing and fearful, licentious to excess and virtuous to the point of terror.

It expected reason to spark storms as well as to yield enlightenment.

243

It only gave way to the nineteenth century once Napoleon had been defeated. And, paradoxically, the period associated with Napoleon—from his crossing of the Saint-Bernard Pass to his sad, grim fate at Waterloo—would continue to obsess the Romantic era. That was perhaps because Napoleon's epic merged with that of Ossian, with the combat of Fingal, king of Morven. In the chateau at Malmaison, a painting by Gérard, *Ossian Evoking Phantoms*, serves as pendant to Girodet's *Ossian and the French Generals*.

Above: Charles-Nicolas Ledoux,
Perspective View of Mme Thelusson's Residence,
from *L'Architecture* by M. Fouquier, 18th century, Paris.
Opposite: Jean-Auguste-Dominique Ingres,
Napoleon I as Consul, 1804. Musée des Beaux-Arts, Liège, Belgium.

THE PEOPLE, ECLECTICISM, PRIMITIVISM

A NEW PLAYER: THE PEOPLE

"We the people" entered the European scene during the French Revolution, playing a new role in nineteenth-century imaginations. History no longer belonged solely to heroes. Peasants, workers, and the proletariat—a word that assumed its fundamentally political dimension with the 1847 publication of *The Communist Manifesto* by Marx and Engels—compelled recognition of a social reality that had been previously ignored (exceptions being the peasants depicted either in books of hours such as *Les Très Riches Heures* or on canvas by the Le Nain brothers).

None of the men facing a Napoleonic firing squad by the light of a lantern on May 3, 1808, were named in Goya's 1814 painting of the uprising in the Moncloa neighborhood of Madrid. The man in the white shirt, spreading his arms like a crucified Christ, represents the Spanish people rejecting the oppressive empire, or antichrist.

Opposite:
Francisco Goya, *The Third of May, 1808*, 1814. Prado, Madrid, Spain.

Following pages:
Left: Giuseppe Pelizza da Volpedo, *The Fourth Estate*, 1901, Pinocoteca di Brera, Milan, Italy.
Right: Eugène Delacroix, *Liberty Guiding the People*, (detail), 1830. Musée du Louvre, Paris, France.

None of the men on the corpse-littered barricade were named in Delacroix's painting of the July revolution that toppled French King Charles X in 1830. It is the people who are guided by Liberty, herself shown bare breasted like the Christian personification of Charity. As Delacroix said at the time, "Although I didn't fight for my country, at least I could paint for it." The French soldiers, workers, and burghers who overthrew the Bourbon monarchy were fighting for the concept of democracy (some of them even hoped to establish a republic, which eventually occurred after another revolution eighteen years later). Since the turn of the nineteenth century, the men depicted by Goya and Delacroix had become players in a society that had itself become the

protagonist of novels. All of society was being described via the characters in Balzac's *Human Comedy,* Dickens's *David Copperfield,* and Gorky's *Lower Depths.*

The full range of nineteenth-century art—from novels to paintings and from opera to sculpture—reveals the two key concerns then weighing on "the people's" mind: national identity and social fate. Nineteenth-century art constitutes a journal of battles against oppression, of struggles for national independence, universal suffrage, free trade unions, and freedom of the press.

The battle to establish emerging nation-states led to a revival of ancient legends throughout Europe, unearthing and glorifying various forms of popular art. In Poland, for instance, the need to fire the people's imagination inspired not only Mickiewiecz's literary epic *Pan Tadeusz* (Mylord Thaddeus, 1834) and Sienkiewicz's novelistic *Pan Wolodyjowksi* (Mr. Wolodyjowski, 1888), but also Chopin's musical *Polonaises.*

The novels of Sir Walter Scott—whose death in 1832 sounded the death knell of Romanticism—were exemplary insofar as his historic tales dared to turn fishermen, beggars, and shopkeepers into characters who were no longer confined to supporting roles. Scott wove his stories around what he confessed was half-invented history; these legends and collective memories lent greater reality to Scottish consciousness. Reservations expressed by the likes of Chateaubriand, who accused Scott of "perverting novels and history" did not prevent him from influencing (and winning praise from) writers such as Balzac and Hugo in France; Andersen in Denmark; Goethe in Germany; Manzoni in Italy; and Pushkin, Gogol, and Tolstoy in Russia.

History and Anonymity

Strangely, the anonymous figures who paraded through the century were not associated with a single, unique style. Characters of common folk could be found in romantic epics as well as in naturalistic or realistic novels and accounts, and they also served as models for paintings that were totally disparate in style.

Georges Seurat,
Bathers, Asnières,
1883–1884. Tate
Gallery, London,
Great Britain.

For example, the anonymous shipwrecked sailors and colonists depicted in Géricault's *Raft of the Medusa,* exhibited in the Salon of 1819, are academic and even classical, whereas Delacroix's *Massacre at Chios,* executed in 1823 and 1824, is a romantic painting of the Greek people's terrible struggle for independence. The mourning peasants standing at the edge of the open grave in Courbet's 1849 *Burial at Ornans,* meanwhile, are realist in style.

The employees, laborers, apprentices, and shopgirls picnicking on Sundays along the Seine and the Marne rivers were rendered impressionistically on Renoir's canvases of 1881. But the people painted by Seurat in 1883 and 1884, shown bathing at Asnières opposite chimney-topped factories, reflected scientific impressionism insofar as they respected what Signac called "the laws of contrast, the methodical separation of elements—light, shadow, local color, reactions—in their accurate proportions and balance." The sowers on the plain of La Crau painted by Van Gogh in 1888 were already post-impressionist, while Gauguin's harvesters, shown by the sea in 1890, represented examples of synthetism. Yet the subject was always "the people." Whatever the scene depicted,

the people were always the leading players. The insurgents executed in May 1808 (painted by Goya) and the Greeks massacred at Chios (painted by Delacroix) belonged to history—through their struggle, the people were now making History with a capital H.

SUBJECT AS BUGBEAR

Political authorities, however, were a long way from agreeing that history was made by the people alone. The execution depicted by Goya was long relegated to the storeroom before it was hung in an obscure gallery of the Prado (and it was only added to the museum catalogue in 1872). Similarly, Delacroix's *Liberty Guiding the People* was not publicly exhibited for years—bought by King Louis-Philippe in 1831, it hung in the Luxembourg Museum for a few months and was then returned to Delacroix (only entering the Louvre in 1874). Some people were frightened by "the people."

In a strange coincidence, depictions of the people and their history provoked artistic scandals year after year.

Delacroix later wrote, "I think it was after the *Massacre at Chios* that the academy began to look upon me as a subject of aversion and a kind of bugbear." The academy would have to deal with one "bugbear" after another.

When he began painting *Liberty,* Delacroix noted, "I have begun a modern subject, a barricade." His choice of a modern subject rejected history as it had been conceived for centuries by the official genre of history painting. Thirty years later, a painter such as Frédéric Bazille could still complain: "If I'd painted Greeks and Romans, I'd been doing fine now—we're still at that stage."

Modern subjects provoked anger and contempt from authorities and art connoisseurs as well as from the critics whom Gauguin envisioned "arrayed in a quarantine line around the nation's museums." Yet, as Pissarro pointed out, "novelty doesn't lie in the subject, but in the way it is expressed." Subject matter wove a thin thread through the various styles.

Jacques Réattu,
*The Triumph
of Civilization,*
1795. Kunsthalle,
Hamburg, Germany.

253

THE CASE OF INGRES

The oeuvre of J.A.D. Ingres reveals, as few other nineteenth-century oeuvres do, the ambivalent and complex relationship between subject and style.

There is no doubt that Ingres's 1808 *Oedipus and the Sphinx* is classical in style. Ingres was therefore a classic artist. He remained one in 1813 when he painted *The Dream of Ossian,* even though Ossian's vision in a dream of his dead son, Oscar, was one of the sources of romantic imagination. Such imagination in no way altered Ingres's style, as classical in 1813 as it was in 1808.

His 1814 *Grande Odalisque,* meanwhile, featured a concubine with Turkish-style accessories—turban, pipe, fly-swatter—yet this orientalism did not induce Ingres to adopt a rococo style. In 1821 he painted *Ceremonial Entrance into Paris by the Dauphin, the Future Charles V.* This history subject did not turn Ingres into a troubadour painter (the term *troubadourisme* was used dismissively in France in the 1820s to show disdain for the rage for everything medieval).

Meanwhile, Ingres signed his *Apotheosis of Homer* in 1827 with the words *INGRES PINGbat* on the stone on which Poussin is shown leaning; Ingres deliberately decided to conjugate the Latin verb *pingere*—"to paint"—in the imperfect past (*pingebat*), because Pliny had mentioned that Apelles, the only painter Alexander the Great permitted to do his portrait, used the imperfect tense. Furthermore, Ingres placed this signature just below Poussin's elbow, and Poussin is pointing toward Apelles, who stands next to Raphael. The position of this signature and these painters constituted a manifesto and a mark of fidelity: from Ingres to Poussin, from Poussin to Raphael, and from Raphael to Apelles, an entire genealogy of painting was being presented by Ingres—namely, the tradition of a classicism to which Europe continually returned, century after century.

As far as Ingres was concerned, there could be no question of breaking with that tradition. Thus he could handle subjects which were romantic, orientalist, or troubadour without altering his style. He was and would

remain "classic." Ingres's rigor was the sign of his conscientiousness; a conscientiousness that considered itself the repository of an ideal unaffected by the passing of time. He felt he was heir to an artistic conscientiousness based on draftsmanship. Ingres claimed that "art's integrity lies in draftsmanship." Classicism, neoclassicism, and academicism all displayed this integrity in turn, in recognition of the fact that Europe's first academy, founded by Vasari in 1563, was called the *Accademia delle arti del disegno,* the "Academy of the Arts of Drawing."

ROMANTIC FEVER

Romanticism replaced this integrity with color. Or rather, colors—colors and movement. As opposed to the contours of draftsmanship, it was color and movement that lent form to romanticism. Similarly, the romantic spirit of movement nudged symphonic music toward the symphonic poem, just as it loosened the regular caesuras of Alexandrine verse with enjambments and run-on lines.

Around 1795, artist Jacques Réattu completed *The Triumph of Civilization,* a canvas designed to show that the French Revolution's military campaigns in Europe were primarily campaigns against obscurantism. The figure of France, crowned with laurels and protected by Hercules (who puts a hand on her shoulder), welcomes the cities drawn toward her light. The figure of Learning, seated near France, brings together Poetry, Music, and Sculpture as well as Mathematics and Astronomy. At France's feet is Darkness, drawing a dark veil over his face, while vices are thrust into deep shadow. Réattu's painting, in its own way, brought to a close the eighteenth century, which had been certain it would bequeath Enlightenment to the next century. Yet it was from the shadows that the nineteenth century drew new sources and new strength of imagination.

Classicism's certainties had already been under challenge for half a century. Back in 1751, Raphael's *School of Athens* served as model for Reynold's *Parody of the School of Athens,* in which conceited "connoisseurs" were shown in a Gothic setting (no one, however, was assigned the roles of Plato and Aristotle). The ideal represented by Raphael was no

ARCHITECTURE'S NEW MATERIALS AND TECHNIQUES
COULD BE SEEN IN FUNCTIONAL PUBLIC BUILDINGS,
WHILE A CLASSICAL APPROACH WAS STILL USED TO CONVEY PRESTIGE AND POWER.

Opposite: Joseph Paxton, *Crystal Palace in London.* Musée F. Blandin, Nevers, France.
Above: Grand salon, Napoleon III's apartments. Musée du Louvre, Paris, France.

longer considered valid—but where was art headed once such a landmark was removed?

THE SUBLIME

That vacuum was soon filled by the quest for the sublime. For Fuseli, writing in 1771, the sublime could also reside in evil, since even the impious could have something admirable about it. He cited as example the speech with which Satan greeted hell after his fall in the first book of Milton's *Paradise Lost:* "Hail horrors, hail Infernal world, and thou profoundest Hell."

This quest for the sublime conjured up infernal creatures. A procession of such creatures haunted the romantic imagination, like the saraband of appalled, frightened, and grotesque figures seen in Goya's darker paintings, like all those witches and gnomes. It was a threatening universe of horrors and disasters. *Dante and Virgil,* painted by Delacroix in 1822, crossed into hell. Mephistopheles enticed Faust to attend the witches' sabbath known as Walpurgisnacht on Mount Blocksberg. Wagner's *Ring Cycle* ended apocalyptically with *The Twilight of the Gods* (the full cycle was performed together for the first time from August 13 to 17, 1876, at the Festspielhous in Bayreuth). For the librettos of his operas, Wagner called upon the epic German poem of the *Niebelungenlied* and upon *Edda,* an anthology of twelfth-century Scandinavian songs.

Ancient legends were being revived throughout Europe, as were characters from Ossian's poems. The metamorphoses of Greek and Roman mythology gave way to the fantastic imagery of ancient epics. Imaginations were nourished on Scandinavian, Icelandic, and Germanic sagas, on the tales of King Arthur and the knights of the Round Table. Poems, ballads, and epics were part of an awakening of national consciousness everywhere. Everywhere, plays recounted episodes from national history. In Spain, Angel de Saavedra, duke of Rivas, pioneered historical drama with his *Don Alvaro or the Power of Fate.* Models suggested by the likes of Shakespeare, Lope de Vega, and Calderón de la Barca spurred Heinrich von Kleist to pen *The Prince of Homburg* and

Francisco Goya,
*Saturn Devouring
his Children,*
1821–1823.
Prado, Madrid.

THE WHIRLWIND OF TURNER'S INDISTINCT SHAPES AND THE TRENCHANT CHAOS
OF FRIEDRICH'S CANVASES BOTH DEPICTED A POWERFUL NATURE BEYOND MAN'S GRASP
—THIS WAS THE POWER THAT CAPTIVATED THE ROMANTIC SOUL.

Opposite: William Turner, *Snowstorm (Steam Boat off a Harbor's Mouth),* 1842. Tate Gallery, London, Great Britain.
Above: Caspar David Friedrich, *Mer de Glace,* 1823–1824. Kunsthalle, Hamburg, Germany.

Pushkin to write *Boris Godunov*. Meanwhile, the music that Mussorgsky composed for Pushkin's play in 1869 was designed to be quintessentially Russian. Composers throughout Europe, from Liszt to Brahms and from Smetana to Sibelius, turned to the special features of their own nation's folk melodies and rhythms, evoking local dances, songs, and popular motifs.

THE POWER OF POETRY

As an expression of national spirit, romanticism—in the words of German poet Novalis—dealt with "a world made dreamlike, a dream made world." In order to convey this transmutation, romanticism was obliged to transgress the rules followed by traditional genres. It did so in order to express a reality that could be grotesque and sublime, spiritual and vulgar, fantastic and authentic. Poets were the first to express this complexity. Visionary and prophetic, poets became demiurges. They passionately voiced the key feeling known in German as *sehnsucht* (yearning), an ardent desire to know the world, to achieve absolute plenitude, to recover an irreparably lost paradise. A poet had to be heroic in order to fully experience this feeling in which idealism wrestled with fatalism. All poets agreed with Wordsworth that poetry was "the spontaneous overflow of powerful feelings." And all poets felt they were addressing feelings shared by everyone. Victor Hugo warned his readers—"Ah! Foolish the reader who thinks I am not you!" Shelley's 1820 poem *Prometheus Unbound* exemplifies the challenge taken up by poets, the fate they assumed. As exceptional beings, they accepted the risk of an intense life of revolt, they ran the risk of despair and violent death. That was the cost of being prophets in their own times: Byron died on the battlefield, Pushkin was killed in a duel, Kleist and Nerval committed suicide, Poe and Hölderlin were victims of alcoholism and madness.

THE RIDDLE OF NATURE

"The contemplation of nature is the most general and highest form of religion," argued Friedrich Schleiermacher.

In 1802, the painter Philipp Otto Runge noted that "abstractions are collapsing, everything has become lighter, airier, everything tends toward landscape. People seek something determinate amid this lack of determination, yet they don't know how to achieve it." He went on to ask, "Isn't there thus, in this new art which we might call landscapism, a summit to reach? One that might be more beautiful than the last?"

Rousseau's novel *Julie, or the New Héloise,* read throughout Europe, made everyone look at nature in a new way. Many painters recalled the observations made by Saint-Preux, one of the novel's characters: "The spectacle [of nature] has an indefinable hint of magic and the supernatural, which delights the mind and senses; one forgets everything, one forgets oneself, one no longer knows where one is." The cause of Saint-Preux's heady impression was soon defined by theorists such as Burke and Schiller: "The sensation of the Sublime is a mixed sensation. It is a composition of painful emotions, which, in their ultimate degree, produce a frisson of horror and joy that can reach the heights of rapture." This "sublime" was pictured in paintings such as Turner's terrifying *Fall of an Avalanche in the Grisons* (1810) and Caspar David Friedrich's looming glacier, *Mer de Glace* (1823–1824).

Ruins, those remnants of an irrevocably lost past, might also trigger a "delightful horror" leading to the sublime. In 1809 and 1810, Friedrich painted *Abbey in an Oak Forest,* in which a ruin—its broken wall pierced with Gothic windows—rises amid tombs and twisted tree trunks. Friedrich explained that "the days of the magnificence of the church and its servants are over. The ruins of this site give birth to another period and another desire for truth and clarity." In 1835, Constable took up an earlier drawing in order to execute a painting of the ruins of Stonehenge, which he captioned as follows: "The mysterious monument of Stonehenge, standing remote on a bare and boundless heath, as much unconnected with the events of past ages as it is with the uses of the present, carries you back beyond all historical recall into the obscurity of a totally unknown period." Yet Friedrich and Constable did not give similar form to their reciprocal, anxious meditations on time. Friedrich's images

LANDSCAPE BECAME *THE* SUBJECT WHICH ALLOWED PAINTERS TO CHALLENGE
ACADEMIC CONVENTIONS. MOVEMENTS FROM ROMANTICISM TO FAUVISM EXPLOITED LANDSCAPE,
MORE THAN ANY OTHER GENRE, TO DEVELOP THEIR FREEDOM AND NEW ARTISTIC CRITERIA.

Opposite: Paul Cézanne, *On the Grounds of Château Noir,* 1900. Musée de l'Orangerie, Paris, France.
Above: Paul Serusier, *The Talisman,* 1888. Musée d'Orsay, Paris, France.

were modeled by light and shadow, whereas Constable's skies were forged from slashing brushstrokes that left scars of color. Friedrich asserted that "an artist's feeling is law," and Constable agreed that painting was "synonymous" with feeling. They shared the same certainties: both knew that painters henceforth had to confront nature alone, both knew that nature no longer had anything to do with "historic landscapes." In 1817, France inaugurated a new Prix de Rome specifically for the genre labeled "historic landscape." Although it was Pierre-Henri de Valenciennes's somewhat austere landscapes which inspired the new prize, it was, paradoxically, the studies he painted in Italy—the play of light on hills, a section of wall or a series of roofs—that inspired younger painters to abandon the genre painting which Jules and Edmond de Goncourt ridiculed as "a composed, traditional site with its heroic parsley of foliage and its monumental, age-old tree (cedar or beech) inevitably sheltering some crime or mythological tryst."

LIGHT AND PLOW

Light assumed a leading role in the paintings of Camille Corot, who, in 1825, left France for Italy, where he stayed for three years. His modest gaze focused primarily on the sparkle of a white-washed window, or the stiff trunk of a cypress, or the darker, inclined curves of umbrella pines standing against the sky, or all those peeling yet shimmering ochre façades.

It was not the light of Italy that inspired Théodore Rousseau, whom Baudelaire called the "absolute antithesis" of Corot; to lend reality to a landscape, Rousseau turned instead to Dutch painting of the seventeenth century, notably the canvases of Ruysdael and Hobbema. From romanticism, Rousseau took the storms and setting suns of his skies. However, he nevertheless rejected those styles in 1848, once he joined other painters already working in Barbizon. A year later the group was also joined by Jean-François Millet. The humble sowers and gleaners painted by such artists permanently ousted historical and mythological characters as painting became more naturalistic and realistic. These visual records of

Claude Monet, *Houses of Parliament, London*, 1905. Musée Marmottan, Paris, France.

the labor of peasants already suggested nostalgia for a world that was no longer solely agricultural.

LIGHT AND SUBURBS

Factory chimneys were beginning to rise on the suburban fringes of cities. They rose among the landscapes that Monet painted at Argenteuil. They rose behind Manet's boat-cum-studio, painted in 1874. Nature was becoming the setting for rural picnics by urban workers. This natural setting, forsaken for city and suburbs yet reachable by railroad, can be seen in *Young Ladies on the Banks of the Seine,* depicted by Courbet in 1856. The same type of women were painted by Monet and Renoir at La Grenouillère. Their sons and daughters may even have been the figures who posed in 1881 for Renoir's *Luncheon of the Boating Party.* The subjects painted by Renoir, Monet, and Pissarro could still be described as naturalist or realist, so if art critic Louis Leroy dubbed them impressionist in 1874 intending contempt and mockery when borrowing the term from

ULTIMATELY, THE TWIN POLES OF THE 19TH CENTURY'S (MALE) VISION OF WOMANHOOD
ARE REPRESENTED BY A DROWNED OPHELIA AND A BRAZEN OLYMPIA.
WOMAN COULD BE VIRGIN AND VICTIM, OR SHE COULD BE LOOSE AND CYNICAL.

Above: John Everett Millais, *Ophelia,* 1852. Tate Gallery, London, Great Britain.
Opposite: Edouard Manet, *Olympia,* 1863. Musée d'Orsay, Paris, France.

London Train Station, 1860. Engraving.

Monet's painting titled *Impression, Sunrise*—that was because their canvases suggested that painting itself had become more important than any subject.

There was nothing theoretical about these impressionists assertions, as clearly illustrated by a comment by Renoir. "The truth is that, in painting as in other arts, there is no single procedure, however minor it may be, that can be usefully elevated into a rule. In painting there is something that can't be explained, which is its core. If you come to nature with theories, nature will fling them to the ground." Although no impressionist espoused a theory, all of them wanted to "create light through color." According to Emile Zola, "what they all shared was a similar vision. They saw nature unclouded, without the sienna earths and bitumen glazes used

by the romantic painters." Once again, the label "impressionist"—applied to painters whose works challenged tired academic certainties—was a misunderstanding. As Courbet had pointed out earlier: "The label 'realist' was pinned to me the way the label 'romantic' was pinned to the men of 1830. At no period have labels provided an accurate idea of things; were it otherwise, the works themselves would be superfluous."

The last joint impressionist show took place in Paris in 1886. Pissarro insisted that it include a painting by Georges Seurat, *Sunday Afternoon on the Island of La Grande Jatte.* In Seurat's opinion, Pissarro—over thirty years his senior—was one of those he called "romantic impressionists." It mattered not a whit that the subject of the Sunday river outing presented by Seurat in the year 1886 might still pass for a naturalistic or

realistic one. Seurat was confident in what he was doing, confident he had just invented the "chromoluminist" technique.

THE SCIENCE OF COLOR

Although "chromoluminism," the term invented by Seurat himself, was later supplanted by the labels "neo-impressionism" and "pointillism," it perhaps represented the first major intrusion of science into the history of painting since the development of perspective. Pissarro, convinced of the relevance of Seurat's theory, explained its two fundamental goals in a letter to art dealer Durand-Ruel: "To seek a modern synthesis via scientifically based methods, which are based on M. Chevreul's *Théorie des Couleurs* and on experiments by Maxwell and measurements by N. O. Rood. To replace the blending of pigments by optical blending—in other words, to divide colors into their constituent elements. Because optical blending produces much more intense luminosity than the blending of pigments."

Seurat's scientific reading included not only Chevreul's 1839 book on the "simultaneous contrast of colors," but also research by Maxwell, Dove, Rood, and an essay by Hubert de Superville on "unconditional signs in art." Seurat was the first person to attempt to apply scientific laws to painting. In a century that considered itself to be an era of progress—at a time when Jules Verne described how new means of transportation could enable Phineas Fogg to win a bet by traveling around the world in eighty days—there was no longer any doubt that science could make a contribution to art.

Seurat's scientific bent represented a sharp break with the early nineteenth-century spirituality of artist Philipp Otto Runge's *Farbenkugel* (color sphere).

Composed of triangles of primary colors (red, yellow, and blue) and complementary colors (green, violet, and orange) Runge's sphere alluded to the Trinity even as it established poles for the "real" and the "ideal," which were linked by concepts of masculine passion and feminine passion. This sphere bore similarities to medieval cosmography and was perhaps a

Gustav Klimt, *The Beethoven Frieze,* 1902. Österreische Galerie, Vienna, Austria.

272

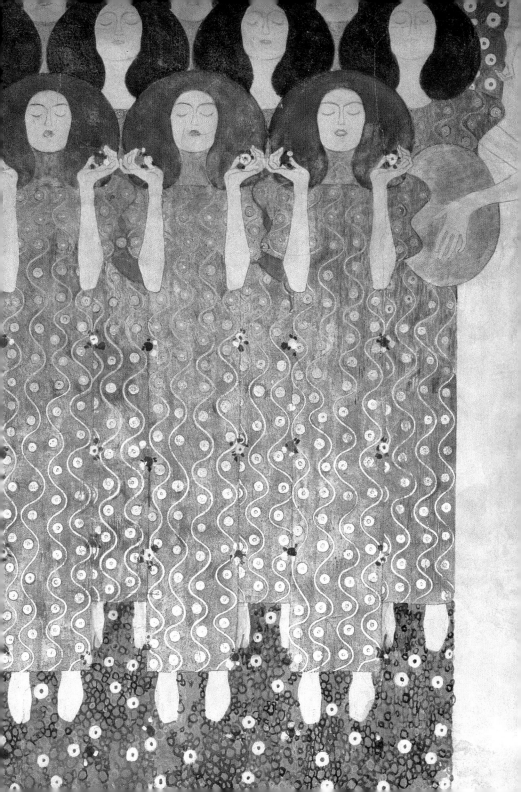

contributing element to Goethe's own theory of color, published in 1806. Yet Seurat was not interested in either Runge's infinite color sphere (which implied a mystical experience of the world) or Goethe's circle (which associated the color purple with "the Beautiful"). Prior to Seurat's scientific and artistic resolve, the century's inventions and advances had provided painting with little more than new techniques—which does not mean that such techniques were insignificant. Renoir reported, "What allowed us to paint completely from nature were easily transportable colors in tubes. Without colors in tubes, [there would have been] no Cézanne, no Monet, no Sisley, no Pissarro, none of what the journalists would call impressionism." In June 1841, the London firm G. Rowney & Co. announced that it was going to market painters' colors in squeezable tubes, as invented by an American painter named J. G. Rand. The development of "color in tubes" precisely fulfilled the requirements of painters who wanted to work in the open air, "from life." Paint in tubes did not invent impressionism, but it provided artists with a tool crucial to meeting the challenge of making light itself a model, of revealing its subtle nuances through color—something that photography seems never to have managed.

PHOTOGRAPHY

On January 7, 1830, François Arago presented a fascinating invention to the French Academy of Sciences. "In a word, in Monsieur Daguerre's camera, light itself reproduces the shapes and proportions of exterior objects with almost mathematical precision; the photometric relationships of the various white, black, and gray parts are preserved exactly; but red, yellow, green, etc., are represented by halftones, because this method creates drawings rather than colored paintings." Photography met with instant success. Daguerre's own brochure on the history and technique of "daguerreotype and diorama"—which sought to minimize the contribution of Nicéphore Niépce—was reprinted thirty-two times in the space of eighteenth months and was translated into six languages. Daguerreotype studios opened throughout Paris. Baudelaire commented that

Gustave Moreau,
Dalila,
watercolor,
19th century.

"Loathsome society is rushing, Narcissus-like, to contemplate its vulgar image on metal." A statistical study of 1849 established that 100,000 people had already "had a portrait done." André Adolphe Eugène Disdéri achieved fame and fortune by inventing small-format portrait photographs called *cartes-de-visite*. The same fashion in London was dubbed "cardomania." Photography created an alarmed stir in painters' studios, where portraiture had long been an artist's bread-and-butter.

In 1851, the first photography magazine, *La Lumière,* was published. In that same year of 1851 the Heliographic Society was founded in Paris to "encourage the perfection of photography," and one of its founding members was painter Eugène Delacroix. Photographs had made their way into Delacroix's studio—evicting live models—because they could hold poses without getting cramps. Delacroix did not share the fear felt by other artists such as Paul Delaroche, who realized that photography had stolen the other arts' exclusive claim to imitation, and thereupon declared: "From today, painting is dead." Nor did Delacroix share the contempt expressed by people such as Ingres. Ingres initially admitted that "photography is very beautiful . . . very beautiful, indeed, but don't tell anyone!" By 1862, however, Ingres signed a manifesto in which "the undersigned artists protest against any assimilation that might be made between photography and art." A Paris appeals court issued a cautious reply in a decision arguing that "photographic drawings should not necessarily, in every case, be considered as totally devoid of artistic character."

Even as the "fine arts" were being dispossessed of a role they had held for centuries—that of imitation—they were being dispossessed of their role in recording history. Men in battle—during the Crimean War of 1854–1856—were photographed for the first time. And everything became a subject for photography, from the pyramids of Egypt to the American West.

The threat that certain painters thought they perceived in photography was of no concern to a Parisian grouped called La Société Anonyme des Artistes Peintres, Sculpteurs, et Graveurs. After the official Salon had

Nicéphore Niepce,
The Set Table,
1822.

refused their work in 1874, they were offered exhibition premises by a photographer called Nadar, in his former workshop on 35 Boulevard des Capucines in Paris. The members of the group included Monet, Pissarro, Renoir, Cézanne, Berthe Morisot, and so on. Among all the sarcasm and ridicule heaped on these "impressionists," one lone voice was raised in the April 25 issue of *La République Française.* The anonymous article ended with the following words: "This is a young battalion that will make a breakthrough. It has already conquered—and this is the point—people who like painting for itself."

Painting had more to fear from the development of lithography than from the arrival of photography. Invented by Aloys Senefelder in 1798, lithography was quicker and cheaper than engraving and therefore accompanied the rise of illustrated books and press. Lithography enabled Delacroix to publish his vision of Goethe's *Faust;* it allowed Daumier to denounce, graphically, the violence of the July monarchy and the

Following pages:
Paul Gauguin,
*Jacob Wrestling
with the Angel,*
1888. National
Gallery of Scotland,
Edinburgh,
Great Britain.

complacency of the bourgeoisie; it enabled caricature to become a weapon of political struggle in a press that was fighting for its freedom everywhere in Europe.

NAPOLEON III STYLE

It was for London's Universal Exhibition of 1851 that the nineteenth century erected its first "Temples of Progress" in the form of vast halls for the display of industrial machine tools and their products. Six million visitors headed for the twenty acres of the London Exhibition, which featured an immense hall of glass and iron called the Crystal Palace. This extraordinary assemblage of iron pillars and beams allowed the possibility of disassembly, making it all the more fascinating.

In 1855, Paris outdid the technical exploit of the Crystal Palace via the Palais de l'Industrie, built on the Champs-Elysées. This exhibition hall, in the form of a gigantic Palladian basilica, was endowed with a façade inspired by the Belvedere in Rome; industry wanted to adorn itself with the glamour of culture even as it demonstrated the feats it could accomplish. London went one better again, in 1868, with the Saint Pancras train station, whose seventy-three-meter span of glass and iron long remained the vastest in the world. (In 1889, France's Third Republic celebrated the centenary of the French Revolution with a splash, hosting a Universal Exposition in Paris for which the Eiffel Tower was erected.) Although it was iron that made such an exploit possible, the façade of Saint Pancras was dressed in conventional Gothic style. On construction sites all over Europe, architecture was sticking similarly hybrid façades over its technical exploits.

During the Second Empire in France, Baron Haussmann launched the largest construction site anywhere: the entire city of Paris was to be remodeled. By annexing surrounding villages, the city grew to twenty *arrondissements.* Buildings in the old center were demolished, broad boulevards were laid out, new parks were created. These construction projects pushed the working class to the outskirts of town and gave rise to middle-class apartment buildings whose façades were ennobled with

Corinthian columns and whose carriage gates were adorned with cary-atids and atlantes. Haussmann's example was soon followed in Vienna (which demolished its ancient ramparts to make way for the Ring) and Brussels (which developed a new downtown center around Place de Brouckére and Place de la Bourse).

Eclecticism became a model everywhere in Paris. At the head of Boulevard Saint-Michel, a monumental fountain designed by Gabriel Davioud imitated the appearance of the Trevi Fountain in Rome; Victor Baltard gave the church of Saint-Augustin an iron dome comparable with the Duomo in Florence, whereas its neo-Gothic façade and sculptures were topped by a more or less classical pediment. The apotheosis of this eclecticism was the Paris Opera House by Charles Garnier. When plans for the Opera House were first presented to Empress Eugénie, she won-dered what name would be given to this new Parisian style. Garnier unhesitatingly answered, "Napoleon III style, your majesty." Such a style—if indeed it was one—seemed like an anthology which combined Louis XIV decoration with Boulle-style furniture, which upholstered sofas and chairs with damasked padding, which used frilly tiebacks on heavy velvet drapes, and which dotted salons with new little chairs of black or gilded wood (called *chiavari,* after the Italian town where they were first made). Napoleon III style was a disparate clutter, almost a garage-sale style.

Sculpting Glory

In 1837, a museum was inaugurated in Versailles, which Louis-Philippe, King of the French, dedicated to "all of France's glories." A few months later, Victor Hugo wrote, "What King Louis-Philippe has done in Versailles is good. He has given a magnificent book called the *History of France* a wonderful binding called [the chateau of] Versailles." Ever since the French Revolution had reinforced the idea of "nation" all across Europe, buildings, parks, and squares everywhere were adorned with sculpture that glorified national figures.

This political priority remained constant throughout the nineteenth

century, from Canova to Rodin. Decade after decade, every style adopted, in its own way, the same goal of transmitting the image of glorious heroes to future generations. David d'Angers relied on "constant study of antiquity" when he sculpted his statue of *Condé* in 1817, whereas Rodin was convinced that "antiquity can't be taught" when he aimed at similar glory with his *Burghers of Calais* (erected in 1895) and his *Balzac* (which shocked the French Writers' Society in 1898).

In the end, "glory" was nineteenth-century sculpture's primary sitter. Perfectly aware of sculpture's power on the imagination, Napoleon—who wanted to avoid "flattering homages and a statue, like that of Louis XIV, exposed to public scorn"—called on Danish sculptor Thorvaldsen and Italian sculptor Canova. His dread of "public scorn" led Napoleon to have Canova's statue of him (as *Mars Unarmed and Peaceful*) placed behind a wall when it arrived in Paris in 1811.

In all the countries of Europe, governments were asserting their legitimacy and the "reality" of their people's national awareness by erecting statues of great men—and great women. Statues of famous Danishwomen adorn the queen's staircase in the palace at Christiansborg, while the queens of France can been seen in the Luxembourg gardens in Paris.

Romantic sculpture sought to achieve the same goal as neoclassic sculpture. François Rude, when sculpting the figure that represented the Spirit of Nationhood for the Arc de Triomphe in Paris, constantly told his model to "shout louder!" Everywhere sculpture was designed to make the voice of the people heard; everywhere it was supposed to acknowledge, as Napoleon put it, "the preeminence of those special people who emerge from time to time in history as shining beacons."

It hardly mattered what form the beacon took. The Albert Memorial (1863–1872) that Queen Victoria erected to her late husband assumed a Gothic form, while the thirty-two sculpted groups that Emperor Willem II set in the Tiergarten in Berlin took neoclassical or academic form.

Auguste Rodin,
Danaïde, 1885.
Marble. Musée
Rodin, Paris, France.

To borrow a phrase used by Alexandre Dumas the Elder, all public monuments erected in nineteenth-century Europe, whether bronze, stone, or marble, were designed to record an exemplary epic "in capital letters."

Statuary turned cities into history books that called citizens to take note of the grandeur of state and nation.

IRON AND ECLECTICISM

Brussels graced itself with a new courthouse, designed by Joseph Poelaert, which was another "anthology" of classical architecture that combined the colonnade of the Louvre in Paris with the dome of Saint Paul's Cathedral in London. The building incarnated government in an urban setting. The same was true of Britain's Houses of Parliament, rebuilt in Westminster between 1840 and 1850; their Gothic style echoed the church of Saint Augustine in Ramsgate, built during the same period. Through such projects, architect Augustus Welby Pugin perhaps wanted convey to Anglican England all the fervor of the Catholic faith to which he had converted in 1835.

His ideas accord with those of Chateaubriand, who wrote in *The Genius of Christianity*, "These vaults chiseled with foliage, these wall-bracing posts that end suddenly like broken tree trunks, these cool vaults, this shadowy sanctuary, these dark wings—everything in Gothic churches emulates a labyrinthine woods, everything evokes religious dread of the woods with its mysteries, its divinity."

Like Pugin, Eugène Viollet-le-Duc, who rebuilt a chateau at Pierrefonds for Napoleon III, reinvented the Middle Ages. Another variation on the theme of the Middle Ages, a restaging of this dream, was the Neuschwanstein castle built for Ludwig II of Bavaria.

It was rare for the use of a relatively new material such as iron to induce architects to invent forms, but Pierre-François-Henri Labrouste managed it with the Sainte-Geneviève Library, built in Paris between 1843 and 1850, as did Victor Baltard when he built the central Market Halls in the French capital between 1845 and 1870.

Through an inability to invent its own style, nineteenth-century architecture always seemed to develop neo-something or other. It covered its palaces with neo-romano-byzantine mosaics and frescoes, it erected neo-antique peristyles, it raised neo-Gothic vaults, and so on.

SCHOOL AND ACADEMY

One of the many sources of stylistic eclecticism in the nineteenth century was probably the Museum of French Monuments, founded by Alexandre Lenoir in 1795 during the turmoil of the French Revolution. The revolution was divesting church and cathedral façades of all their statues of the Old Testament kings (mistaken for kings of France) even as it began tearing down castles and other monuments of the monarchy's disgraced feudal power. When the monastery of the Petits-Augustins—where Lenoir had stored the architectural remnants of revolutionary vandalism—was replaced by a new School of Fine Arts, architect Félix Duban placed fragments from the original museum in the courtyard of the school. Duban was thereby pointing to the past in the courtyard of a school where painter Paul Delaroche decorated the Awards Hall with a mural honoring great artists throughout history. The School of Fine Arts had absolutely no doubt about the values and rules it was supposed to transmit. Its best students would win the Prix de Rome, reestablished in 1798, enabling them to spent a few years in the French Academy in Rome, henceforth housed in the Villa Medici (bought by Napoleon in 1804). On return to Paris, they would become teachers themselves. Finally, in a supreme tribute to a career that illustrated and defended the value of academicism, France's best artists would be elected to the Academy of Fine Arts, one of three elite assemblies making up the Institut de France, restored in 1795. Only professors at the School, the guardians of sacrosanct values, could sit on the jury of the annual Salons.

Teaching at the School was based on two principles. The first concerned drawing, which was, in Charles Blanc's words, "art's male organ." The second concerned subject matter—noble subjects derived from ancient Greek and Roman texts. The fundamental role of drawing was confirmed by Kant in his *Critique of Judgment* (1790): "In painting, in sculpture and other plastic arts, in architecture, and in the art of gardening just as in the fine arts, the main thing is drawing." He felt that "colors which embellish drawing are a lure." A painter like Fuseli shared Kant's conviction, affirming before the Royal Academy in 1802 that color was nothing other

than a debauch of the senses. Such principles brooked no disagreement. Viollet-le-Duc lamented in 1882: "A young artist can enter the School [of Fine Arts] and win medals, but at what cost! On condition of precisely respecting and never deviating from any of the limits imposed by the teaching corps, of submissively following a rut, of having only those ideas approved by the teaching corps, and above all never presuming to have any ideas of his own."

SALON EXHIBITIONS

Despite the rut of conformism and the concern for political and social respectability, nineteenth-century artists managed to invent new idioms. But they could do so only at the cost of struggle and solitude. They could do so only by being bold and sacrilegious.

Gustave Courbet was the first to do so. When his two canvases, *Painter in his Studio* and *Burial at Ornans* were rejected by the selection committee for the Universal Exposition of 1855, Courbet withdrew all his other paintings that had already been accepted. He then exhibited a set of forty canvases in a "Pavilion of Realism," which he erected not far from the Palace of Industry, where the official artworks were displayed. According to Baudelaire, Courbet's act took on "the air of insurrection." Critics were amazed: "A strange school, is it not, which has neither master nor disciple, whose only principles are independence, sincerity, and individualism?"

In Paris, henceforth Europe's capital of art thanks to Haussmann's policies and the Salon des Refusés (where "rejected" artists exhibited), the rejection of academic rules and principles gave birth to a "bohemian" attitude and the myth of the "doomed artist." The *rapins*—work-a-day painters excluded from commissions and honors—looked upon official artists as *pompiers,* that is to say, "firemen"; the term was coined from the similarity between the helmets worn by Parisian firemen and those depicted on Greek and Roman soldiers by all members of the Academy of Fine Arts. Such contempt did not prevent academic artists such as Thomas Couture from painting *The Romans of the Decadence* nor Alexander

Vincent Van Gogh, *Portrait of Old Tanguy*, 1887. Musée Rodin, Paris, France.

Cabanel from producing a *Birth of Venus* that was a slick, polished Salon gold-medal winner.

At the time, the official Salon was the only place where an artist could establish a reputation. Art galleries, which began springing up during the Second Empire (1850–1870), were primarily antique shops; although they exhibited a few contemporary painters, they showed only canvases by artists who had already made a name by winning a Salon medal or prize. What art lover would be so foolhardy as to buy a work dismissed by the Academy of Fine Arts and mocked by critics? In 1863, the jury's selections were so severe that they triggered an outcry, and Napoleon III authorized the opening of a Salon des Refusés. The majority reaction to this new Salon went something like: "Before this show we had trouble imagining what a bad painting looked like; now we know." Yet a few voices, such as Emile Zola's, replied: "It was like an open window in that old kitchen where traditional bitumen glazes were cooked up. . . . Wasn't this the long-awaited dawn, the new day breaking for art?" The most scandalous painting at the Salon des Refusés was Edouard Manet's *Déjeuner sur l'Herbe*. Outraged critics disregarded Manet's declared ambition: "I wanted to redo Giorgione's painting with its transparent atmosphere, with identical figures by the water." Nor could those critics accept "modernity," the depiction of "modern life" that Baudelaire expected of Manet, to whom he wrote on May 11, 1865. "Are you a greater genius than Chateaubriand and Wagner? And yet even they were mocked. It didn't kill them, and, to deflate your pride a little, I'd say that these men were models, each in his field, within a very rich world; while you, you are merely the best within a decrepit art." With this harsh term—"decrepit"—the history of modern painting began.

THE ROLE OF MUSEUMS

With rejects such as Manet and Cézanne, painting evolved *despite* museums yet also *for* museums. It is worth recalling the admission made by Cézanne at the end of his life: "I won't deny that I, too, was an impressionist. But I wanted to make impressionism something solid and lasting,

an art for museums." An art for museums: since the early nineteenth century, museums had begun assembling, for the first time, works previously found only in private collections. One wing of the Prado opened in Madrid in 1819; work on London's British Museum and Berlin's Altes Museum began in 1823; in Munich, the Glyptothek opened in the 1831 and the Alte Pinakothek in 1836.

Museums inaugurated a new relationship to artworks. Like temples, they consecrated the works they held. They inspired new respect—almost religious respect—for all the statues, altarpieces, and paintings taken from churches, as well as for all other artworks of whatever origin. Young artists, for whom regular trips to the museum became an absolute necessity, had no other choice but to rebel or submit. Cézanne began by shouting, "We must burn the Louvre!" Years later, he repented. "To think I once wanted to burn all that. . . . When you don't know, you think those who do know are holding you back. But if, on the contrary, you spend time with them, instead of obstructing you they take you by the hand and kindly lead you along, help you stammer out your own little story." Rare are the artists who summon up enough determination, alone, to manage to "stammer out" their own "little story."

ARTISTIC SOLIDARITY

Right from the start of the nineteenth century, artists felt an intense need to group together. Together they could define new challenges in terms of subject matter, techniques, and resources; they could perhaps sketch a theory or draw up a manifesto. Such solidarity helped ward off difficulties, compensated for lack of money, and healed the wounds provoked by contempt, sarcasm, and—worse—indifference.

In 1809, Johann Friedrich Overbeck and Franz Pforr founded the "brotherhood of Saint Luke" (Lukasbrüderschaft) in Vienna. A year later they were in Rome, living in the monastery of Sant'Isidoro on the Pincio Hill. They were joined by Peter von Cornelius, Wilhelm von Schadow, Julius Schnorr von Carolsfeld, and Philipp Veit, all of whom adopted the ascetic search for a sacred art. With equal firmness, they rejected academic

MING NATURE AND SPRAWLING INDUSTRY, THE "ART NOUVEAU"
MOVEMENT CREATED NEW ART FORMS. ALTHOUGH OF SHORT DURATION,
THIS FIN-DE-SIÈCLE STYLE CONQUERED ALL OF EUROPE.

Above: Antoni Gaudí y Cornet, *Casa Batlo,* 1904–1906. Barcelona, Spain.
Opposite: Charles Rennie Mackintosh, Glasgow Art School, 1897–1899. Scotland, Great Britain.

conventions as well as what Novalis described as Protestantism's "withering of the Holy Spirit." For these artists, both art and religion were divine entities. They adopted Raphael and Dürer as their guides in this mission. Around 1810, Overbeck drew them all kneeling, holding hands before an allegory of the arts. The tender embrace of *Italia and Germania*, painted by Overbeck between 1815 and 1828, is another allegory of a "nostalgia that pulls the North toward the South." The decision by these young German painters to part their hair in the middle—an allusion to Dürer's self-portrait of 1500 in which he gave himself the look of Christ—earned them the nickname "Nazarenes." Their deliberate purification of forms, simplification of composition, and idealization of faces reflected their admiration for primitive artists. The blend of Roman and German qualities in their work led to several Nazarenes being summoned to Munich by Ludwig I of Bavaria, who had met them during his trip to Rome in 1818. In Munich, they painted a patriotic fresco showing the deeds and acts symbolizing the uniqueness of German national awareness (at that time, the Italy they had left and the Germany to which they returned were embryonic countries—the unification of each nation only became a political reality after 1870).

Meanwhile, the painters who gathered around Théodore Rousseau and Jean-François Millet in Barbizon, France, had a shared ambition, namely to depict the daily life of peasants, to depict a nature which was more than just the setting for some heroic deed or mythological tryst. Barbizon, in the forest of Fontainebleau, was the first of a series of rendezvous kept by nineteenth-century painters. Other artists would gather outside Paris, in Honfleur or in Pont-Aven, where one or another of them perceived the "motifs" that corresponded to what they all hoped painting would become.

MOVEMENTS AND MANIFESTOES

One stage led to another, as artistic movements overlapped each other. In the 1840s, Serafino De Tivoli was returning to Italy from Paris, where he had attended the Universal Exposition. He stopped at Barbizon; the

Early film strips, Lumière brothers, 1895. Association des frères Lumière.

landscapes he saw there and described once back in Florence comforted the position of Florentine painters such as Diego Martelli, Giovanni Fattori, Telemaco Signorini, and Silvestro Lega, who met at the Caffè Michelangelo and were known as the "Macchiaioli" (from the Italian *macchia*, "blob" or "patch" [of paint]).

In 1865, Monet induced Frédéric Bazille to come to Chailly-en-Bière (a village located, like Barbizon, on the edge of the forest of Fontainebleau), where "realist" landscape painters were discovering their new light. With that light, Monet painted *Déjeuner sur l'Herbe* out-of-doors, prefiguring the style that critics would later label "impressionist."

In 1874, Monet the impressionist took Manet to paint at Asnières, outside Paris. And it was at Asnières that Seurat would paint the *Bathers* which launched neo-impressionism or pointillism.

It was at Pont-Aven, where he went for the first time in 1886, that Paul Gauguin found the "wild, primitive" setting he need to develop synthetism after having participated in several impressionist shows. Among the painters who joined Gauguin there was Paul Sérusier, who in 1888 painted a spare landscape titled *The Talisman* that would become an emblematic canvas for symbolists and a group called the Nabis.

With strange steadfastness, a quest for primitivism—for various primitivisms that were perhaps totally unrelated—generated new styles throughout the nineteenth century. The Nazarenes wanted to rediscover the "primitive" painters who predated Raphael. Gauguin stayed at Pont-Aven, because he sensed something "primitive" there. The artists who joined Dante Gabriel Rossetti, John Everett Millais, and William Holman Hunt in 1848 dubbed themselves the Pre–Raphaelite Brotherhood, because they were inspired by the innocence of the "primitives." Pissarro asserted, in the name of the impressionists, that "the primitives are our masters, because they are naïve yet learned." Throughout Europe, the standard academicism that promoted Raphael's oeuvre as the sole model of accomplished painting provoked a rediscovery of primitivism. Cézanne was a notable exception; describing his regular visits to the Louvre, he admitted that he "almost never entered the little room of primitives. It

was not my type of painting." Yet the same Cézanne could affirm at the end of his life that he "was perhaps just the primitive [practitioner] of a new art."

JAPANESE VARIATIONS

In 1855, Japan finally opened itself to the West. The first Japanese diplomatic mission was dispatched to the United States in 1860, while the first Japanese delegation to Europe landed at Marseilles on April 3, 1862; when it reached Paris, this delegation had itself photographed at Nadar's studio on Boulevard des Capucines. The following year, Baudelaire was already marveling at how newly available Japanese prints were "colored with incredible artistry." Millet and Rousseau were among the first artists to acquire Japanese prints, inaugurating a fascination that would last for over forty years.

Edmond and Jules de Goncourt described the reaction of a painter—the protagonist of their novel *Manette Salomon*—to these prints: "On seeing these albums of Japanese drawings, there dawned for him a shadowless day that was nothing but light." Many painters experienced the same thing.

According to one critic, Monet "was the first to be so brazen as to take his color as far [as the Japanese]. And that was what excited the greatest mockery, because lazy European eyes still perceived as gaudy the range of tones, so true and delicate, used by artists from Japan." Japanese art had the same decisive impact on painters from Manet and Whistler to Monet and Cassatt, from Degas and Gauguin to Seurat, Signac, Beardsley and Bonnard (dubbed the "very Japanesy Nabi"), not to mention Vuillard, Toulouse-Lautrec, and Redon. Vincent van Gogh, who painted a *Portrait of Old Tanguy* surrounded by prints in Paris in 1887, explained in a letter from Arles to his brother Théo, dated September 1888, that "serious" art lovers would be shocked that people could admire these penny prints "just as they once considered it bad taste to like Rubens, Jordaens, and Veronese." The painters mentioned by Van Gogh were colorists, either Flemish or Venetian. Such a preference was unacceptable to a

ONCE PHOTOGRAPHY ANNEXED PORTRAITURE,
PAINTING WAS FREED FROM THE NEED TO PRESENT A "LIKENESS."

Above: Odilon Redon, *Women with Veiled Face,* circa 1895–99.
Otterlo Kröller-Muller, Rijksmuseum, Holland.
Opposite: Dante Gabriel Rossetti, *Venus Verticordia,* 1864–1868.
Russell Cotes Art Gallery, Bournemouth, Great Britain.

stubborn academicism convinced that draftsmanship was the dominant criterion.

In 1876, an American journalist observed that Japanese art as a whole was having a profound impact on Europe's artistic sensibility. An English reporter soon confirmed this observation, noting that a wave of "Japonism" in Europe was infiltrating not only the ceramic arts but all the applied arts, from bronze to textiles to paper. All arts were going Japanese.

Emile Zola's novel about a nineteenth-century department store, *Au Bonheur des Dames* (Ladies delight), included the comment that "Japan needed just four years to win over the entire artistic clientele of Paris." In just another few years what were still curios would become a whole new style.

ART NOUVEAU

The painter Jan Verkade, nicknamed "the obelisk Nabi," recounted that, "around 1890, from one studio to another, a warcry went up: 'no more easel painting! Painting shouldn't wrongfully claim a liberty that isolates it from the other arts!'" This war cry by Nabi artists, described as "Ideationist painters" by critic Félix Fénéon in 1891, assumed its full meaning in December 1895, when art dealer Siegfried Bing, who had long been selling prints imported from Japan, inaugurated a new gallery in Paris called Art Nouveau (New art). Also known as *Jugendstil* in Germany and Liberty Style in London, Art Nouveau was the latest incarnation of Japonism. It permanently broke with academic criteria and conventions, rejecting the hierarchy of genres even as it rejected naturalism's and realism's social themes.

There had been precursors earlier in the century, the most important being the 1861 founding by William Morris of Morris, Marshall, Faulkner & Co. This furnishing and decorating firm was inspired by the ideas of John Ruskin, who decried the vulgarity of industrial work and who dreamed of a resurrection of medieval craft values.

Gustav Klimt, Josef Hoffmann, and Josef Olbrich, meanwhile, founded

the Sezession—or Vienna "Secession" movement—in 1898. The Sezession aesthetic was indebted to a style developed in Germanic countries between 1815 and 1848, a style mocked by a humorist who labeled it the "Biedermeier" taste, after a pretentious middle-class character. The bentwood chairs produced by Michael Thonet from 1849 onwards were "Biedermeiers."

Japonism did not end with the nineteenth century. In Paris, the underground train system that opened its doors in 1900 featured unique decoration that Hector Guimard designed for the stations. And, still in 1900, Antoni Gaudí began designing the park known as Parque Güell in Barcelona.

CHALLENGES, DOUBTS, SCANDALS

Hoodlums and Foreigners

During the inauguration of the 1900 Universal Exposition in Paris, the painter Jean-Léon Gérôme suddenly spread his arms wide in order to prevent the French president from entering one of the rooms. "Don't go in, Mr. President," he said, "this is a disgrace for France." The room in question was hung with a few impressionist paintings, which, in the eyes of this academic stalwart, were an indelible, inexcusable, and intolerable stain. Gérôme died in 1904 and therefore did not live to see "disgrace" carry the day.

In 1912, cubism provoked a scandal at the Salon d'Automne, then being held in the Grand Palais in Paris. A member of the city council was outraged at the use of "a public building by a gang of criminals who behave in the art world like common hoodlums. On the floor of the National Assembly, a legislator chimed in with the comment that these "hoodlums" were "mostly foreigners who come here to consciously or unconsciously bring discredit to French art, in our own national buildings."

Chauvinism remained just as strong on the eve of the Second World War, when another city councilor in Paris complained that the so-called School of Paris was "a bunch of dagoes who've arrived in Paris from their native Lithuania, Poland, or Czechoslovakia, and who've met with lively success thanks to a Holy Trinity of ballyhoo, scheming, and palm-greasing."

France was not alone in expressing nationalist intolerance; it was also on the agenda in Germany. When, a few years before the First World War, the Kunsthalle in Bremen decided to buy *Field of Poppies* by Van Gogh, one critic launched a petition (titled "A Protest by German Artists") to

Opposite:
Edvard Munch,
The Scream, 1895.

Following pages:
Pablo Picasso,
Guernica (4th state).
Photograph by
Dora Maar, 1937.
Musée Picasso,
Paris, France.

denounce a maneuver designed "to force the German people to buy French art at exorbitant prices." This allegedly intolerable situation was all the more unacceptable in that French artists "were themselves renegades acting against their own cultural traditions; even more seriously, people are interested only in these foreign artists and their German imitators, thus breaking with their own national traditions." The 120 signatories of the petition would obtain satisfaction and vengeance in 1933, once Hitler came to power.

When fascism came to power in Italy in 1922, the *Novecento* manifesto, which set out the aesthetic and "moral" values of Italian art, called for purges: "We want a pure Italian art, inspired from pure sources, free from all imported 'isms' that denature it. It must highlight the specific characteristics of our race."

Despite these "nationalist" and "moralist" outcries, twentieth-century art always remained a question of "hoodlums and foreigners."

Divorce

The twentieth century confirmed the divorce between art and state in Europe. In a striking concurrence, this divorce was consummated just when art galleries were taking over from the official Salons, which had been stifled by conformism. (In a similar concurrence, the era of "contemporary art" dawned just when the power of galleries began to wane before the rising tide of public institutions.) Another strange concurrence: the radical breaks that gave birth to modern art—fauvism and cubism— were contemporary with the separation of church and state in France; perhaps art divorced the state once the state was "desanctified."

For centuries, European art had been the business of governments in power. Art of the twentieth century would contest every kind of power. Governments and people who served them continued to think that the main role of art was to serve the state. If French politicians in the early twentieth century used the terms "disgrace" and "discredit" when describing new work being produced by painters, that was because the language employed by those painters served no political cause whatsoever.

Wassily Kandinsky was an artist convinced that art should flee imperatives "the way day flees night." Twentieth-century art would constantly flee all political imperatives. Yet the relationship between governments and art continued to weave a web of misunderstandings and crises, of compromises and failures. Such misconceptions ranged from the Italian futurists' commitment to fascism (Marinetti's manifesto, published in *Le Figaro* on February 20, 1909, spoke of a determination to sing of "the great masses aroused by work, pleasure, or revolt, the multicolored and polyphonic backwash of revolution in modern capitals," anticipating Mussolini's harangues in Rome's Piazza Venezia) to French surrealism's enthusiastic desire "to serve the [Bolshevik] revolution." In 1935, surrealist leader André Breton wrote: "There are still many of us in this world who think that placing art and poetry at the sole service of an idea, however exciting it may be in itself, would mean quickly condemning them to immobility, would mean sidetracking them."

CONSTRUCTIVISM AND THE SOVIETS

That track was the one laid down in the USSR by InKhuK (The Theoretical Institute of the Ministry of Public Education with Responsibility for the Arts), which decreed in 1921 that the last easel painting had been executed. Henceforth, its members would have to engage in "productivism," that is to say industrial design and the graphic arts.

Sculptors Antoine Pevsner and his brother Naum Gabo attempted to hold out against Vladimir Tatlin, who insisted that art play an immediate, useful role in the Bolshevik revolution. They published a Realistic Manifesto, which proclaimed that movement in space was more important than volume: "We reject volume as spatial expression. Space can no more be measured by volume than liquid can be measured by a linear meter. Depth is the unique form of spatial expression. . . . We declare that the elements of art are based on dynamic rhythmics." Among all the peremptory assertions that go into manifestos, the one which spawned the term "constructivism" was, "We construct our works."

A riposte came from Tatlin and Alexander Rodchenko in the form of their

P M '35

THE FUNCTIONALIST CONVICTIONS OF THE BAUHAUS AND DE STIJL MOVEMENTS
WERE NOT VERY DIFFERENT, NOR WERE THEIR SOCIAL AND POLITICAL GOALS.
BOTH SOUGHT TO CREATE RIGOROUS YET GENEROUS COHERENCE IN THE WORLD.

Opposite: Lucia Moholy, balcony of the Prellerhaus (detail), circa 1926–1927. Gropius Estate.
Above: Piet Mondrian, *Composition C, Composition No. 3. Composition with Red, Yellow and Blue*, 1935.
Tate Gallery, London, Great Britain.

"Productivist Program." Neither artist condoned the independence claimed by the abstract constructivists. Soon Pevsner and Gabo would be obliged to leave the Soviet Union as a result of Lenin's disapproval of abstract art (even when dubbed "suprematist" by the likes of Kasimir Malevich) and of Stalin's increasingly implacable condemnation of artists who "made art for decadent capitalists."

Only Laszlo Moholy-Nagy continued to design abstract posters to serve the revolution and the promise it held out—but he was working in Germany, far from the USSR. Moholy-Nagy's constructivist ideas were shaped by his contact with the De Stijl group and the Bauhaus school. As to Malevich—who had asserted in his 1915 pamphlet *From Cubism and Futurism to Suprematism* that "the revolutionary artistic styles of cubism and futurism were precursors of the political and economic revolution of 1917," who was convinced that "our art world has become new, non-figurative, pure. Everything is gone, all that remains is the mass of material from which new forms will be constructed. In suprematist art, forms will live alongside all the living forms of nature"—this Malevich just kept quiet. Although he was still head of the Department of Pictorial Culture (also known as the Department of Formal and Theoretical Research) in 1925, the following year an article he wrote was censored. The Soviet government dismissed the suprematism which Malevich hoped to extend to architecture. The meditative state induced by Malevich's spare, ascetic "icons" of absence, typified by *Black Square on White Ground* in 1913 and another *Black Square on White Ground* in 1918, could not be tolerated by a government that insisted that art be realist and socialist. Malevich claimed to have "reached the white world of the absence of objects, the revelation of nothingness." Arrested in 1930, he had the time to meditate on something he had written ten years earlier—"people always want art to be understandable, but people never accept the duty of making their minds understand."

Similarly, fascism and nazism wanted art to serve them. Like Zhdanov on Red Square in Moscow, Goebbels used the public squares and stadiums of Berlin and Nuremberg to stage the pomp and magnificence of an

Vassily Kandinsky,
The Bridge.
Private collection,
Paris, France.

empire supposed to last 1,000 years. It was up to artists to give shape to official values. The Aryan athletes sculpted by Arno Breker were no different from the muscular heroes in the Foro Mussolini in Rome nor from the proletarians raising high their hammers and sickles.

The twentieth century's official masquerades no longer belong to the history of art; rather, they concern the history of propaganda. Propaganda involved a deliberate policy of manipulating the masses, and it employed all methods, including radio and the movies.

It had the same goal as the *Congregatio de propaganda fide* (Congregation of the propaganda of the faith) established by Pope Gregory XV on June 22, 1622: to enthrall and win the public. Nations therefore demanded serviceable conformism from art, whereas artists insisted on breaking the rules. The complex relationships between art and state, between art and political commitment, were symptomatic of the rifts that marked the twentieth century.

One terrific exception was Picasso's *Guernica,* which he painted to express "his horror at the military clique that plunged Spain into a sea of pain and death." His painting, steeped in old memories of art—from Goya's *Third of May* to Poussin's *Massacre of the Innocents*—met with reservations from Spanish republicans and Communists, who inevitably found the canvas "antisocial" and felt it was "unsuited to the proletariat's mental health."

New Directions and Avant-Gardes

In Paris and London, Weimar and Vienna, Prague and Brussels and Barcelona, the twentieth century immediately began devising new art forms by combining painting and architecture with the decorative arts. The century's new ambitions could be seen in the Nabis's Art Nouveau show at the Bing gallery in Paris (where a Society of Decorative Artists was founded in 1901), in Guimard's decoration for the Paris subway (which so fascinated Gaudí), in the Jugenstil in Germany and Sezession in Vienna, and in the building of a School of Fine and Decorative Arts in Weimar in 1906 (where Walter Gropius would pursue these ambitions at

André Derain,
The Dance, 1906.
Private collection.

the Bauhaus). Objects produced by industry were henceforth expected to display a new formal beauty.

In the manifesto accompanying the 1919 launch of the school called the Bauhaus, Gropius wrote, "Together we will conceive and produce a new architecture, the architecture of the future, where painting, sculpture, and architecture will be one, raised someday toward the sky by the hands of millions of workers, the crystalline symbol of a new faith."

BAUHAUS

The Bauhaus, whose founding manifesto declared "the supreme goal of all creative activity [to be] architecture," intended to meet three challenges. It wanted to break down the barrier between artisans and fine artists, creating a synthesis of their talents; it wanted to put an end to the very distinction between artist and artisan, arguing that "the artist is a glorified artisan"; and it wanted to attract the people who practiced "the country's manual and industrial trades." The Bauhaus also rejected the distinction between professors and students and adopted the ancient example of guilds, which welcomed masters, journeymen, and

After Braque invented collage, even simple objects became part of the artistic vocabulary. Deprived of their function, associated with other, equally pointless items, such objects spurred imaginative freedom.

Above: Raoul Haussmann, *The Spirit of Our Age,* 1919. Mechanical head, wooden puppet with various objects attached. Musée national d'Art moderne, Paris, France.
Opposite: Georges Braque, *Collage.* Private collection.

apprentices—an evocation of the Middle Ages, when the masons' and builders' guilds were called *Bauhütten*. The name that Gropius gave to his school combines the noun *Bau*, which means "construction" in German, with the verb *bauen*, "to cultivate the land." The Bauhaus was designed not only to construct but to cultivate, to help minds to mature.

The Bauhaus was exactly contemporaneous with the Weimar Republic; transferred from Weimar to Dassau in 1924, it was closed for good on April 11, 1933, on the orders of Adolf Hitler, who had become chancellor in January. Yet the Bauhaus had trained some 1,200 students in fourteen years of existence. Nazi intolerance drove into exile such teachers as Gropius, Kandinsky, Itten, Moholy-Nagy, and Mies van der Rohe. Some immediately left for the United States, while others joined De Stijl, a movement with similar aims.

DE STIJL

Piet Mondrian used the phrase *nieuwe beelding* (new plasticism) to describe a new vision of the world. Neoplasticism entailed a global conception of every aspect of creativity. The movement's review, *De Stijl* (Style), edited by Theo van Doesburg from its founding in 1917 until his death in 1931, was a key platform for expression and experimentation and had a crucial impact not only in the Netherlands, where it was based, but also in France, Poland, Germany, Italy, Great Britain, and the United States. The first issue of the magazine, dated October 1917, included a manifesto-like introduction, which claimed that the movement's goal was "to prepare the possibility of a deeper culture, based on the collective forging of a new plastic consciousness." This implied an almost moral commitment: "a spiritual community can not be built without renouncing an individuality in search of fame. It is only by the logical and precise application of this principle that, through new relationships between artists and the world, plastic beauty will reveal itself as style in everything that exists." There were to be ramifications on the social level, too: "A pure plastic vision should build a new society." Mondrian, meanwhile, asserted that "the truly modern artist sees the metropolis like a physical

form of abstract life; it is closer to him than nature, and gives him the feeling of beauty. . . . The proportions and rhythms of architectural lines and surfaces speak more directly to the artist than nature's caprices; that is where the mathematical artistic temperament of the future will develop, that is where the New Style will emerge."

These demands and aspirations assumed architectural form in the work of architects such as Charles Rennie Mackintosh (Scotland), Henry van de Velde (Belgium), and Frank Lloyd Wright (United States).

UTOPIAS

On February 20, 1909, the pages of *Le Figaro* published Filippo Tommaso Marinetti's Futurist Manifesto, which notably proclaimed: "We declare that the splendor of the world has acquired a new beauty—the beauty of speed." Although the manifesto initially addressed poets, urging them to write only in free verse, which alone could convey dynamism and polyphony, Marinetti was soon arguing, "We must do something similar in painting!"

As of February 1910, the painters Boccioni, Russolo, and Carrà drew up the *Manifesto of Futurist Painters,* in which they vehemently asserted the need to shake up Italian art. They wanted art to be part of a "swirling life of steel, pride, fervor, and speed." They claimed that "universal dynamism should be rendered in painting as dynamic sensation" and that "movement and light [would] destroy the materiality of bodies." Convinced they also had a social role to play, in May 1911 the futurist group organized an exhibition of their paintings in a disused factory, with the proceeds going to the unemployed; the artists stood before their canvases in order to explain the meaning of their art to the workers. The futurist movement soon extended into architecture, the decorative arts, and fashion. Balla designed the fabulous Luna Park that functioned as a total metaphor for modern urban space, a stage on which to display all the promises of the paradise being built by industrial civilization.

The art movements and manifestos that appeared in the early twentieth century all shared the same faith: the century just dawning was to be a

culminating era, an era of social revolution, an era of freedom for all.

Why should anyone doubt that? Progress seemed to be keeping its promises. Everything seemed to point to a radiant future, from the electricity that dazzled the Universal Exposition of 1900, to telephones, to recordings of the human voice and music, and even to the concrete used for new buildings such as the Théâtre des Champs-Elysées, where the Ballets Russes performed Igor Stravinsky's *Rite of Spring* in 1913.

AMBIVALENCE AND TRANSGRESSION

Nietzsche died in 1900, Cézanne in 1906. Their writings and paintings, emblematic of the questions facing the new century, inaugurated a period of challenges to be confronted.

Although Cézanne wanted "to do Poussin again, from nature," the formal purity of his oeuvre inevitably triggered a break with previous tradition.

Although Nietzsche's philosophy called for a new Apollonian order, it glorified a Dionysian dimension that ultimately triumphed.

Once old landmarks faded, new challenges came to the fore. The century forged ahead.

FAUVISM

In 1905, Gallery VII of the Salon d'Automne was hung with works by Matisse, Marquet, Manguin, Camoin, Girieud, Van Dongen, Vlaminck, and Derain. In the middle of the room stood a marble bust by a certain Albert Marquet. At thirty-six, Matisse was the oldest of the group and clearly the leader. Key influences on Matisse included the works of Van Gogh, Gauguin (and, in another vein, the free brushwork of Toulouse-Lautrec), as well as a few sculptures from Africa and Oceania. All the painters associated with Matisse sought to produce canvases sparkling with a light in which "pure color played the role of leading actor." That light was found in places like Collioure, Saint-Tropez and L'Estaque (these artists went to L'Estaque, a port near Marseilles, almost on pilgrimage, since that is where Cézanne had painted). Matisse admitted that "in moments of doubt, when I was still seeking and was sometimes alarmed

Marcel Duchamp, *Fountain*, 1917. Musée national d'Art moderne, Centre Georges-Pompidou, Paris, France.

HOW COULD THE VISUAL ARTS—WHICH ARE STATIC—
CONVEY NOT JUST A MOTION BUT MOTION ITSELF?
DUCHAMP PROVIDED A CUBIST ANSWER, BOCCIONI A FUTURIST ONE.

Opposite: Marcel Duchamp, *Nude Descending a Staircase, No. 2,* 1912. Museum of Fine Art, Philadelphia, United States.
Above: Umberto Boccioni, *Unique Forms in the Continuity of Space,* 1913. Galleria civica d'arte moderna, Milan, Italy.

by my discoveries, I'd think: 'If Cézanne's right, I'm right,' and I knew that Cézanne had not been mistaken."

Because these brightly colored paintings were hung around a prudently classical sculpture, critic Louis Vauxcelles was prompted to write in the October 17, 1905 issue of *Gil Blas* that the exhibition was like "Donatello being surrounded by wild beasts [*fauves*]!" Matisse was their leader because he chose to "drive onward, wandering in passionate exploration, forcing pointillism to deliver greater vibration and luminosity." The word *fauve*, "beast," soon led to fauvism, a label which enjoyed a career not unlike impressionism thirty years earlier—a term of contempt became an art-historical reference.

Those artists labeled "fauves" nevertheless kept their distance from impressionism, as Cézanne himself had done long ago. According to Vlaminck, fauvism "pointed toward a path which was perhaps full of traps but which provided a breath of fresh air. It offered new expressive possibilities that avoided the dryness of divisionism and the affected flutter of impressionism."

CUBISM

At the end of 1907, Matisse and Derain first saw a painting that Pablo Picasso had just completed in his studio at Montmartre. This canvas, titled *Les Demoiselles d'Avignon,* troubled Picasso's closest friends not because of its subject—a brothel—but because of the very forms it adopted. Those forms seemed to suggest a new—and as yet unnamed—way of constructing space. (Georges Braque, who probably entered Picasso's studio for the first time late in 1906, greeted *Les Demoiselles d'Avignon* with the comment, "This painting looks as though you're trying to make us swallow turpentine.")

On November 14, 1908, Louis Vauxcelles devoted a few lines in *Gil Blas* to a show of paintings by Georges Braque that had opened at the Kahnweiler gallery on November 9th. Vauxcelles noted with annoyance that Braque "constructs metallic, deformed figures with a disregard for shapes, reducing everything—places, figures, and houses—to geometric

patterns, to cubes." The word was out: works by Braque and Picasso would be known as "cubist" from then onward. It was the critic Charles Morice who first employed the new label "cubism" in a review of the Salon des Indépendants.

A descriptive term born of scorn should be used with caution, although Picasso himself did not seem to mind, as demonstrated by a painting of early 1912 that suggested a pun: the still life included, among other objects, the packaging for "Kub" bouillon cubes. When caught off guard by a critic who asked him years later what cubism meant, Picasso quipped, "Ask Juan Gris." Poet Paul Eluard, in another vein, wrote that if Picasso's paintings were "mockingly called cubist," that was merely an admission of "how startling Picasso's approach was." The same was true of Braque, who, like Cézanne, concentrated more on the spaces, voids, and relations between things rather than on the things themselves, thereby beginning to "deconstruct" figures. Points of view intersected, planes shifted and overlapped, shapes and volume were fragmented and flattened: this meant a terrific upheaval for an art that had been organized around perspective for five centuries. But Cézanne was not the cubist painters' only master; so was the Iberian and African sculpture they discovered at the time.

Another mark of cubism—for "cubism" it is, now divided by art historians into three periods, "Cézannean" from 1907 to 1909, "analytical" from 1909 to 1912, and "synthetic" from 1912 to 1914—was the use made by artists of cardboard, sawdust, sheet iron, stencils, and industrial paints and tools. Cubism also meant the use of wallpaper that imitated wood paneling or chair caning, newspapers, and packets of cigarettes or tobacco stuck directly onto the canvas. As Picasso wrote to Braque on October 9, 1912, "I'm using your latest paperistic and dustified methods." The era of "do-it-yourself" collage had arrived.

"DO-IT-YOURSELF ART"

That era had begun back in Rodin's day, when the sculptor collected casts of antique pieces in his studio and where he also stored his own sketches

Ceci n'est pas une pipe.

Above:
René Magritte,
The Treachery of Images, 1929.
County Museum of Art, Los Angeles, United States.

Opposite:
L. Kassak, cover of a Hungarian translation of Tristan Tzara's *Cœur à gaz,* circa 1924.

of fragments, all of which were constantly recomposed into new works. Rodin realized that placing one fragment next to another could suddenly give both of them a new meaning. Thus, among other examples, he reused his 1880 *Sphinx* on several occasions. Starting in 1894, when a new work required the enlargement or reduction of pieces, Rodin would simply call on a firm specialized in "reducing and enlarging all artistic and industrial objects by a mathematically perfected method."

In May 1912, Picasso salvaged some oilcloth with a pattern of caning, which he used in *Still Life with Chair Caning.* Nor did he hesitate to use Ripolin industrial paint; as far as he was concerned, it was paint like any other. Picasso the sculptor would also use everything and anything: curtain tassels for a wood *Still Life* executed in 1914, a bicycle seat and handlebars for his 1943 *Bull's Head,* a toy car for the head of *Baboon with Young.*

On the back of a photograph of the still life Fruit Bowl and Glass, Braque noted, "first *papier collé,* Sorgues, September 1912." The wallpaper

322

dada

TZARA

Braque used in his "paper collage" was imitation wood—a real "do-it-yourself" choice.

Another type of do-it-yourself art was Marcel Duchamp's 1913 *Bicycle Wheel,* which he affixed to a stool. Even Duchamp was far from appreciating the consequences of his "ready-made" work.

Kurt Schwitters began constructing do-it-yourself assemblages on cardboard in 1911. When he exhibited these glued and nailed canvases at the Der Sturm gallery in Berlin, he gave the name *Merz* to his new method of painting with objects. Schwitters became a scrap collector who salvaged rusty, soiled refuse, which he built little by little into a proliferating construction called the *Merzbau* (1921 onward).

Max Ernst also devised a do-it-yourself technique called "frottage": a pencil would be rubbed over a piece of paper placed on floorboards or other rough surface, making landscapes and buildings appear. André Masson became another do-it-yourselfer when he threw sand into his paintings.

The mobiles Alexander Calder began making in 1932 were done in the do-it-yourself spirit, endowing sculpture with movement for the first time.

The colorful totems painted by Gaston Chaissac on planks torn from old fences had a do-it-yourself feel, as did the cut-out gouaches that Matisse pinned everywhere, like insects, to the walls of his apartment in Nice.

There was a do-it-yourself touch to Yves Klein's *Anthropométries,* in which the paint-coated bodies of nude women were directly printed onto canvas.

The garbage cans in which Arman heaped detritus, and the destructions in which he demolished a violin, chair, or piano were all do-it-yourself projects.

Do-it-yourself applies to César's "compressions" (and, later, "expansions") of cars compacted in the scrap yard, as it does to Jean Tinguely's clanking, rattling machine sculptures. Do-it-yourself continued into the 1980s with Tony Cragg's assemblages of plastic detritus found on the beach, amusingly arranged by color to depict an artist's palette.

Painting and sculpture were not the only twentieth-century arts to indulge in a do-it-yourself approach. A typewriter was included in the musical score for *Relâche,* performed by the Ballets Suédois in 1924 at the Théâtre des Champs-Elysées in Paris; the music was by Erik Satie, from an idea by Francis Picabia, and the program advised the audience "to bring sunglasses and something to stuff in your ears." And how much more "do-it-yourself" can you get than Pierre Henry's "score" titled *Variations for a Door and a Sigh*?

The use of all materials, without exception, was one of the challenges modern art set itself. A double transgression was involved: such do-it-yourself works reject not only the ancient notion of noble material but also of subject. As Derain noted in 1906, "We are perhaps a fortunate generation in the sense of being the only one which realized that stone, color, etc.—or any other material that appealed to the human mind—had its own life, independent of what it was supposed to represent." And that generation killed off the first definition of the word "art," which implied skill and mastery. The "fine arts" gave way first to the power of primitive arts and later, in the 1950s, to "domestic arts."

PRIMITIVE ART

For centuries, Europe had been helping itself to forms used in art throughout the world, adopting and annexing those forms. It erected Egyptian obelisks on its squares, built Chinese pagodas in its gardens, staged Turkish entertainments in its theaters. Suddenly the gaze Europe brought to the "primitive arts" challenged its own codes and certainties—the objects on show at Universal Expositions revealed that the colonizing West could no longer claim to be the sole civilization.

"The Chinese, the Negroes from Guinea, from New Zealand, from Hawaii and the Congo, the Assyrians, the Egyptians, the Etruscans, Phidias, the Romans, [and] the Indians" were all included in the list Derain made of the British Museum in London, in a 1906 letter to Vlaminck. Derain was struck more than anything by the "colossal, staggering expressiveness" of primitive arts. And these arts—Polynesian divinities, Iberian sculpture

AFRICAN MASKS AND STATUES BROUGHT BACK TO EUROPE
WERE NOT MERE OBJECTS OF ETHNOGRAPHIC STUDY. THE "PRIMITIVE" ARTS
INSPIRED EUROPEAN ARTISTS MORE THAN ANY OTHER FOREIGN INFLUENCE.

Opposite: Amadeo Modigliani, *Head.* Musée national d'Art moderne, Centre Georges-Pompidou, Paris, France.
Above: Alexeï Jawlensky, Abstract Head, 1918. Private collection.

and African figures—modified the formal vocabulary of Western art as never before. Archaic, they seemed to be endowed with an intense presence over which time and history had no purchase.

In a different vein, Matisse had to come to terms with the light of Morocco just as, in April 1914, Paul Klee and Auguste Macke confronted Tunisian light. Klee's quest for a different culture represented his need to explore "reality in the interest of expressiveness and the psychic revelations that may result."

When the Surrealist gallery opened on Rue Jacques Callot in Paris on March 26, 1926, the biggest scandal was caused by the indecency of a statue from the South Pacific island of Nias. Six years earlier, when Brancusi exhibited *Princesse X* at the Salon des Indépendants, the same sort of scandal occurred, because his sculpture seemed to be a phallus. Meditations on African art were behind Brancusi's pure forms—from the polished curves of *Prometheus* (1911) to the tubular shape of the *Torso of a Young Man* (1916) to the taut lines of *Bird in Space* (1928–1931)—just as they were behind the elongated oval shape of the stone heads that Modigliani exhibited at the Salon d'Automne in 1912.

CHALLENGES

Modern art broke with a centuries-old tradition of art. It made the break once that tradition had become nothing more than a convention, a dead language. Rodin was convinced that "academic formulas lead to a weak, timid art, which is sometimes scrupulous but always indecisive, always limited, rooted in recollections, a slave to preconceptions and conventional truths, repeating what has been learned, never looking truth in the face. Whereas the great masters opened their eyes to the light of truth." Throughout the centuries, great artists never stopped proclaiming their uniqueness. They deliberately committed "grammatical mistakes" as a way of inventing new idioms, but they never challenged the very language itself.

Modern art, however, was not content merely to reject academic formulas. It deliberately set out to contravene the language itself. As Jean

Paulhan observed, "Old painters began with meaning and then sought signs for it. But the new ones begin with signs, for which a meaning has to be found. That produces a certain impression of insolence and bravado in their work."

A "fauve" artist like Derain was not concerned with insolence and bravado. He nevertheless admitted a terrible premonition in a letter to Matisse in 1906: "Taking what we discussed to the limit, that is, to stop doing anything that represents anything, would mean art for art's sake, absolute egotism."

Such "egotism" speaks a foreign language. A unique language. Untranslatable.

The poet Apollinaire described Sonia Delaunay's canvases as ". . . the art of painting new ensembles with elements taken not from visual reality but entirely created by the artist and endowed by her with a powerful reality." Apollinaire concluded, "It's pure art."

"Art for art's sake," a "pure" art, or a "purified" art?

FREEDOM

Throughout Europe in the early years of the twentieth century, artists found the art of the past unbearable. The shackles of old rules inevitably gave rise to calls for freedom—a freedom that became absolute. Freedom was the only means to put an end to the old world, whose corpse was still in the way.

In Dresden in 1905, four young artists who had studied together at technical college—Fritz Bleyl, Erich Heckel, Ernst Ludwig Kirchner, and Karl Schmidt-Rottluff—founded a movement they called Die Brücke (The Bridge). Together they hoped to summon "all factors of revolution and fermentation" and to attract all artists who wanted to recover "in a direct and authentic manner, the impulse that drove them to create." They were joined by other artists as of 1906, the same year that Die Brücke organized its first exhibition in a Siefert lamp factory. The group proclaimed: "Because we believe in the emergence of a new generation that wants to simultaneously create and enjoy, we call on all young people to

POUR QUE V US AIMIEZ
QUELQUE CH SE IL FAUT
QUE VOUS L'AY 7 VU « ENTENDU

M.U.E.E

DEPUIS LONGTEMPS TAS D'IDIOTS

FRANCIS PICABIA

André Breton
as a target at
the Dada festival at
Théâtre de l'Œuvre.
Paris, France, 1920.

unite; and aware that, as young people, we represent the future, we want the freedom to act and live in order to combat the established forces of the past." The group first made a name among connoisseurs with its woodcuts. It soon realized that its concerns, goals, and determination were shared by Munich-based artists Franz Marc, Auguste Macke, Wassily Kandinsky, and Alexeï Jawlensky, whose 1911 album, published under the title *Die Blaue Reiter* (The Blue Rider), revealed interests similar to Die Brücke's. Both groups were German fauvists; exhibiting with the French fauves led Kirchner to predate some of his canvases, in order to avoid being accused of imitating what had been done in Paris.

Expressionism, whose virulent colors were partly inspired by Van Gogh's paintings (exhibited as early as 1901 by dealers Bruno and Paul Cassirer),

Oskar Schlemmer,
*Triadic Ballet: Disk
Costume,* 1922.
Württembergisches
Landesmuseum,
Stuttgart, Germany.

adopted still other forms in music. The first atonal work composed by Arnold Schönberg—who had to be pushed down the atonal path by his students Alban Berg and Anton von Webern—employed a variety of colors, rhythms, and harmonies that immediately suggested the term "expressionist." The strange ambiance of that 1909 composition, *Five Pieces for Orchestra,* op. 16, was found again in *Pierrot Lunaire* of 1912, which notably employed *sprechgesang* (a kind of recitative halfway between speech and song). Schönberg had been developing a serial technique since 1908. These unheard-of atonal and serial works seemed to spur artists to take the risk of executing paintings whose only reality was the painting itself. Something that had never been seen echoed, something that had never been heard.

ABSTRACTIONS

Maurice Denis coined a well-known dictum: "Remember that a painting—before being a war horse, a nude woman, or any other anecdote—is basically a flat surface covered with colors assembled in a certain order." Yet he probably never imagined that painting could do without a "subject" entirely.

The shadows, leaves, and willow branches painted by Monet for his *Water-lilies* series began to resemble simple patches of color, just as the trees, rocks, and cabins painted by Cézanne began to resemble cylinders, spheres, and cones precisely because painting was henceforth more concerned with *how* rather than *what* was depicted.

A 1910 watercolor in which Kandinsky added strokes in pencil and India ink was the first work to rid itself of representation. "I was the first to break with the tradition of painting existing objects. I founded abstract painting."

By 1912, the variety of approaches to what would be called "abstract art" had already been broached. Kandinsky's canvases were already lyrical in their effusiveness, Kupka's were already organized around geometric rigor, Delaunay's were orchestrated around a well-tempered clavichord. Abstraction constituted a new quest, one that mobilized theoretical as well as visual energies for decades. On one page of his sketchbook Mondrian noted, "The surface of things gives joy, their depth gives life."

Representation itself was no longer reassuring; under an illusionist painting of a pipe, René Magritte wrote, "This is not a pipe." Nothing would ever be a pipe again. The Mona Lisa henceforth sported a mustache. Representation was no longer about reference but about irreverence.

The era of manifestoes had arrived.

ANGER

Alberto Giacometti, *The Surrealist Table,* 1933. Musée national d'Art moderne, Centre Georges-Pompidou, Paris, France.

A fundamental difference existed between the manifestoes issued prior to 1914—as utopian and confident in the future as they were provocative—and the relentlessly angry ones that followed the First World War.

Tristan Tzara announced in the Dada Manifesto of 1918: "There is a

great, negative task of destruction to be done. A sweeping away. A clean-
ing out." Dada's faith was unshakeable: "We will not tremble, we are not
sentimental. Like a furious wind, we will tear the shroud of clouds and
prayers. We are preparing a grand spectacle of disaster, fire, decay."

In the 1920s, one of German expressionism's aims was to shatter artistic
conformism and to rid painting of routine and abnegation. German soci-
ety, guilt-ridden and wounded after the defeat of 1918, needed art that
was authentically, uncompromisingly expressive.

Surrealism displayed the same determination to put an end to a senile
world, as clearly expressed by Aragon: "First, we'll ruin this civilization so
dear to you, which casts you like fossils in stone. Western world, we sen-
tence you to death."

Twenty years later, Jean Dubuffet expressed similar loathing. "I would
prefer that art didn't exist, that it had no name." He was pursuing the
same battle. "To put an end to culture, which has held sway for thou-
sands of years, we must first destroy the idea on which it is based: the
value of the production of artworks."

The disgust felt by Dubuffet following the Second World War could hard-
ly be anything other than nihilistic.

WARS

Europe was stunned. August 1914–November 1918: fifty-one months of
war, which people had initially expected to be "joyous and refreshing."
But the toll was dreadful—several million dead. The tragedy reached a
scale never before seen in any of the wars that had torn Europe.

In 1924, Otto Dix published some fifty etchings under the title *War*, a ter-
rible and macabre "sequel" to similar series by Callot in the seventeenth
century and Goya in the nineteenth. The "walking wounded" included
the very spirit of Europe—minds were hit by propaganda the way bodies
were hit by bombs and gas. Empires crumbled, and along with them went
the entire framework of criteria and standards that had underpinned
Europe's certainties ever since the Renaissance.

Although a novelist such as Marcel Proust could still conceive a vast

Joan Miró,
*Person Throwing
a Stone at a Bird*,
1926, Museum
of Modern Art,
New York,
United States.

fictional cycle, the title *Remembrance of Things Past* suffices to indicate its inherent nostalgia; and perhaps the very title of James Joyce's *Ulysses* was the sign of yet another nostalgia.

In 1919, Paul Valéry made this awful admission: "An extraordinary shudder has shaken Europe to the marrow. She felt, throughout her mental core, that she was no longer quite herself, could no longer recognize herself, was going to lose consciousness—a consciousness acquired thanks to centuries of manageable misfortune, to thousands of first-rate men, to countless geographic, ethnic, and historical opportunities." No longer would anyone assert, as Baltasar Gracián had done in 1651 in *El Criticon* (The Disabused Man), that "Europe is the admirable face of the world: serious in Spain, pretty in England, debonair in France, refined in Italy, hearty in Germany, precious in Sweden, affable in Poland, languid in Greece, and somber in Moscow."

"Somber in Moscow"—the revolution of October 1917 embodied terrific

Above:
Otto Dix,
The Assault, 1924.
Private collection.

Opposite:
Charlie Chaplin,
actor/director of
The Great Dictator
(1940).

hopes all across Europe, just as it sparked irrepressible fear among capitalist democracies. Yet in just a few years the illusion of an artistic revolution at the service of the Soviet revolution had faded. The Kremlin decreed that the pose of a commissar who died for the revolution could be no less dignified than a Greek hero who died before Troy; the only justification for new artistic forms was to promote Soviet industrialization.

Such arts were, or aspired to be, a political weapon in countries where fascism was rising to power; John Heartfield's photomontages, for example, denounced the threat represented by Hitler and nazi power in Germany. And although Charlie Chaplin denounced them, too, minds were perhaps less focused on revolution than on the voice of Marlene Dietrich, the rhythm of jazz bands, the beauty of Greta Garbo, and the gags of Buster Keaton.

Some thirty years after Valéry's comments, French writer Georges Bernanos was obliged to make another bitter assessment at a lecture given on September 12, 1946. "Ladies and Gentlemen, Europe has lost confidence in itself. Without that confidence, there can be no European

THE CLASSICISM THAT LONG SERVED AS AN ARTISTIC NORM
IS A CONVENIENT YARDSTICK FOR TOTALITARIAN REGIMES, BECAUSE IT ENABLES
PROPAGANDA TO HAVE AN INSTANT IMPACT ON THE GREATEST NUMBER.

Opposite: Arno Breker, *The Party,* 1938–1944. Stone sketch for a bronze statue. New Chancellery, Berlin, Germany.
Above: May 1st Parade, Soviet poster, 1933.

spirit. The European spirit was the faith Europe had in itself, in its destiny, in its universal mission. Europe has lost it, and lost it doubly, because it has found nothing with which to replace it." Nothing—there was nothing left.

Bled dry by the end of the Second World War, Europe then discovered the horror of the concentration camps. The list of death camps was appalling: Dachau, Treblinka, Bergen-Belsen, and Auschwitz (designed by Himmler to be "the largest extermination center of all time"). The Nuremberg trials, which tried nazi dignitaries for war crimes and for crimes against humanity, lasted from November 20, 1945 to October 1, 1946, but could never totally exorcise or conjure away the dreadful shame that haunted Europe's conscience.

Western civilization henceforth knew it was capable of the worst. And with the bomb dubbed "Little Boy," dropped on Hiroshima on August 6, 1945 on the orders of U.S. President Harry Truman, the era of atomic terror began.

Italian author Primo Levi reported in *If This is a Man*—an account of his concentration camp experience—that at Auschwitz his attempt to recite some verses by Dante meant "that for a moment [he] forgot who [he] was and where [he] was." Levi could also assert—having experienced it in its most extreme form at Auschwitz—that "a civilized man who thinks too much is inseparable from a survivor." And yet Levi's belief in the power of culture was swept away by one question: how could an SS officer, humming a Schubert lied, have paused to order that the iron doors of the gas chamber be closed, *and then pick up the lied where he left off*? German philosopher Theodor Adorno drew the harshest of conclusions in a text published in 1951: "to write poetry after Auschwitz is barbarous . . . it has become impossible to write poetry today." Yet camp inmates themselves wrote poems at Auschwitz.

The ruins littering Europe in 1945 nevertheless included its conscience. The absurd became a philosophy. *Waiting for Godot* became a fable. Kafka, who died in 1924, suddenly appeared to be one of the century's prophets.

Fernand Léger,
The Builders, 1950.
Musée national
Fernand Léger,
Biot, France.

Lucian Freud, *Small Naked Portrait*, 1973–1974. Ashmolean Museum, Oxford, Great Britain.

Finally, in the aftermath of the Second World War, Europe found itself crippled: an "iron curtain" had cut it in half, a "cold war" would set Western Europe against Eastern Europe for nearly half a century. Two Europes would mistrust and malign one another.

Europe Dismissed

Fascism, followed by war, forced architects such as Gropius, painters such as Masson and Ernst, and composers such as Schönberg to flee Europe for the United States.

During a lecture given in 1941, an American poet compared their arrival to the contribution made by Byzantine artists and humanists arriving in Rome after the fall of Constantinople to the Turks in 1453. He asserted that "for America, they represent boundless wealth."

In a matter of years, this "wealth" translated into power. The aesthetic idioms developed by artists who fled Europe, and the challenges they posed, were adopted and transformed by American artists. Once seeded, these ideas took root.

Critic Clement Greenberg claimed in 1946 that nineteenth-century Bohemian Paris was just a foretaste of what would come to fruition in New York. In that same year, Greenberg drew harsh conclusions from an exhibition on *The School of Paris 1939 to 1946*, unfavorably comparing European art to America's recent accomplishments and arguing that the premises of Western art had shifted to the United States. The previous year, the magazine *View* had already asserted that New York had become the world's intellectual and artistic center. By the early 1960s, an American review could claim that "America has now become the protector of Western civilization, at least militarily and economically." It had also become the center of gravity of Western art.

The new "wealth" of the United States became evident in another manner, namely the development of an art market. Between 1940 and 1946, the number of galleries in Manhattan quadrupled. By 1944, many of them saw their sales triple or quadruple every year. In 1950, there were thirty galleries. By 1961, their number had increased ten-fold, and they organized some four thousand exhibitions. At the same time, the prices of individual works were on the rise. In 1946, not one of Mark Rothko's canvases sold for over $150 at the Betty Parsons Gallery (one of the three most important New York galleries, along with Peggy Guggenheim's Art of Our Time and the Samuel Kootz Gallery). In 1948, Rothkos were selling for $300 to $600, and by 1950 they had risen from $650 to $2,200.

In the wake of the 1948 Marshall Plan, which enabled the ruined old continent to rebuild itself, Europe discovered jazz and Marilyn Monroe's smile. Although the Italian film industry pioneered neorealism, the likes of Renoir and Hitchcock were shooting in Hollywood. And all of Europe watched Gene Kelly dance, marveled at Cecil B. DeMille's spectacles, enjoyed westerns by John Ford and Howard Hawks, and thrilled to James

DUBUFFET: ". . . I THINK IT'S ENOUGH THAT MY PAINTING EVOKES THE FACE OF A HUMAN BEING, WITHOUT THOSE PARTICULAR FEATURES THAT ARE SO VAIN." IN CONTRAST, FACES PAINTED BY BACON ARE PORTRAITS, VANITY THAT COMES ACROSS AS ANXIETY.

Above: Francis Bacon, *Portrait of Isabel Rawsthorne* (three studies), 1965. Sainsbury Center for Visual Arts, Great Britain.
Opposite: Jean Dubuffet, *I'm Listening,* 1966. Private collection.

Above:
Anselm Kiefer,
Adelaide, 1945.
Private collection.

Opposite:
Antoni Tapiés,
Grand X, 1988.
Lelong Gallery,
Zurich-Paris-
New York.

Dean portraying a *Rebel Without a Cause.* Novels by Hemingway, Steinbeck, and Dos Passos became the new models for literature.

Although Paris was the birthplace of the CoBrA croup (whose initials stood for the cities of Copenhagen, Brussels, Amsterdam), it was the school of New York—the abstract expressionism variously labeled "action painting" or "painterly abstraction"—that dominated the crucial debate. Between 1958 and 1959 a traveling exhibition titled *The New American Painting* demonstrated to European eyes the powerful inventiveness of American art.

One of the artists included in the show was Jackson Pollock. According to one witness, "he had everything. He was really the great American painter. Who, if you think about it, had to be a real American, not a European transplant. . . . He had to spring from native soil, not from Picasso or Matisse. He had to be a somewhat crazy inventor—a guy who shows up with his own thing. And he had to suffer from what Hemingway called the great American vice—booze. Hardly surprising that Pollock was featured in *Life,* because he was so authentic, so

unusual, such an oddball, with that great American face. He had it all."
In the 1960s, Pop Art developed an idiom in America that glorified the
power of the media.

Jasper Johns created its emblem in 1958, in the form of an American flag
painted in encaustic on canvas. Then were the multiple silk-screen por-
traits that came out of Andy Warhol's Factory—portraits of celebrities
from Marilyn Monroe to Jackie Kennedy and Liz Taylor, but also "por-
traits" of products whose fame alone merited a picture, from Campbell
soup cans to Brillo pads and Coke bottles.

For the remainder of the twentieth century, the United States continued
to impose its own myths on a world now viewed primarily as a market,
from Pollock's drip paintings to Hollywood superproductions to rock stars
to Jeff Koons's pornographic provocations (exhibited at the Venice
Biennial in 1990). In this market, the U.S. established the new roles to be
played by photography, "happenings," and installations.

ACCELERATION

The very stakes of culture itself were altered by economic growth in the
Western world during what is known in France as "the thirty glorious
years" (1945–1975), by the laws and requirements of industry, and by
speculation. Consumer society demanded "products" designed for the
greatest number. Protest itself had to be merchandized, the better to
denounce the system that granted it speech. The anger and distress put
to music by pop and rock groups notably yielded "gold" records.
Television, still black-and-white in the 1950s, soon altered the scale of
things, creating a world where the role played by communication left no
room for anything else.

In contrast to the gerontocracy of a socialist world that was apparently
petrified, the West was in constant search of novelty. That was the case
not only with fashion (Christian Dior's "New Look"), but with movies
(France's "New Wave"), literature (the "New Novel") and philosophy
(the "New Philosophy"). Always trying to go one better, the century
mutated and sought new values.

Lucio Fontana,
Concetto spaziale,
1959. Private
collection.

Many artworks conceived in the second half of the twentieth century no longer attempted to be what Baudelaire, in his nineteenth-century poem Beacons, called "the best witness . . . we can give . . . of human dignity." Although some works still embodied the "ardent sob" that "rolls onward from age to age," they were no longer interested in "dying" for any "eternity" whatsoever.

Soon the "real" time demanded of computer systems recognized only the present. In those same years, the role of sensuality and sensibility seemed to give way to intellectual theories, which alone defined the stakes of a given work.

Western civilization, having abandoned both religion and ideology (those counterfeit creeds), had only Sigmund Freud's psychoanalysis to fall back upon. The discovery of the unconscious, although it unlocked the imaginative faculty, undermined certainties that centuries of enlightenment and progress had developed from the capacities of reason. Simply deciphering the unconscious, however, reveals a framework that offers

YVES KLEIN, FOLLOWING PICASSO AND DUCHAMP,
MARKED A TURNING POINT IN 20TH CENTURY ART IN EUROPE. BY MAKING RAW MATERIALS
THE SUBJECT OF ART, HE INTRODUCED A CERTAIN AUSTERITY.

Above: Jean-Pierre Raynaud, the artist's house at Rueil-Malmaison, France.
Opposite: Yves Klein, *Blue Sponge Relief: RE 19, 1958,* Ludwig Museum, Cologne, Germany.

neither a political agenda nor a philosophy of life. Art, a question of tran-scendence for centuries, is now giving way to transgression as art. Art has been, by turns—though not in any particular order—abstract, brut, *informel,* conceptual, naïve, kinetic, *povera,* and hyperrealist. It has taken the form of Land Art, New Figuration, New Objectivity, New Realism; it can be Op, or Pop, or what-have-you. The avant-garde is becoming a Transavant-garde. Modern art has given way to art described as "post-modern." No other century experienced such a swift torrent of change.

Several factors explain this acceleration. On one hand, the only tradition recognized by artists, regardless of the medium and materials they use, is that of novelty. And on the other, fundamental changes in the interna-tional art market throughout the free-trade world (as opposed to planned economies, where the criteria of socialist realism reigned, willy nilly, for forty-five years), led to a notion of speculation that reached a heyday in the 1980s. Finally, artists are no longer expected to produce works that fulfill expectations of "beauty"; instead, artists produce "creations" assessed according to the way they "function."

An artist must henceforth establish, alone, his or her own rules. Like German artist Joseph Beuys in 1974, this might mean spending a week with a coyote in a New York gallery, or like Greek artist Jannis Kounellis in 1979, it might mean exhibiting twelve live horses in a gallery in Rome. Or, like Daniel Buren, it might mean designing installation after installa-tion, year after year, using the same cloth of alternating stripes—white and another color—whose width is always 8.7 centimeters wide. Torn posters, graffiti, advertising images, video, and rubbish, not to mention a phrase written on a museum wall, a gesture, or a pose are now consid-ered valid materials for a work, if not the work itself.

THE DEATH OF ART

The effervescence of contemporary creativity that has seized on new computer technology generates profound unease among the general public. At the same time, it has provoked intense aesthetic and philosophical debate on the status of the artist and the role and place of

artworks. Artists apparently continue to be obsessed by the "death of art" predicted by the German philosopher Hegel back in the nineteenth century.

Another debate was triggered by the groundbreaking role played by Marcel Duchamp's ready-mades. By exhibiting a manufactured object—such as a bottle rack or urinal, the latter signed with the manufacturer's name, "R. Mutt"—in a venue devoted to art, Duchamp implied that it was the place, rather than the work, that defined art. This implication was confirmed by Duchamp's own career. It was the museums that, in the 1960s, suddenly attributed to him a crucial role in the history of twentieth-century art; at the time, he was living in a kind of limbo, viewed as a freak accident. In October 1963, the Pasadena Art Museum organized the first retrospective of Duchamp's work; ten years later the Museum of Modern Art in New York and the Philadelphia Museum of Art confirmed his consecration.

The contemporary art being consecrated in the West is now promoted by museums, unlike modern art, which had to fight its battles in the galleries. A contemporary artist can affirm, with no fear of being contradicted, that "when I say museums offer the only viewpoint on and about art, that's not a critique, it's a fact." It was the Stedelijk Museum in Amsterdam which was the first to open its doors to the most contemporary art, when it put on a show of the CoBrA group in 1949.

A paradox of contemporary art is that a work might simply be an artist's decision not to execute works: the intention becomes the work. In another paradox, rebellion is now enshrined in the institution of museums, in contemporary art centers such as the Kunsthalle, and in international celebrations such as art fairs and biennials. Museums are no longer content to reveal the history of past art, they now promote events and keep a diary of today's art.

Art lovers are being insidiously elbowed out by "specialists." And "contemporary art" has now become a registered trademark that seems to display a genealogical tree featuring solely those branches that join the master trunk of Duchamp.

Christian Boltanski,
Monument, 1985.
Fonds national
d'art contemporain,
Musée de
Grenoble, France.

Alongside this genealogy (where Claude Viallat's draped canvases are related to the strange "chapels" erected by Christian Boltanski and to Joseph Beuys's assemblages of felt, wax and rubber), the painting that so many people declared dead has continued to thrive powerfully.

It has done so in the work of Balthus (an exception who stands outside of time), in Francis Bacon's tormented faces and bodies (who, the artist claims, are unconvinced of their own existence, in stinging response to figures painted decades earlier by Léger, designed to demonstrate that "the new art brings peace and happiness"), and in works by Miguel Barcelo, Sandro Chia, Gérard Garrouste, and Jörg Immendorf.

Throughout the twentieth century—that wrenching, hectic century—artists have appropriated every right as their own.

All frontiers have been explored, all taboos broken, all certainties challenged. The avant-gardes wanted to believe that history might still have a meaning, but history set them straight. The manifestoes, schisms, and constant escalation of art seem to have sown only confusion.

Yet there remain—vigilant and demanding, with no user's guide to help

Joseph Beuys,
*Homogeneous
Infiltration for
Grand Piano,* 1966.
Musée national
d'Art moderne,
Centre Georges-
Pompidou, Paris,
France.

recognize them within this ample profusion of gambles, power plays, and refinements—bold moves that spark the paradoxical, incomparable, and satisfying awe associated with art. May Europe, after having built an economic community, after having forged monetary union, and after having torn down its iron curtain, remember that its most ancient identity lies in the arts and cultures it has created and shared.

EUROPEAN MUSEUMS GUIDE

AUSTRIA

Graz

Alte Galerie des Steiermärkischen Landesmuseum Joanneum

NEUTORGASSE 45, 8010 GRAZ

• Religious art from the Middle Ages and Italian, German and Austrian paintings from the 14th to the 17th centuries. Works by Lucas and Hans Cranach, P. Brueghel the Younger, etc.

Linz

Neue Galerie der Stadt Linz/ Wolfgang-Gurlitt-Museum

BLÜTENSTRASSE 15, 4040 LINZ

• The world's largest collection of works by Kubin (600 drawings) and many works by Liebermann, Corinth, Kokoschka, Klimt, Schiele, Pechstein and Nolde.

Salzburg

Residenzgalerie Salzburg

RESIDENZPLATZ 1, 5010 SALZBURG

• European art from the 14th to 18th centuries. Minor Italian, German and Austrian masters. Paintings from the Romantic period.

Rupertinum

WIENER-PHILARMONIKER-GASSE 9, 5010 SALZBURG

• Early 20th-century German and Austrian artists (Kollwitz, Barlach, Kubin, Dix) and the Austrian avant-garde: Rainer, Brus, Attersee.

Vienna

Gemäldegalerie der Akademie des Bildenden Künste

SCHILLERPLATZ 3, 1010 WIEN

• Italian, French, Spanish, Dutch and German masters from the 14th to 18th centuries: Botticelli, Titian, Tiepolo, Guardi, Murillo, Robert, Bosch, Rembrandt, etc.

Graphische Sammlung Albertina

AUGUSTINERSTRASSE 1, 1010 WIEN

• One of the world's largest collections of drawings, engravings and prints (50,000 drawings and 1.5 million prints). Masterpieces by Dürer, Raphael, Rembrandt, Rubens, etc.

Österreichische Galerie Belvedere

PRINZ EUGENSTRASSE 27, 1030 WIEN

• Religious art from the Middle Ages. European art in 1900: Klimt, Schiele, Kokoschka, Van Gogh, Monet, Renoir. Works from the Romantic period and the Biedermeier style.

Kunsthistorisches Museum

MARIA THERESIEN PLATZ, 1010 WIEN

• Medieval, Renaissance and baroque art. Paintings, sculptures, tapestries, jewelry. Masterpieces by Dürer, Titian, Rubens. A unique collection of work by P. Brueghel.

Museum moderner Kunst Stiftung Ludwig Wien

20er Haus Schweizer Garten,
1030 Wien

• Art from the 1950s to the present. Works by Beuys, Merz, Weiner. Sculpture garden with work by Moore, Wotruba and Lavier. A series of galleries devoted, respectively, to expressionism, cubism, futurism, constructivism, surrealism, new realism and the Viennese action artists.

Wiener Secession

Friedrichstraße 12,
1010 Wien

• Temporary exhibitions are held in this historic gallery which boasts monumental frescoes painted by Klimt in 1902.

BELGIUM
Antwerp

Museum Plantin-Moretus

Vrijdagmarkt 22,
2000 Antwerpen

• The Plantin Printing Works was founded in the 16th century and today is a museum of tapestries, ceramics, porcelain and paintings (including eighteen works by Rubens).

Rubenshuis

Wapper 9-11,
2000 Antwerpen

• One year after marrying Isabella Brant, the famous artist and diplomat Peter Paul Rubens bought this magnificent residence where he lived and worked. Rubens's personal collection and some of his own works are on display.

Koninklijk Museum voor Schone Kunsten

Leopold de Waelplaats, 2000 Antwerpen

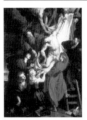

• Fine art from the 14th century to the present; masterpieces by Van Eyck, Van der Weyden, Memling, Hals, Rubens, Jordaens, Van Dyck, Fouquet, Martini, Titian, etc. Major collection of works by Ensor, Magritte and Delvaux, etc.

Museum Mayer Van Den Bergh

Lange Gasthuisstraat 19, 2000 Antwerpen

• Medieval sculptures, enamels, tapestries, furniture, ceramics and Flemish paintings (including Brueghel's *Twelve Proverbs*).

Bruges

Groeninge Museum

Dijver 12, 8000 Brugge

• Flemish primitives, Flemish painting from the 16th and 17th centuries and modern Belgian art. Works by Bosch, Memling, P. Brueghel and Pourbus, among others.

Memling Museum

Mariastraat 38, 8000 Brugge

• Six outstanding works by Hans Memling constitute the core of this museum, set in a 12th-century hospital.

Brussels

Musées royaux des Beaux-Arts de Belgique

3, rue de la Régence, 1000 Bruxelles

• A group of several museums covering the history of the fine and decorative arts in Europe. To cite just a few names: Brueghel, Rubens and Jordaens, and, for the modern era, Delavaux, Magritte, Chagall, Bacon, Dali, Miró, etc.

Ghent

Museum van Hedendaagse Kunst

CITADELPARK, 9000 GENT

• This museum features the main representatives of post-1945 art in Europe: Magritte, Delvaux, Bacon, the Cobra group, Arman, Beuys, Panamarenko, etc.

Museum voor Schone Kunsten

Citadelpark, 9000 Gent

• Art from the 14th century to the present, especially Flemish work. Bosch, Brueghel, Rubens, Hals, Snyders and Tintoretto as well as Rodin, Courbet and Daumier.

DENMARK
Ålborg

Nordjyllands Kunstmuseum

KONG CHRISTIANS ALLÉ 50, 9000 ALBORG

• Designed by Alvar Aalto, this museum has a major collection of works by Giersing, Lundstrøm, Søndergaard, and the Cobra group as well as sculptures by Jacobsen.

Århus

Kunstmuseum

PARC DE VENNELYST, 8000 ARHUS

• A collection presenting various aspects of Danish painting and sculpture.

Copenhagen

Thorvaldsen Museum

PORTHUSGADE 2, 1213 KOBENHAVN K

• Built during the artist's lifetime, this museum is devoted entirely to the neoclassic sculptor Bertel Thorvaldsen.

Ny Carlsberg Glyptotek

DANTES PLADS 7, 1556 KOBENHAVN V

• This institution is one of the largest in the country and houses many paintings by 19th-century Danish masters as well as works by Gauguin, Van Gogh, Rodin, Daumier, Degas, Corot, Courbet, Toulouse-Lautrec, Picasso, etc.

Statens Museum for Kunst

SOLVGADE 48-50, 1307 KOBENHAVN K

• This museum's varied collection is devoted to art in Denmark and the rest of Europe (notably 17th-century Dutch and 19th-century Danish painting); works by Rubens, Munch, Lundstrøm, Rouault, Matisse and others.

National Museet

NY VESTERGADE 10, 1220 KOBENHAVN K

• A varied collection devoted to Danish art and history, among others.

Ordrupgaard

VILVORDEVEJ 110,
2920 CHARLOTTENLUND

• Set in a park, this museum boasts an outstanding collection of works from the golden age of Danish art and of 19th-century French paintings: Hansen, Købke, Larsen, Ingres, Delacroix, Manet, Corot, Pissaro, Renoir, Degas, Gauguin, Cézanne, etc.

Kunstindustrimuseum

BREDGADE 68, 1260 KOBENHAVN K

• A collection of various aspects of applied and decorative arts in Europe from the Middle Ages to the present.

Louisiana Museum of Modern Art

GL. STRANDVEJ 13,
3050 HUMLEBÆK

• Exceptional from every standpoint, this museum specializes in modern art, including works by Arp, Bacon, Bille, Dubuffet, Ernst, Giacometti, Heerup, Jacobsen, Jorn, Miró, among others.

Horsens

Museum of Fine Arts

CAROLINELUNDSVEJ 2S, 8700 HORSENS

• Basically devoted to Danish artists such as Kvium, Zieler, etc.

Kolding

Kunstmuseet Trapholt and Dansk Mobeldesign

AEBLEHAVEN 23, STRAORDHUSE,
6000 KOLDING

• Paintings, sculptures, video and design—various forms of modern and contemporary art from Denmark and elsewhere.

Ribe

Ribe Kunstmuseum

SCT. NICOLAI GADE 100, 6760 RIBE

• A collection devoted to various forms of art, notably paintings from Denmark from the 18th century to the present.

FRANCE
Albi

Musée Toulouse-Lautrec

PALAIS DE LA BERBIE, 81003 ALBI

• This collection reflects all aspects of the art of Henri de Toulouse-Lautrec as well as works by Dufy, Matisse, Rouault, Utrillo, and others.

Antibes

Musée Picasso

CHÂTEAU GRIMALDI, 06600 ANTIBES

• Ceramics, engravings, sculptures and paintings by Picasso, plus works by Adami, Alechinsky, Ernst, Klein, Picabia, Raysse, Spoerri, Viallat, etc.

Avignon

Petit Palais

PLACE DU PALAIS DES PAPES,
84000 AVIGNON

• This museum features medieval sculpture as well as works by old masters including Botticelli, Carpaccio, Di Paolo, Quarton, Lieferenxe.

Bayonne

Musée Bonnat

5, RUE JACQUES-LAFITTE, 64100 BAYONNE

• Artist Louis Bonnat bequeathed his collection to his home town; items include 16th-century ivories, Spanish sculpture, Flemish tapestries and paintings by Murillo, Ribera, Goya, Rubens, Van Dyck, Reynolds, David, Corot, Courbet, Delacroix, Géricault, Degas, etc.

Biot

Musée national Fernand Léger

CHEMIN DU VAL DE POME, 06410 BIOT

• A collection of nearly 350 works by Léger, including ceramics and tapestries as well as paintings.

Bordeaux

Musée des Beaux-Arts

20, COURS D'ALBERT, 33000 BORDEAUX

• The Rohan residence, built in the 18th century, contains a major collection of paintings by artists such as Titian, Perugino, Veronese, "Velvet" Brueghel, Rubens, Snyders, Hals, Delacroix, Isabey, Corot, Redon, etc.

CAPC Musée d'Art contemporain

7, RUE FERRÈRE, 33000 BORDEAUX

• A selection of works representing the major trends in contemporary art.

Caen

Musée des Beaux-Arts

LE CHÂTEAU, 14000 CAEN

• A large collection of prints (50,000) as well as paintings by Veronese, Perugino, Guercino, Tiepolo, Rubens, Poussin, Gleizes, Villon, Vieira da Silva, and so on.

Céret

Musée d'Art moderne

8, BOULEVARD MARÉCHAL-JOFFRE, 66400 CÉRET

• The collection basically features works by artists who spent time at Céret, such as Matisse, Picasso, Chagall, Cocteau, Dali,

Gris, Gargallo, Herbin, plus works by Ben, Bertrand, Jaccard, Rebeyrolle, Viallat, etc.

Châlon-sur-Saône

Musée Nicéphore Niepce

28, QUAI DES MESSAGERIES, 71100 CHÂLON-SUR-SAÔNE

• This museum is devoted to the history of photography, particularly to one of its inventors, Nicéphore Niepce.

Chantilly

Musée Condé

CHÂTEAU DE CHANTILLY, 60631 CHANTILLY

• This chateau boasts several collections of manuscripts and books, furniture, sculpture, as well as French, Italian and Northern paintings.

Colmar

Musée d'Unterlinden

1, RUE D'UNTERLINDEN, 68000 COLMAR

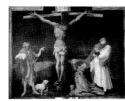

• This former Dominican monastery houses a collection of paintings and sculptures from the high Middle Ages and Renaissance (Haguenau, Grunewald, Cranach, Holbein, etc).

Dijon

Musée des Beaux-Arts

PALAIS DES ETATS DE BOURGOGNE, 21000 DIJON

• This museum's varied collection (relics,

furniture, sculptures, paintings) retraces the history of art in Europe from the Middle Ages to the present.

Ecouen

Musée national de la Renaissance

CHÂTEAU D'ECOUEN, 95440 ECOUEN

• This 16th-century chateau exhibits tapestries, enamels, weapons and armor, glasswork, ceramics, paintings and sculptures.

Fontainebleau

Musée national du château de Fontainebleau

CHÂTEAU DE FONTAINEBLEAU, 77300 FONTAINEBLEAU

• A varied collection covers seven centuries of French history from the coronation of Louis VII to the fall of the Second Empire in 1870.

Grenoble

Musée de Grenoble

5, PLACE DE LAVALETTE, 38000 GRENOBLE

• A collection of paintings by masters such as Zurbarán, Rubens, La Tour, Matisse, Marquet, Bonnard, Léger, Picasso, Tanguy, Ernst, Miró, Soulages, Morellet, Lavier and so on.

Lille

Musée des Beaux-Arts

PLACE DE LA RÉPUBLIQUE, 59000 LILLE

• A collection of art and objects from the

Middle Ages to the 19th century: ivories, precious metalwork, enamels, manuscripts, tapestries, liturgical objects, paintings by Jordaens, Rubens, Van Dyck, Raphael, Titian, Champaigne, La Tour, Corot, Rousseau, Fantin-Latour, Monet, Van Gogh and others.

Lyon

Musée des Beaux-Arts

20, PLACE DES TERREAUX, 69001 LYON

• The former Abbey des Dames, built in the 17th century, now houses a collection of sculpture, ceramics, furniture, prints, drawings and paintings by French, Flemish, Dutch, Italian and Spanish masters.

Marseille

Musée des Beaux-Arts

PALAIS LONGCHAMP, 13004 MARSEILLE

• A collection of paintings by Bassano, Vannini, Tiepolo, Rubens, Zurbarán, Van Cleve, Snyders, Ruisdael, Puget, Vernet, Daumier, Puvis de Chavannes, etc.

19, RUE GRIGNAN, 13006 MARSEILLE

• Works of modern art (paintings, drawings, sculptures, photography) by Braque, Dufy, Picabia, Ernst, Dubuffet, Klein, Arp and others.

Montauban

Musée Ingres

19, RUE DE L'HÔTEL-DE-VILLE,
82000 MONTAUBAN

• This 12th-century bishop's palace displays a major collection of works by Ingres as well as sculptures by Bourdelle and paintings by Lesueur, Mignard, Boucher, Delacroix, David, Debré, Vieira da Silva, etc.

Montpellier

Musée Fabre

39, BOULEVARD BONNE-NOUVELLE,
34000 MONTPELLIER

• Housed in a former Jesuit school, this collection features ceramics from Montpellier as well as paintings by Teniers, Brueghel, Rubens, Steen, Botticelli, Veronese, Ingres, Delacroix, Géricault, Courbet, Cabanel, Degas, and 18th-century sculpture by Pajoud, Roland, Houdon.

Nancy

Musée des Beaux-Arts

3, PLACE STANISLAS, 54000 NANCY

• Sculpture, painting and drawings by Tintoretto, Caravaggio, Rubens, Lorrain, Champaigne, Boucher, Courbet, Manet, Monet, Modigliani, Utrillo, Matisse, Vlaminck, Vuillard, Arp, Duchamp-Villon, Zadkine, etc.

Nantes

Musée des Beaux-Arts

10, RUE GEORGES-CLEMENCEAU, 44000 NANTES

• This museum's collection ranges from the

13th century to the present, including works by La Tour, Ingres, Courbet, Delacroix, Monet, Signac, Dufy, Ernst, Chagall, Picasso, Soulages, Morellet, Viallat, and others.

Nice

Musée des Beaux-Arts

33, AVENUE DES BAUMETTES, 06000 NICE

• This collection covers various aspects of art in Europe, notably works by Natoire, Robert, Fragonard, Degas, Boudin, Monet, Sisley, Bonnard, Vuillard, Van Dongen, Picasso, etc.

Musée Matisse

164, AVENUE DES ARÈNES DE CIMIEZ, 06000 NICE

• Paintings, drawings, collages, sculptures, engravings, illustrated books, photographs and objects from Matisse's personal collection.

Musée d'Art moderne

PROMENADE DES ARTS, 06300 NICE

• An overview of the major trends in modern and contemporary art, including a good collection of "new realists": Arman, César, Hains, Klein, Saint-Phalle, Rotella, Tinguely, among others.

Nîmes

Carré d'Art contemporain

PLACE DE LA MAISON CARRÉE, 30000 NÎMES

• Paintings, sculptures, photography and works on paper from the 1960s to the present, and more.

Orléans

Musée des Beaux-Arts

1, RUE FERNAND-RABIER, 45000 ORLÉANS

• Various aspects of art from the 16th to 20th centuries: Tintoretto, Correggio, Velázquez, Courbet, Boudin, Gauguin, Sérusier, plus sculpture by Houdon, Rodin, Maillol, Zadkine, etc.

Paris

ARC-Musée d'Art moderne de la Ville de Paris

11, AVENUE DU PRÉSIDENT-WILSON, 75116 PARIS

• An overview of 20th-century art in Europe based on works by major artists.

Musée des Arts décoratifs

107, RUE DE RIVOLI, 75001 PARIS

• A vast collection of 200,000 examples of the decorative arts from the Middle Ages to the present.

Musée Carnavalet

23, RUE DE SÉVIGNÉ, 75004 PARIS

• Various collections of furniture, drawings, prints and paintings pertaining to the 18th and 19th centuries in France.

Musée Nissim de Camondo

63, RUE DE MONCEAU, 75008 PARIS

• Count Moïse de Camondo was a great collector whose residence in Paris was filled with wonderful examples of 18th decorative art, notably furniture; he bequeathed his home and its contents to the Union Centrale des Arts Décoratifs in memory of his son, Nissim.

Musée Cognacq-Jay

8, RUE ELZÉVIR, 75003 PARIS

• The collections of philanthropist Ernest Cognacq (1839–1928): furniture, Meissen porcelain, tapestries, terracotta, precious metalwork, enamels and ivories, paintings by Chardin, Boucher, Greuze, Fragonard, Watteau, Ingres, Rembrandt, Tiepolo, Canaletto, Guardi, Reynolds and others.

Musée Jacquemart-André

158, BOULEVARD HAUSSMAN, 75008 PARIS

• This grand residence houses a collection of furniture (18th century), tapestries, sculptures and paintings by Fragonard, Boucher, Chardin, Nattier, Vigée-Lebrun, Rembrandt, Hals, Van Dyck, Uccello, Mantegna, Botticelli, Tiepolo.

Musée du Louvre

PALAIS DU LOUVRE, RUE DE RIVOLI, 75001 PARIS

• One of the most important collections of European art in the world, from the Middle Ages to the mid 19th century: sculptures by Michelangelo, paintings by Giotto, Mantegna, Botticelli, Leonardo, Titian, Dürer, Rembrandt, Rubens, Vermeer, Poussin, Chardin, Fragonard, Watteau and more.

Musée Marmottan

2, RUE LOUIS-BOILLY, 75016 PARIS

• This private residence has a varied collection of Italian primitives, Flemish and German painting, Empire furniture, illuminated manuscripts, plus works by Manet,

Pissarro, Renoir, Sisley and an outstanding collection of paintings by Monet.

Musée national du Moyen Âge – Thermes de Cluny

6, PLACE PAUL-PAINLEVÉ, 75005 PARIS

• This museum specializes in medieval life and arts: stained glass, tapestries and textiles, furniture and paintings.

Musée national de l'Orangerie

JARDIN DES TUILERIES, 75001 PARIS

• This gallery houses Monet's famous *Water lilies* as well as works by Rousseau, Renoir, Cézanne, Soutine, Matisse, Derain, Picasso, etc.

Musée d'Orsay

1, RUE DE BELLECHASSE, 75007 PARIS

• Housed in the former Orsay train station, this museum is devoted to 19th-century arts: furniture, decorative arts, sculptures by Daumier, Claudel, Rodin, Bourdelle and paintings by Manet, Toulouse-Lautrec, Monet, Cézanne, Degas, Gauguin, Van Gogh and many more.

Musée du Petit Palais

AVENUE WINSTON-CHURCHILL, 75008 PARIS

• The history of European art from its origins to the 19th century: stained glass, ceramics, clocks, majolica ware, furniture, sculptures, and paintings by Mantegna, Botticelli, Rubens, Rembrandt, Courbet, Delacroix, Daumier, Monet, Pissarro, Sisley, etc.

Musée Picasso

5, RUE DE THORIGNY, 75003 PARIS

• A collection of works covering every period of Picasso's output (paintings, sculptures, collages, drawings, prints and ceramics). The museum also displays works from Picasso's own collection: Cézanne, Braque, Matisse, Miró and furniture by Diego Giacometti.

Centre national d'Art et de Culture Georges-Pompidou

19, RUE BEAUBOURG, 75004 PARIS

• All the major trends of 20th-century art are represented through works by Picasso, Braque, Matisse, Duchamp, Kandinsky, Chagall, Léger, Miró, Ernst, Dali, Giacometti, Bacon, etc.

Musée Rodin

77, RUE DE VARENNE, 75007 PARIS

• Rodin's former studio and gardens now house numerous works by the sculptor: bronze, plaster and marble statues, plus drawings and watercolors, as well as works by Camille Claudel and paintings from Rodin's own collection (Renoir, Monet, Van Gogh, etc).

Reims

Musée des Beaux-Arts

8, RUE DE CHANZY, 51100 REIMS

• A varied collection: 18th-century furniture, 19th- and 20th-century ceramics and pottery, and German, Flemish, Dutch and French paintings (including works by Cranach, David, Rousseau, Millet, Boudin, Monet, Pissarro).

Rennes

Musée des Beaux-Arts

20, QUAI EMILE-ZOLA, 35000 RENNES

• Art from the 14th to the 20th centuries: drawings by Leonardo, Dürer, Rembrandt, paintings by Veronese, Lebrun, La Tour, Chardin, Corot, Gauguin, Caillebotte, Picasso, sculptures by Magnelli, Richier, etc.

Rouen

Musée des Beaux-Arts

SQUARE VERDEL, 76000 ROUEN

• Art and objects from the 16th to the 20th centuries: faience, silver, jewelry, sculptures and paintings by Veronese, Perugino, Guerchino, Caravaggio, Velázquez, Ribera, Rubens, Steen, Poussin, Géricault, Millet, Monet, etc.

Saint-Etienne

Musée d'Art moderne

LA TERRASSE, 42000 SAINT-ETIENNE

• Major trends in 20th-century art: works by Rodin, Monet, Matisse, Picasso, Léger, Duchamp, Ernst, Miró, Picabia, Dubuffet, Fautrier, Hartung, Manessier, Soulages, Penk, Baselitz, Lüpertz.

Saint-Paul-de-Vence

Fondation Maeght

06570 SAINT-PAUL-DE-VENCE

• The exceptional setting of Marguerite and Aimé Maeght's Foundation houses a set of works by Braque, Miró, Chagall, Dubuffet, Giacometti, Chillida, Hantaï, Alechinsky, Viallat and others.

Sèvres

Musée national de la Céramique

PLACE DE LA MANUFACTURE, 92310 SÈVRES

• This museum is devoted to various aspects of the history of ceramics.

Strasbourg

Musée des Arts décoratifs et des Beaux-Arts

PALAIS ROHAN, 2, PLACE DU CHÂTEAU, 67000 STRASBOURG

• The Rohan palace houses two museums, one devoted to decorative arts (17th to 19th centuries), the other to fine arts (works by Giotto, Botticelli, Raphael, Veronese, Canaletto, Rubens, Van Dyck, Goya, Vouet, Boucher, Corot, Courbet, etc).

Toulouse

Musée des Augustins

21, RUE DE METZ, 31000 TOULOUSE

• This former monastery, dating from the 14th century, now houses a collection of Gothic sculptures, plus paintings by Murillo, Van Dyck, Rubens, Delacroix, Corot, Courbet, Toulouse-Lautrec, Morisot, Vuillard, Utrillo and sculptures by Rodin and Maillol.

Tours

Musée des Beaux-Arts

18, PLACE FRANÇOIS-SICARD, 37000 TOURS

• This former bishop's palace boasts furniture and artworks including paintings by Mantegna, Rembrandt, Rubens, Boucher, Delacroix, Degas, Monet, and others.

Valenciennes

BOULEVARD WATTEAU,
59300 VALENCIENNES

• Sacred art, paintings from the Flemish and French schools, plus a major set of works by Jean-Baptiste Carpeaux (sculptures, paintings and drawings).

Versailles

78000 VERSAILLES

 • The royal chateau and its gardens not only represent the epitome of 17th-century architecture, they also house a vast collection of furniture, objects and artworks.

Villeneuve-d'Ascq

1, ALLÉE DU MUSÉE,
59650 VILLENEUVE-D'ASCQ

• Art of the 20th century: Braque, Laurens, Picasso, Léger, Klee, Masson, Miró, etc.

GERMANY
Aachen

WILHELMSTRAßE 18, 52070 AACHEN

• Medieval sculpture, Renaissance and baroque religious art; 15th- to 17th-centuries painting from Flanders, the Netherlands and Germany. Prints by Piranesi, Dürer, Rembrandt, Goya, etc.

Berlin

BODESTRAßE 1-3, 10178 BERLIN

• Works by Von Menzel and Lieberman; French painting (Rousseau, Corot, Courbet and also Manet, Monet, Renoir, Pissarro and Cézanne); sculptures by Rodin, Maillol and Degas, etc.

KLINGELHÖFERSTRAßE 14, 10785 BERLIN

• Paintings by Kandinsky, Klee, Schlemmer, Feininger; works by Itten, Albers and Moholy-Nagy; furniture, ceramics, sculpture, architecture, photography and theater costumes.

MARTIN-GROPIUS-BAU,
STRESEMANNSTRAßE 110, 10963 BERLIN

• Paintings, drawings, sculptures and photography from the 20th century: expressionism, dadaism, Dix, Grosz, etc.

BUSSARDSTEIG 9, 14195 BERLIN-DALHEM

• This museum features the Die Brücke group of artists (1905–1913): Schmidt-Rottluf, Heckel, Kirchner, Nolde, Pechstein, etc.

ARNIMALLEE 23-27,
1495 BERLIN

• European painting from the 13th to 17th centuries. Masterpieces by Dürer, Holbein, Altdorfer, Van Eyck, Brueghel, Bosch, Giotto, Botticelli, Mantegna, Vermeer, Rubens, Rembrandt, etc.

Neue Nationalgalerie

POSTDAMER STRAßE 50,

10785 BERLIN

• A building designed by Mies Van der Rohe houses a permanent collection of key figures from the major trends in 20th-century European art.

Bonn

Kunstmuseum Bonn

FRIEDRICH-EBERT-ALLEE 2,

53113 BONN

• 20th-century art in Germany: Macke, Campendonk, Ernst, Beuys, Polke, Knoebel, Baselitz. Major collection of 20th-century drawings.

Braunschweig

Herzog Anton Ulrich Museum

MUSEUMSTRAßE 1,

38100 BRAUNSCHWEIG

• Flemish, Dutch, Italian, German and French masters. Works by Rembrandt, Rubens and Vermeer. Drawings, prints and illustrated books from the High Middle Ages to the 20th century.

Dortmund

Museum am Ostwall

OSTWALL 7,

44122 DORTMUND

• This museum boasts a major collection of works by artists from Die Brücke and Blue Rider groups, as well as collections featuring various art movements in Europe from 1950 to the present.

Dresden

Staatliche Kunstsammlungen Albertinum

BRÜLHSCHE TERRASSE, 01067 DRESDEN

• This museum has various items from medieval days to the present (ivory, precious metalwork, jewelry and sculpture), plus 19th-century German painting (Böclin, Menzel, among others) and a set of Impressionist paintings.

Staatliche Kunstsammlungen Alte Meister

SEMPERBAU AM ZWINGER, 01067 DRESDEN

• European painting from the Renaissance to the 18th century: Raphael, Giorgione, Titian, Correggio, Rubens, Van Dyck, Rembrandt, Vermeer, etc.

Duisburg

Wilhelm-Lehmbruck-Museum

FRIEDRICH-WILHELM-STRAßE 40,

47049 DUISBURG

• 20th-century sculpture plus drawings, prints and photography: works by Wilhem Lehmbruck, Barlach, Kollwitz, Archipenko, Duchamp-Villon, Picasso, Arp, Dali, Ernst, Beuys, and so on.

Düsseldorf

Kunstmuseum Düsseldorf im Ehrenhof

EHRENHOF 5, 40479 DÜSSELDORF

• Prints from the 15th century to the present, glass, textiles, Dutch and Flemish painting from the 16th and 17th centuries, French and Italian painting from the 18th century.

GRABBEPLATZ 5, 40102 DÜSSELDORF

• 88 paintings and works on paper by Paul Klee constitute the core of this collection which covers the major movements of 20th-century art.

Essen

Folkwang Essen

GOETHESTRAßE 41, 45128 ESSEN

• European art of the 19th and 20th centuries: drawings, prints, photographs, painting and sculpture by Böcklin, Leibl, Manet, Corot, Courbet, Delacroix, Monet, Cézanne, Van Gogh, Dali, Ernst, Miró, Magritte, Tanguy, etc.

Frankfurt am Main

Städelsches Kunstinstitut und Städtische Galerie

HOLBEINSTRAßE 2, 60598 FRANKFURT AM MAIN

• European art from the 14th to 20th centuries. Paintings by Cranach, Dürer, Altdorfer, Holbein, Van Eyck, Campin, Van der Weyden, Rembrandt, Vermeer, Rubens, Fra Angelico, Botticelli, Tintoretto, Watteau, Chardin, Corot, Delacroix, Monet, Degas, Cézanne, plus numerous German works from the 19th and 20th centuries.

Museum für Moderne Kunst

DOMSTRAßE 10, 60311 FRANKFURT AM MAIN

• This museum is devoted to post-1960 art and features work by Palermo, Richter, Rainer, Bacon, Rainer, Richter, Ruthenbeck, among others.

Hamburg

Hamburger Kunsthalle

GLOKENGIEßERWALL, 20095 HAMBURG

• Medieval art, 17th-century Dutch painting, 19th- and 20th-century German artists (Corinth, Liebermann, Beckmann, Kirchner, Nolde, Marc, etc).

Museum für Kunst und Gewerbe Hamburg

STEINTORPLATZ 1, 20099 HAMBURG

• Applied arts and crafts in Europe from the Middle Ages to the present: precious metalwork, ivory, glass, majolica, faience, ceramics, porcelain, tapestries, musical instruments, etc.

Hannover

Niedersächsisches Landesmuseum Hannover

WILLY-BRANDT-ALLEE 5, 30169 HANNOVER

• This museum notably possesses a major collection of drawings and prints (as well as paintings) and feature works by Cranach, Botticelli, Rubens, Rembrandt, Poussin, Friedrich, Liebermann, Corinth, etc.

Sprengel Museum

KURT-SCHWITTERS-PLATZ, 30169 HANNOVER

• 20th-century art: Picasso, Léger, Klee, Laurens, Schwitters, Arp, Barlach, Moore,

Rotella, and Hains, to name only a few.

Cologne

BISCHOFSGARTENSTRAßE 1,
50667 KÖLN

• The major 20th-century art movements are represented by paintings, sculptures, installations and a large collection of photographs.

BISCHOFSGARTENSTRAßE 1,
50667 KÖLN

• Painting and sculpture from the Middle Ages to the present: works by Rubens, Rembrandt, Gellée, Courbet, Manet, Monet, Renoir, Degas, Cézanne, etc.

Leipzig

DIMITROFFPLATZ 1, 04107 LEIPZIG

• European art from the Middle Ages to the present: drawings by Schongauer, Cranach, Baldung Grien, paintings by Friedrich, Böcklin, Liebermann, Corinth, and others.

Ludwigshafen

BERLINER STRAßE 23,
67059 LUDWIGSHAFEN

• Ivory, illuminated manuscripts and metalwork from the Middle Ages and Renaissance, plus many works from the first half of the 20th century: El Lissitsky, Picasso, Mondrian, Malevich, Delaunay, Schwitters.

Mainz

GROßE BLEICHE 49-51, 55116 MAINZ

• This museum is devoted to various aspects of the history of printing as well as to Gutenberg's life.

LIEBFRAUENPLATZ 5, 55116 MAINZ

• Art and applied arts in Europe from the Middle Ages to the present: paintings by Brueghel, Jordaens, Van Goyen, Ruysdael, to name only a few.

Mönchengladbach

ABTEISTRAßE 27, 41061 MÖNCHENGLADBACH

• Expressionism and contemporary art: Beuys, Broodthaers, Rückriem, Richter, Polke, etc.

Munich

BARER STRAßE 27, 80799 MÜNCHEN

• One of the largest collections of paintings in the world. Works by Cranach, Dürer, Altdorfer, Rembrandt, Rubens, Van Dyck, among others.

LUISENSTRAßE 33, 80333 MÜNCHEN

• Works by artists from the school of Munich, plus expressionists and contemporary artists such as Beuys, Fahlström, Jorn,

Kiefer, Nitsch, Penk, Polke, Rainer, etc.

Neue Pinakothek

BARERSTRAßE 29, 80799 MÜNCHEN

• 19th-century European painting: Friedrich, Menzel, Goya, Turner, David, Manet, Courbet, Monet.

Staatliches Museum für Angewandte Kunst

PRINZREGENTENSTRAßE 3, 80538 MÜNCHEN

• One of the largest museums of 20th-century design and applied arts.

Staatsgalerie Moderner Kunst

PRINZREGENTENSTRAßE 1, 80538 MÜNCHEN

• Modern and contemporary art: Marc, Kirchner, Beckmann, Klee, Kandinsky, Beuys, among others.

Münster

Westfälisches Landesmuseum für Kunst und Kulturgeschichte

DOMPLATZ 10, 48143 MÜNSTER

• Paintings, sculptures, drawings and prints from the Middle Ages to the present.

Nuremberg

Germanisches Nationalmuseum

KARTÄUSERGASSE 1, 90402 NÜRNBERG

• Various collections relating to the artistic and cultural history of Central Europe.

Sarrebrücken

Saarland Museum

BISMARCKSTRAßE 11-19, 66111 SAARBRÜCKEN

• Art from Saar, Lorraine and Luxembourg from the 12th to 19th centuries, plus modern drawings, prints and paintings: Ensor, Kubin, Archipenko, Marc, Beuys.

Schwerin

Schwerin-Kunstsammlungen, Schlösser und Gärten

ALTER GARTEN 3, 19055 SCHWERIN

• A broad collection of European art from the Middle Ages to the present, including major Dutch and Flemish works by Brueghel, Rubens, Rembrandt, Hals and others.

Stuttgart

Galerie der Stadt Stuttgart

SCHLOßPLATZ 2, 70173 STUTTGART

• Many works by German artists from 1800 to the present.

Staatsgalerie Stuttgart

KONRAD-ADENAUER-STRAßE 30-32, 70173 STUTTGART

• A vast collection (sculpture, painting, drawing, prints) traces the history of art in Europe from the 14th century to the present: Memling, Rembrandt, Picasso, Beckmann, Beuys, Kiefer, etc.

Weil am Rhein

Vitra Design Museum

CHARLES EAMES STRAßE 1, 79576 WEIL AM RHEIN

• The history of design illustrated through works by the most famous designers.

Weimar

Kunstsammlungen zu Weimar

BURGPLATZ 4, 99423 WEIMAR

• A museum with collections covering baroque et rococo sculpture, faience, porcelain and glass, plus paintings by Cranach, Dürer, Tintoretto and Veronese, works by Böcklin, Liebermann, Rodin and Monet, as well as over 500 works and documents relating to the history of the Bauhaus.

GREAT BRITAIN
Aberdeen

Aberdeen Art Gallery

SCHOOLHILL, ABERDEEN, SCOTLAND AB 10

• The collection covers various aspects of the decorative arts, plus a set of canvases by British painters of the 18th century (Hogarth, Raeburn, Reynolds) and 20th century (Nash, Nicholson, Bacon) as well as works by Monet, Pissarro, Bonnard, etc.

Belfast

Ulster Museum

BOTANIC GARDEN, BELFAST BT9 5AB

• This museum boasts several collections covering European science, history and arts: ceramics, jewelry, glass and precious metalwork and paintings (English and Irish artists from the 17th to the 20th century).

Birmingham

Birmingham Museum and Art Gallery & The Gas Hall

CHAMBERLAIN SQUARE, BIRMINGHAM B3 3DH

• Fine and applied arts in Europe from the Middle Ages to the present, including Pre-Raphaelite stained glass and paintings, plus Italian, English and French paintings (Martini, Bellini, Gentileschi, Canaletto, Reynolds, Gainsborough, Turner, Degas, Pissarro, Renoir).

Barber Institute of Fine Arts

THE UNIVERSITY OF BIRMINGHAM, EDGBASTON, BIRMINGHAM B15 2TS

• This museum houses a collection of illuminated manuscripts and rare books as well as paintings, drawings and sculptures by Bellini, Poussin, Gainsborough, Turner, Rosseti, Whistler, Monet, Degas, Renoir, etc.

Cambridge

Fitzwilliam Museum

TRUMPINGTON STREET, CAMBRIDGE CB2 1RB

• The collection includes several sections on the applied arts, along with Italian painting from the 15th century, Flemish and Dutch works, French Impressionist painting, and works by British artist such as Turner, Stubbs and Constable.

Chichester

Pallant House Gallery

9 NORTH PALLANT, CHICHESTER PO19 ITJ

• 20th-century artists such as Moore, Hepworth, Nicholson, Severini, Klee, Picasso, etc.

Durham

The Bowes Museum

BARNARD CASTLE, DURHAM DL12 NP

- This collection was assembled primarily between 1850 and 1874 by Mr. Bowes and includes decorative arts along with some 1,400 paintings by the likes of Sassetta, Primaticcio, Tiepolo, Canaletto, El Greco, Goya, Boucher, Robert, Courbet, etc.

Edinburgh

National Gallery of Scotland

THE MOUND, EDINBURGH EH2 2EL

- A collection of drawings, prints and paintings from the Renaissance to the late 19th century: Velázquez, Rembrandt, Vermeer, Turner, Constable, Monet, Van Gogh, etc.

Royal Museum of Scotland

CHAMBERS STREET, EDINBURGH EH1 1JF

- Fine art in Europe from 1200 to 1800, decorative arts from 1850 to the present.

Scottish National Gallery of Modern Art

BELFORD ROAD, EDINBURGH EH4 3DR

- A collection devoted to 20th-century art: Moore, Matisse, Picasso, Ernst, Freud, Baselitz, etc.

Glasgow

Art Gallery and Museum

KELVINGROVE, GLASGOW G3 8AG

- Precious metalwork, jewelry, glass and ceramics, paintings by Botticelli, Giorgione, Rembrandt, Millet, Van Gogh, Monet,

Derain, Picasso, to name only a few.

Leeds

Leeds City Art Gallery

THE HEADROW, LEEDS LSI 3AA

- Old masters plus art of the 19th and 20th centuries: Constable, Turner, Fantin-Latour, Sisley, Renoir, Kossof, Bacon, and sculpture by Moore, Hepworth, Rodin, etc.

Liverpool

Walker Art Gallery

WILLIAM BROWN STREET, LIVERPOOL L3 8EL

- European art from the 14th to the 20th century, notably Victorian and Pre-Raphaelite painters.

London

Royal Academy of Arts

BURLINGTON HOUSE, PICCADILLY, LONDON W1V ODS

- A collection of paintings and sculptures, with four works by Michelangelo (including the famous *tondo*).

British Museum

GREAT RUSSELL STREET, LONDON WC1B 3DG

- Works from the Middle Ages, the Renaissance and the modern period.

Courtauld Gallery

SOMERSET HOUSE STRAND, LONDON WC2

- A collection of paintings by Botticelli, Tiepolo, Rubens, Goya, Manet, Van Gogh, Cézanne, etc.

Dulwich Picture Gallery

COLLEGE ROAD, LONDON SE21 7AD

• A collection that includes works from the Renaissance as well as the 17th and 18th centuries.

Leighton House Museum and Art Gallery

12 HOLLAND PARK ROAD, LONDON W14 8LZ

• Art from the Victorian era: paintings by Leighton, Burne-Jones, Millais, etc.

National Gallery

TRAFALGAR SQUARE, LONDON WC2N 5DN

 • European art from the 13th to the 20th century: paintings by Van Eyck, Piero della Francesca, Botticelli, Leonardo da Vinci, Raphael, Titian, Veronese, Rembrandt, Vermeer, Turner, Cézanne, Van Gogh, Seurat, etc.

National Portrait Gallery

SAINT MARTIN'S PLACE, LONDON WC2H OHE

• The largest collection of portraits in the world (paintings, miniatures, sculptures, photographs, etc).

Tate Gallery

MILLBANK, LONDON SW1P 4 RG

• English painting from the 16th century to the present, European art and modern art (works by Turner, Bacon, Freud, etc.).

Victoria and Albert Museum

CROMWELL ROAD, SOUTH KENSINGTON, LONDON SW7 2RL

• Furniture, precious metalwork, ceramics, paintings and visual arts including the largest collection of works by Constable.

Wallace Collection

HERTFORD HOUSE,
MANCHESTER SQUARE,
LONDON W1M 6BN

• Majolica, miniatures, glass, precious metalwork, Limoges enamels and paintings by Titian, Canaletto, Rembrandt, Rubens, Hals, Velázquez, Gainsborough, etc.

Manchester

Manchester City Art Galleries

MOSLEY STREET,
MANCHESTER M2 3JL

• A collection of decorative arts, paintings and sculptures: Turner, Gainsborough, Stubbs, Pre-Raphaelites, Freud, Bacon, Nicholson, etc.

Oxford

Ashmolean Museum and University Galleries

BEAUMONT STREET,
OXFORD OX1 2PH

• A collection of paintings, drawings, sculpture and decorative arts.

Saint Ives

Tate Gallery Saint Ives

PORTHMEOR BEACH,
SAINT IVES TR26 1TG

• Collection of modern art, sculpture garden with works by Hepworth, etc.

Southampton

CIVIC CENTRE,
SOUTHAMPTON, SO14 7 LP

• European art from the 14th to the 20th century, including contemporary British artists such as Gordon, Gilbert & George, Flanagan, Gormley, etc.

York

York City Art Gallery

EXHIBITION SQUARE,
YORK Y01 2EW

• Six hundred years of painting in Europe: Italian, English and French work (Parmigianino, Bellotto, Reynolds, Boudin, etc).

IRELAND
Dublin

Irish Museum of Modern Art

ROYAL HOSPITAL KILMAINHAM, DUBLIN 8

• Founded in 1911, this museum specializes in 20th-century art in Ireland and the rest of the world.

National Gallery of Ireland

MERRION SQUARE (WEST), DUBLIN 2

• European painting from the 12th century to the present: Fra Angelico, Titian, Tiepolo, Rembrandt, Vermeer, Rubens, Van Dyck, Velázquez, Goya, David, Delacroix, Monet, Reynolds, Turner, etc.

National Museum of Ireland

KILDARE STREET, DUBLIN 2

• This art and archaeology museum retraces the history of the Irish isle.

ITALY
Bari

Pinacoteca Provinciale di Bari

VIA SPALATO 19, 70121 BARI

• Medieval sculpture, frescoes and icons from the 13th and 14th centuries, ceramics and statues from the 18th century, paintings by Bellini, Bordone, Veronese, Tintoretto, etc.

Bologna

Pinacoteca Nazionale

VIA BELLE ARTI 56, 40126 BOLOGNA

• This former Jesuit school houses frescoes and paintings by Giotto, Perugino, Titian, El Greco, the Carraccis, Reni, Guerchino, etc.

Florence

Casa Buonarroti

VIA GHIBELLINA 70, 50122 FIRENZE

• Devoted to the oeuvre of Michelangelo, this museum boasts his youthful marbles, sculptures and a major collection of drawings.

Galleria d'Arte Moderna

PIAZZA PITTI 1, 50125 FIRENZE

• Designed by Brunelleschi, the Pitti palace now houses several museums. Its collections cover works by Tuscan and foreign artists: Signorini, Boldini, Tofanelli, Landi, Canova, Böcklin, etc.

Galleria degli Uffizi

PIAZZALE DEGLI UFFIZI 6, 50122 FIRENZE

• One of the finest collections of painting in the world: Giotto, Fra Angelico, Masaccio, Uccello,

Botticelli, Ghirlandaio, Raphael, Perugino, Leonardo da Vinci, Michelangelo, etc., as well as Flemish, German and Spanish works.

Galleria dell'Accademia

VIA RICASOLI 60, 50123 FIRENZE

• When founded in 1874, this museum presented the paintings collected by the Grand Duke Pietro Leopoldo. It now boasts, among other things, a set of sculptures by Michelangelo (*David, Pietà di Palestrina,* the *Captives*) and a collection of Florentine paintings, etc.

Museo di Palazzo Vecchio

PIAZZA DELLA SIGNORIA,
50122 FIRENZE

• Frescoes by Vasari, Borghini, Stradano, Zucchi, Ghirlandaio; sculptures by Michelangelo, Verrocchio, Donatello, Bandinelli, Rossi, plus a collection of musical instruments.

Museo di San Marco

PIAZZA SAN MARCO 3,
50121 FIRENZE

• This former medieval monastery, rebuilt in the 15th century, preserves frescoes by Fra Angelico (the *Life of Christ* and the *Annunciation*), Ghirlandaio, Fra Bartolomeo, Sogliani, Gherardini, Ulivelli, etc., as well as a collection of psalters and illuminated manuscripts.

Museo Nazionale del Bargello

VIA DEL PROCONSOLO 4, 50122 FIRENZE

• One of the oldest buildings in Florence was turned into a national museum in 1865. Its extensive collection (marbles, bronzes, medieval sculpture, terracotta, applied arts, frescoes and paintings) includes works by Donatello, Ghiberti, Brunelleschi, Verrochio, Cellini, Michelangelo, etc.

Opera di Santa Maria del Fiore

PIAZZA DEL DUOMO 9, 50122 FIRENZE

• A collection of paintings, mosaics, precious metalwork, liturgical objects, reliquaries and religious sculpture from the 14th to the 16th centuries, including works by Pisano, Donatello, Della Robbia, Michelangelo, etc.

Museo Storico Topografico Firenze Comer

VIA DELL'ORIUOLO 24, 50122 FIRENZE

• Geographic maps, drawings, prints and paintings illustrating the history of Florence from the 15th century onward.

Genoa

Galleria di Palazzo Bianco

VIA GARIBALDI 11, GENOVA

• This museum's collection includes works by Strozzi, Magnasco, Lippi, Veronese and Caravaggio, plus Memling, David, Rubens.

Galleria di Palazzo Rosso

VIA GARIBALDI 18, 16124 GENOVA

• Built in the 17th century, the Rosso palace houses a collection of paintings, sculpture, furniture, and frescoes (works by Veronese, Bordone, Carracci, Reni, Guerchino,

Cambiaso, Strozzi, Van Dyck, Rigaud, etc).

Galleria Nazionale di Palazzo Spinola

PIAZZA PELLICERIA 1, 16126 GENOVA

• The Spinola palace boasts a varied collection of furniture, textiles, tapestries, porcelain and precious metalwork from the 17th and 18th centuries, as well as works by Messina, Parodi, Castello, Pisano, Giambola, Van Cleve, Van Dyck, Rubens, etc.

Museo di architettura e scultura ligure di Sant'Agostino

PIAZZA SARZANO 35, 16124 GENOVA

• This 13th-century church and 17th-century cloister houses a collection of engravings and documents on the history of Genoa, plus works by Pisano, Gaggini, Parrodi, Canova, etc.

Milan

Museo Poldi Pezzoli

VIA MANZONI 12, 20121 MILANO

• Works by Botticelli, Solario, Boltraffio, Canaletto, Tiepolo, Guardi, plus a varied collection of armor and weapons, jewelry and enamels, glass from Murano, ceramics, tapestries, etc.

Galleria d'Arte Moderna

VIA PALESTRO 16, 20121 MILANO

 • This neoclassical "villa" displays works by Marini, Rosso, Spadini, Nittis, Boldini, Segantini, Chirico, Boccioni, Corot, Millet, Van Gogh, Gauguin, Toulouse-

Lautrec, Picasso, Matisse, among others.

Pinacoteca di Brera

VIA BRERA 28, 20121 MILANO

 • Dating from the 17th century, the Brera palace hosts work by Raphael, Piero della Francesca, Palma Giovane, Veronese, Tintoretto, Carpaccio, Correggio, Caravaggio, Tiepolo, frescoes by Bramante and Luini, a sculpture by Canova, canvases by Van Dyck, Rubens, El Greco, Reynolds, etc.

Naples

National Museum of Ceramics Duca di Martina

VIA CIMAROSA 77, 80100 NAPOLI

• Ceramics and porcelain from Meissen, Capodimonte, Ginori, Rouen, Chantilly, Saint-Cloud, Mennecy and Sèvres, majolica from Gubbio, Deruta, Faenza and Palermo, plus collections of glass, tapestries, enamels, ivories and paintings (including the Neapolitan school).

Museo di Capodimonte

VIA MIANO 1, 80137 NAPOLI

• This palace houses a remarkable selection of paintings largely coming from the Farnese collection, plus a gallery of 19th-century paintings. The palace's historic apartments and a collection of majolica are also on display.

Parma

VIA VECCHIA DI SALA 18, 43030 MAMIANO

• In a centuries-old setting, the Mamiano di Traversetolo "villa" houses a collection of furniture and paintings (works by Da Fabriano, Lippi, Dürer, Titian, Rubens, Van Dyck, Goya, Monet, Renoir, Cézanne, Morandi, Burri, etc).

Pavia

PIAZZA CASTELLO, 27100 PAVIA

• From the Middle Ages to the present: bas-reliefs, mosaics, terracotta, marbles, paintings (Messina, Luini, Bellini, Tiepolo, as well as works by 19th- and 20-century Italian painters and sculptors).

Perugia

PALAZZO DEI PRIORI, CORSO VANNUCCI, 06100 PERUGIA

• The world's largest collection of Umbrian art: jewelry, fabrics, ceramics, paintings, etc. Works from the 13th to 19th centuries by Arnolfo di Cambio, Guido da Siena, Duccio, Gentile da Fabriano, Fra Angelico, Piero della Francesca, Pinturicchio, etc.

VIA ALBIZZINI 1,
06012 CITTA DI CASTELLO-PERUGIA

• Dating from the 15th century, the Albizzini palace houses a major collection devoted to the oeuvre of A. Burri.

Rome

PIAZZA DELL'ACADEMIA DI SAN LUCA 77,
00187 ROMA

• Built in the 16th century, the Carpegna palace displays works by Florentine, Venetian and Flemish masters: G. and B. Bassano, Mola, Pellegrini, Canova, Rubens, Van Dyck, etc.

VIA DELLE BELLE ARTI 131, 00197 ROMA

• European art in the 19th and 20th centuries: Italian Art Nouveau, plus works by Boccioni, Severini, Prampolini, Morandi, Magnelli, Degas, Rodin, Klimt, Modigliani, Mondrian, Duchamp, Kandinsky, etc.

VIA QUATTRO FONTANE 13,
00184 ROMA

• The baroque architecture of the Barberini palace houses frescoes by Pietro da Cortona and works by Lippi, Perugino, Raphael, Lotto, Titian, Tintoretto, Caravaggio, Bernini, Tiepolo, Canaletto, Holbein, Boucher, Fragonard, etc.

PIAZZALE SCIPIONE BORGHESE 5,
00197 ROMA

• Built in the 15th century for Cardinal Borghese, this "villa" now boasts a gallery of sculptures and paintings by Bellini, Perugino, Lotto, Raphael, Titian, Bronzino, Veronese, etc.

Musei Capitolini

PIAZZA DEL CAMPIDOGLIO 1, 00186 ROMA

• This museum's collection, begun in 1471, includes frescoes and sculptures as well as paintings by Titian, Veronese, Tintoretto, Caravaggio, Rubens, etc.

Museo di Palazzo Venezia

VIA DEL PLEBISCITO 118, 00186 ROMA

• This 15th-century palace boasts a varied collection of sculpture in wood, bronze and marble, weapons and armor, ivories, majolica, terracotta, tapestries, ceramics and paintings by Veneziano, Gozzoli, Guerchino, to name only a few

Rome, Vatican

Monumenti, Musei e Gallerie Pontificie

00120 CITTÀ DEL VATICANO

• An outstanding group of buildings, museums and collections including, among other things, sculptures such as the *Belvedere Apollo* and the *Laocoon*.

Siena

Museo dell'Opera del Duomo

PIAZZA DUOMO 8, 53100 SIENA

• Frescoes by Sienese artists of the 15th and 16th centuries, sculptures by Donatello and Ghiberti, precious metalwork, illuminated manuscripts, tapestries, urns and reliquaries, plus paintings by Duccio, Lorenzetti, etc.

Turin

Galleria Civica d'Arte Moderna e Cont.

VIA MAGENTA 31, 10128 TORINO

• Numerous paintings, sculptures and prints from the 18th century to the present: Modigliani, Balla, Severini, Boccioni, De Chirico, Morandi, Manzoni, Klee, Paolini, Anselmo, Penone, Zorio, Ernst, Picabia, etc.

Galleria Sabauda

VIA ACCADEMIA DELLE SCIENZE 6, 10123 TORINO

• This palace, dating from the 17th century, features a collection of Flemish, Dutch, German, French and Italian artists (including Fra Angelico, Botticini, Botticelli, Bellini, Veronese, Tintoretto, Bassano, Reni, Memling, Van der Weyden, Van Eyck, Rembrandt, Rubens, etc).

Venice

Palazzo Ducale

PIAZZA SAN MARCO 1, 30124 VENEZIA

• The Doges's palace is decorated with frescoes, paintings and bas-reliefs plus canvases by Tintoretto, Veronese, Bassano, etc.

Peggy Guggenheim Collection

DORSODURO 701, 30123 VENEZIA

• Works by representatives of the major 20th-century trends in art: Mondrian, Kandinsky, Picasso, Miró, Magritte, Ernst, Brancusi, Giacometti, etc.

Galleria dell'Accademia

CAMPO DELLA CARITA, 30121 VENEZIA

• Venetian painting (including ceiling and wall frescoes) from the 14th to 18th centuries: Cozzi, Jacobello del Fiore, Veneziano, Veronese, Tintoretto, Titian, Zucarelli, Tiepolo, Canaletto, Guardi, etc.

Museo Correr
PIAZZA SAN MARCO 52,
30124 VENEZIA

• A museum of art and history comprising porcelain, prints, statues and bas-reliefs (including certain works by Canova), plus frescoes and paintings by Carpaccio, Antonello da Messina, Bellini, Cosmè Tura, etc.

LUXEMBOURG
Luxembourg

Musée d'Histoire de la Ville de Luxembourg
14, RUE DU SAINT-ESPRIT,
1475 LUXEMBOURG

• This museum's varied collection (religious art, furniture, weapons, costumes, everyday objects, etc.) covers 1,000 years in the history of the city of Luxembourg.

Musée Jean-Pierre Pescatore
PARC MUNICIPAL, AVENUE REUTER,
2090 LUXEMBOURG

• A collection devoted primarily to Flemish and Dutch masters of the 17th and 18th centuries: Teniers, Van Dyck, Steen, Wouwerman, plus Swiss, German and French artists of the 19th century (including Delacroix, Courbet, etc).

Musée national d'Art et d'Histoire
3, RUE WILTHEIM,
MARCHÉ-AUX-POISSONS,
2345 LUXEMBOURG

• Medieval sculpture, altarpieces, folk art and ceramics, plus paintings by P. Brueghel the younger, Cranach, Van Dyck, Jordaens, Teniers, etc.

NETHERLANDS
Amstelveen

Cobra Museum of Modern Art
SANDBERGPLEIN 1-3, 1181 ZX AMSTELVEEN

• This museum features over 500 works by artists in the group dubbed CoBrA (Copenhagen, Brussels, Amsterdam): Appel, Constant, Jorn, Alechinsky, Dotremont, etc.

Amsterdam

Rembrandthuis
JODENBREESTRAAT 4-6, 1011 NK AMSTERDAM

• Rembrandt's former house is now a museum that boasts almost his entire engraved oeuvre.

Rijksmuseum
STADHOUDERSKADE 42, 1071 ZD AMSTERDAM

• European sculpture and decorative arts from the Middle Ages to the present, plus the commercial, military and maritime history of the Netherlands, and prints from the 15th to the 20th century. The painting collection boasts works by, among others, Rembrandt (*The Night Watch*), Vermeer, Hals, Steen, etc.

Stedelijk Museum Museum of Modern Art
PAULUS POTTERSTRAAT 13,
1071 CX AMSTERDAM

• An overview of modern and contemporary art (painting, sculpture, drawings, prints, photographs, applied arts): Van Gogh, Cézanne, Monet, Malevich, Kandinsky,

Chagall, Picasso, Matisse, Dubuffet, Constant, Corneille, Toorop, etc.

Van Gogh Museum

PAULUS POTTERSTRAAT 7,

1007 CX AMSTERDAM

• Several hundred paintings and drawings by Vincent Van Gogh are on permanent display alongside works by Toulouse-Lautrec, Gauguin, Fantin-Latour, Monet, etc.

Amsterdam Historical Museum

KALVERSTRAAT 92, 1012 RM AMSTERDAM

• This museum's varied collection—furniture, metalwork, costumes, glass and porcelain, engravings, portraits, anatomical drawings (including Rembrandt's *The Anatomy Lesson of Dr. Deijman*)—is devoted to the history of the city of Amsterdam.

Nederlands Scheepvaartmuseum Amsterdam

KATTENBURGERPLEIN 1,

1018 KK AMSTERDAM

• This museum presents the Netherlands' maritime history (models of ships, navigation instruments, maps, paintings).

Joods Historisch Museum

JONAS DANIËL MEILERPLEIN 2-4,

1011 RH AMSTERDAM

• A collection showing the multiple facettes, past and present, of Judaism in the Netherlands.

Dordrecht

Dordrechts Museum

MUSEUMSTRAAT 40, 3311 XP DORDRECHT

• A collection of paintings, drawings and prints from the 17th century to the present: Cuyp, Maes, Van Hougstraten, Van Goyen, Scheffer, Toorop, Sluyters, Appel, Lataster, among others.

Eindhoven

Stedelijk Van Abbemuseum

VONDERWEG 1,

5611 BK EINDHOVEN

• A selection of works from the heyday of the 20th-century avant-garde to the present: El Lissitzky, Moholy-Nagy, Mondrian, Delaunay, Picasso, Chagall, Kiefer, Beuys, Merz, etc.

Enschede

Rijksmuseum Twenthe

LASONDERSINGEL 129-131,

7514 BP ENSHEDE

• This museum has a varied collection of fine and applied arts from the 13th to 19th centuries, plus modern and contemporary works: manuscript, rare books, furniture, glass and metalwork, sculpture, plus paintings by Cranach, Holbein, Brueghel, Ruisdael, Van Goyen, Monet, Sisley, etc.

Groningen

Groninger Museum

MUSEUMEILAND 1,

GRONINGEN

• The Netherlands' maritime and merchant history is featured in the collection of this art and history museum (porcelain, sacred art, traditional and modern, etc).

Haarlem

Frans Hals Museum

GROOT HEILIGLAND 62, 2011 ES HAARLEM

• Eight group portraits by Hals constitute the core of this collection, which also includes paintings from the 17th century (Goltzius, Leyster, Heda, Van Ostade, etc.), a series of modern and contemporary works (Corneille, Appel, etc.), and a major collection of furniture, metalwork and ceramics from Haarlem.

The Hague

Mauritshuis

KORTE VIJVERBERG 7, 2513 AB DEN HAAG

• Built in the center of The Hague in the 17th century, the Mauritshuis houses a collection of paintings of Flemish et Dutch masters of the 15th and 16th centuries as well as key canvases by artists from the "golden age": Rembrandt, Vermeer, Steen, Hobbema, etc.

Leiden

De Lakenhal (Stedelijk Museum)

OUDE SINGEL 28-32, 2312 RA LEIDEN

• Painting and the decorative arts in Holland from the 16th to the 20th century: Leiden silver, pewter, and engraved glass plus paintings by Rembrandt, Lievens, Steen, Dou, Toorop, Van Doesburg, etc.

Maastricht

Bonnefantenmuseum

250 AVENUE CERAMIQUE,
6221 KX MAASTRICHT

• A museum of art and archaeology whose collections include a set of medieval sculptures, works by Italian primitives and Dutch painting of the 16th and 17th centuries (P. Brueghel the Younger, etc.), plus contemporary art (Beuys, Broodthaers, Dibbets, Kounellis, Merz, etc.)

Otterlo

Kröller-Müller Museum

HOUTKAMPWEG 6, 6731 AW OTTERLO

• The grounds feature sculpture by Maillol, Rodin, Dubuffet, Moore, Hepworth, Arp and Noguchi, while the museum itself displays paintings by Redon, Léger, Seurat, Signac, Picasso and, above all, an outstanding collection of nearly 100 works by Van Gogh.

Rotterdam

Museum Boijmans-Van Beuningen

MUSEUMPARK 18-20, 3015 CX ROTTERDAM

• This museum offers an overview of the decorative arts from the Middle Ages to the present (majolica, pewter, glass and metalwork), drawings and prints (Dürer, Goya, Giorgione, etc), paintings (Bosch, Van Eyck, Brueghel, Rembrandt, Van Gogh, Monet, Kandinsky, Magritte, Dali, etc).

Utrecht

Museum Catharijneconvent

NIEUWEGRACHT 63, 3512 LG UTRECHT

• This 15th-century convent now houses a museum devoted to the Catholic and

Protestant religions in the Netherlands, and their varied arts: medieval sculpture, manuscripts, precious metalwork and paintings (Rembrandt, Hals, Saenredam, etc).

Centraal Museum Utrecht
NIEUWEGRACHT 63,
3512 LG UTRECHT

• Holland's oldest municipal museum features canvases by the Utrecht school of Caravaggists (Ter Brugghen, Van Honthorst), plus objects, furniture and art from the 12th to the 20th century.

NORWAY
Bergen

Kunstmuseet
RASMUS MEYERS ALLÉ 7,
5014 BERGEN

• A collection assembled by an art critic, featuring Norwegian artists from the 19th and 20th centuries, including several works by Munch.

Stenersen Samling
RASMUS MEYERS ALLÉ 3,
5014 BERGEN

• A museum with works by Dahl, Petersen, Munch, Klee, Kandinsky, Picasso, the CoBrA group, etc.

Lillehammer

Lillehammer Kunstmuseet
STORTORGET 2, 2609 LILLEHAMMER

• Various aspects of Norwegian painting, especially the country's own version of the Romantic movement.

Oslo

Munchmuseet
TOYENGATA 53, 0578 OSLO

• This museum is entirely devoted to the art of Edvard Munch (1863–1944) and possesses the largest collection of his work (over 1,000 drawings, prints and paintings).

Nasjonalgalleriet
UNIVERSITETSGATEN 13, 0164 OSLO

• Paintings by realist and Romantic Norwegian artists, plus major works by Munch, Cranach, Greco, Rubens, Jordaens, Delacroix, Van Gogh, Gauguin, Bonnard, Braque, Matisse, Picasso, etc.

Kunstindustrimuseet
ST. OLAVS GATE 1, 0165 OSLO

• A varied collection devoted to the decorative arts in Europe from the Middle Ages to the present.

Henie-Onstad Kunstsenter
1311 HOVIKODDEN

• This foundation features the collection of a Norwegian couple who acquired works by, among others, Alechinsky, Bonnard, Bazaine, Corneille, Ernst, Klee, Matisse, Miró, Picasso and Staël.

Tromsø

Nordnorsk Kunstmuseet
MUSEGATA 2,
9008 TROMSØ

• A varied collection (paintings, drawings and sculpture) showing various aspects of Norwegian art, including works by Munch and Krohg.

Trondheim

Trondheim Kunstmuseet

LARGO DR. JOSÉ RODRIGUES, 3000 COIMBRA

BISPEGATE 7B, 7013 TRONDHEIM

• This museum specializes in Norwegian painters of the 19th and 20th centuries: Backer, Cappelen, Dahl, Krohg, Munch, etc.

PORTUGAL
Coimbra

Museu Nacional de Machado de Castro

LARGO DR. JOSÉ RODRIGUES, 3000 COIMBRA

• Art and objects from the Middle Ages to the 19th century: a major collection of Portuguese sculpture, paintings by Master Pero, Chanterenne, Metsys, Isenbrandt, etc.

Lisbon

Museu Nacional de Arte Antigua

RUA DAS JANELAS VERDES, 1293 LISBOA

• Furniture, rugs and tapestries, ceramics, precious metalwork; the painting collection covers works from the 14th century to the second half of 19th century: Piero della Francesca, Memling, Bosch (*The Temptation of Saint Antony*), Cranach, Holbein, Dürer, Tiepolo, Zurbarán, etc.

Museu Calouste Gulbenkian

AV. DE BERNA 45A, 1093 LISBOA

• One third of the Gulbenkian collection is devoted to European art: 14th-century ivories, illuminated manuscripts, French and Italian furniture and tapestries, precious metalwork, bronze and marble statues, plus a major set of canvases by Ghirlandaio, Carpaccio, Rembrandt, Van Dyck, Hals, etc.

Museu Do Chiado

RUA SERPA PIUTO 6, 1200 LISBOA

• An overview of art in Portugal from 1850 to 1950 (realism, Romanticism, symbolism, naturalism, modernism). Drawings and sculptures by Rodin.

Museu Nacional do Azulejo

RUA MADRE DE DEUS 4, LISBOA

• This former monastery, founded in 1509, houses a unique collection of decorative tiles produced in Spain, Portugal, the Netherlands, Belgium, etc, from the 15th century to the present.

Centro de Arte Moderna J. de Azeredo Perdigao

RUA DR. NICOLAU BETTENCOURT, 1093 LISBOA

• Modern and contemporary art in Portugal. European artists include Sonia and Robert Delaunay, Vieira da Silva, Szenes, Torres-Garcia, Blake, Hodgkin, Gorky.

Porto

Museu Nacional de Arte Antigua

RUA DE SERRALVES 977, 4150 PORTO

• 1,600 artworks from the 1960s to the present by Portuguese and foreign artists: Rego, Sarmento, Canogar, Saura, Tapiés, Richter, Cragg, Fischli and Weiss, etc.

SPAIN
Barcelona

Museu d'art de Catalunya

PALAU NACIONAL, PARC DE MONTJUIC, 08038 BARCELONA

• Catalonian art: frescoes from the 12th and

13th centuries, medieval, gothic and Catalonian sculpture of the 14th and 15th centuries. Works by Rubens, Ribera, Velázquez, Tiepolo, Fragonard and Goya.

Joan Miró Fundació

PARC DE MONTJUIC, 08038 BARCELONA

• A collection based on the artist's estate (paintings, drawings, prints, sculpture and ceramics) as well as works by Alechinsky, Balthus, Ernst, Francis, Gonzalez, Caro, Chillida, Duchamp, Matisse, Moore and others.

Museu Picasso

MONTCADA 15-19, 08003 BARCELONA

• Over 3,600 works by the famous artist from Catalonia, including important pieces from his early period (1890–1897), blue period and pink period, as well as variations on the theme of Velázquez's *Las Meniñas*.

Bilbao

Museo de Bellas Artes de Bilbao

PLAZA DEL MUSEO 2, 48011 BILBAO

• The museum is divided into four parts devoted to ancient and medieval art, the applied arts, Basque art and contemporary art. Works by El Greco, Velázquez, Murillo, Zurbarán, Goya and also Van Dyck, Jordaens, Ruisdael, etc.

Museo Guggenheim

AV. DA. ABANDO IBARRA 2, 48001 BILBAO

• In a remarkable building designed by Frank O. Gehry, this museum offers 240,000 square feet of gallery space for presenting major modern artists from the Guggenheim collection, complementing museums in New York and Venice.

Cadiz

Museo de Cadiz

PLAZA DE MINA,
CADIZ 11004

• A museum devoted to the province of Cadiz from the paleolithic period to the present. Many artworks and objects including canvases by Zurbarán and Murillo, plus Flemish and Italian baroque art.

Madrid

Monasterio de San Lorenzo del Escorial

AVENIDA JUAN DE BORBON Y B.,
28200 SAN LORENZODES ESCORIAL, MADRID

• A major collection of relics and reliquaries, as well as paintings by Ribera, Titian, El Greco, Velázquez, are housed in a palace that is an architectural masterpiece.

Museo nacional centro de arte Reina Sofia

SANTA ISABEL 52, 28012 MADRID

• This museum specializes in 20th-century art. Works by Picasso (*Guernica*), Gris, Miró, Dali, Gonzalez, Gargallo, Tapiés, Chillida, Magritte, Ernst, Masson, etc.

Palacio Real

CALLE BAILÉN, 28071 MADRID

• This neoclassic palace houses many 18th-century bronzes and sculptures as well as an outstanding set of Flemish tapestries based on cartoons by Raphael.

Museo del Prado

PASEO DEL PRADO,
28014 MADRID

 • Renaissance and classical sculpture. Spanish, Italian, German and Flemish painting from the Middle Ages to the 19th century: El Greco, Zurbarán, Murillo, Velázquez, Goya, Angelico, Botticelli, Mantegna, Titian, etc.

Museo de la real academia de bellas artes de San Fernando

CALLE ALCALA 13,
28014 MADRID

• This baroque palace, built by Churiguera, boasts a major collection of painting, sculpture and engravings (including a series of canvases by Goya).

Thyssen-Bornemisza Museum

PASEO DEL PRADO 8, 28014 MADRID

• An exceptional collection ranging from the Renaissance to the 20th century, including many Impressionist, post-Impressionist, and expressionist works.

Seville

Museo de bellas artes de Sevilla

PLAZA DEL MUSEO 9, 41001 SEVILLA

• This former 17th-century convent houses a collection of ceramics, furniture, painting and sculpture from the Middle Ages to the present, including fine examples from the school of Seville. Masterpieces by Murillo and Zurbarán, etc.

Toledo

Museo de El Greco

CALLE LEVI 3, 45001 TOLEDO

• A museum devoted exclusively to the work of El Greco. The period 1600–1614 is particularly well represented.

Valencia

Museo de bellas artes San Pio V

CALLE DE SAN PIO V 9, 46010 VALENCIA

• An overview of art in Valencia from the 14th century to the present. Italian and Flemish masters. Collection of prints (including Piranesi and Goya).

Valladolid

Museo nacional de escultura

CADENAS DE SAN GREGORIO 1,
47011 VALLADOLID

• Religious sculptures from the 13th to the 18th centuries. Flemish and Spanish gothic art. Spanish mannerist and baroque artists: Alonso Beruguete, Juan de Juni, Gregorio Fernandez.

SWEDEN
Gävle

Länmuseet

SÖDRA STRANDGATAN 20, 80128 GÄVLE

• Various aspects of Swedish art and crafts from the 19th century to the present.

Göteborg

GÖTAPLATSEN AVENYN, 41256 GÖTEBORG

- Swedish and European art from the 17th century to the present. Works by Milles, Larsson, Liljefors, Munch, Gauguin, Renoir, Monet, Chagall, Picasso, Bacon, etc.

Malmö

Konstmuseet
MALMÖHUS VÄGEN,
20124 MALMÖ

- This museum has a varied collection including a set of works by 19th-century Swedish artists.

Konsthall
JOHANNESGATAN 7, 20010 MALMÖ

- An exhibition space primarily devoted to contemporary Swedish art.

Stockholm

Moderna Museet
SKEPPSHOLMEN,
10327 STOCKHOLM

- This major museum, which inaugurated a new building in 1998, is devoted to modern and contemporary art (sculpture, painting, video) with work by Duchamp, Matisse, Picasso, and others.

National Museum
SÖDRA BLASIEHOLMSHAMNEN,
10324 STOCKHOLM

- Paintings, sculptures and the decorative arts. Works by Arcimboldo, Cranach, Rubens, Rembrandt, Zurbarán, La Tour, Chardin, Watteau, Manet, Renoir, Cézanne and Degas, plus Swedish artists of the 19th and 20th centuries.

Statens Historika Museet
NARVAVÄGEN 13-17, 11484 STOCKHOLM

- Various aspects of Swedish history as well as a collection of Gothic religious art.

Millesgarden
CARL MILLES WÄG LIDINGÖ 2,
18134 STOCKHOLM

- The home of sculptor Carl Milles (1875–1955) now houses his work and his own collection of other art objects.

SWITZERLAND
Aarau

Aargauer Kunsthaus Aarau
AARGAUERPLATZ, 5001 AARAU

- Art in Switzerland from the late 18th century to the present; paintings by Fuseli, Böcklin, Hodler, etc.

Basel

Fondation Beyeler
BASELSTRASSE 101, 4125 RIEHEN/BASEL

- A long building designed by Renzo Piano in the Berowerpark now houses the collection of the Hildy and Ernst Beyeler Foundation (over 150 modern paintings and sculptures). Temporary exhibitions provide a juxtaposition with contemporary art.

Musée Jean Tinguely
GRENZACHERSTRASSE, SOLITUDEPARK,
4002 BASEL

- Designed by Danish architect Mario Boota, this museum is devoted to Swiss artists Jean Tinguely, who died 1991 (over 70 sculpture-machines and numerous drawings),

thanks to an important bequest by his widow, Niki de Saint-Phalle.

Kunstmuseum
ST. ALBAN-GRABEN 16, 4010 BASEL

• Paintings, drawings and prints by masters from the Rhineland, plus Renaissance artists (including a large set of canvases by Holbein).

Bern

Bernisches Historisches Museum
HELVETIAPLATZ 5, 3000 BERN

• The history of the city of Bern from the Middle Ages to the present via a varied collection of paintings, furniture, tapestries, porcelain, glass.

Kunstmuseum Bern
HODLERSTRASSE 8-12, 3000 BERN

• A collection of paintings from the 14th to 20th centuries: masters of the Italian Renaissance, Swiss painters (Böcklin, Hodler), Manet, Courbet, Van Gogh, Cézanne, Degas, Bonnard, Braque, Picasso, etc. Numerous works by Paul Klee.

Geneva

Musée d'Art et d'Histoire
2, RUE CHARLES-GALLAND, 1206 GENÈVE

• This is one of Switzerland's largest museums, with an extensive collection of art and archaeology, including medieval sculpture, stained glass, French and Italian painting from the 16th to the 18th century, plus a major collection of works by the 18th-century pastelist Jean Etienne Liotard.

Cabinet des estampes du musée d'Art et d'Histoire
5, PROMENADE DU PIN, 1204 GENÈVE

• A collection of over 300,000 prints covering 500 years of history. Works by Piranesi, Callot, Corot, Redon, Valoton, etc., as well as many contemporary printmakers (Van Velde, Baselitz, etc).

Petit-Palais-Musée d'Art moderne
2, TERRASSE SAINT-VICTOR, 1206 GENÈVE

• European art from 1880 to 1930 (Impressionism, post-Impressionism, cubism, school of Paris): Manet, Monet, Sisley, Renoir, Degas, Cézanne, Denis, Bonnard, Matisse, Léger, etc.

Lugano

Museo Cantonale d'Arte
10 VIA CANOVA, 6900 LUGANO

• An overview of European art in the 19th and 20th centuries: Degas, Renoir, Pissarro, Hodler, Schlemmer, Arp, Klee, Richter, etc.

Fondazione Thyssen-Bornemisza
VILLA FAVORITA, 6976 LUGANO-CASTAGNOLA

• The major trends in European art in the 19th and 20th centuries as represented by their most famous practitioners: De Chirico, Ernst, Freud, Itten, Larionov, Malevich, Marc, Masson, Munch, Schiele, etc.

Wintherthur

Museum Oskar Reinhart am Stadtgarten
STADTHAUSSTRAßE 6, 8400 WINTHERTHUR

• Oskar Reinhardt's collection notably

features Swiss, German, and Austrian artists, including works by Liotard, Fuseli, Böcklin, Segantini, Menzel, etc.

Zürich

Fondation E. G. Bührle

ZOLLIKERSTRASSE 172, 8008 ZÜRICH

• The collection assembled by the late E.G. Bührle includes medieval sculpture and art as well as paintings by Manet, Van Gogh, Gauguin, Cézanne, Monet, Renoir, Pissarro, Degas, Toulouse-Lautrec, etc.

Kunsthaus Zürich

HEIMPLATZ 1, 8024 ZÜRICH

 • Old masters, Swiss artists and modern and contemporary artworks by the likes of Fuseli, Böcklin, Hodler, Valloton, Munch, Kokoschka, Corinth, Matisse (sculpture), Picasso, Ernst, Miró, Bacon, Baselitz, Penk, Kiefer, among others.

Schweizerisches Landesmuseum (Musée national suisse)

MUSEUMSTRASSE 2, 8023 ZÜRICH

• The Swiss national museum boasts a varied collection (ceramics, costumes, jewelry, furniture, painting, sculpture, etc.) presenting multiple facets of Swiss history and culture.

For more information: www.divento.com
Divento.com, international cultural web site, makes it easy to discover the museums of large European cities. Divento.com describes and details the history of the collections of the museums it lists. It also offers a ticketing service on line for easy access to the exhibitions.

Index

Pico della Mirandola, Giovanni (Ferrara 1463-Florence 1494), Italian philosopher, p. 108

Piero della Francesca, (c. 1416-1492), Italian painter, p. 100, 124, 134

Pietro da Cortona (Cortona 1596-Rome 1669), Italian painter and architect, p. 170

Pilon, Germain (Paris c. 1537-1590), French sculptor, p. 124

Piranese, Giovanni Battista (Mogliano di Mestre 1720-Rome 1778), Italian artist and engraver, p. 156, 157, 211, 232, 233, 236, 238

Pisanello, Antonio (Pisa c. 1395-1455), Italian painter, p. 140

Pissarro, Camille (Saint-Thomas 1830-Paris 1903), French painter, p. 253, 270, 272, 277, 294

Plato (Athens 428-348 B.C.E.), Greek philosopher, p. 118, 130, 258

Pliny the Elder (Como 23-Stabies 79), Roman naturalist, p. 93

Pliny the Younger (Como 61-c. 114), Latin writer, p. 101, 254

Poe, Edgar Allan (Boston 1809-Baltimore 1849), American writer, p. 262

Poelaert Joseph (Brussels 1817-1879), Belgian architect, p. 284

Pollock, Paul Jackson (Cody 1912-East Hampton 1956), American painter, p. 346, 348

Pontormo, Jacopo Carucci (Pontormo 1494-Florence 1557), Italian painter, p. 120, 133

Porta, Giacomo della (Porlezza 1539-Rome 1602), Italian architect, p. 169, 170

Poussin, Nicolas (Villers 1594-Rome 1665), French painter, p. 158, 184, 185, 254, 310

Pozzo, Andrea (Trent 1642-Vienna 1709), Italian painter, p. 161, 164

Primaticcio, Francesco (Bologna 1504-Paris 1570), Italian painter, p. 135

Proust, Marcel (Paris 1871-1922), French writer, p. 335

Pucelle, Jean (?- Paris 1334), French illuminator, p. 79

Puget, Pierre (Marseille 1620-1694), French sculptor and painter, p. 181, 182

Pugin, Augustus Welby (London 1812-Ramsgate 1852), English architect, p. 284

Pushkin, Alexander Sergeyevich (Moscow 1799-Saint Petersburg 1837), Russian writer, p. 250, 262

Quarenghi, Giacomo (Valle Imagna 1744-Saint Petersburg 1817), Italian architect, p. 234

Quatremère de Quincy, Antoine Chrysostome (Paris 1755-1849), French archaeologist and politician, p. 152

Quevedo y Villegas, Francisco Gomez de (Madrid 1580-Villanueva de los Infantes 1645), Spanish writer, p. 188

Rabanus, Maurus (Mainz 780-Winkel 856), Benedictine theologian, p. 29-30

Rabelais, François (La Devinière c. 1483-Paris 1553), French writer, p. 112, 145

Racine, Jean (La Ferté-Milon 1639-Paris 1699), French playwright, p. 192, 214

Raphael Sanzio (Urbino 1483-Rome 1520), Italian painter, p. 106, 120, 135, 140, 182, 184, 254, 258, 292, 294, 295

Rastrelli, Bartolomeo Carlo (Florence c. 1675-Saint Petersburg 1744), Italian sculptor, p. 230

Réattu, Jacques (Arles 1760-1833), French painter, p. 252, 255

Redon, Odilon (Bordeaux 1840-Paris 1916), French painter, p. 295, 296

Rembrandt Harmenszen van Rijn (Leyden 1606-Amsterdam 1669), Dutch painter, p. 174, 175, 185-187

Reni, Guido (Bologna 1575-1642), Italian painter, p. 184

Renoir, Pierre Auguste (Limoges 1841-Cagnes 1919), French painter, p. 251, 267, 270, 274, 277

Reynolds, Sir Joshua (Plympton 1723-London 1792), British painter, p. 235, 258

Ribera, Jusepe (Javita 1591-Naples 1652), Spanish painter, p. 184, 185

Ricci, Sebastiano (Belluno 1676-Venice 1734), Italian painter, p. 230

Richardson, Samuel (Derbyshire 1689-London 1761), British novelist, p. 210

Riemenschneider, Tilman (Osterode c. 1460-Würzburg 1531), German sculptor, p. 144

Riesener, Jean-Henri (Gladbeck 1734-Paris 1806), French furniture-maker, p. 227

Rigaud, Hyacinthe (Perpignan 1659-Paris 1743), French painter, p. 199, 200, 234

Rivas, Ángel de Saavedra, duke of (Cordova 1791-Madrid 1865), Spanish politician and writer, p. 262

Robert, Hubert (Paris 1733-1808), French painter, p. 238, 239

Rodchenko, Alexander Mikhaïlovich (Saint Petersburg 1891-Moscow 1957), Soviet painter, sculptor and decorator, p. 308

Rodin, Auguste (Paris 1840-Meudon 1917), French sculptor, p. 282, 283, 322, 328

Ronsard, Pierre de (Vendômois 1524-Saint-Cosme-lez-Tours 1585), French poet, p. 145

Rossetti, Dante Gabriel (London 1828-Birchington on Sea 1882), British painter, p. 294, 297

Rosso Fiorentino, Giovanni Battista (Florence 1494-Paris 1540), Italian painter, p. 135

Rothko, Mark (Dvinsk 1903-New York 1970), American painter, p. 343

Rousseau, Jean-Jacques (Geneva 1712-Ermenonville 1778), Genevan writer and philosopher, p. 210, 242, 263

Rousseau, Théodore (Paris 1812-Barbizon 1867), French painter, p. 266, 292, 295

Rubens, Peter Paul (Siegen 1577-Antwerp 1640), Flemish painter, p. 171, 185, 186, 298

Rude, François (Dijon 1784-Paris 1855), French sculptor, p. 282

Runge, Philipp Otto (Walgast 1777-Hamburg 1810), German painter, p. 263, 274

Ruskin, John (London 1819-Lancashire 1900), British art critic and sociologist, p. 298

Ruysdael, Jacob Van (Haarlem c. 1628-c. 1682), Dutch painter, p. 180, 266

Sabbatini, Niccolò (Pesaro c. 1574-1654), Italian architect and theorist, p. 161

Sablet, Jacques (Morges 1749-Paris 1803), French painter, p. 236

Saint-Simon, Louis de Rouvroy, Duke of (Paris 1675-1755), French chronicler, p. 177

Salvi, Niccolò (Rome 1697-1751), Italian architect, p. 198

Saly, Jacques-François (Valenciennes 1717-c. 1776), French sculptor, p. 230

Sansovino, Andrea Contucci (Monte san Savino c. 1467-1529), Italian sculptor, p. 96

Sansovino, Iacopo Tatti (Florence 1486-Venice 1570), Italian sculptor and architect, p. 148

Satie, Erik (Honfleur 1866-Paris 1925), French composer, p. 325

Schadow, Wilhem von (Berlin 1788-Düsseldorf 1862), German painter, p. 292

Schiller, Friedrich von (Marbach 1759-Weimar 1805), German writer, p. 263

Schleiermacher, Friedrich (Breslau 1768-Berlin 1834), German philosopher and Protestant theologian, p. 263

Schlüter, Andreas (Hamburg 1664-Saint Petersburg 1714), German architect, p. 230

Schmidt-Rottluff, Karl (Rottluff 1884-Berlin 1976), German painter, p. 329

Schnorr von Carolsfeld, Julius (Leipzig 1794-Dresden 1872), German painter, p. 292

Schobert, Johann (Silesia c. 1730-Paris 1767), German composer and harpsichordist, p. 234

Schönberg, Arnold (Vienna 1874-Los Angeles 1951), American composer, p. 331, 342

Schongauer, Martin (Colmar c. 1445-Brisach 1491), Alsatian painter and engraver, p. 112, 132, 135

Photographic credits

2000 The Oskar Schlemmer Theater Estate/Bühnen Archiv, I-28824, Oggebio: 331
ADAGP, Paris 2001: 302–303, 309, 311, 312, 313, 322, 327, 333, 336, 341, 344, 345, 351, 354, 355; Antoni Tapiés Foundation, Barcelona: 347; P. Goetlen/Denyse Durand-Ruel Archive 1975–77: 350; Mondrian/Holzman Trust: 307; Marcel Duchamp Estate: 317, 318.
AKG Photo, Paris: 7, 18, 46, 61, 71, 80–81, 87, 89, 91, 105, 106, 113, 127, 128, 156–157, 163, 171, 178–179, 180, 185, 201, 202, 203, 207, 213, 216, 219, 220, 228, 229, 232–233, 237, 240–241, 244, 245, 261, 275, 278–279, 283, 287, 297, 307, 309, 311, 318, 327, 335, 336, 337, 338, 339, 344, 345, 346, 347, 358, 359, 362, 372, 374, 389; British Library, London: 23, 27; Cameraphoto: 50, 149; Pierpont Morgan Library, New York: 62; Schütze/Rodemann: 25; Visioars: 26; Jean-François Amelot: 72; Orsi Battaglini: 95; Jérôme Da Cunha: 154–155; S. Domingié: 96–97, 133, 136, 142, 378; Stefan Drechsel: 69; Jean-Paul Dumontier: 30, 31; Hilbich: 21; Erich Lessing: 19, 22, 32, 51, 53, 57, 63, 68, 83, 86, 94, 98–99, 102–103, 107, 111, 125, 129, 137, 150, 167, 173, 174, 190–191, 196, 208–209, 212, 221, 224–225, 247, 249, 251, 259, 260, 264, 268, 269, 273, 326, 341, 361, 365, 368, 369, 371, 375, 377, 379; Gilles Mermet: 112
Artephot, Paris: 162, 175, 248, 380, 385
Association des frères Lumière, Paris: 293
Bauhaus-Archiv, Berlin: 306
Beinecke Rare Book and Manuscript Library, New Haven: 323
Bibliothèque nationale de France, Paris: 35, 47, 92
Bridgeman Art Library, Paris: 342
Walker Brooks/FMR, Milano: 146–147
Casa Buonarroti, Firenze: 141
Centre canadien d'architecture, Montreal: 41
Centre Georges-Pompidou, Paris: 313, 330, 355
Jean-Christophe Dartoux: 159
All rights reserved: 301
Fotowerksatt, Hamburg: 252, 358
Giraudon/Pix, Paris: 73, 116, 117, 123, 151, 153, 183, 265, 267, 319, 322, 373, 379
Laziz Hamani/Editions Assouline: 17, 20, 33, 39, 54
Courtesy Galerie Karsten Greve/Lucio Fontana Foundation: 349
Kröller-Müller Museum, Otterlo: 296, 385
MNAM, Centre Georges-Pompidou, Paris: 312, 333
Musée Nicéphore Niepce, Châlon-sur-Saône: 277
Osterreichische Nationalbibliotek, Wien: 15
Doges's Palace, Venice: 119, 143
RMN, Paris: 42, 158, 189, 195, 217, 223, 302–303, 368
Roger-Viollet, Paris: 64–65, 76–77, 168–169, 197, 256; Viollet Collection: 270–271
Keiichi Tahara/Editions Assouline: 257, 290, 291

Acknowledgments

The author would like to firstly thank Barbara for her patience and her steadfastness. He would also like to thank Camille Reeves and Maria Gutenschwager for their attentive readings, their questions and their remarks. Finally, he would like to congratulate Soko Phay-Vakalis, Nathalie Batton and David Rosenberg, as well as the Assouline team who had given birth to this book.

The publisher wishes to thank Laurent Bonelli, Catherine Couton-Mazet and Max Dhéry for their invaluable collaboration, as well as Fabienne Grévy (AKG Photo, Paris) for her assistance from the start of this project.